Altered Conditions

disease,
medicine,
and
storytelling

julia epstein

routledge / new york and london

Published in 1995 by
Routledge
29 West 35th Street
New York, NY 1001

Published in Great Britain by
Routledge
11 New Fetter Lane
London EC4P 4EE

LIBRARY OF CONGRESS CATALOGING-IN-PUBLICATION DATA
Epstein, Julia.
 Altered conditions : disease, medicine, and storytelling / Julia Epstein
 p. cm.
 Includes index
 ISBN 0-415-90717-9. — ISBN 0-415-90718-7
 1. Case studies. 2. Social medicine. 3. Medicine—Philosophy.
 4. Body. Human. I. Title.
 RC66.E67 1994 94-14893
 306.4'61—dc20 CIP
British Library Cataloguing-in-Publication Data also available

For my parents
Aubrey Epstein and Irene Raab Epstein

Contents

Acknowledgments ix

Introduction 1

1. *Defining Disease* 7

PRODUCING CASE HISTORIES 23

2. *Story, History, and Diagnosis* 27

3. *Case History and Case Fiction* 57

ALTERED CONDITIONS 77

4. *Ambiguous Sexes* 79

5. *Dangerous Wombs* 123

6. *Explaining AIDS* 157

Epilogue 185

Notes 187

Index 259

Acknowledgments

This book was researched and written with the support of fellowships from the Rockefeller Foundation and the National Endowment for the Humanities. I am grateful for the research leaves from my teaching duties at Haverford College that accompanied these grants. I have also received gracious help from librarians at Haverford and Bryn Mawr Colleges, Van Pelt Library and the Biomedical Library at the University of Pennsylvania, the National Library of Medicine in Bethesda, and the Historical Collections of the College of Physicians of Philadelphia.

It was at the College of Physicians of Philadelphia that most of the research for this book was conducted, and I want to thank Diana Long and Nancy Tomes, who were exemplary colleagues during the year I spent as a Rockefeller Humanities Fellow in Residence there. My colleagues at Haverford College have been wonderful friends and sounding boards. I would especially like to thank Kim Benston, Israel Burshatin, Kaye Edwards, Elaine Hansen, Aryeh Kosman, Anne McGuire, Randy Milden, Rajeswari Mohan, and Deborah Roberts. I owe an enormous debt to Haverford biologist Kaye Edwards and to the students in our course, "Disease and Discrimination." I also want to thank several classes of students at Haverford who have studied the relationships between medicine and literature with me. Audiences at Bryn Mawr College, Haverford College, the College of Physicians of Philadelphia, The Johns Hopkins University, Villanova University, the University of Pennsylvania, and the Yale University School of Law responded with suggestions that aided me in refining my views about disease and storytelling. My editor at Routledge, Cecelia Cancellaro, has been patient and helpful. I also want to thank Elsa Efran for smart, witty editorial assistance.

A number of friends, family members, and colleagues read portions of the manuscript or let me practice my theories in conversation with them and offered useful insights and suggestions: Barbara Bates, Estelle

Cohen, Aubrey Epstein, Irene Raab Epstein, Janet Golden, Ann Rosalind Jones, Nigel Paneth, Ellen Pollak, Mary Poovey, M. Elizabeth Sandel, Carroll Smith-Rosenberg, Peter Stallybrass, and Kristina Straub.

The heaviest debt I have incurred finds its expression in the endnotes. My ideas rest on a foundation built by historians, social and cultural critics, legal scholars, feminist and gay and lesbian thinkers, and literary scholars who have charted various pieces of the terrain I explore in *Altered Conditions*. I hope that this book will participate in a conversation about cross-cultural and cross-disciplinary approaches to social problems, in addition to contributing to our knowledge of the cultural past. I also believe that such knowledge can intervene in a world fragmented by differences and violence.

My deepest gratitude and love belong to the people who influence me the most, provide me with a loving haven, and make my life a pleasure—my partner Betsy Sandel and our precious daughters, Anna and Maria.

Earlier versions of some material have been published: "Historiography, Diagnosis, and Poetics" in *Literature and Medicine* 11(1) (1992): 23-44; "Either/Or—Neither/Both: Sexual Ambiguity and the Ideology of Gender" in *Genders* 7 (1990): 99-142; and "AIDS, Stigma, and Narratives of Containment" in *American Imago* 49(3) (1992): 293-310.

JE
Philadelphia

Introduction

I do not dwell solely in a human body, but also in an ancient and dilapidated flat in a decrepit alley submerged in garbage.
Naguib Mahfouz[1]

Western philosophy has grappled with the foundational question of the relation of the body to the self at least since Plato's discussions of form and matter. Late twentieth-century approaches to this question have included Michel Foucault's influential histories of sexuality and medicine, and post-structuralist discussions of the body as a "discursive formation." The body is a physical object and a biological entity; it also houses subjectivity and personhood. We live within our bodies, and we invest our bodies with history and meaning. This book makes only oblique attempts to rethink large philosophical ideas that have long histories in Western thought. Its aim, rather, is to pose particular questions about body and self. How has Western culture produced explanatory narratives about the body within the domain of medicine? How are medical narratives instrumental in the production of embodied stories in the law, in social ideologies, and in human experience?

Modern biomedicine presupposes that the body's anatomy and physiology can be probed, decoded, and explained at a remove from the individual's production of meaning within that body as it operates inside culture. Patients in the health-care system frequently internalize this conceptualization of the body as they come to view their bodies as war zones.[2] In the biomedical model, disease is written on and in the body and can be diagnosed, explained, and treated by clinical interventions. Clinicians have long understood the importance of sociocultural factors in therapeutic success,[3] and recently cultural critics too have begun to question and to supplement the notion of a neutral biomedical model of disease. It is by now accepted that diseases are cultural artifacts and social

1

constructions as well as biological processes, and that individually, historically, and socially determined subjectivities impinge upon the relation of the body to the self.

Indeed, the role of medical technologies in formations of personal identity is widely recognized, with the most stunning example being the biosurgical capacity to alter sex assignment. Biosurgical technologies also play strikingly with fashion and art in the 1990s. For example, the "Styles" section of the Sunday *New York Times* for November 21, 1993, juxtaposed without comment two articles on this trend. The first examined the sudden "hipness" in couturier circles for body piercing and tattooing, fashions that have moved into the mainstream from the worlds of punk, S & M clubs, and the gay scene. Body decoration is ancient, of course, not to mention culturally ubiquitous. The *New York Times* article proposed two explanations for its reinvention in the postcapitalist West in the form of navel and nose rings, nipple studs, and tongue jewelry: a manifestation of increasing ethnic tribalism around the world, and a response to the loss of mystique in lingerie as a hidden pleasure "now that everyone knows Victoria's Secret."[4] These explanations, one globally political and the other about the loss of privacy in fantasies of desire, coexist uncomfortably. Perhaps they even cancel each other out.

The second *New York Times* article described an even more extreme form of skin art. It profiled the French multimedia perfomance artist Orlan, who has constructed a computer composite of a female face that takes each of its features from a different work of Western art: the forehead of Mona Lisa, the nose of a statue of Diana, the mouth of Boucher's Europa, the chin of Botticelli's Venus. In a series of elaborately staged and costumed cosmetic surgeries, she is having her own face transformed to match this composite. The operations are "performed" live (the surgeons have waived their fees). The most recent procedure, the first to be staged in the United States, was transmitted via an oversize video screen to an audience at the Sandra Gering Gallery in SoHo, literalizing the term "operating theater." This was Orlan's seventh surgical procedure. "It's a critique of beauty and a critique of cosmetic surgery," she says of her art. "I have given my body to art."[5]

Are these art forms or psychopathologies? Do they represent the sculpting of the self, or ritual scarification, or self-mutilation? In any case, they proclaim the malleability of the physical body in their efforts to push anatomic materiality to the limits of meaning. Skin art of this kind suggests a border skirmish between bodies and the cultures they inhabit,

much as cultural historian Donna Haraway describes the cyborg as a key player in the border war between body and biomechanism. Haraway defines the cyborg as "a kind of disassembled and reassembled postmodern collective and personal self." She writes, "We are all chimeras; theorized and fabricated hybrids of machine and organism."[6] For Haraway, the mind/body distinction is only one of many dichotomies—nature/culture; private/public; human/animal; self/other—that have fractured in the late twentieth century. The blurring of difference between physical and nonphysical and the capacity of machines to simulate consciousness artificially have fueled this fragmentation and dispersal of identities.

Despite the murky politics of late twentieth-century biocultural visions of the human body, a dichotomization of positions—the biomedical model of objective science versus the cultural model of social and ideological constructions—has calcified. Even within attempts to connect these positions, camps have emerged that suggest a postmodern reincarnation of the "two cultures" debate made famous by C.P. Snow in the late 1950s. As we face persistent ethical dilemmas imposed on us by our apparently unchallengeable belief that all scientific knowledge is "progress" and therefore to be pursued, it has become imperative that we demystify the splits among knowledge methodologies in various disciplines. The thorny questions raised by maternal surrogacy, fetal-tissue research, embryo cloning, assisted suicide, and gene therapy are not going to go away; nor are infectious diseases, disabling accidents, or the powerful mythologizing efforts we make to explain them. Phenomena such as body-piercing and the transmutation of plastic surgery into plastic art may, indeed, represent active ways of coming to terms with a proliferation of meanings for the human body in its multiple sexualities, ethical ambiguities, and new viral morbidities.

Political investments in individual autonomy accompany many questions about human embodiment, questions that are often posed in a proprietary language of liberation and personal choice: Who "owns" frozen embryos and has a "right" to make decisions about them? What is the best "choice" for a woman who learns she is carrying a fetus with a severe birth malformation? Human difference, however, does not always or necessarily or even usually involve choice. Bodies are imprisoned within their cultural circumstances at the same time that they participate in producing (and sometimes denouncing) those circumstances.

The body is also the site from which human beings act to achieve and to protest the normalizing practices—fashion codes, recreational styles,

and medical routines[7]—that dictate physical ideals. Actual bodies, of course, rarely manifest these ideals except on the airbrushed pages of glossy magazines. It is surprising then that normalizing practices have achieved any historical or social hegemony at all, given the dizzying array of sizes, shapes, colors, and definitions the human body comes in, even within particular cultures, ethnicities, and socioeconomic communities. Still, regulatory controls everywhere constrain the social deployment of human bodies. It is my contention that cultures produce explanatory stories about the human body in order to contain human beings safely within recognized social norms, to hold their anarchic potential in check, and to underwrite sanctioned cultural expectations, particularly about sexual practices.

Proliferating identity categories overlap and compete with one another and have become increasingly politicized. Contemporary body politics further vex the always difficult, even intractable, relations between self and body. Selfhood now has to be negotiated across categories of race, ethnicity, class, national origin, gender, religion, age, sexual orientation, and physical ability. Disintegrating political, ethnic, and national fault lines and governing systems in places as diverse as the former Soviet Union, the former Yugoslavia, the former two Germanies, Somalia, Haiti, Nigeria, Mozambique, Burundi and Rwanda are only the most recent signs that self-determination and the self/body relation are under extreme stress.[8] The death of one form of totalitarianism in the late twentieth century has spawned a political eruption of brutal ethnic power conflicts. These conflicts underscore the political stakes in the identity formations of marginalized groups.[9] The notions of selfhood, history, and reason often associated with European Enlightenment philosophy and political thought have given way to new kinds of disorder, insecurity, and uncertainty, and to concomitant new assertions of absolute identity boundaries.[10]

The atomization of peoples into ethnic identities that are in conflict parallels in many ways the fragmentation of the health-care delivery system into chilling "product lines," medical professions into subspecialties, and the human body into organ systems. Instead of moving toward a more unified understanding of *psyche* and *soma*—mind/self and material body as an aggregate economy of the human—the superspecialized organization of medical professionals works in the opposite direction. The growth subspecialites that carry the most prestige and highest earning capacities

are those that most anatomize and resect the human body: a different doctor for the ears and throat, the heart, the kidneys, the lungs, the urinary tract, the brain, the reproductive system, the eyes, the bowels, the bones. Microbiological researchers, too, isolate organisms in an effort to understand and control them. This research can only be removed from the laboratory and applied in clinically useful ways if its isolating impulses reassemble themselves into an approach to macroorganisms. Such reassemblage happens infrequently. We have become not selves or even whole bodies or human ecosystems, but rather compilations of organs and tissues and environmental habitats.

It is not too farfetched, therefore, to suggest a "governing" analogy between the body biologic and the body politic. As centralized national management conglomerates such as the Soviet Union have collapsed and have been replaced by smaller, more fiercely affiliated national entities, there have been enormous increases in refugees moving across international borders. In 1970, there were 2.5 million people in the world in this predicament. In 1993, there were 19.7 million international refugees— and another 24 million in exile within their own countries. The United Nations High Commission for Refugees reported in 1993 that one in every 130 people in the world is a political refugee.[11] Globally disenfranchised millions, cut off from their homelands, resemble, at least metaphorically, the disassembled body parts in which the high-tech biomedical system specializes. Our internal differentiations mimic an autoimmune disorder, as we madly try to locate and expel the antigenic foreign body.

This book begins and ends with acquired immunodeficiency syndrome (AIDS), the disease that cries out to be conjugated: it wastes, it is a waste, it is a wasting disease. My interest in stories about human ailments began at about the same time I was acquiring, with millions of others around the globe, a store of grief and anger over the loss of friends and acquaintances. Over the seven years that I have worked with the ideas presented in *Altered Conditions*, AIDS has become commonplace, an ordinary object in the landscape of postmodern blight, another chronic cancer produced by conjunctions of elemental taint: tainted blood, tainted water, tainted food, tainted air. Needles and sex make the picture more dramatic, even lurid, but drugs and sex are neither new nor newly lethal. AIDS stories are sedimented with the detritus of poverty, racism, and bigotry: sex for sale, the Western bestialization of an imagined "Africa," hate

crimes. AIDS crystallizes one intersection of bodies and storytelling in its relentless assault on personal identity as a risk factor and as a symptom of disease in which identity has been forced to participate. Reactions to AIDS have inspired an infectious language of leakage and containment.

Altered Conditions takes up two aspects of bodily containment. First, I look at definitions of disease, the history of medical record-keeping and patient narratives, and the applicability of theories of history, narrative, and ethnography to the telling of medical stories about the body. I also examine the narrative languages and discursive rhetorics of these stories. Until now, discussions of this material have taken place piecemeal and almost entirely in academic writings, and are scattered across a wide range of disciplines from anthropology to historiography to the social history of medicine to literary theory. I have tried to frame my analysis of disease and medical history in a way that is accessible to nonspecialist readers. (Specialist readers will find an extensive bibliography from all these fields in the notes, which others may wish to skip.) I sketch the history of medical storytelling and interpret examples from a variety of writings, both medical and literary. My aim is to make clear, or at least clearer, how cultural ideas saturate medical language, how biomedical conceptions of the body put pressure on social ideologies, and how much we take for granted the idea that we can establish an objectively defined delineation of the "normal" with respect to the human body. The second part of the book then analyzes three provocative medical diagnoses—hermaphroditism, birth malformations, and AIDS—to demonstrate in particular cases the ways cultural norms drive medical explanations and in turn are driven by them.

1. *Defining Disease*

We are all diseas'd,
And with our surfeiting and wanton hours
Have brought ourselves into a burning fever,
And we must bleed for it.
 Archbishop of York
 Shakespeare, *Henry IV, Part Two*
 Act IV, scene i, ll. 54–57

In an 1847 essay called "Standpoints in Scientific Medicine," German pathologist Rudolf Virchow wrote that "diseases are neither self-subsistent, circumscribed, autonomous organisms, nor entities which have forced their way into the body, nor parasites rooted on it." In other words, diseases do not stand alone. Rather, Virchow went on, "they represent only the course of physiological phenomena under altered conditions." The task of practical medicine, in consequence, is to maintain or to reestablish "normal physiologic conditions." To achieve this goal, medicine "presupposes a knowledge of the normal course of the phenomena of life and the conditions under which this course is possible."[1] "*All pathological formations,*" Virchow insisted in an 1855 account of cellular pathology, "*are either degenerations, transformations, or repetitions of typical physiological structures*"(p. 80; italics in original). Decades before the germ theory of disease became received knowledge, Virchow's writings repeatedly underscored his proposition that disease is merely "physiology with obstacles . . . healthy life interfered with by all manner of external and internal influences"(p. 81), that diseases are always "reducible to disturbances"(p. 100).[2] For Virchow, the difference between health and disease lay in an alteration not of essence but of conditions (p. 169).[3]

What is the importance of this way of conceptualizing disease? Preliterate cultures understood disease within a magico-religious frame-

work, as *object-intrusion* or *spirit-loss*.[4] The Hippocratic writings from the fifth and fourth centuries B.C.E. naturalized and individualized disease as an imbalance among the humors, an idea that went through multiple permutations but persisted in one form or another across many centuries in Western European, Arabic, and Asian medical traditions.[5] Not until the seventeenth century did a notion of physiologic systems begin the more than 200-year process of replacing humoral or tensional frameworks for explaining disease.[6] Since the seventeenth century in the West, the human body and its functions have come almost entirely under the aegis of a biomedical science that assumes the body obeys a mechanistic logic.[7]

Virchow offered his own answer to the question of why it matters how we explain disease. "If disease is only an orderly manifestation of certain phenomena of life, normal in themselves, that occur under abnormal circumstances, with deviations which are merely quantitative," he wrote in 1849, "then all treatment must be directed essentially against the altered conditions."[8] Without yet knowing about the operations of the immune system, Virchow intuitively understood that it is the body's response to disease, not the disease itself, that most affects individuals. It is from Virchow's canny definition of disease as an alteration of *normal* conditions of life that this book takes its title. Virchow distinguished between disease *etiology* and the *nature* of disease processes; together, cause and nature produce a set of interlocking circumstances that impinge on normal human life and function. Virchow's discussions raise questions about how we decide what counts as normal and what we label as abnormal.

Clearly, Virchow referred only to physiologic phenomena by the phrase "altered conditions." (Indeed, he later admitted that a person in prison suffered from changed conditions without necessarily having a disease.) But the terminology of physiologic conditions itself—the language we use to designate kinds of alterations from the normal—suggests that the human body is positioned within social categories that go beyond physiology. These categories are freighted with ideological investments in establishing normative conditions. Medical sociologists differentiate among the terms *disease* (a biological agent), *illness* (the individual's self-perception of a breach of health), and *sickness* (the placement of an individual within a socially constructed realm of disease and illness). These distinctions have proved useful, but I want to go beyond them to pose questions about the domain of *abnormality* to which medicalized persons are assigned by looking at the language of bodily norms. Hence, my concern here is with disease in its root form as *dis-ease*, as malaise and dis-

comfort with respect to sociocultural categories of the normal. I want to examine the processes and explanations through which some conditions but not others are classified as falling outside societal expectations.

The significance for the history of medicine of Rudolf Virchow's pioneering work in cellular pathology cannot be underestimated.[9] Virchow's influential writings participated in an important modern debate concerning the concept of disease. *Ontological* definitions of disease hold that diseases are separate entities with specific remedies. *Physiological* ideas of disease propose that disease represents not an isolated entity but rather a derangement of function. Although both conceptions consider an organic cause for disease, the physiological view accords more weight to the disease *process*. Virchow argued for the physiological view, which might also usefully be called a functional understanding of pathology and its ramifications for daily living. Virchow's definition of disease as inseparable from bodily and life function—as "the course of physiologic phenomena under altered conditions"—compellingly articulates the intersection between medicine and storytelling that I investigate in this book.

At about the beginning of the twentieth century, following in an oblique way the lead suggested by the work of Sigmund Freud and the experimental physiologist Claude Bernard, medical anthropologists began to propose a psychophysical idea of the body as more than the sum of its anatomy and its physiological functions.[10] Since World War II, a lively discussion concerning definitions of disease has appeared in academic journals on the philosophy of science and medicine. Most of these accounts make some place for extraphysiological circumstances and for the idea that disease is, in greater or lesser part, socially constructed. As early as 1945, medical historian Lester L. King defined disease as "the aggregate of those conditions which, judged by the prevailing culture, are deemed painful, or disabling, and which at the same time, deviate from either the statistical norm or from some idealized status."[11] Other, more recent definitions refer to "disorder" of "the minimal integrity of body and mind relative to prudential functions"[12] or to "a state of malfunction of body or mind."[13] But these definitions are so relative, so contingent, so vague, so dependent on how given terms (disability, disorder, malfunction) are culturally understood, that they do not help much when we try to make sense of, for example, a phenomenon such as the imputation of *drapetomania*—the running away of slaves—as a disease designation in mid-nineteenth-century America for a pathology peculiar to African-Americans.[14]

For definitions of disease to be useful for cultural analysis, they must

take the regulatory function of normativity into account. Why was it not enough, for example, to outlaw the escape of slaves? What cultural functions did pathologization add to criminal sanction? Anthropologist Emily Martin has pointed out that "the normalizing practices of bio-power define the normal in advance and then proceed to isolate and deal with anomalies given that definition."[15] In this view, which I share, the very idea of normativity is coercive. H. Tristram Engelhardt, Jr., a medical historian, offers a definition that begins to move in the direction of accounting for prescriptive ideologies of the normative. "The concept of disease," he proposes, "is used in accounting for physiological and psychological (or behavioral) disorders, offering generalizations concerning patterns of phenomena which we find disturbing and unpleasant. The concept of disease is a general scheme for explaining, predicting, and controlling dimensions of the human condition."[16]

Needless to say, the state of medical knowledge influences definitions of disease because increased information about physiology continually kindles renegotiations of the body in relation to culture. The germ theory and the discovery of viruses top the list of changes in information about disease that have occurred since Virchow proposed his notion of "altered conditions." These discoveries might be used to argue for the existence of autonomous disease entities that, in the pervasive military metaphors of biomedicine, invade the body and attack its defenses.[17] The discovery of antibiotics—nearly a century after Virchow first articulated his ideas about the cellular basis of all life—for a time launched great optimism in that most potent of military metaphors: the "magic bullet" approach to medical therapy. Gene therapy currently promises another paradigm shift in ideas about therapeutic power.

A political language of struggle also inheres in the distinction clinicians make between *colonization* and *infection*. The mere presence in the body of biological agents that can cause disease (pathogens) does not inevitably result in clinical illness. In fact, given the variable susceptibility of humans to diseases caused by particular pathogens, the variability of the capacity of different strains of microorganisms to produce disease, and the enormous number of microorganisms, pathogenic or not, to which the human body plays host, it is the exception rather than the rule when clinical symptoms occur. Much of the time human host and microorganism live together *commensally*—without prejudice or harm to either—or the microorganism *colonizes* the human host.[18] Colonization differs from infection in that it remains a benign asymptomatic state rather than an

acute clinical manifestation of disease.[19] This benignity contrasts sharply with the imperial sense of colonialism as a usurpation of resources and power, the unwanted incursion of an outsider into the host country's decision-making autonomy.

The initiating cause of a disease's altered conditions may indeed often be an isolatable entity: a mycobacterium (tuberculosis and leprosy), a spirochete (syphilis and leptospirosis), a gram-negative (cholera and whooping cough) or gram-positive (staphylococcal or streptococcal infections) organism, a parasite (malaria and leishmaniasis), a fungus (blastomycosis and aspergillosis), an arborovirus (yellow and dengue fevers), or an enterovirus (poliomyelitus). Other, less isolatable conditions may also provide a favorable environment for disease: an immune system dysfunction (allergy), an immunodeficiency (Wiskott-Aldrich syndrome), a hematologic disorder (hemophilia), a cardiovascular disorder (venous thrombosis), an endocrine anomaly (hypothyroidism), a connective tissue disorder (rheumatoid arthritis), demyelination (multiple sclerosis), an external agent (radiation poisoning), or trauma (fractures). This list does not begin to cover the range of disease etiologies. But whatever their cause, diseases remain *processes* that follow a *course*. Microbiologists and physicians need the specificity of causes, whereas individuals experiencing disease do so at the level of an altered relationship of their bodies to a world of social conventions.

The above list also raises a number of questions. What does our medical vocabulary tell us about the way we categorize bodily conditions? The isolatable entities have clear names: dengue fever or tuberculosis or influenza. We call identifiable processes that we understand or believe we will, in time, come to understand (diseases of "unknown etiology") *diseases*. But what of syndromes, disorders, anomalies? Is there anything that distinguishes between and among these terms and defines their designations of dysfunction beyond their uniform reliance on an apparently agreed-upon but never defined notion of the normal? Disorder implies an idea of order; anomaly suggests something from which a deviation has occurred; disability is an absence of ability.[20] The well-intentioned replacement phrases "differently abled" and "physically challenged" do not address this basic reliance on negating an assumed norm—different from what?—that begs definition. The *normal*, even when understood to represent a curve or continuum, remains an inchoate conception of lack of difference, of conformity, of the capacity to blend in invisibly.

Other questions too are raised by the way we classify bodily differ-

ence. What cultural norms in the West explain, for example, why we understand the practice of male circumcision to be medically routine whereas we find female circumcision horrifying? Why ear-piercing is an unremarkable fashion practice whereas tongue-piercing is labeled as perverse? Why we put eyebrow-plucking, suntanning, and liposuction under the rubric of style but mark foot-binding and scarification as mutilations? These are utterly arbitrary but also powerfully real distinctions.

How do we assign categories to bodily conditions that do not represent what a given culture at a given time holds to be normative about a human body? Subtle, complicated, and fuzzy boundaries delimit what we make of conditions that are not life-threatening, are chronic and therefore normative for a particular individual, or are part of the contested idea of "normal" aging. Where in our system of bodily classifications do we place a person who is missing two fingers on one hand? Who has an extra X chromosome? Who is blind in one eye or deaf in one ear? Who has mild cerebral palsy? Who wears a limb prosthesis? Who carries the gene for Huntington's disease? Whose memory is not as acute as it once was? Are these people ill? How and why? In answering these questions, how do we factor in adaptations to whatever disabilities, if any, a person's conditions entail? What sociocultural functions do our labels and our medicalizations of certain but not all "altered conditions" perform? How do we arrive at these labels?

We can frame the problem these sets of questions raise within our current most pressing global epidemic of human immunodeficiency virus (HIV) and acquired immunodeficiency syndrome (AIDS), the subject of Chapter 6. Simultaneous diagnoses of Kaposi's sarcoma, thrush, and cytomegalovirus in a person who is seropositive for HIV and has a T-cell count of 28 would meet any criteria for disease. This person with what is often referred to as "full-blown AIDS" decidedly manifests an incidence of "the course of physiological phenomena under altered conditions." At this writing, we can treat only the separate opportunistic infections. The opportunity these infections capitalize on is an altered condition par excellence—the HIV infection that decimates T-cells. But AIDS is called a syndrome rather than a disease in official medical parlance because it represents a heightened susceptibility to and accumulation of infections instead of a single predictable disease process such as bubonic plague, the Black Death to which the social devastation of AIDS has been compared.[21]

HIV infection and AIDS are often merged in ways that erase distinctions. Nevertheless, AIDS requires as its *pre*condition an altered circumstance that is not itself a disease: HIV seropositivity. The asymptomatic person who is HIV-antibody positive and has a T-cell count of, say, 800, is not ill in any of the usual senses. Here is a concise way of stating the problem: With respect to social categories, persons with HIV infection are morally dangerous whereas persons with AIDS, while we do not cede their moral dangerousness, reside more thoroughly in the realm of the medicalized physically ill.

HIV-positive persons also suffer (a verb I choose deliberately) from altered conditions. Their future is tenuous at present, certainly, and the social stigma attached to AIDS forces them to face decisions about whether to reveal their serostatus, when, and to whom.[22] In a different but analogous way, a healthy person who uses a wheelchair for mobility, wears a patch over a missing eye, or communicates with American Sign Language also suffers from altered conditions, not just of range of motion or peripheral vision or hearing impairment but also of self-image and social perception. The common experience of people in wheelchairs that they are looked over or through makes it clear that their suffering derives from a fundamental irony: Their *visibility* as different produces a special kind of public *in*visibility. They often find themselves almost literally erased because others refuse to see them. What is at stake when we place such people—who may function successfully at home and at work, in public and in private—in the category of the diseased? There may often be sound reasons for these people to be evaluated and treated by the medical system, but their medicalization alone provides only the beginning of an answer to this question. We can better understand our categorizations when we admit that it is the people standing upright on their own legs who feel difference or dis-ease in the presence of a person in a wheelchair.

Only through a comprehensive approach to the interconnections between biological agents and social conditions can we begin to analyze the cultural functions of medical storytelling. One model for such an approach exists in the literature of a relatively new (post–World War II) medical specialty, Physical Medicine and Rehabilitation. Health-care providers in rehabilitation medicine use a multidisciplinary team approach to patient care in an attempt to integrate their patients' medical, cognitive, psychological, occupational, and social needs. For a long time, there

was no standard language for disability categories treated within this specialty[23] In 1980, the World Health Organization in Geneva published the *International Classification of Impairments, Disabilities and Handicaps: A Manual of Classification Relating to the Consequences of Disease.*[24] The WHO distinguished between *impairment* (organ dysfunction), *disability* (difficulty with tasks), and *handicap* (social disadvantage).[25] *Impairment* refers to "any loss or abnormality of psychological, physical, or anatomical structure or function." *Disability* covers "any restriction or lack (resulting from an impairment) of an ability to perform an activity in the manner or within the range considered normal for a human being." A *handicap* is "a disadvantage for a given individual, resulting from an impairment or a disability, that limits or prevents the fulfillment of a role that is normal (depending on age, sex, and social and culture factors) for that individual."[26] These definitions explain nonphysical circumstances such as "social and culture factors" and suggest that normality falls within a "range" rather than constituting a static state. Nevertheless, the terms still rely on an assumed agreement, given shared sociocultural circumstances, on the category of the *normal.*[27]

The National Advisory Board on Medical Rehabilitation Research in the United States published a new discussion of the terminology used in disability classifications in 1993. The Board "rejected a linear model of pathology, impairment, functional limitation, disability, and societal limitation because the progression is not always sequential or unidirectional."[28] The National Advisory Board added the term "societal limitation" to the lists of categories used by the World Health Organization as a separate aspect of the problems faced by disabled persons. They argue that "the scientific enterprise needs to turn its attention to the functioning of the whole person within our society"(p. 47). Their table showing "Terminology in Disability Classification" (Fig. 1) distinguishes between effects on persons with disabilities as against the impact of disability on the able-bodied. Here, too, definitions assume a notion of the normative. Pathophysiology refers to "interference with normal . . . processes or structures"; impairment entails "abnormality . . . of structure or function"; disability is gauged against "levels expected within physical and social contexts"(p. 33).

The National Advisory Board provides a telling example of the uses of normativity. Here is part of their discussion of research on loss of function in adults:

CLASSIFICATION SCHEMA PROPOSED BY	Impact on the Person with Disability				Impact On Others
WHO	Disease	Impairment	Disability	Handicap Disadvantage in Life Roles	
NAGI DISABILITY IN AMERICA MODEL	Patho-physiology	Impairment	Functional Limitations	Disability	
PHS TASK FORCE	Underlying Cause	Organ Level	Person Level	Interaction of Environment on Person	Family Community
NCMRR	Patho-physiology	Impairment	Functional Limitation	Disability	Societal Limitation

Pathophysiology: Interruption of or interference with normal physiological and developmental processes or structures.

Impairment: Loss or abnormality of cognitive, emotional, physiological, or anatomical structure or function, including all losses or abnormalities, not just those attributable to the initial pathophysiology.

Functional Limitation: Restriction or lack of ability to perform an action in the manner or within the range consistent with the purpose of an organ or organ system.

Disability: Inability or limitation in performing tasks, activities, and roles to levels expected within physical and social contexts.

Societal Limitation: Restriction, attributable to social policy or barriers (structural or attitudinal), which limits fulfillment of roles or denies access to services and opportunities that are associated with full participation in society.

Figure 1. National Center for Medical Rehabilitation Research, Terminology in Disability Classification (1993)

From *Research Plan for the National Center for Medical Rehabilitation Research*, National Institutes of Health, U.S. Department of Health and Human Services, NIH Publication No. 93-3509 (March 1993): 33.

Research on the restoration of function in individuals with later onset of disability obviously makes use of the knowledge of normal functioning; for example, comparing the gait of an amputee with the gait profile of a non-amputee. Another approach in medical rehabilitation research is to compare functional capacities of individuals with disabilities to their own reference group: comparing the gait of the amputee with that of other amputees who developed gaits which meet their daily needs but may not emulate the appearance of normal gait. The goals of these approaches may be quite different. In the first case, using normal gait as a basis, the goal may be to have the amputee appear to walk in a normal fashion to improve his or her self-image and gain acceptance in the larger community. The second approach might focus on reduced energy expenditure to provide more time and energy for other aspects of the individual's life. Treatment goals could be based on studies of amputees who have developed a functional gait. This optimal functional gait would be the basis of a model for developing a training method for the amputee to reach the greatest level of prosthesis utilization. (p. 45)

What, after all, is a *normal* gait for an amputee? Is it the gait of a non-amputee, or a gait that offers optimal function? Is the goal to achieve the *appearance* of normality, to hide the amputation? Or is it to achieve the greatest mobility and comfort?

It is not useful to discount the enormous social advantages of a conforming appearance. Nevertheless, in an ideal world, the gait that achieves optimal function without pain or instability for that reason alone should earn the status of being normal for that individual. Definitions of the normative must change along with changes in bodily function, so that concepts of the normal represent not a specific point but rather a continuum dependent on circumstances and cultural variables. The two approaches outlined in the National Advisory Board's *Research Plan* clearly present the problem: the price of normal appearance may be inadequate function and/or discomfort at the expense of social acceptability; the price of optimal function may be the loss of normal appearance and therefore consignment to the realm of abnormality and dis-ease.

It would seem, then, that our shared assumptions about normality and abnormality with respect to the human body and its functions depend on how we explain disease, whereas disease explanations, in turn, rely on a prior understanding of bodily or embodied norms. This circular chain of reasoning holds the key to another element in our understanding of the

body in its sociocultural contexts. We somatize social mores and cultural assumptions by thematizing bodily structures and functions. In other words, disease explanations almost always take the form of stories, of narratives that create medical and social categories by assigning cause and effect to the human body's signs and symptoms. AIDS provides the most recent example of somatic narrative.

▼ ▼ ▼

AIDS offers a special case of the socially prescriptive construction of the normal curve. A move from HIV seropositivity status to Person With AIDS status—from danger to illness, or from moralization to medicalization—is not easy to track, and its designations have been officially revised by the Centers for Disease Control in Atlanta. Social fears about HIV transmission, indeed, have constructed a powerful story that relegates people with AIDS to a premorbid status as abnormal. Unless you can prove that you are an "innocent victim," something must have been wrong with you from the start for you to have contracted this disease.[29] A 1991 article in a medical journal opens with a sentence that underlines the dichotomy between disease and health on which cultural conceptions of the normal depend. "In only a decade," this article begins, "the acquired immunodeficiency syndrome (AIDS) has evolved from a novel immune deficiency disorder of unknown etiology in homosexual men to an infectious disease of pandemic proportions that has challenged the basic fabric of society."[30] Note that in this formulation, AIDS as it affects gay men is a disorder, whereas it becomes an infectious disease caused by a blood-borne pathogen when it affects anybody else.

The AIDS epidemic has spawned a discourse of normative prescriptions that makes clear a cultural dependence on dividing the diseased from the rest of the population. This sentence implies that "homosexual men" do not participate in "the basic fabric of society." The authors of this otherwise important and humane overview of the role of rehabilitation medicine in treating AIDS patients and those who are HIV-antibody positive[31] reproduce one of the narratives about AIDS in the United States, which goes something like this: It was for a while an obscure set of diseases experienced first only by gay men and then also by intravenous drug users and so not much worthy of concern, but now it has leaked out of those groups through their irresponsible infiltration into mainstream society and its blood supply, and it threatens all of us.

A number of things must be remembered as we look at manifestations of this AIDS story such as the sentence in the medical journal, a sentence that proposes an AIDS trajectory from obscurity to prominence. Interestingly, this sentence echoes the language of a sentence in an early article in the gay press that exhorted members of the gay community to change their sexual activity in radical ways because the liberatory sexual practices of the 1970s "now threaten the very fabric of gay male life."[32] The language of textile-rending continues to articulate social perceptions about AIDS. The author of a demographic study of population decline in some urban areas on the African continent due to growing numbers of AIDS deaths spoke in August 1991 of an attack by the epidemic on "the very fabric of society."[33]

Perhaps this metaphor of tearing a fabric recurs so frequently because it also suggests, yet at the same time occludes, the rending of coverings in general, from the drapery that hides private fissures in the body's surfaces to the epithelial membranes whose intactness signals innocence and, therefore, safety from infection. However, the social fabric, it turns out, was already torn. As we uncover more of the early history of HIV infection, it becomes clear that by at least the 1970s the virus was already making major inroads into the immune systems of a number of diverse populations in the United States (the retrospectively diagnosed epidemic of "junkie pneumonia" in New York City in the late 1970s, for example[34]) and had for some time been causing devastation in several countries in Africa. President Ronald Reagan may have been unable to utter the acronym for the syndrome, but by 1981 there was already an AIDS epidemic.

Implanted in many narratives of AIDS is the notion that the groups first affected by HIV are to blame for not containing the virus within their already morally contaminated communities. From 1981, when the syndrome was tellingly dubbed GRID, for gay-related immunodeficiency, the search for an explanation of this medical phenomenon was a search for etiology—origins and causes—rather than for therapies or treatments. Both kinds of investment, of course, need to be made; effective therapies and eventually vaccines depend on an understanding of the virus itself. The etiological search yielded the discovery (itself a contested moment in biomedical research) of a virus (HIV is still confusingly referred to as the "AIDS virus"), a discovery announced officially in the United States by Secretary of Health and Human Services Margaret Heckler on April 23, 1984. The identification of the virus led to assays that could locate its pres-

ence in the bloodstream, the ELISA and Western Blot tests. Subsequently, public-health initiatives in Western countries placed a greater emphasis on testing for HIV antibodies and identifying and policing "carriers" than on preventing HIV infection or providing housing, nourishment, or home-care services for people living with AIDS.[35]

The HIV virus itself has intriguingly motivated mainstream media presentations of the epidemic. It is a particularly slippery entity. HIV continually mutates, renews, and transforms itself, thereby eluding efforts to find a vaccine effective against it. This virus has been anthropomorphically rendered as slick, intelligent, and perverse by journalists seeking to explain its operations in lay terms. Similarly, those who have been most affected by HIV have been increasingly understood as participants in narratives of contamination, transgression, contagion, guilt, and blame, despite the fact that although HIV is communicable it cannot be accurately described as contagious—that is, one individual cannot transmit it to another through casual contact.[36] Although HIV infection clearly represents a medical rather than a theological scourge, people who are seropositive and those who are living with the physical manifestations of AIDS are frequently shunned. We seem to require of our bodies and our illnesses that they tell revelatory stories, and HIV infection in what have been dubbed "risk populations" has been read as an elective contaminant. This election comes as a result of a prior choice to reside in the realm of the abnormal. To become ill with AIDS is to have been sick all along.

▼ ▼ ▼

Human bodies are "carriers" not only of pathogens but also of stories that explain our lives. My premise in this book is that narrative desire—the human drive to tell stories—underlies the ways we construct the so-called normal and the aberrant, and the ways we explain disjunctions between the two.[37] The AIDS epidemic houses individual tragedies that unfold daily. AIDS and other medicalized experiences of the human body are configured socially as aberrations. My effort to analyze collective cultural narratives about these conditions is in no way intended to diminish the human pain of the AIDS epidemic or of difference from perceived norms and normative social expectations. On the contrary, I want to argue that human lives are shattered by the explanatory stories we tell as well as by physical difference and illness. In the late twentieth century, AIDS conveys that shattering most obviously. Individuals living with AIDS and those caring for the ill and dying ride a rollercoaster of pain, fatigue, and stress. But they

are also everywhere buffeted by the explanations cultures produce to make sense of a senseless assault on the body's immune systems, to make a particular and politically motivated tyranny of an undiscriminating virus.

Narratives, whether medical, ethnographic, fictive, or historical, come into being for certain reasons and demand certain kinds of interpretive practices. Clinical medicine as an institutional discourse both uses storytelling as a central facet of its professional procedures and produces stories by bringing certain kinds of social phenomena under the umbrella of medical expertise. In clinical medicine as an institutional activity, and in the clinical case studies I take up in Chapters 4-6, storytelling derives from and turns back to the human body in an effort to explain bodily processes and the physical manifestations of what is deemed under certain circumstances to be social deviance.

A highly charged sociocultural politics saturates medicalized explanatory narratives. The social distress of some diagnoses is fueled by their medicalization, and perhaps also prompts the medicalization in the first place. I would like to call these disease narratives medicocultural diagnoses. One result of the level of social disruption created by these diagnoses has been that medical explanations have been joined by the production of other kinds of explanatory narratives in an effort to rein in the threatening aberrational potential of the human body.

Any given human body may be a discrete physical object, but conceptually the human body participates in the collective architecture of a larger social body. This larger body cannot be cordoned off from ideological forces. It cannot be understood to be apolitical or to stand outside the vicissitudes of historical social systems and beliefs. Hence, efforts to understand and to control any given human body in its interactions with other bodies—the task of public-health policy, for example—participate as well in the inevitably political nature of bodies. "To speak of public health policy as if it could be apolitical represents an effort to mask the play of social forces appropriately called forth in the making of decisions affecting the communal welfare," writes public-health historian Ronald Bayer, who goes on to assert that "facts alone do not dictate the course of public health action" and that "the body with which the public health is concerned is no mere passive organism upon which neat clinical maneuvers can be performed. Rather it is the body politic itself."[38]

Philosopher of science Sandra Harding makes an even more far-reaching statement about the politics and metaphors of claims for a value-neutral science:

Humans construct themselves as possible objects of knowledge and have also constructed inanimate nature as a possible object of knowledge. We cannot "strip nature bare" to "reveal her secrets," as conventional views have held, for no matter how long the striptease continues or how rigorous the choreography, we will always find under each "veil" only nature-as-conceptualized-within-cultural projects; we will always (but not only) find more veils. Moreover, the very attempt to strip nature bare weaves more veils, it turns out. Nature-as-an-object of knowledge simulates culture, and science is part of the cultural activity that continually produces nature-as-an-object-of-knowledge in culturally specific forms.[39]

So whereas the human body can be described as an aggregate of organs and fluids and physiological processes, it is more than that. It is also a cultural surface onto which have been mapped social expectations and ideological meanings. As Harding goes on to say, "The objects of knowledge . . . never come to science denuded of the social origins, interests, values, and consequences of their earlier 'careers' in social thought"(p. 74).

The cases examined in the final three chapters of this book have been selected because they exemplify so strikingly what Harding dubs the scientific striptease, the undressing of the physical human body that discloses not only physiologic operations but also the nature of social stigma read from bodily stigmata. These cases represent kinds of bodily disruptions to the normal that signify sociocultural as well as medical anomalies. Hence, narrative explanations of these anomalies have striven to reassure a generically normal group designated as the "general population" and to bracket the conditions as abnormal in order to minimize their potential for social threat.

In the West, from antiquity through the eighteenth century, the historical understanding of hermaphroditism classified deviations from the normal as monstrosity. During this period, explanations for malformed births shifted the terrain in defective births from monstrosity or teratology to human psychopathology in relation to fetal development. These malformations constituted social threats and deviations from the normal that were understood to require containment. AIDS also represents a threat to the human body, but this threat *derives from* deviations from the norm in the social explanations it has spawned, rather than *resulting in* such deviations. In all these cases—hermaphroditism, malformed births, AIDS—one crucial issue concerns the ascription of blame.

In the late twentieth century, infants born with ambiguous genitalia or endocrinological changes that affect their gender assignment are artifi-

cially assigned or reassigned a new gender in the hospital, and thereafter remain invisibly in this assignment. Pregnant women are discouraged from drinking alcoholic beverages or exerting themselves in sports arenas, and in earlier centuries they were literally "confined" to their homes. For many individuals who die of complications from AIDS, the ailment is never named. Their families produce alternative explanations for their deaths, and their obituaries in the mainstream press—when they are accorded obituaries at all—ignore cause of death or speak euphemistically of "a long illness." Young men with Kaposi's sarcoma lesions on exposed parts of their bodies often fear the virulence of public response to their marked bodies so much that they venture outdoors as little as possible. It is not coincidental that certain bodily deviations that call forth explanatory medical narratives are seen as so fearsome that we have collectively tried to render them invisible and have largely succeeded in erasing from social space anyone who can be labeled abnormal or deviant. One of the functions of explanations *is* precisely to categorize threats to the social body so that they seem to go away, or so that at least they are bracketed, set aside, or driven underground.

Other examples of medicalized threats that have been made virtually invisible on the street abound. Women with breast cancer, masked by nonfunctional implants and prostheses,[40] and pre-operative or post-operative transsexuals who "pass" suggest two possibilities for further investigation of the stories cultures tell when bodies, or more to the point perhaps, social categories, are threatened. Multiple Personality Disorder, a controversial psychiatric diagnosis, and the eating disorders anorexia nervosa and bulimia, are also among the medical categories whose historical and cultural constructions need to be unravelled (the medicalization of homosexuality, an obvious case, has received wide attention).[41] In the deployment of each of these medicocultural diagnoses, it is clear that social ideologies inhere in human bodies. We have tended to answer challenges to social taxonomies by physically articulating a sign system of the body politic. Before analyzing these three medicocultural diagnoses in detail, I want to look at the production of diagnostic thinking itself.

PRODUCING CASE HISTORIES

To understand the explanatory narratives engendered in clinical medical practice and then rewritten by the public cultures of normality and deviance, we need to begin with the clinical case history itself as a form of institutional writing. Physicians are storytellers. They interview and examine patients. From these interrogations, they produce a narrative of the patient's history—the case record. In modern Western clinical medicine, this narrative and its interpretation form the core of the diagnostic process. The physician is a historian (*histor*) in a very basic sense: a chronicler of bodily events and a systematic narrator of particular phenomena in a particular context. No simple annalist or compiler of data, the modern physician-historian relates a story that aims to yield a consistent and coherent interpretation: a differential diagnosis. Medical historians Guenter B. Risse and John Harley Warner have argued that patient records are central to the understanding of clinical practice and its contexts. They offer a systematic assessment of how these documents might be used in writing the history of medicine.[1]

Clinical storytelling relies on a chronology of bodily events. The patient subjectively experiences altered conditions—a sequence of disruptions to physiological functioning—and tells this experience to the clinician. The clinician then renders this account into narrative sequences. The process of producing differential diagnoses, therefore, comes to mimic in a variety of ways the process of interpreting other kinds of narrative stories. In other words, clinicians seeking to locate the causes of particular disruptions to the body bring to their task a set of intellectual operations conceptually similar to those used by literary critics, philosophers, ethnographers, and others whose job it is to interpret nonmedical narratives. It can even be argued that all human understanding is finally organized by and achieved through narrativity, that narrative can be said to underpin all Western epistemologies.[2]

Such assertions sounded outlandish a few years ago. Physicians hardly wanted clinical thinking to be compared to the impractical and nonempirically verifiable disciplines of the humanities and social sciences. The human body, after all, however complex its anatomy, physiology,

and biochemistry and however ornery its placement within social ideologies of behavior and morality, remains a concrete object, not a product of the aesthetic imagination or a manifestation of social practices. But recently, respected scholars and historians have begun convincingly to examine the literary potential of medical narratives understood in the broad sense that medicine tells and interprets stories.[3] The notion that fictive and clinical narratives might bear relation to one another has begun to seem less radical and more conceptually useful for an understanding of clinical thinking and the social functions of medicalization.

By their structure and underlying assumptions, case histories present a notion that the human body can be known through etiological narrative, stories that reveal origins. As a consequence, disease etiology serves as an analogue to epistemology: Knowledge of the body comes from an understanding of the causes that disrupt its normal functioning. The best narrative is an efficient narrative: ideally, there is a one-to-one correspondence between causes and effects. Clinicians try to avoid messy cofactors and overdetermination in medical explanations. The case history represents a key aspect of the diagnostic process in clinical medical thinking, as well as the role played in diagnosis by the construction of narratives that map the trajectory of illness and health.

An examination of the medical case history as a special kind of historiography demonstrates that case-writing provides a logical documentary foundation for differential diagnosis. There are rhetorical or formal operations as well as medicolegal protocols that enable the case history to contribute to medical knowledge. The patient history can be examined, in fact, as a problem in the codification of knowledge: How have the forms and procedures of the case record evolved? What motivates medical record-keeping? How do the narrative strategies of the case record operate? Although important work has been done in this area, by Stanley Joel Reiser as well as by Risse and Warner, no comprehensive history has yet addressed the evolution and motivation of record-keeping in medicine from its Hippocratic origins to the present.[4] It is my contention that the patient history as it has evolved contains—in its language, its form, and the uses to which it is put—reflections of prevailing assumptions about explanation in medicine.

2. Story, History, and Diagnosis

Thee I have heard relating what was done
Ere my remembrance; now hear me relate
My story which perhaps thou hast not heard.
 Adam to Raphael
 Milton, *Paradise Lost*
 Book VIII, ll. 203-205

Any standard formulation of the language conventions of a medical case history may demonstrate how prevailing beliefs about disease and diagnosis insinuate themselves into the patient record. Here is one example deemed by a medical educator to be good history-writing:

> Mr. Jones is a 47-yr-old white, Catholic, Irish-born, alcoholic, unemployed lens grinder with diabetes since the age of 12, married, with two teen-age daughters, but separated from his wife and family and living alone on welfare.[1]

This sentence contains two pieces of explicitly medical data: Mr. Jones has a history of alcohol use and has had diabetes for 35 years. Other data are clearly medically pertinent—age, sex, and perhaps race—or may affect Mr. Jones' ability to comply with or to pay for medical advice— he lives alone on welfare. But a patient's case history is a social document in addition to being a record-keeping device embedded in the development of medicolegal institutions. This is also a packed sentence, the terse account of an unhappy life.

There is a life plot in the recognizable standard sentence about Mr. Jones: He has been trained as a skilled craftsman but is not now working at his trade; he has been married and belonged to a family unit but now lives apart from his family. Perhaps his daughters can help with some emotional encouragement, though it is not clear whether he sees them,

and his Irish heritage and religion (identity as Catholic implies but does not guarantee faith) may generate a community of support for him. The separations from job and family have an analogous syntactic relation to each other and, because both are mentioned twice yet left unexplained, a parallel structure. Both represent losses and failures. Is all of this initial information necessary for a diagnosis? Perhaps. Certainly, identifying information is crucial for record-keeping, tracking, and medicolegal purposes. But in addition to its documentary function, this historical sentence also serves a narrative function. It is the first sentence of a story, a story that will focus (one presumes from the use of professional syntax) primarily on Mr. Jones' physical health, but whose discourse will also establish, as George Engel argues, "the uniqueness of the patient as an individual and [define] his place—the social matrix."[2]

The sentence about Mr. Jones, evocative of plot and pathos as it may be, also participates in an immediately recognizable mode of medical discourse. None of us would mistake it for the first sentence of a short story, which would more likely read something like "Walter Jones slumped in his chair, nursing his whiskey and worrying about where he would get the money for his insulin and whether Mary would ever love him again." The clinical sentence reconstructs this alcoholic Irishman whose wife, perhaps, finally got fed up and kicked him out: Poor Walter is now Mr. Jones, 47-yr-old white unemployed lens grinder and a discrete physical body to be interrogated and probed. He has come to the clinic for a specialized kind of surveillance. As Michel Foucault would have it, he is the subject of a "medical gaze" that alienates the body from the subjective person, that creates, in other words, the "patient" as a special type of person.[3] In this view, the uniqueness of the patient extolled by Engel gets lost as the patient becomes not an individual but a medical type. Although it is possible to question much of the controversial theoretical work on "medicalization," the sentence I have been examining cannot be seen as other than a *clinical* sentence.

How did we get to such a sentence? In his 1809 *Vade-Mecum*, physician Robert Hooper defined diagnosis as "the art of converting *symptoms* into *signs*."[4] This came to mean correlating bedside observation with pathological anatomy, and subjective manifestation with objective lesion.[5] But it also means transforming a patient's personal account of suffering into a professional medical discourse, converting inchoate subjectivity into an embodied and interpretable text. The process of conversion into a writable sign, the semeiological investigation that is diagnostic rea-

soning, eventually takes precedence over the fragments of human experience that symptoms represent.[6] In Hippocratic case-writing, diseases were understood to be symptom complexes and interactions between environment, individual, and situation, and they were also investigated semeiologically. By the nineteenth century, physicians gave a higher privilege to specificity and sought pathogenic agents. This gradual turn to specificity, and the shift in the authority inherent in who can read and interpret the human body that it represents, explains in part the unmistakably professional sentence about Mr. Jones, in which authority has moved from private experience to the public expertise of a medical discourse written by an "authorized" medical practitioner.[7]

Insofar as the case history records and renegotiates relationships between individual human beings and disease entities and processes, it also intervenes in the debates over the very concept of disease discussed in the previous chapter. Even the term "disease entity" is misleading, because a disease is not a thing but a complex relation among signs, symptoms, and causes, a structure that explains a particular set of organic conditions.[8] In addition, these relations cannot be understood without a knowledge of the explanatory systems they reflect. For example, Hippocratic case histories are organized around assumptions that differ from those that organize post-bacteriological case histories. Nosology relies on the accumulation of particular case histories that determine, in aggregate, a "natural history of disease." Because histories of the individual case and of the disease itself depend on reading signs and symptoms, it becomes necessary to ask about the reliability of these indicators and the ways in which they are reported and documented.

Are signs and symptoms biological objects only, or are they also products of social life? As philosopher Susan Bordo points out, the doctrine of informed consent is one part of the current Western health-care system that acknowledges that "the body can never be regarded merely as a site of quantifiable processes that can be assessed objectively, but must be treated as invested with personal meaning, history, and value that are ultimately determinable only by the subject who lives 'within' it."[9] If medical "cases" are socially as well as biologically constructed, then case histories participate in producing as well as recording what they observe.

In an argument that relates the medical case history to the novel, the parliamentary inquiry, and the autopsy report, historian Thomas W. Laqueur proposes that these kinds of writings developed in their modern form at around the same time (the eighteenth century), use bodily details

as their shared locus of sensibility, employ narrative form to present misfortune intelligibly, and operate along an axis of cause and effect that prescribes specific action against wrongs. Laqueur names these writings "humanitarian narratives" and suggests that their simultaneous appearance as new genres illuminates the way "the suffering bodies of others engender compassion . . . [that] comes to be understood as a moral imperative to take ameliorative action."[10] Laqueur uses the two published individual case histories of Hermann Boerhaave for his assertion that early medical reporting needed to make its truth claims credible by disassociating itself from the popular tradition of sensationalist tall tales concerning prodigies, monsters, miracle cures, and superhuman physical feats. He remarks on the surplus of circumstantial detail in Boerhaave's accounts:

> Boerhaave's readers know, for example, precisely what the man with the ruptured esophagus ate during his fatal illness, yet the narrator invites trust by admitting tiny gaps in his knowledge: he is unsure whether the sweetbreads were lightly roasted or fried, whether the duck that the patient swallowed but could not digest had been the breast or the thigh, whether the wine was from the Moselle or not.[11] (p. 183)

Although Boerhaave's approach might seem frivolous in its details to us, in the context of eighteenth-century diagnostic practices these details would have been regarded as important—different wines, for example, were thought to have different therapeutic values. In his presentation of the medical case report as a genre of literature, Laqueur presupposes a narrative consciousness in its composition.

History-writing itself, whether medical case history or Edward Gibbon's *The Decline and Fall of the Roman Empire*, shares with imaginative writing a foundation in classical rhetoric. Historians write their accounts either out of qualified conjecture based on inadequate evidence or out of a selection from a supersaturated series of events. Causal relations are frequently inverted, especially in medical histories, in that the meaning of any one event or symptom can depend on its sequelae. Effects lead back to precipitating causes or to forecasts of prognosis more frequently than originary episodes can be seen as leading to final outcomes. The latter movement appears only in retrospect.[12]

The question of the relation of historical explanation to explanatory mechanisms in science, a crucial relation for the clinical history, was raised in 1942 by historian Carl Hempel.[13] Later, W.B. Gallie, Arthur Danto, W.H. Dray, and other "narrativist" philosophers of history took up the

debate as centering on the function of narrative form in history-writing.[14] Most recently, philosopher Paul Ricoeur has forcefully argued that historicity and narrativity depend on one another and that history represents a discourse with a fundamentally narrative form because it derives from a plot that is traced and even determined by a *histor* or narrator. *Emplotment*, Ricoeur holds, is the discourse activity that transforms events into history. For Ricoeur, then, "history is both a literary artifact (and in this sense a fiction) and a representation of reality."[15] All historical understanding, in this account, is a narrative understanding. The inevitable next step from these notions of history as an activity of writing that is inextricably embedded in the vicissitudes of language is to read history not as documentary object but as linguistic code and as fictive subject.[16] If we give validity to these views of historiography, then we must take into account narrative strategies in any effort to understand the medical case history as a form of writing.

In the broadest sense, then, medical case histories engage the conventional features of historical and literary writing, that is, of narrative. As a consequence, a case report's success or failure as an authoritative account of the etiology and progress of disease constitutes a general paradigm for narratives of the human body. Clinical diagnosis, in fact, contains a narrative epistemology in its effort to encapsulate particular kinds of knowledge about the body. The case history's purpose is to narrow the possibilities for disorder by a rigidly structured account that moves from first impressions to hypotheses to firm diagnoses. Three factors enter the discourse of a case report as it has been taught to medical students since the 1890s: first, *symptoms,* or complaints—the patient's own subjective perception of deviations from normal health; second, *signs*—the objective manifestations of disease located by the physician during a physical examination; and third (and historically most recent), laboratory and other *findings.*[17]

The history is presented in a more or less standard order (there are variations, but they remain variations on a theme) that began to be established in the early nineteenth century and became codified in the last decade of the century as follows: (1) Identifying Information; (2) Chief Complaint; (3) History of Present Illness (HPI); (4) Past Medical History; (5) Systems Review (a conventionally ordered list of every organ system, noting all present or absent symptoms referable to that organ); (6) Family History; and (7) Social History. This composition differs fundamentally from other clinico-historical writings (for example, progress notes or dis-

charge summaries) in that its structure conforms to a standard. Even the relatively recent innovation of Weed's "problem-oriented patient record" (the SOAP technique: subjective data—the history itself, objective data, assessments, plans[18]) has historical roots in the nineteenth century. But whatever the system, now as earlier, the central section of the record— the HPI—presents a narrative. It draws together the patient's complaints into a series of logical diagnostic clues. These clues can then be pieced together into a recognizable "clinical picture."

The language of a patient history is as prescribed as its structure, and two crucial guidelines dominate. The "chief complaint" presented by the patient should, if possible, be transcribed in the patient's own words. (Physicians are instructed, for example, to beware translating "I get dizzy" as "Patient experiences vertigo.") Although all other sections of the report may be composed in telegraphic phrases, the HPI is written in complete sentences, a requirement stressed in medical textbooks to the point of exhortation. In the pedagogic literature of medical training, beginning in the nineteenth century, there is no doubt that this narration *as narration* embraces the heart of medical practice.[19] The complete sentence requirement for the HPI exists for a reason: Although a chronological list or set of jotted phrases, like the annals form of historical writing, can be read as a narrative, a list crucially lacks syntax, the written relationship between events and observations that builds clear bridges from fact to fact. It is syntax, in a sense, that undergirds diagnosis.

The HPI requirement for complete sentences is also worth looking at for its theoretical implications, for what it says about how the body can be "written up" into language—that is, into a sequential series of observations that follow syntactic rules. (Facts, findings, and laboratory results can be "written down" in list form; the history is "written up.") In this linear history, Western medical discourse postulates that disease can be dissociated from the ill person, at least momentarily (long enough, that is, to study, classify, and pass judgment on it). This dissociation takes place through the objectified sequencing of bodily events that the physician seeks to elicit from the patient and to impose in the history. Disease is described and understood as something on which it is possible to act or, in Rudolf Virchow's terms, on whose altered conditions of life it is possible to act. Indeed, the case history serves as the arena from which this action will emanate. The history's discourse, then, is technical and materialist.[20]

Corporeal experience, as other experience, comes to us *seriatim*, and the historian's task is to synthesize meaning from an assemblage of these moments and to sequence and prioritize the simultaneous. Narrative in history-writing is itself a form of explanation because it reconstructs a course of events.[21] Any assertion of causality in medical narrative, then, results in a story of improvement, of deterioration, or of oscillation between the two. Narrative history also implies continuity and isolatable causality. But whereas historical writing elides competing versions of the past, the medical case history has evolved into an explanatory process that aims at a differential diagnosis leading to several possible disease agents that might explain all symptoms, even as one singular explanation always represents the efficient ideal.[22]

Enlisting narration at all in a scientific discipline as a major problem-solving technique itself raises questions.[23] The right to narrate, historian Hayden White remarks, always hinges on some defined relationship to authority, but its use in science is suspect because science is "a practice which must be as critical about the way it *describes* its objects of study as it is about the way it *explains* their structures and processes."[24] Philosopher Louis Mink draws a related conclusion, arguing that science, unlike inherently narrative disciplines such as history, can produce what he calls "detachable conclusions," whereas historical assertions are "*represented by the narrative order itself . . . exhibited* rather than *demonstrated.*"[25] The case history as a genre of writing conceives of human experience in a particular way and seems to assume, as literary critic Steven Marcus has argued in a discussion of Freud's history of Dora (*Fragment of an Analysis of a Case of Hysteria*) that a healthy life embodies a connected narrative, a story with a proper linear sequence, whereas disease signifies, in part, an inability to give an adequate account of oneself and produces a narrative of disjunction.[26] Such an assumption oversimplifies the problem of constructing narratives that explain the human body.

Because the modern Western physician is constrained to elicit and produce an account that can yield at least a differential if not a firm diagnosis, the case report can never be read merely as a simple source of information, an analytic description. Case histories always implicitly interpret in the process of their narrative structure. In translating the patient's experience into a clinical "text," the physician must also interpret that experience to produce a diagnostic explanation, then persuade readers that this diagnosis is correct on the basis not only of evidence but also of

rhetorical appeal—the ways in which ruptures in the experience are filled in and in which reconstructions build a clinical picture whose mysteries have been solved. It is important to point out that only diagnosed disease that is fully understood in its physiological progression usually operates in this way—that is, runs an expected course, and even this expectation can at any time be disrupted in an individual case. Narrative truth rests not on evidence or actual events alone but on closure as well. One of the rules for producing the history is a rule that has been called "clinical parsimony"; that is, "the smaller the ratio of explanatory cause to subsequent effect, the better the interpretation."[27] In other words, one cause is better than many.

A theoretical problem of narration is that it ceases to be stable, simple, unfraught, and autonomous storytelling, as soon as we try to detach the told from the telling and thereby open up new epistemological questions.[28] For example, writing about his composition of *The Decline and Fall of the Roman Empire*, Gibbon commented on the falsifications to which problems in the telling may lead the historian. "I owe it to myself, and to historic truth," he wrote, "to declare, that some *circumstances* . . . are founded only on conjecture and analogy. The stubbornness of our language has sometimes forced me to deviate from the *conditional* into the *indicative* mood."[29] Like Henry Fielding, who repeatedly interrupts his "history" of the foundling Tom Jones with admonitions such as "Reader, take care," Gibbon admits the artificiality of his stance.[30] But he does not have the temerity of a Fielding, who deliberately acknowledges his reliance on literary convention and justifies his "new form of writing" (the novel, paradoxically) by arguing "I am not writing a system but a history, and I am not obliged to reconcile every matter to the received notions concerning truth and nature."[31]

The physician-historian cannot get away with this; "every matter" (what the patient had for breakfast, the chemical composition of the patient's urine) must be reconciled in the diagnostic process. The status of historical discourse, Roland Barthes has remarked, is uniformly assertive, certified or certifiable, established and verified. This is a discourse of facts that ignores its own linguistic material, that presumes that it represents a pure and neutral copy of the "real." It is as though the facts targeted by the historian's account of them have an existence outside the text that enfolds them. That text in medical case histories always represents a duality—because it is both a written object and the representation

of an inhabited body.[32] This doubleness produces a tension that derives from the case history's *sui generis* inwardness and that can be located in the contradictions among its presentational modes.

▼ ▼ ▼

In introductory clinical medicine courses, medical students receive exhortations to listen to patients because their words will reveal keys to diagnosis. Such exhortations are not new in Western medicine. The descriptive Hippocratic cases in Books I and III of the *Epidemics* probably inaugurated formal case-recording in the West, though some scholars argue that the Asclepian temple inscriptions count as the first case histories.[33] Other writings from antiquity such as Rufus of Ephesus' treatise "On the Interrogation of the Patient" suggest that anamnesis is not a modern art. The patient's narrative has always been regarded to be at least as important as physical signs (*semeia*) in the diagnosis of disease.[34] For example, the earliest medical and surgical papyri, dating to 2250 B.C.E., contain case accounts. Such records have also always revealed a great deal about their culture's understanding of disease etiology. Historian Gordon L. Miller points out that the construction of patient histories and internal disease lists in the Hippocratic Corpus performed a basic epistemological function in ancient medicine and made possible new forms of clinical knowledge.[35]

A voluminous case literature in which consultations begin with a *casus* or basic description of the patient's history exists for the Middle Ages and the Renaissance. By the sixteenth century, this practice resulted in teaching strategies that were akin to the later hospital clinical lecture.[36] The renewed interest in Hippocratic medicine in the seventeenth century—a medical practice based on interrogation and observation of the patient—resulted in the publication of many treatises on case-taking as well as portions of manuals of physic (clinical medicine) that outlined case-taking procedures. However, these works did not call for record-keeping in a systematic way.[37] The Genevan Théophile Bonet (1620-1689) argued in his "Office of a Physician," for example, for "[a] faithful and true account of the Diseases, their Causes and Symptoms" to derive from systematic patient interviews.[38] Peter Shaw, one of Thomas Sydenham's disciples, made a similar argument in his 1726 textbook, *A New Practice of Physic*.[39] Many manuals of physic of the period contained detailed semeiologies and categorized, as Galen's writings had before

them, the signs the physician was to note as diagnostic, prognostic, or anamnestic.[40] Hermann Boerhaave even claimed of semeiotics, "You had much better be ignorant of Anatomy, Chymistry, and Mechanicks, than this."[41] But not until the nineteenth century were these signs translated into particular techniques of notation and data organization in patient histories.

In his 1704 treatise on the *Practice of Physick*, Giorgio Baglivi, an Italian iatrophysicist who was one of the important early modern proponents of the crucial place of observation in physic, wrote: "Every young Student knows that he can't find a more learned Book than the Patient himself, whose Disease will quickly and faithfully lay open to the diligent Observer a great many things worthy to be known, that perhaps a tedious course of many years Reading would not bring to his Knowledge." This entire section of Baglivi's treatise is entitled "The preposterous reading of books." In his view, patients make the best and most useful reading. He went on to argue, "The patient affords a true and lively Description of the Disease; but Books make Fictitious and Deprav'd Histories, by a Redundant Jargon of Fallacies and vain Speculations."[42] Baglivi divided physic into two species, the history of diseases and the cure of diseases. It is the first—his dedication to nosography—that is pertinent here. The "pure History of Diseases," he wrote, could only be obtained "by sole Observation at the sick Man's Bed, and related by the Patients themselves" because medicine could only be conceived as a "Science, or Fund of Knowledge" insofar as it relied on observation and on "the Narratives of sick people" (p. 206).

In the course of these suggestions, Baglivi proposed some techniques for writing the patient history. He suggested using "the same simplicity and sincerity" that the physician employed to observe the progress of disease in his patient; he was not to add "any thing of his own, or of the Doctrines of Books and other Sciences" (p. 28). The physician should witness rather than judge and should "let his Observations be set down in a rough and unpolish'd Style, that is, in the same sort of words that Patients use when they express their ails" (p. 220). "In compiling . . . this History of Diseases," Baglivi argued, "we must not fly off from the coherence of things, and give our Minds a loose at every turn as the Poets do; but submit our Wit to the real appearance of things, conquer Nature by Obedience, and learn the peculiar Language in which it speaks" (pp. 206-207).

Baglivi argued for careful, descriptive observation free from bias, and he wanted it rough, not lyricized. He wanted a story, a narrative. What

he called "the Narratives of sick people" must be filtered through the lens of observation and converted into a physician's diagnostic, nosographic account, but the narrative form was to be retained. Although published case histories from later in the century—works such as John Coakley Lettsom's *Medical Memoirs of the General Dispensary in London, for Part of the Years 1773 and 1774*—indeed employed narrative form, it was only toward the end of the nineteenth century that such form became part of an institutional recording mandate as it is today. Baglivi's arguments were prescient but premature; his contemporaries did not accord the patient's narrative the same weight.

Owsei Temkin locates the development of modern case-recording in the work of Thomas Sydenham, for whom disease represented an abstract, self-contained natural object from which the case or *historia morbi* could be derived.[43] For Sydenham, the case history was not so much an account of individual illness as a progress report on a disease process produced in order to arrive at a collective description of a given disease as a separate (though interactive) entity from its inhabited human host. Temkin argues that each patient history reflects the scientific perception of its time and represents a genuine by-product, what he calls its written fixity, of the treatment of the case. In Temkin's view, the entire situation and scientific foundation of medicine, its social organization and training system, are contained in the case history.

Sydenham's insistence on the importance of observation along with Boerhaave's initiation of bedside teaching at Leiden and the subsequent founding of clinical centers at Edinburgh and Vienna by his students, made record-keeping necessary as well as possible, though specific calls for systems of record-keeping began around the time Baglivi was writing in the early eighteenth century. Jean Devaux, for example, published a treatise in 1703 called *L'Art de Faire les Raports en Chirurgie* [*The Art of Surgical Reporting*] that included specific formats and styles to use for surgical record-keeping.[44] The first such call for record-keeping in medicine came in 1714, with the publication in England of John Bellers' *Essay Towards the Improvement of Physick*. Bellers offered twelve proposals, including several for the establishment of hospitals for the poor, the blind, and the incurable, and he argued "that each *Patient* be Registered in a Book, with the Daily Prescriptions that is made for them, and how they Succeed. . . . All which Proceedings, should be ready to be seen by any *Physitians*, for the Universal spreading of *Knowledge* among the *Faculty* and good of the *Publick*; that their Advice may be the more Effectual

when any *Patient* may want their Assistance."[45] According to Bellers, such a register would help in the project of classifying diseases and provide clinical experience for students. It should be noted, however, that the written culture of these records contains no space for inclusion of the oral culture of the patient/physician encounter.[46] With a nice sense of irony, Bellers encouraged physicans not only to record their bedside observations and therapeutic successes but to publish them, "considering that the Physician may dye himself, for want of a seasonable Application of his own Secret, when Sickness may make him unfit to prescribe for himself" (p. 17).

It can be argued, as even my brief sketch demonstrates, that a medical case literature existed and was even a highly cultivated genre well before the seventeenth century. But despite the existence of dozens of examples of extant case history collections before the early modern period, case-taking did not become a formalized or systematic procedure until it became connected with clinical schools and institutions and their need to produce and codify a professional discourse. The writings of physicians such as Sydenham and Baglivi point to the origins of systematic case-recording in the seventeenth-century return to empirical observation in physic. According to Sydenham, therapeutics derived from nosology. He wrote: "I think our Art may be best improved, first, by a History, or Description of all Diseases, as graphically and naturally as possibly may be, and secondly, by a perfect and stable Practice or Method respecting them."[47] Bellers connected his call for patient registers to his proposals for hospital building. Later recording systems also made connections between institutionalized clinical practice and the social functions of record-keeping.

Another important early proponent of case-taking was Francis Clifton, who was trained in Leiden and edited the writings of Hippocrates. In 1731, Clifton published a work entitled *Tabular Observations recommended as the plainest . . . way of practising and improving Physick*, and he reiterated what he called his "tabular method" the next year in a treatise called *The State of Physick, Ancient and Modern, briefly consider'd*. These represent the first formal system of case-recording in England.

Clifton also argued that the core of good physic lay in observation at the bedside. His lifelong devotion to Hippocrates rested clearly on his belief that the ancients were better physicians than the moderns because

they emphasized accurate observation. The opposite of observation for Clifton was philosophy or theory. He referred to "such Physicians as, out of an overfondness for any particular opinion, are above considering how the case really is in nature; and, rather than give up a favourable Scheme, will run the hazard of losing the Patient."[48] His comparative history of physic—from the Greeks to the Romans to the "Arabians" to a section on European physic from 1453 to the present—culminated in an argument for the improvement of physic that depended entirely on the displacement of theories in favor of observation, a trend that can be seen in dozens of other treatises of physic from the mid-eighteenth century. Clifton was a representative example of the new arguments for an empirical, bedside-centered clinical practice.

According to Clifton, from observation came skill in the treatment of patients as well as discovery about the nature and course of diseases. The trouble with "modern" physicians, in Clifton's view, was that they rarely wrote down their observations of patients, and when they did, they did so on the basis of memory alone. He cited Francis Bacon, who argued that the first deficiency of physic was, in Clifton's paraphrase: "the discontinuance of that useful method of *Hippocrates*, in writing *narratives* of particular cases" (p. 131). Clifton praised Sydenham as a great exception who proved the efficacy and necessity of observation in physic. To conclude his argument, Clifton wrote:

> For if a Physician has skill enough to examine [the Patient] right, and will be at pains to set his case down from day to day, is it not much more likely, that he should be a better judge of the case, than one who sees him seldom, and trusts entirely to his memory? Certainly: and the better the case is known, the better chance the Patient stands, beyond all doubt. So that, take it which way you will, a wise and diligent observer will always have the advantage of any other Physician, who either has not skill enough to observe, or time enough to write down the case. (p. 165)

The problem, of course, was "to know what to observe" and "to range our Observations in the best and easiest manner" (p. 134).

The historical importance of Clifton's book is in the final section of *The State of Physick*, called "A Plan for the Improvement of Physick." Here he reprised material from the *Tabular Observations* he had published the previous year and provided a complete outline system for the production and maintenance of patient records. First, he proposed "that

three or four persons of proper qualifications should be employ'd in the *Hospitals*, (and that without interfering with the Gentlemen now concern'd) to set down the cases of the Patients there from day to day, *candidly* and *judiciously*, without any regard to private opinions or public systems, and at the year's end publish these facts just as they are, leaving every one to make the best use of 'em he can for himself" (p. 171). Although Clifton did not specify what the "proper qualifications" of these individuals entailed, he obviously believed such individuals could easily be found and should be paid good salaries and treated agreeably. Later, he spoke of private physicians keeping their own cases, but here there was a clear distinction between the case-taker and the attending physician. This is interesting in itself. Indeed, ward clerks of various sorts rather than the attending clinician kept most early hospital records. Similarly, it is usually the situation in academic centers today that the first-line comprehensive history and physical is written by a medical student, intern, resident, or nurse-practitioner rather than by the attending physician.

This distinction suggests that case-recording may have been understood primarily as a clerical task, and the Bellers-type register certainly could have been construed in this way. Although case-taking manuals are occasionally difficult to distinguish from clerical handbooks, especially in the late nineteenth and early twentieth centuries, Clifton claimed that written patient histories serve diagnostic or epistemological functions in themselves. In addition, Clifton's reference to individuals making what they can or will from the annual publications of these records suggests that a case once thus written (or a group of cases taken collectively) could stand on its own, literally disembodied, apart from the patient or setting. Public readers (physicians? the lay populace? Clifton does not specify) could read these cases as histories of particular diseases or particular patients, or as signs of the proficiency of certain physicians. There were ambiguities everywhere here about the relation of case writers to cases, about the definition of audience, and about the purpose of publication.

Beginning in 1732, the year Clifton published these plans, discussion and publication of clinical cases contributed to medical training at the Edinburgh Medical School. In his study of the Royal Infirmary of Edinburgh, Guenter Risse remarks on the ward journals, kept in columns even more extensive than those Clifton proposed, by clerks who took dictation from the house physicians.[49] Unfortunately, no pages from these ward journals have survived. Risse also mentions Clifton's proposals (pp. 43-44) in his history of the house rules and regulations at the Edinburgh

hospital, whose revised procedures in 1743, for example, created the position of "clerk of the house" who gave care in the absence of physicians and surgeons, kept medical records, and dictated clinical cases to students (p. 33). Clifton held that the writing of clinical cases should be public and should foster candid communication between physicians without jealousy in addition to suppressing idle pieces of Quackery by "ignorant pretenders" and legitimizing "Gentlemen of the Profession" by making them better respected. The function of document production in the service of professional development was evident in these arguments.

The "*tabular method*" Clifton outlined (Fig. 2) contained six columns: (1) sex, age, temperament, occupation, and manner of life; (2) days of illness; (3) morbid phenomena (symptoms and signs); (4) day of the month; (5) remedies; and (6) outcome. He advised exactitude, completeness, and using abbreviations to save time and Latin to save space. He also advised

TABULA MEDICA GENERALIS.					
Sexus, Ætas, Species, Temperies, Occupatio, & Victus Ægri.	Dies Morbi.	Morbi Phænomena.	Dies Mensis.	Remedia.	Eventus.

Figure 2. Francis Clifton's *Tabular Method* (1732).

[From Francis Clifton, *The State of Physick, Ancient and Modern, briefly consider'd: with a plan for the improvement of it* (London: W. Bowyer for John Nourse, 1732): 175.] Courtesy of the Historical Collections, College of Physicians of Philadelphia.

setting down only those cases that the physician attended to the end. "By doing this early and often," Clifton wrote, "physicians cannot help but come to know diseases perfectly and be rewarded with esteem" (p. 179), a telling joint agenda. He asserted that he would never write on any subject without "*tabular authority*" (p. 180), asked his readers to read Hippocrates in every minute spared from keeping these tables, and concluded, "If this plan be follow'd, the consequence will be, that Diseases will be better known, and easier cur'd, even supposing the *Materia Medica* shou'd stand as it does" (p. 191). In other words, the accumulation of data generated by observation could enhance clinical proficiency and advance medicine even if all else in physic remained static. To record is to know.

Clifton's system was a system of data-recording. It was organized and it was rule-bound. But in terms of history-taking itself, Clifton's system bears more analogy to the *annaliste* school of historical scholarship than it does to today's organization of the patient history.[50] The tables Clifton's cases produced can be codified. That is, statistics, frequencies, lists of symptoms, conclusions about onset and course, and pharmacological trials could be based on them.[51] Indeed, the modernity of this approach lay in its very quantifiability. Although Clifton's tables potentially yielded a narrative of diseases of the sort Baglivi praised, this narrative emerged only by implication and required the interpreter to add conjunctions and to produce conjectural causal explanations.

Clifton's system documented and described, but it did not explain causes or predict consequences in and of itself. "To explain *how* a situation changed," writes philosopher C.B. McCullagh, "is not the same as explaining *why* the change occurred."[52] McCullagh wants to refute the work of twentieth-century narrativist historians. To this end, he concludes that historical writing need not be narrative and that narrative form merely adds dramatic interest.[53] I disagree with this view. No form of writing can ever be neutral. Narrative form selects, organizes, suggests relationships, and thereby reflects the whole gamut of conceptual beliefs it embodies, but it is also necessary for history-writing.

For medical records to serve any epistemological purpose, they need to rely on biomedical systems of explanation that, in turn, empower physicians to create a sequential history, to subordinate or suppress some factors while emphasizing others as they recount their patients' stories of illness and turn them into cases of disease. Case records that propose etiology and diagnosis imply a belief in the possibility of disease identification and classification, of disease as separable from the individual who suf-

fers. Case narratives depend on time sequences and presuppose and pro-
mote causal links, so that in many ways clinical thinking or diagnostic
reasoning is a fundamentally narrative enterprise. Indeed, modern med-
icine can propose (though perhaps not usually confirm) diagnoses from
patients' narratives alone, especially because some diseases are defined as
clusters of manifestations. Etiology, diagnosis, and prognosis are missing
from the "tabular" modes of case-recording precisely because they lack
narrative form.

By the last decades of the eighteenth century, the kind of concern for
accurate observation that Clifton emphasized became one of the foun-
dations for clinical medicine in Western Europe. Observation was com-
municated in written records of a wide variety, such as annual reports,
patient registers, admission and discharge lists, ward ledgers and journals,
medical student casebooks from hospitals, casebooks, diaries, and
account ledgers from private practitioners, case reports published in med-
ical periodicals, and case presentations by and for medical students and to
medical societies. This development derived in part from concerns such
as Clifton's to record observations in order to piece together the precise
nature and course of diseases from accumulated data. In this sense,
record-keeping was essential to produce nosologies and to give medicine
a scientific basis.

Beginning in the eighteenth century, medical experts received part
of their training by keeping detailed case notebooks on the patients they
observed.[54] Students of Pierre Foubert, chief surgeon at the Charité hos-
pital in Paris from 1735 to 1745, counted among their clinical responsi-
bilities the obligation "to keep an exact journal of the disease and of the
course of treatment of those who had been confided to him. At the end
of the cure, in cases of cures and, after the autopsy, in cases of deaths, he
would write up his findings in the form of a reasoned observation."[55] In
their 1778 proposal for a teaching hospital, Claude-François Duchanoy
and Jean-Baptiste Jumelin included under student duties the requirement
to "carefully observe everything which occurs relative to the diseases and
medications in order to be able to give a precise and accurate account (by
memory and in writing) to the physicians and their colleagues during the
next rounds."[56] Because even in the late eighteenth century sophisticat-
ed technologies and laboratory data did not yet impinge from outside the
physician's observational ken (and physicians were only then beginning
to touch their patients), a focus on the patient's sense impressions made
clinical case histories very concrete.[57]

Philippe Pinel was among those who argued that precise observations at the bedside were crucial in order for medicine to be exact in its conclusions and to follow the procedures used in other branches of natural science.[58] Pinel suggested that second-year medical students in Paris attend clinical rounds, follow several patients closely, record their observations, and write histories of their patients' illnesses; indeed, he proposed the establishment of a case-writing competition.[59] Even earlier, Edward Foster's 1768 treatise on hospital architecture and administration included a sample case book procedure for hospital patients similar to Clifton's tables, except that Foster's record is in English rather than Latin (Fig. 3).[60]

Record-keeping was idiosyncratic until records became absolutely necessary to the practice of medicine not only as a scientific system but also as a social authority system, that is, until barber-surgeons and surgeon-apothecaries gave way to physicians who were university-trained members of regulated professional organizations. The general historical assumption has been that medicine remained a "bedside" or "proto-clinical" practice until the French Revolution, at which time the "clinic"—or modern hospital medicine—was born.[61] Early clinics were simply nosological theaters, whereas practical observational diagnosis and treatment require an institutional structure to support hospital teaching, ambulatory services, dispensaries, and the development of pathological anatomy itself. The human body became less opaque partly as a consequence of clinical practices such as the autopsy (autopsies became routine by the end of the eighteenth century) that involved the composition of rigidly structured reports. But the hospital could only become a new site for clinical experience and for the production, accumulation, and reproduction of medical knowledge insofar as institutional records could be kept, and as conventional expectations and formal requirements for these records were established.[62]

Many physicians participated in formal calls for case-taking. Francis Home, a Professor of Materia Medica at the University of Edinburgh, advocated keeping regular (once or twice daily) reports of symptoms, changes, remedies, and responses, and he reviewed these reports in his clinical lectures. Home argued that medicine could become "as certain as most other sciences" if it produced careful descriptions of this sort, because "[r]emedies exhibited in such diseased states of the body, and the effects resulting from their operation, when accurately and faithfully

described, are real experiments in this branch of natural knowledge." Like Clifton, Home believed "a minute recital of facts" to be "the most certain method of improving medicine."[63] John Ferriar's 1793 *Medical Histories and Reflections* also made this argument, though Ferriar cited Sydenham on the inutility of drawing conclusions from or publishing single cases. Ferriar wrote that from the time of Bacon "observation has been generally pursued, equally as the road to truth and reputation." With Clifton, Ferriar held that

> [o]ne of the chief obstacles to accuracy in relating observations, has been the unhappy proneness of medical writers to form systems. Such gentlemen would do well to read Mr. Locke's chapters on the abuse of language. A system ought to be nothing more than an arrangement of facts, in convenient order for the memory. So far, systems are neither true nor false; it is only of importance that the facts comprehended be true and well told.[64]

This sounds like another "tabular" prototype of the patient history, a form of history in which data-recording reigned over causal analysis or predictive conclusion.[65]

In the early part of the nineteenth century, many physicians in North America and in Europe outlined methods for bedside case study and recording for medical students.[66] In 1837, Guy's Hospital in London published a seven-page pamphlet containing "Directions for Case-Taking," and dozens of such instruction manuals began to appear thereafter.[67] Although many of these are as dull as they sound, they uniformly subscribed to the notion that medicine was, as William Augustus Guy put it, "a science of detail" and a science that depended on the accretion and proper interpretation of this detail for the maintenance of its professional status.[68] In an article in the *Western Lancet* in 1845, for example, H.M. Bullitt proposed that case reports should be so complete that they verify themselves.[69] Samuel Crompton published a text entitled *Medical Reporting; or, Case-Taking* in 1847 (printed in phonotypy, a method of phonetic printing); in 1853, the London Medical Society of Observation produced a manual titled *What to Observe at the Bed-Side and After Death in Medical Cases*; and an article entitled "What to Observe at the Bedside" appeared in the *Virginia Medical and Surgical Journal* in 1859.[70] John Southey Warter proposed what he called a "systems" method of case reporting in his 1865 *Observation in Medicine or the Art of Case-Taking*.[71] In 1870, Alfred K. Hills took a different approach, and wrote a handbook

A SPECIMEN of a CASE BOOK for HOSPITALS.

(54) DONALD McDONALD.

1765.

Month and Day.	History and Symptoms, &c.	Regimen and Remedies.	Disease, Remarks, and Event.
Jan. 18.	Aged 17 Years, accustomed to Country Labour, and of a middle Habit of Body; has upon his Right Hip a broad Scab, which discharges a small Quantity of Matter, and upon a nearer Inspection appears to consist of a Number of smaller run together; the Lips of these have a callous Appearance and are elevated in different Parts of the Sore above it's Level. There are two or three distinct One's of the same Kind round it's Edge: He has also a small Blotch on the Inside of his Thigh, which is almost healed. 'Tis about two Months since these Sores	Let him be put upon the full diet. R. Tart. Emet. gr. v. solve in aq. font. ℥x. capt. Cochl. j. mane & vesperi. Let the Sore on his Hip be dressed with Basilic flav. ℥j. Ung. Ægypt. ℥j.	Cutaneous Foulness.

Figure 3. Edward Foster's Hospital Case Book (1768).

[From Edward Foster, *An Essay on Hospitals, Or, Succinct Directions for the Situation, Construction, & Administration of County Hospitals. With an Appendix, wherein the Present*

A SPECIMEN of a CASE BOOK for HOSPITALS

Donald Mc Donald.

1764. (55)

Month and Days	History and Symptoms, &c.	Regimen and Remedies.	Difeafe, Remarks, andEvent
Jan.	broke out ; but he had one entirely fimilar about fix years ago, on the other Hip, which continued two Years, and then went away without Medicines. Apetite good ; Belly natural ; he has been bled, and got two Dofes of Decoctum Tamarindorum ; his Sores are dreffed with Bafilicon.		
19	Sweated very profufely laft Night and to Day, without any ficknefs at Stomach, form his Medicine.	Continuatur folutio Tart. Emet. fed capt. Cochl. ij. pro dofi omni mane & vefperi.	
20	Sweated well; fore on his Hip eafier; difcharge from it lefs copious ; he has fome appearance of Itch on this Hands. *	Cont. r Solut. ad Cochl. iij. hora Somni & ij. mane. Applicetur ung. Sulph. manibus.	

* A Continuation of the Cafe is unneceffary ; and I have only inferted it, with a defign of fhewing by an Example from an Hofpital, which may be juftly efteemed a Pattern, that the Treatment of Sores ftrictly belongs to the Province of a Phyfician.

SECT.

Scheme for establishing Public County Hospitals in Ireland, is impartially considered (Dublin: W.G. Jones, 1768): 54–55.] Courtesy of National Library of Medicine, Public Health Services, National Institutes of Health, Department of Health and Human Services, Bethesda, MD.

of advice for patients who found themselves needing to communicate their symptoms in writing to a physician.[72] In 1887, W.H. Allchin argued that without detailed records, every case would become an exception instead of an opportunity to accumulate knowledge about causation and pathology.[73] It was also around this time, the final decades of the nineteenth century, that stereotyped case report forms and grids began to be published (Fig. 4).[74]

Records, of course, serve other than diagnostic purposes. The statistical movement's impact on medical record-keeping focused on the administrative functions of records. This was true in the sixteenth century, when the steward of St. Bartholomew's Hospital in London kept a book of admissions along with an account ledger for provisions and the hospitaler kept registers of patients, cures, and dismissals. It remains true today, with the legal function of records as crucial as their medical function. John Graunt's 1662 *Natural and Political Observations made upon the Bills of Mortality* inaugurated an interest in medical statistics in Britain, though the first textbook did not appear until Francis Bisset Hawkins' 1829 *Elements of Medical Statistics*.[75] Finally and conclusively, the important vital statistics innovations of William Farr in the mid-nineteenth century argued for a "uniform statistical nomenclature" and built on the disease taxonomies of Boissier de Sauvages, William Cullen, and Mason Good to produce the first statistical nosology.[76] From this point on, the British statistical movement provided the necessary precondition for the development of public-health bureaucracies because it fostered the registration of causes of death by locality and applied political arithmetic to popular medical concerns.[77] The public-health uses of statistics operate in concert with their medicolegal uses.[78] But once the state required documentation of births and deaths, recording the ups and downs of health, disease, and injury in between followed logically.

While all these recording systems were being proposed, the actual information susceptible to be included in case reports was changing as a result of new technologies and increasing emphases on physical examination. Physical diagnosis and the development of sophisticated diagnostic machinery fundamentally changed the case record not only by adding new kinds of information to be recorded but by altering the physician's emphasis on observation and on interpretation of the patient's history of symptoms.[79] Even today, the interrogation of the patient has remained crucial (although streamlining and stereotyping techniques such as the

Figure 4.

James C. Howden's *Index Pathologicus* (1894).

[From James C. Howden, *Index Pathologicus for the Registration of the Lesions Recorded in Pathological Records or Case-Books of Hospitals and Asylums* (London: J. & A. Churchill, 1894): 64.] Courtesy of the Historical Collections, College of Physicians of Philadelphia.

Cornell Medical Indices and other intake questionnaires have eroded the intimacy and comprehensibility of many patient-physician interviews). Case records now serve decisive medicolegal functions that often seem to override the diagnostic and educational role of the patient history. John Warner points out, for example, that when the Massachusetts General Hospital began keeping records in 1823, these documents often ran to ten or more pages, but increasing uses of abbreviation and quantification and the demands of larger numbers of patients severely shortened these records by the 1870s.[80]

The history-taking categories currently used in internal medicine—chief complaint, present illness, past history, systems review, and the like—were already in place by the 1890s, as was the notion of letting the patient "tell his story in his own words." Shifts in case-taking methods can be tracked by looking at successive editions of one widely used textbook, Hutchinson and Rainy's *Clinical Methods*. In its first edition (1897), this text declared that "accurate and systematic case-taking" gave a "sure foundation" to "clinical knowledge," but the authors stated that the method for investigating and recording cases did not matter as long as the system chosen was comprehensive and concise. By the eighth edition in 1924, this sentence was modified, and incorporated a remark about the "divergence of opinion" concerning methods of case-taking. By the fifteenth edition in 1968, the sentence was deleted altogether, but in the sixteenth edition in 1975, the introductory material on the importance of case-taking (which had gotten shorter and shorter from 1897 to 1968) was heavily expanded with the addition of new material using the work of Michael Balint on the importance of effective interviewing skills and nonverbal communication in the physician-patient relationship.[81] The twelfth edition of Cabot and Adams' *Physical Diagnosis* in 1938 added a new chapter on history-taking and argued that "the history is the key to diagnosis" and that "more errors are traceable to lack of acumen in eliciting or interpreting symptoms than have ever been caused by failure to hear a murmur, feel a mass, or take an electrocardiogram."[82] The most widely used textbook today, Barbara Bates' *Guide to Physical Examination and History Taking*, newly incorporated in its fourth edition of 1987 a wide range of instruction on patient interviewing and approaches to symptoms and a section on clinical thinking, and demonstrated the ways case records function as key parts of the diagnostic process.[83] This text emphasizes that the Present Illness section of a history should give "a full, clear, chronological account of how each of the symptoms developed and

what events were related to them" (p. 2) and that this account should be "narrative" (p. 3).

▼ ▼ ▼

The historical trajectory I have been tracing for the development of the case record as a recognizable genre of medical documentation and a memory aid to the medical practitioner is, like most historical trajectories, not entirely linear. Some physicians in every period recorded accounts of their patients and their observations regarding them, but such accounts did not become systematic and were not flagged as playing a role in diagnosis and therapeutics, until physicians such as Bellers and Clifton began calling for a more formal approach to record-keeping in the first half of the eighteenth century. They argued that case records in and of themselves could improve clinical medicine. At around the same time, the case record became a fundamental text in the teaching of clinical medicine in Western Europe. Case presentations became part of clinical lectures, and medical students learned case presentation technique by serving as scribes and taking down cases from bedside dictation by their professors. (This development occurred later in North America and is particularly vivid in a debate about the relative merits of didactic lectures and recitations as opposed to case presentations that was initiated by Walter Cannon, then a Harvard medical student, who published an essay called "The Case Method of Teaching Systematic Medicine" in the *Boston Medical and Surgical Journal* in 1900.[84]) In the eighteenth century, hospitals began to institute a variety of record-keeping regulations and practices, from ward journals to admissions and discharge ledgers, to keep track of their inpatient clientele (there was not yet any systematic follow-up after discharge) and to prove that they deserved the philanthropical support they were receiving. (Again, this happened later in North America, one of the key events being the establishment in 1917 by the American College of Surgeons of a committee to act on the reform and standardization of hospital records.[85])

By the last quarter of the eighteenth century in Western Europe, case records served a complex set of interrelated purposes as clinical tools for medical treatment and education, and as generators of data that were instrumental in developing a socioeconomic agenda for the rapidly professionalizing community of medical practitioners.[86] One can argue that from the middle of the eighteenth century to the coming of age of physical diagnosis with Laënnec's stethoscope in 1819, the case record was the centerpiece of the medical practitioner's repertoire. It seemed to prove

that the public was being well served, and it entered the medical practice system by providing a foundation for clinical education.

The maintenance of records that could generate statistics permitted medicine to become part of a social regulatory system because morbidity and mortality statistics gave civil authorities the power to invoke questions of community health. The existence in 1981 of the Center for Disease Control's *Morbidity and Mortality Weekly Report*, for example, significantly speeded up the recognition that an epidemic of immune system deficiency had gotten under way in the United States. In addition, medical data such as morbidity and mortality statistics could be used not only to improve therapeutics but also to promote epistemological standards against which medicine could measure itself by comparison to other sciences.[87]

Systems of medical explanation in given periods have always influenced the subject matter of case histories, from concern with air and water in early Greek medicine to the modern search for specific pathogenic causative agents or controlling genes for disorders as different from each other as Alzheimer's, cancer, and AIDS. Nevertheless, an underlying shift has occurred from particularity in individual cases to generality in the idea of typical disease courses. We have moved from the study of individual manifestations of disease in Hippocratic medicine to an analysis of causally determined and determining natural histories of disease.[88] This move requires an important distinction. The case history as a document differentiates, both explicitly and implicitly, between those items designated as objective signs and those labeled subjective symptoms, a distinction that has received recent attention as a disturbing disjunction between the physician's biomedical explanations of disease and the patient's personal experience of illness.[89]

The relation between nosological description and the story of a particular suffering human being determines the nature and form of the clinical history and raises the fundamental question posed by any case history: Does the disease derive from the life of an individual, or is the individual life constructed by a disease? Walther Riese believes that the clinical history starts with subjectivity and that diagnoses and therapeutic plans derive from the signification of subjective signs. Riese argues that *"[i]t is not the history of the disease which leads to an understanding of the life history but the latter which may induce an understanding of the former."*[90] Historically, the move has been away from an individually located and environmentally connected suffering human body to a suffering body

that is increasingly open to interrogation by observation and technology and that is, therefore, increasingly instrumentalized and taxonomized. The organization of nineteenth-century hospitals permitted adequate clinical data collection to establish and describe disease entitites as such. At the same time, standards for the "normal" could be reconstituted, thereby detaching the uniquely suffering individual from her or his particular status to a status more or less removed from the yardsticks that measure and define health and disease.[91]

Michael Taussig analyzes the problem of individuality in illness experience in a polemical essay that argues that disease disturbs social conventions and that the health-care system is too highly commodified. He is especially critical of the problem-oriented approach to medicine (SOAP): "'Soap'," Taussig writes, "the guarantee of cleanliness and the barrier to pollution! Subjectivity, objectivity, analysis [assessment], and plan! What better guarantee and symbolic expression could be dreamt of to portray, as if by farce, the reification of living processes and the alienation of subject from object?"[92] Although the political motivations behind arguments that the medical system reifies patients make a certain sense, these arguments seem to me to be misguided. The terms "subjectivity" and "objectivity" in the SOAP acronym are, however, perhaps especially biased and meaningless abstractions for a program of case-recording meant to *unify* the patient's experience with the physician's observations.

The specificity of disease entities and diagnostic signs briefly generated another technological development in the codification of medical knowledge that began in the late 1950s and peaked in the 1970s: a move to computerize history-taking, or to develop "present illness algorithms."[93] Interventions such as percussion and auscultation, thermometry and radiography and magnetic resonance imaging have displaced to a degree the authority of the patient's narrative of symptoms. Were the patient-physician dialogue itself to become fully technologized, the final move in the metamorphosis of ill human being into pathologic physical body would be complete, though challenges to this metamorphosis were launched at the same time as computer-intake models were being constructed, and the computer expectations of 20 years ago have faded.[94] Because narrative is indispensable to diagnosis, it is not possible for physicians to stop listening altogether to their patients or to stop chronicling health histories in case records.

The details in a particular case history are presented against an implicit background of assumptions and explanatory models. Would patients

recognize their own experience as "cases," for example, or is the case record a physician's rather than a patient's dossier?[95] The fact that observation itself is never a neutral activity bears reiteration. George Devereux has argued in a book intriguingly entitled *From Anxiety to Method* that subjective countertransference permeates all efforts to collect data in the social sciences.[96] In 1846, French physician Antonio Mattei argued that to prove that writing patient histories requires predisposed kinds of reasoning, one needed only to ask 10 different physicians to write the same patient's history without indulging in theoretical speculation. "In each observation there will be the tendency," Mattei wrote, "to make it prove one doctrinal point more than another." He recommended discussing theory and assumption explicitly in order to avoid this kind of ideological infiltration into supposedly objective texts.[97] But every medical history turns its patient into a case of a disease.

One twentieth-century textbook on differential diagnosis and the interpretation of clinical data, for example, discusses cases as had Francis Home in analogy with scientific experiments, and is worth a long quotation:

> Disease presents itself to the clinician as a natural, spontaneously evolving experiment that may be very brief or may last for several decades. It differs from the usual scientific experiment in that the experimenter—the clinician—does not initiate it and has no control over the conditions of its early progress. He must form his hypothesis—his working diagnosis—at a variable stage in the course of the experiment [elsewhere the authors compare the clinician to a drama critic who must review a five-act play after seeing only three acts]. After this has been done the experimenter can then be steered along the path used by the more traditional scientist, with careful observations, objective tests and measurements, unbiased recording and critical evaluation. But the clinical experimenter is subjected to influences that do not affect other scientists. The subject of the experiment is a sick human being, and it may be necessary to disturb the pattern of the experiment by taking steps to relieve suffering, or, if the patient is critically ill, to institute treatment on the basis of an unconfirmed hypothesis. Furthermore, as long as his patient is alive the clinician cannot abandon his experiment if his hypothesis proves to be incorrect; he must devise a new hypothesis while the experiment is still in progress and steer the course along new paths.[98]

The subject of the experiment using this analogy to scientific method is not, as the authors would have it, a "sick human being." Rather, the subject is a disease whose host figures in the analogy as an implied tension between science and ethics: The experiment's integrity must be disturbed in order to relieve suffering, and the patient cannot be abandoned until and unless the disease causes death. In this account of the clinical situation, subjectivity has been omitted altogether.

Layers of meaning are embedded in medical records. A patient's history translates the bodily aspects of a life into a documented aggregate of symptoms and turns what might be a human story into the professional discourse of medicine by encapsulating illness into the forms and languages of a highly bureaucratized health-care system. Only by this process of converting patient into case can this system bring to bear its formidable tools of interpretation and therapeutics. Case histories, and the sometimes disjointed evolution of their forms and functions, reveal as much about the underlying assumptions of the culture that organizes, institutionalizes, and controls health care as they do about the clinical skills of physician case-takers and the sufferings of patients. The methods with which we codify knowledge go a long way toward explaining what we know and how we apply it.

3. Case History and Case Fiction

I was alarmed, and prayed GOD, *that however he might afflict my body, he would spare my understanding. This prayer, that I might try the integrity of my faculties, I made in Latin verse.*

> Samuel Johnson
> Letter to Hester Thrale
> June 19, 1783

The entry for June 23, 1817, from the case book of Philadelphia physician Hugh Lenox Hodge (1796-1873) is titled with the diagnosis "Chorea St Viti—":

> Mary Ann Carraway about 7 yrs of age came into the Alms House yesterday——She has always been very dull & stupid so as to excite a suspicion of some disorder of the mind—She is of a thin delicate appearance & of a pale complexion—She has always appeared to have been of a mild & gentle disposition—Last Thursday her bowels were somewhat disordered—& from some cause not known she became very much enraged, attempting even to injure her father—From that time she was observed to be affected by an involuntary motion of her limbs & body—& to be incapable of properly assisting herself—Or of speaking or swallowing with her usual facility–When she came into the house she was unwilling to remain— became angry & thus increased the irregular action of her muscles-

By mid-August Mary Ann was relatively well; that is, according to Hodge, "She remained a little awkward in her movements—& had an [idiotic] expression of the countenance"—in other words, the case report concluded, "it was said she was as well in every respect as ever—."[1] Children present particular problems, of course, for physicians taking their histories, but even so a curious mixture of symptom recounting, psychologizing, and annoyance emerges from Hodge's report about Mary

Ann Carraway. The imputation to the child of an apparently native "dull-ness and stupidity" and "delicate appearance" established questionably vague premorbid norms against which her clinical progress might be mea-sured. Of course, any assessment was colored by the physician's loaded terms—"dull," "stupid," "delicate," even "pale"—which cannot be divorced from the array of social, class, and cultural meanings for women that they implied.

Compare this to Hugh Lenox Hodge's account, a month earlier, of a similar complaint in an adult man also diagnosed with "Chorea Sancti Viti":

> Robt Myer came into the Alms House yesterday afternoon. He states that about 3 yrs ago, he was exposed to much cold & wet while a soldier in our army that about the same period he was attacked by an inability to perform the usual motions of his limbs with steadiness—this inability gradually increased—& in a short time his limbs were constanly [sic] in motion he had no power over them, either to keep them still, or to perform any desired action. This complaint has now lasted 3 yrs. . . .[2]

Mr. Myer's condition improved for a time under Hodge's care, until he could carry a cup of liquid without spilling it, then worsened steadily for several months while he was treated with massive doses of purgatives and quantities of infusions and potions, but the tone of Hodge's history never altered from this clipped formality.

The ailment Hodge designated as "Chorea Sancti Viti" is officially known as Sydenham's Chorea and commonly as Saint Vitus' Dance. It is an acute disorder of the nervous system characterized by involuntary movements and is usually self-limiting; that is, there is still no real treat-ment for it, and it generally resolves on its own.[3] Given the nature of the ailment, it is not surprising to find psychological causes ascribed to it. Hodge's case book entries rendered not only accounts of this disease and its diagnosis, treatment, and outcomes but also stories of the complicated interactions between a physician and his patients. These accounts frame a social discourse that produces patient-physician interactions—and there-by diagnoses.

Recently, scholarly and critical attention has been turned to the sig-nifying practices and to the *poetics* of clinical case histories such as Hodge's or, as neurologist Oliver Sacks calls them, "clinical tales."[4] But this atten-tion also raises some problems. Medical narratives cannot easily be read as literary artifacts, with the methodologies of literary criticism invited to

scrutinize them, without neglecting their foundation in the experience of the body and in the social as well as medical roles of clinical diagnosis. In the process of reconstituting the patient's history into a case record, authority is displaced from the patient giving the history to its recorder, and ultimately to the text itself. The narrative explanation of illness takes over from both empirical medical observation about disease course and from the individual patient's experience of that course.[5] The patient history represents one way of knowing the human body and the human being. It depends for its structure on a codified narrative form that works with the materials of chronicle, ethnography, and biography.[6] The patient history charts an epistemology of the body that is suffused with conventions of the normal.

In the previous chapter, I sketched the gradual turn to organized case-recording in medical practice that began toward the end of the seventeenth century in Western Europe. This increased focus on case history-writing coincided with a burgeoning of narrative forms in other cultural arenas; the eighteenth century in Europe witnessed in particular the birth of periodical journalism and of the novel.[7] This merger of a descriptive or scientific form of case-recording with other forms of writing that partook more clearly of social and cultural change (demographic shifts, the formation of a mercantile class, the spread of literacy, and the birth of a marketplace for words as well as for commercial goods) is for many reasons not surprising. The physician's shifting social place itself mandated participation in the production of cultural discourses, in part because physicians were gradually taking over for clergymen in matters of health. At first, this occurred largely in the social realm, as demonstrated by the language of lay medical advice. We know from the period's diaries and correspondence that patients put themselves "into the care of" or "in the hands of" or "under" medical practitioners, and these practitioners "pronounced," "declared," or were "of the opinion."

Nevertheless, medical knowledge was not spirited away to its own domain and professionally guarded there until the beginning of the nineteenth century. This is clear, as Roy Porter has shown, from the evidence of eighteenth-century periodicals: The *Gentleman's Magazine*, for example, instituted a medical correspondence feature in 1751, and its technical nature—it included "nice anatomical disquisitions . . . [and] chemical experiments on the materia medica"—seems to confirm that medical knowledge of a quite sophisticated sort existed in a common province and was not yet exclusively owned by trained consultants.[8] This shared world

of knowledge allowed patients and physicians to negotiate at the bedside about therapeutic intervention.[9] Disease in the eighteenth century was no longer read as a providential sign or instrument, and the narrative of illness was no longer, in part, a spiritual narrative in which the body operated merely as a casing for the soul. However, the spectacle of disease, though becoming increasingly understood as a *material* spectacle, was also not yet a monopolized zone inhabited solely by the prognosticating medical expert.[10] The patient chart, from this point on, becomes coadjutant with patients and physicians themselves in the production of what has come to be called the "clinical picture." The examples that follow illustrate how such pictures were produced.

▼ ▼ ▼

Hippocrates' cases in the *Epidemics* are preceded by detailed accounts of the seasonal "constitutions" in which they occurred: the state of the atmosphere and of general health during given times of the year. Hippocratic medicine was highly environmental; we learn about heat and cold, wind and damp, along with pestilence and the frequency of fractures. Many of the case reports remark on the location of the patient's lodgings ("near the Cold Water," "above the Temple of Diana," "by the New Wall," etc.). Most omit personal information, though into the general absence of individuation come occasional odd observations: one man is noted to be bald, marital status is frequently remarked of women, and one female patient in Book III is described as "of a melancholic turn."[11] Precipitating factors are noted in only a handful of the 42 cases, with comments such as "from fatigue, drinking, and unseasonable exercises, he was seized with fever" (I, p. 372); "a man, in a heated state, took supper, and drank more than enough" (I, p. 379); "Charion, who was lodged at the house of Demaenitus, contracted a fever from drinking" (I, p. 392); "a woman of those who lodged with Pantimides, from a miscarriage, was taken ill of fever" (I, pp. 396–397); and "in Abdera, Nicodemus was seized with fever from venery and drinking" (I, p. 416). Drinking features prominently when initiating causes are cited.

Case XV exemplifies what is meant by Hippocratic observation, and bears close analysis:

> In Thasus, the wife of Dealces, who was lodged upon the Plain, from sorrow was seized with an acute fever, attended with chills. From first to last she wrapped herself up in her bedclothes; still silent, she fumbled, picked, bored, and gathered hairs (from them); tears, and again laughter; no sleep;

bowels irritable, but passed nothing; when directed, drank a little; urine thin
and scanty; to the touch of the hand the fever was slight; coldness of the
extremities. On the ninth, talked much incoherently, and again became
composed and silent. On the fourteenth, breathing rare, large, at intervals;
and again hurried respiration. On the sixteenth, looseness of the bowels
from a stimulant clyster; afterwards she passed her drink, nor could retain
anything, for she was completely insensible; skin parched and tense. On the
twentieth, much talk, and again became composed; loss of speech; respira-
tion hurried. On the twenty-first she died. Her respiration throughout was
rare and large; she was totally insensible; always wrapped up in her bed-
clothes; either much talk, or complete silence throughout. Phrenitis. (I, pp.
419-420)

There is a precipitating cause—"sorrow"—and a final diagnosis—
"phrenitis"; these two features make the case atypical. There is also extra-
ordinary detail: This brief paragraph depicts acute fever symptoms as
vividly as anything ever written. Its repeated images of clutched bed-
clothes, gestures, speech, silence, and labored breathing bring the deliri-
ous patient into our presence alomost as Gustave Flaubert many centuries
later made gruesomely vivid Emma Bovary's death by arsenic poisoning
that provides the graphic climax to *Madame Bovary*. Indeed, acuteness of
observation and the fine clinical detailing that characterize this case report
are the hallmarks of Hippocratic medicine. The physician misses nothing,
and records everything.

In his 1726 *Comment* on Hippocrates' *Epidemics*, Sir John Floyer
explained Hippocratic pathology and the Hippocratic understanding of
fevers, then summarized and annotated all forty-two cases. Floyer's
methodology reveals the eighteenth-century need for point-by-point eti-
ological explication in a disease course, a need the descriptive Hippocratic
case does not display. In Floyer's time, each sign was assigned a single cause.
Here is Floyer's version of Case XV:

A Fever from Grief, with disorders in the Head

Real's [sic] Wife had an acute Fever with a Horrour, by melancholic
Sadness, but she bare being covered in Bed in the beginning, and was silent
to the end of the Fever, she felt with her Fingers, and pulled, scratch't, and
gathered Hairs; she Wept, and afterwards Laugh'd, she slept not, had
motions to Stool without any, she drank a little as she was advised, the
Urines were thin, and small, the Fever felt small with a coldness in the
Extremities; on the ninth, she was Delirious in her talking, and afterwards
was quiet, and silent; on the fourteenth, the breathing was rare and great
for sometime, and again short breathed; on the seventeenth, her Stools were
windy and violent, and her potions passed that way, and they had no con-

sistence, she was insensible of them; the Skin was distended and dry; on the twentieth, she talked much, and was quiet again, without Speech, short Breath'd; on the twenty first, she Dyed, her Breathing to the end was rare, and great, she was insensible of all things, was always covered, and talked much, or was silent to the last; this was a Phrenitis.[12]

Floyer's retelling is oppressively verbose and puts into relief the admirable economy of the Hippocratic text. But the commentary that follows marks the stunning differences between Hippocratic observation and Enlightenment explanation. Floyer glossed each phrase in the case history and argued finally that "since the Humours of the Head were fixt, bleeding in the Neck and Cupping are most convenient; and Blisters, shaving the Head, and Fomentations to move the stagnating melancholic Blood, and to discuss the inflammation of the membranes, a Bath of warm Water and perfusion of it on the Head, after Bleeding in the Arm or Foot, might have relieved this Case" (p. 118). At least the Hippocratic physician apparently allowed his patient to die without such an onslaught of unpleasant treatments. Floyer's treatment prescriptions reflect prevailing ideas about therapeutics in the early eighteenth century.

The Hippocratic history designated "sorrow" as the precipitant of this fever. Floyer went farther:

This is a Fever from the passion of Grief, that stopt the motion of the Heart, and made the Fever less hot, besides the Blood of the Melancholic is grumous, and moves slowly; this Fever had a Horrour, that is a shivering in the Skin, and this is less cold than in Rigours, but more than in coldness from Air . . .(p. 117)

Floyer's diagnostic and etiological reasoning remains unquestioning throughout; there is always a one-to-one correspondence between cause and effect. Fever derives from grief, silence and delirium from melancholy, laughter from bile, and thin urine from the fixation of "febrile Humours" in the head.

Juxtaposing the longer eighteenth-century version of this case with its Greek original makes clear the subtle changes that occur in history-writing and diagnostic reasoning over time and with changes in medical thinking. The details of humoral thought that Floyer included derived from Greek medicine and, indeed, had not changed much since their Hippocratic and Galenic originals. But the Hippocratic writings themselves did not assign nearly the specificity that Floyer pronounced in their

diagnostic conclusions. Hippocrates' sorrowful patient is in many ways more vivid than Floyer's, and more individual in her bedclothes-wringing, precisely because she is not as typical. Her history does not rely rhetorically only on the usual suspects of humoral pathology.

A later eighteenth-century case history, from John Coakley Lettsom's *Medical Memoirs* of 1774, offers another contrast to the still Hippocratic and humoral account of disease:

> Susannah Taylor, aged 43, was admitted a patient to the General Dispensary in March 1773. She had enjoyed good health till about two years before, at which time she was first seized with convulsive twitchings in the left side, accompanied with a most acute pain under the short ribs, shooting towards the region of the stomach. These fits continued from half an hour to three hours at each attack, coming on mildly at their commencement, but increasing in violence and pain to such excess, as to excite convulsions through the whole day; under which the patient appeared to suffer the most excruciating torture, till at length (nature being exhausted) she sunk into a state of stupefaction, and in a short space of time regained her usual strength.
>
> . . . Besides laxative remedies, she had tried bleeding, camphor, volatiles, blisters, bark, acids, alkalies, flowers of zinc, and fetids in various forms, agreeable to the directions of physicians at home and abroad, but without benefit.[13]

Lettsom ascribed the symptoms to flatulence, ordered opiates, emetics, lime water, calcine magnesia, and a paregoric elixir, and reported that within two weeks Susannah Taylor was in perfect health and no longer needed medication.

Lettsom's report uses a professional language more akin to modern clinical discourse than to the pure description of the Hippocratic history. Today's clinical histories, however, are unlikely to mingle the physician's observations of signs ("her countenance had a freshness and color denoting healthiness and vigor") with the patient's perspective on symptoms (under the affliction of her "convulsions," "the patient appeared to suffer the most excruciating torture"). Susannah Taylor had consulted many physicians and tried many remedies—the case, indeed, lists a veritable eighteenth-century polypharmacy. More than in the description of the sorrowful feverish wife of Dealces reinvoked by Floyer, Susannah Taylor became a *case* in Lettsom's writing. She arrived with symptoms and departed in restored health; her life before and after these episodes did not concern her physician.

▼ ▼ ▼

During the same period that Lettsom was cataloging cases at the General Dispensary in London, the later eighteenth-century's best-known patient was making his mark in medicine as well as in literature, criticism, lexicography, and history. Samuel Johnson was a cultural monument whose legendary character became so titanic even during his own lifetime that it threatened to obscure both the man and his cultural achievement. Johnson's monumentality resided in part in his larger-than-life embodiment, and much posthumous medical speculation has accompanied accounts of his striking physical traits and multiple ailments. Contemporary information about Johnson's various conditions comes largely from nonprofessional accounts. In aggregate, these accounts provide one of the most complete eighteenth-century descriptive case histories we have.

Here is Frances Burney's impression of Johnson, whom she met for the first time in March of 1777:

> He is, indeed, very ill-favoured! Yet he has naturally a noble figure; tall, stout, grand, and authoritative: but he stoops horribly; his back is quite round: his mouth is continually opening and shutting, as if he were chewing something; he has a singular method of twirling his fingers, and twisting his hands: his vast body is in constant agitation, see-sawing backwards and forwards: his feet are never a moment quiet; and his whole person looked often as if it were going to roll itself, quite voluntarily, from his chair to the floor.[14]

"In short," Burney tells us, "his whole person is in *perpetual motion.*"[15] James Boswell's *Life of Johnson* (an enormous biography about which Johnson himself might have said, as he remarked of *Paradise Lost*, "None ever wished it longer") also contains contemporary physical descriptions of the man Burney and others called "Lexiphanes." Boswell depicts Johnson in 1734 as a young man courting his future wife:

> [H]is appearance was very forbidding: he was then lean and lank, so that his immense structure of bones was hideously striking to the eye, and the scars of the scrophula were deeply visible. . . . he often had, seemingly, convulsive starts and odd gesticulations, which tended to excite at once surprise and ridicule.[16]

Boswell's *Life* and his *Tour to the Hebrides* abound with physical descriptions of Johnson. To cite just one further example, Boswell presents Johnson at the age of 64 during their travels together:

> His person was large, robust, I may say approaching to the gigantic, and grown unwieldy from corpulency. . . . His head and sometimes also his body shook with a kind of motion like the effect of a palsy; he appeared to be frequently disturbed by cramps or convulsive contractions, of the nature of that distemper called St. Vitus's dance.17

Like Hugh Lenox Hodge several decades later, Boswell diagnosed Sydenham's Chorea, an always frightening ailment that seemed to suggest a kind of possession. Other contemporaries offered similar portraits of the great man—the poet Alexander Pope wrote of Johnson, "He has an infirmity of the convulsive kind, that attacks him sometimes, so as to make him a sad Spectacle"[18]—but not everyone imputed Johnson's strange mannerisms to an organic cause. Sir Joshua Reynolds believed the supposed "convulsions" to be misnamed and concluded that "the great business of [Johnson's] life was to escape from himself." Reynolds explained, "[Johnson's] actions always appeared to me as if they were meant to reprobate some part of his past conduct."[19]

Another anecdote recounted by Boswell further muddies the diagnostic waters. Johnson was a frequent visitor at the home of the novelist Samuel Richardson. One day William Hogarth also chanced to be visiting, but he was not aware there was other company. Hogarth engaged his host in a debate about George II's recent execution of Archibald Cameron for treason and, thus embroiled, Boswell relates what followed:

> While [he] was talking, [Hogarth] perceived a person standing at a window in the room, shaking his head, and rolling himself about in a strange ridiculous manner. He concluded that he was an ideot [sic], whom his relations had put under the care of Mr. Richardson, as a very good man. To his great surprize, however, this figure stalked forwards to where he and Mr. Richardson were sitting, and all at once took up the argument, and burst out into an invective against George the Second, as one, who, upon all occasions, was unrelenting and barbarous. . . . In short, he displayed such a power of eloquence, that Hogarth looked at him with astonishment, and actually imagined that this ideot [sic] had been at the moment inspired.20

Needless to say, Johnson and Hogarth were not introduced to each other on this inauspicious occasion.

Several retrospective hypotheses about Samuel Johnson's afflictions have been advanced. (In fact, an astonishing number of articles speculating on the etiology of Johnson's condition have been published, amounting to a kind of mini-industry within Johnson scholarship.) He suffered prolonged anoxia at birth (he was even briefly thought to have been stillborn), and athetoid cerebral palsy, among other things, has been suggested as resulting from his birth trauma.[21] But one of Johnson's modern biographers, Walter Jackson Bate, holds that organic explanations of his subject's convulsive movements are misguided. Bate cites Joshua Reynolds approvingly, believing Johnson's gestures to represent a "psychoneurotic" disorder born of early emotional trauma and, Bate writes, "an instinctive effort to control—to control aggressions by turning them in against himself."[22] Others propose that Johnson was afflicted with a neurologic (or neuropsychiatric—the lines are fuzzy here) ailment called Gilles de la Tourette Syndrome, a disease first described by Itard in 1825 but definitively categorized by Gilles de la Tourette, one of Charcot's pupils, in 1885. Tourette Syndrome is characterized by the extravagant and involuntary production of mannerisms, tics, impulsions, and vocalizations. Many believe Tourette Syndrome to have a definite organic basis despite the fact that its etiology has still not been completely tracked down.[23]

The diagnosis of Tourette's has a certain appeal for understanding Samuel Johnson. As Oliver Sacks has pointed out, the involuntary compulsions and impulsions of the disease lead to "an odd elfin humour and a tendency to antic and outlandish kinds of play." Sacks correlates the disorder with "swiftness of thought and association and invention" because, he argues, it imparts its stamp to every facet of the affective, instinctual, and imaginative life.[24] If we think of disease, perhaps neurologic disease in particular, as one means of imposing a design on the world for the ill person, one way in which the body organizes its interactions with an environment as well as with itself, then Samuel Johnson not only cannot be separated from his disorder but may have been, at least in part, its intellectual product.

Unfortunately, Samuel Johnson is not available for examination and never himself wrote and rarely spoke about the habits that were read as signs and that so engrossed those who observed him (although he was preoccupied enough with his bodily ills to write extensively of his asthma, his coughs, his dropsy, his gout, his stroke, and his assorted other physical ailments). Any effort to arrive at an absolute diagnosis beyond the most general conclusion that he suffered from some type of involuntary movement or tic disorder would be futile. It is, however, interesting to note that

Johnson's literary fame—his canonization as a *monument* in the history of literary criticism—comes, in part, from the larger-than-life *monument* his physical presence apparently created. If he suffered from Tourette Syndrome, he had a mild and probably an acquired form of that odd disorder, a form that allowed him to function more or less normally. Still, Johnson's biographers match his quirky, ticcy, craggily monumental body to the brilliant monumentality of his intellectual pronouncements. His involuntary movements and tics, in fact, fueled the legend of his mental prowess. A Touretter with fewer cultural credentials would have been summarily classified (Hogarth's "ideot"), dismissed, and, as many probably were in early modern Europe, incarcerated.[25]

Samuel Johnson's physical condition, whatever its etiology, comes to us in unscientific form. The materials from which I have been quoting might be called *pathographies*—aesthetically careful descriptions of a physical condition—but they cannot be construed as *historiae morbi*, or as clinical case histories in any strict sense.[26] First, Johnson did not conceive of himself as an ill person, never mind as a patient, in relation to his mannerisms. In addition, the writers for whom he served as a subject did not understand themselves to be performing a clinical function in their writing. More to the point, the *genre* of the clinical case history was only beginning to come into being as a socially constituted form of scientific discourse toward the end of Johnson's lifetime.

The Johnsonian literary-pathographic "picture" retains a kinship to clinically produced pictures such as those of Mary Ann Carraway and Robert Myer, but it is a distant one. A more clinical patient history—of a twentieth-century American woman diagnosed to be suffering from "a severe behavioral disturbance and movement disorder . . . which seems to be a variant of Tourette's syndrome"—demonstrates that. This patient— she is real but her identity has been obscured in various ways and I will refer to her as Nancy Copewell—had been misdiagnosed and enrolled in a workshop for the severely mentally retarded for want of any more therapeutic institutional environment. One physician described her this way in the patient history:

> She was very exuberant, friendly, somewhat ceremonial in her social interactions, frequently ending sentences with "sir," curtsying to the physicians present. Her discourses were punctuated by assorted tics and movements, including blowing on her hand, bobbing her head, and jumping about the room. At one point when she was in the washroom, she began to make duck quacking sounds and produced assorted other expletives that may have been precipitated by her looking into the mirror.

A second physician characterized this patient's disorder as "a syndrome of multiple tics including duck quacking" and described her in this way:

> The patient continues to be extremely motorically active. This movement includes multiple tics including wide-eye opening, head rolling, contorted facial expressions, blowing on her hand and vocalizations. . . . Social behavior remains extremely inappropriate. Affect is jubilant and cooperative, but out of context. She tends to speak in a rather loud friendly voice in rapid bursts. She continues to exhibit English lady-in-waiting politeness in her style of addressing the examiner.[27]

These two passages not only differ fundamentally from the consciously literary depictions of Samuel Johnson but also differ remarkably from each other. The first is conversational and anecdotal, employing a casual syntax and focusing on the scene of patient-physician interaction itself. The second works hard to distance the historian from his subject by eliding that subject from his sentences with phrases such as "social behavior remains" and "affect is." Yet despite these differences, both clinicians insist on particularity and immediacy, on the human being as an aggregate of corporeal and affective detail. These patient histories seem to heed the warning Milton's Adam offers the Angel Raphael in Book VIII of *Paradise Lost*: Nancy Copewell's physicians aim to characterize "that which before us lies in daily life," and nothing more.[28] Copewell's physicians are modern medical practitioners with specialist training in neurology, but we still sense in their case histories a horror of the plight of their afflicted patient, a horror perhaps engendered by the recognition of their own inability to offer effective therapeutic intervention even though they can provide a diagnosis.

Although it would be neither fair nor neurologically accurate to compare Johnson to Nancy Copewell, it is instructive to correlate the various attempts to describe behavior in both cases. The literary narratives about Johnson flow with a kind of physical aesthetic ("a singular method of twirling the fingers . . . his vast body is in constant agitation"). The physician accounts, in contrast, aim at an objective accuracy of exposition that sets the patient firmly inside a clinical setting and a clinical discourse and that promotes linguistic distancing, disjunction, and discontinuity ("The patient continues to be extremely motorically active"). Nevertheless, all the passages—from Burney and Boswell and the twentieth-century physicians as well as from the Hippocratic *Epidemics*—aspire to precision of language and assume that to capture in words the gestures of their subjects is

to capture something essential about the conditions of these subjects in the world.

Let us return now to Samuel Johnson and to a written account by Johnson himself of what was clearly a cerebrovascular accident. On June 17, 1783, Johnson wrote the following story:

> On Monday, the 16th, I sat for my picture, and walked a considerable way with little inconvenience. In the afternoon and evening I felt myself light and easy, and began to plan schemes of life. Thus I went to bed, and in a short time waked and sat up, as has long been my custom, when I felt a confusion and indistinctness in my head, which lasted, I suppose, about half a minute. I was alarmed, and prayed GOD, that however he might afflict my body, he would spare my understanding. This prayer, that I might try the integrity of my faculties, I made in Latin verse. The lines were not very good: I made them easily, and concluded myself to be unimpaired in my faculties.
>
> Soon after I perceived that I had suffered a paralytick stroke, and that my speech was taken from me. I had no pain, and so little dejection in this dreadful state, that I wondered at my own apathy, and considered that perhaps death itself, when it should come, would excite less horrour than seems now to attend it.
>
> In order to rouse the vocal organs, I took two drams. Wine has been celebrated for the production of eloquence. I put myself into violent motion, and I think repeated it; but all was vain. I then went to bed, and, strange as it may seem, I think, slept. When I saw light, it was time to contrive what I should do. Though GOD stopped my speech, he left me my hand; I enjoyed a mercy which was not granted to my dear friend Lawrence, who now perhaps overlooks me as I am writing, and rejoices that I have what he wanted. My first note was necessarily to my servant, who came in talking, and could not immediately comprehend why he should read what I put into his hands.
>
> I then wrote a card to Mr. Allen, that I might have a discreet friend at hand, to act as occasion should require. In penning this note, I had some difficulty; my hand, I knew not how nor why, made wrong letters. . . . My physicians are very friendly, and give me great hopes; but you may imagine my situation. I have so far recovered my vocal powers, as to repeat the Lord's Prayer with no very imperfect articulation. My memory, I hope, yet remains as it was; but such an attack produces solicitude for the safety of every faculty.[29]

Johnson's speech improved rapidly, though for a time his articulation was slow, and talking for more than short periods fatigued him. This event,

recounted in a letter to his friend Hester Thrale in Bath, presaged the beginning of Johnson's physical decline. By 1783, he suffered not only from a chronic bronchitis that had turned into emphysema but also from congestive heart failure suggested by his complaints of dropsy, from circulatory problems that may have culminated in this cerebral event, and from the progressive arthritis that he persisted in calling "gout," a fairly all-purpose medical term in the eighteenth century. He died in December of 1784, eighteen months later. It is not possible from Johnson's narrative alone to pinpoint the exact anatomical location of the lesion that precipitated this event. But despite the fact that he could not have understood the physiology of what had happened in his brain, Johnson's self-diagnosis—a "paralytic stroke"—was accurate: He had suffered a cerebral ischemic attack that evolved into a mild stroke.[30]

One of Samuel Johnson's physicians was the well-known William Heberden (1710-1801), who saw his patient on June 17, 1783, the day of his stroke. In the Heberden manuscripts at the Royal College of Physicians, London, in a section on "Paralysis," the doctor jotted the following observation on Johnson: "Voice suddenly went in man aged 74, mind and limbs affected; voice almost restored within a few days."[31] Johnson has become here not human being or even human body, but an accumulation of voice, mind and limbs. Heberden wrote about his patient as alienated from his body; this clipped account differs from Johnson's version of his experience in that its staccato, stripped-down language reveals a radical, metaphorical absence of the subject in official clinical prose. Indeed, what is so remarkable about Johnson's own account of his stroke is the absolute presence of its subject, of the great Lexiphanes himself in full literary regalia. Johnson's clinical self-portrait presents him not as "other" in relation to his narrating voice, but as a man determined to remain in control of his mind and of his body.

It is useful to compare the prose of Johnson and Heberden to a more self-consciously composed autobiographical narrative. This is a third-person account published in 1973 by a Swedish neuroanatomist writing about his own illness:

> The patient is a 62-year-old professor of anatomy who was suddenly taken ill during a lecture-trip abroad. He had had no serious ailments. About a year before, one evening in the course of a few minutes he suddenly had paraesthesiae around the left corner of the mouth, in the radial side of the left hand and in the left great toe. There was dizziness on vertical movements of the head. The paraesthesiae and the dizziness persisted, although in diminishing intensity, for nine months.

The present illness started suddenly when the patient woke up and turned in his bed on the morning of April 12, 1972. In the course of a few minutes an initial heavy, but uncharacteristic, dizziness was followed by dysarthria, double vision and a marked paresis of the left arm and leg. There was no loss of consciousness, no headache or vomiting and no stiffness of the neck. In the very beginning, there were paraesthesiae of the left side of the head, especially the scalp.[32]

Brodal, the author of a neuroanatomy textbook as well as the victim of an insult to the brain, understood, unlike Samuel Johnson, the physiology of what was happening to him. He dwelt particularly, as Johnson did, on everyday disturbances, and we sense his sudden realization of disorder when his world uncharacteristically altered as he turned over in bed. But this patient had access to a specialized vocabulary (dysarthria, paraesthesia, paresis) with which to describe his experience. By subsuming himself as patient into the role of formal narrating historian and dividing private from professional self through the use of the third-person voice, Brodal produced a narrative that presents a man determined to come to terms with the slippage of bodily control.

Brodal described an experience one researcher calls "a sudden discontinuation of self," in which the stroke patient experiences himself or herself "as a stranger and an alien in his own environment."[33] Surely this could also be said of Samuel Johnson. Brodal's account is specific enough (with its accompanying data) to locate the site of his lesion as a branch of the middle cerebral artery. It reproduces a clash between the patient's experience of physical uneasiness, of change from his normal experience of the world, and the distancing terminology that explained this change in pathophysiologic terms. In Brodal's case, the conjunction of patient and physician that the third-person grammar tried to occlude makes the clash especially poignant.

A 1986 account of a woman eventually diagnosed with malignant lymphoma of the central nervous system contains some of the features of disjunction present in both Johnson's and Brodal's case narratives. This patient came to the hospital with neurologic complaints and died as a result of respiratory failure. The case presentation begins:

A 55-year-old right-handed woman was admitted to the hospital because of blurred vision.

She was well until 28 months earlier, when she began to experience blurring of vision in both eyes. An ophthalmologist found no history of a preceding respiratory tract infection and made a diagnosis of "papillitis." Her

symptoms resolved in six weeks on prednisone. She was then well until nine months before admission, when numbness developed in the right hand, and she dropped a cup of coffee from that hand. The numbness waxed and waned during several days and then worsened, accompanied by headache and slurred speech.[34]

This history clearly draws on material elicited from the patient: she remembered the dropped cup of coffee as a key sign to her of something wrong, and the physician's account maintains that sense of everyday gestures gone awry by including this detail. We get a sense of the patient as an individual who was careful and controlled, not the sort of person to lose her grip on a coffee cup. The case presentation depicts someone whose chief complaint of blurred binocular vision was also in a larger way a complaint about the loss of control over her body.

This history's opening is written in the language of its subject. The authors avoid technical jargon in such a way that the reader can imagine the questions the physician asked in order to elicit the information. However, the language changes later in the report. At a subsequent visit, we learn that "while the patient was playing tennis, she noticed difficulty in depth perception. She subsequently observed a 'purplish haze' in the right visual field" and "the patient reported the onset of diplopia five days earlier, and four days thereafter she was aware of drooping of the right upper lid and dizziness. That evening a mild headache developed in the right periorbital area." Even a patient described, in one of the report's oddest phrases, as "a thin woman with excellent use of language" is unlikely to refer to "diplopia" to report double vision, nor is she apt to locate a headache "in the right periorbital area." The physicians took over as the case record moved away from the history to the physical and then on to more technical accounts of studies ordered and medications given.

The case reports concerning Johnson's and Brodal's strokes and the patient with CNS lymphoma each demonstrates in a different way that a certain sense of self-division characterizes neurologic ailments and that the fear of losing self-control characterizes patients' anxieties. In a lesser way, this fear also underlies the accounts Hugh Lenox Hodge gave of his patients with chorea. In addition, the twentieth-century reports reflect the modern acceptance of physican authority and, relatedly and perhaps of greater importance, of the authority of scientific description and technological intervention. For Heberden, Brodal, and the *New England Journal of Medicine* historians, the patient is "clinicalized" in medical language. As the report proposes, the human woman who dropped coffee cups and

played tennis at the onset of her disease becomes as the report progresses an accumulation of CT scan findings and increasingly severe pathologies.

Johnson and Brodal are, of course, not typical clinical historians for many reasons, but chiefly because they were doing self-description. However, each of these histories demonstrates in its own way how case records participate in constructing stories about human bodies and that the construction of these stories is part of the politics of the "cure" the patient seeks. If pain and illness themselves clamp down on language and constrict the production of discourse, as Elaine Scarry has argued, then the physician works with the patient to rebuild narrative "speakability."[35] But to describe, diagnose and understand serious disease is to confront mortality, another kind of unspeakability. The codified structure of the modern patient history derives from the combined desirability and threat of putting bodily changes into language.

Johnson in the eighteenth century and Brodal in the twentieth make in many ways ideal case historians, following the dictum once proposed by Plato that those who want to become physicians should first experience all the illnesses they want to cure.[36] This view holds that sense experience precedes other ways of understanding the world, that the body produces the primary kind of knowledge from which all other knowing must derive. Case histories—by the physician, by the patient, or by the biographer—try to mirror sense experience, to reembody the body in language. This phenomenon explains in part the "life-style" features in popular magazines, in which illness is humanized through personal portraits of the afflicted. These articles have become a special hallmark of the media response to AIDS; journalists present AIDS patients as bearing a unique relation to a postmodern understanding of death.[37] According to Jean Starobinski, "Knowledge [in the French sense of *science*] of the body can and must be understood as knowledge which issues *from* the body and not as knowledge which aims *at* the body."[38]

Tensions in a case narrative derive from the necessarily incomplete relation between the case historian's representation of disease and the patient's sense of inhabiting a symptomatic body. Generic nosological description can rarely, if ever, duplicate the experience of a given suffering human being. This tension emerged as a central theme in George Cheyne's 1733 work, *The English Malady; or, A Treatise of Nervous Diseases of all Kinds, as Spleen, Vapours, Lowness of Spirits, Hypochondriacal, and Hysterical Distempers, &c.* Cheyne presented his own case most thoroughly, apologizing for his apparently "*indecent* and *shocking Egotism*" (p. 362)

in making himself his own subject.[39] In the final section of the work, "The Case of the Author," Cheyne commented on the case history as a narration. "I have," he wrote, "written *this* in a plain *narrative* Stile, with the fewest Terms of Art possible, without supposing my *Reader*, or shewing *myself*, to have look'd ever into a *physical* Book before" (p. 363). In Cheyne's case, the pages of case histories that conclude his book serve as proofs of his theories about certain kinds of disorders and anchor his controversial proposals for therapy.

Cheyne discussed case-history-writing in relation to the eighteenth-century social context of clinical diagnoses. He remarked that composing the third section of his work, entitled "Variety of Cases that illustrate and confirm the method of cure," was the "most difficult and unpleasant Part of my Work."[40] Some of his patients were still alive, and he worried about incurring their wrath:

> The *Distempers of Patients are sacred*, (*Res sacra miser*) and *nervous* Distempers especially, are under some kind of *Disgrace* and *Imputation*, in the Opinion of the *Vulgar* and *Unlearned*; they pass among the Multitude, for a lower degree of *Lunacy*, and the first Step towards a *distemper'd Brain*: and the best Construction is *Whim, Ill-Humour, Peevishness* or *Particularity*; and in the *Sex, Daintiness, Fantasticalness* or *Coquetry*. (p. 260)

In an effort to counteract these superstitions, Cheyne argued vigorously that "nervous distempers" are as much bodily ills as are fevers and smallpox, though he went on to reveal medicocultural assumptions himself when he wrote that such distempers virtually never occur "to any but those of the liveliest and quickest natural Parts, whose Faculties are the brightest and most spiritual, and whose Genius is most keen and penetrating," even arguing he had "seldom ever observ'd a *heavy, dull, earthy, clod-pated Clown*, much troubled with *nervous* Disorders" (p. 262).

Cheyne's discussions of nervous diseases and their cultural interpretations took into account the eighteenth century's need to explain every symptom with a cause, a need also demonstrated in Floyer's Hippocratic commentaries. The cultural ideas Cheyne imputed to ignorant superstition reveal the difficulties inherent in any institutional effort to explain a core term of cultural life—the human body in its actions, its rituals, its complaints. Anthropologist Clifford Geertz's notion of "thick description" in ethnography, a term he borrowed from philosopher Gilbert Ryle, might be applied to this difficulty. Geertz argues that ethnography's object

is to sort out its data into structures of signification that explain not the ontological status of human behaviors and rituals but rather their import.[41] Data thus interpreted—that is, "thickly" (intelligibly) described within a cultural context—become another order of interpretation within anthropological writings. In this sense, the medical case history can be seen as a type of ethnographic account. In fact, Geertz uses medicine in his discussion of "clinical inference" or generalization within cases (p. 26). "Symptoms," he writes, "are scanned for theoretical peculiarities—that is, they are diagnosed"; put differently, clinical inference "begins with a set of (presumptive) signifiers and attempts to place them within an intelligible frame" (p. 26). In another essay, Geertz argues that "there is more to diagnosis, either medical or sociological, than the identification of pertinent strains; one understands symptoms not merely etiologically but teleologically—in terms of the ways in which they operate as mechanisms, however unavailing, for dealing with the disturbances that have generated them."[42]

I have been concerned not with therapeutics but rather with medical practice's inaugurating gesture: to know and to record status changes in the human body. Physicians act as ethnographers, historians, and biographers when they take and record patient histories and when they write up case reports. Recognizing these historiographic functions of the diagnostic process in the context of other kinds of historiography allows us to recognize as well the way medical practice participates in the production of cultural discourses. The case report, if we read it within Geertz's model of interpretive writing, produces a context around groupings of symptoms and signs and findings and articulates these data into a narrative whose goal is to move toward explanation, therapy, and resolution. In the end, ethnographic expositions and patient histories disclose prevailing explanatory schemes and the social ideologies inevitably subscribed to by their authors. These writings thereby anchor themselves in particular times and places as well as in particular evolutions of knowledge about their content. This context production, the development of a framework of knowledge and assumptions on which to attach a patient's symptoms, is at the heart of the diagnostic process.

ALTERED CONDITIONS

The cultural discourses and institutional recording practices of medicine emerge from their professional confines to seep into explanations about the human body that appear more publicly and popularly. Street meanings of disease and disability are informed to a greater or lesser extent by the empirical observations and isolating mechanisms of biomedicine and by how these observations and mechanisms are reported in the media. In addition to enumerating empirical details—microbes and risks, prevention and incubation and therapies and recuperation—stories written in cultural as well as professional languages situate health and disease within a normative chronology of origin, course, and mortality, or beginning, middle, and end. Causes are assigned; contagion, or at least influence, is assumed; blame is handed out. The chapters that follow examine the intersections between competing explanatory systems when they are applied to several conditions of the human body that inspire dread—sexual ambiguity, birth abnormalities, and AIDS These conditions challenge the frameworks of medical epistemology because those frameworks depend on the discovery of explanations and therapies that can act upon the physical body and alter it. They also put into relief—and challenge—the mechanisms through which social ideologies that contain and isolate the human body are produced. Not coincidentally, the three types of bodily condition I have selected to illustrate these operations centrally call into question the Ur-creator of dread in Western cultures—sex.

4. Ambiguous Sexes

I just couldn't tell, you'll think I'm a fool
If she was a woman or a man.
> Richard Thompson
> "Woman or a Man?"

In this chapter I am concerned with the particular gender disorder that in earlier times was called hermaphroditism. That term remains in use, but the disorder now usually goes by the less mythological, more bio-medical designations intersex and intersexuality. This category of person lives within blurry boundaries. The category certainly includes the relatively rare cases of "true hermaphrodites" (individuals who have one ovary and one testis or whose internal structures are mixed but equally female and male) and the strangely named cases of "pseudohermaphrodites" (those who have ambiguous internal structures in which both ovarian and testicular tissue are present and/or have ambiguous external genitalia). In addition, the category of intersex embraces a wide variety of gender disorders that either explain the embryological development of pseudohermaphroditism, or that in themselves create one form or another of sexual ambiguity. These disorders include androgen insensitivity syndrome, congenital adrenal hyperplasia, 5-alpha reductase deficiency, 21-hydroxylase deficiency, Klinefelter's and Turner's Syndromes, and a range of other endocrinological and chromosomal anomalies.

Estimates have placed the incidence of sexually ambiguous individuals—covering all of these conditions—at from 2% to 3% of the population.[1] But it is notoriously difficult to pin down the incidence of intersexed births, and numbers as disparate as 1 in 13,000 and 1 in 25,000 can be found in the literature.[2] Two factors render these estimates even more difficult. First, chromosome tests are not routinely performed at birth, and sex assignment is made solely on the basis of external genitalia.

Therefore, many intersexed conditions manifest themselves not at birth but at puberty, and sometimes even later, for example when an individual comes to clinical attention with a concern about infertility. Second, such conditions are rarely made public beyond the immediate family, and current treatments entail making a firm sex assignment (or maintaining sex assignment) at the time the individual comes into clinical care, and undertaking whatever hormonal or surgical interventions are required to match the external body and as many of its internal functions as possible to this sex assignment.

A panoply of intersexed conditions occur as normal variations in nature and have been recognized since antiquity, yet both physicians and families invariably view this natural phenomenon, which can be altered only through a kind of medicosurgical intervention that was not available until the twentieth century, as a profoundly *unnatural* and intolerable deformity that needs to be corrected so that the affected individual can participate in normal social categories.[3] True hermaphroditism, intersex in its perfect or ideal state, rests at one end of a spectrum of natural bodily sexing. At the other end lies gender dysphoria, the official *Diagnostic and Statistical Manual of Mental Disorders* term for transsexualism (individuals who request hormonal treatment and surgical sex reassignment for psychological rather than anatomic or physiological reasons). Transsexuals present themselves to medical professionals wanting to alter their bodies to conform to their psychological gender, whereas the families of intersexed newborns present sex-ambiguous bodies to the medical establishment for correction—that is, for a determination of sex from which, presumably, their psychological adaptation will follow. Persons whose intersexuality is discovered at puberty or afterwards almost always want their bodies altered to match the gender in which they have been living.[4] All of these conditions call into question the very foundations of categories of normality in the sexed human body as well as in human sexual identification and sexual object choice. A historical examination of the understanding and treatment of these conditions discloses the ideological power of ideas of normativity in relation to sex.

The normative with respect to sex turns out not merely to require clear-cut biological oppositions between male and female or even to depend on rigid cultural constructions of masculinity and femininity. Challenges to sexual differentiation pose different threats that go beyond the obvious ones. They blur the boundaries between what is inside the body and, thus, private, and what is outside the body and, thus, on pub-

lic display. Such challenges also always represent a calling into question of the heterosexual principles of social and familial organization and produce a realm outside social organization altogether, a realm of degeneration or abjection, of the nonhuman. In order to shore up heterosexuality as a normative social construction, biomedicine and the social structures that rely on it have framed this realm of debasement as something to be eradicated. Only by bracketing off ambiguous sex not just as immoral or illegal or diseased but as *nonexistent* can these challenges be countered and held at bay. The social by-product of such bracketing, I shall argue, is homophobia, defined as the fear that heterosexuality may not be the only viable principle on which to base kinship. As performance critic Lynda Hart defines homophobia, it is "a fear that the category of heterosexuality is *already* adulterated."[5] The degree to which the mythologically derived term hermaphrodite still serves the needs of biomedical language suggests the degree to which biomedicine paradoxically but powerfully holds both that such a thing *is* and that such a thing *cannot be*.

AMBIGUOUS SEX AND SOCIAL THREAT

English guitarist and singer-songwriter Richard Thompson composed a song titled "Woman or a Man?" and recorded it on his 1984 album, *Small Town Romance*. "Woman or a Man?" was also recorded in 1988 in a zydeco version by the Louisiana band Michael Doucet and Cajun Brew. These are its lyrics:

> I stepped on the dance floor feeling very cool
> I thought I saw an angel sitting on a stool
> I just couldn't tell, you'll think I'm a fool
> If she was a woman or a man.

> She was the kind of woman that a man could crave
> From her high-heeled shoes to her permanent wave
> Except maybe she was needing a shave
> Was she a woman or a man?

> Oh I asked her to dance and I took her by the hand
> She held me so tight it was hard for me to stand
> Built like a lumberjack I couldn't understand
> If she was a woman or a man.

> Well I walked her home it was quarter past four
> My heart was thumpin' as we ducked in the door

And then when she kissed me I thought I was sure
If she was a woman or a man.

Oh she stole my wallet and she knocked me off my feet
She tied on her roller skates, made her retreat
All I found was a blond wig a'lyin' in the street
Was she a woman or a man?

Well I don't care if she seemed unkind
She stole my heart as she robbed me blind
I love her so much that I still wouldn't mind
If she was a woman or a man.[6]

In addition to taking up questions of sexual identity, gender role, trans-
vestism, and courtship politics, "Woman or a Man?" also arguably chal-
lenges the cultural functions of gender boundaries. Although the speaker
worries that "you'll think I'm a fool" because he "just couldn't tell . . . if
she was a woman or a man," the song's energy comes from its juxtaposi-
tion of culturally opposed sexual markers; its subject is a bewhiskered
"angel" in high-heeled shoes who is "built like a lumberjack." The song's
central moment then coolly literalizes the clichéd "she knocked me off
my feet" as its mysterious subject leaves behind only a blond wig as the
trace of sexual masquerade and objectified duplicity. The lyrics' two
moments of ambiguity—the kiss and the ambiguous final two lines—sug-
gest a kind of seductiveness in the very plasticity of gender designations.
The song's play with seduction raises issues of how and why gender dif-
ferentiation has been socially mandated and how that mandate has been
empowered.

The lyrics to "Woman or a Man?" recreate in the late twentieth cen-
tury some aspects of controversies over public gender differentiation that
raged in England in the *Hic Mulier* and *Haec-Vir* debates from the 1570s
to 1620,[7] recurred in concerns over the molly houses of the eighteenth
century,[8] and have always lurked in the wings of theater history.[9] These
controversies focus primarily on disruptions to the semiotics of clothing
in the sartorial ambiguity of cross-dressing. Transvestism depends on
rigidly hierarchical gender codes that reproduce—in the world of
appearances—an underlying social organization. Its threat to social
boundary delineations is external but profound; to cross-dress is to reify
and dramatize the power dynamics and the sexuality of costume.[10]
"Drag" is always a kind of theater, a play on the possibilities of sexual
blending and sexual difference, a putting on and taking off of "the oppo-

site sex" at will. This theatrical dislocation can be marginalized and contained by custom, by popular rituals (either in the street or in underground subcultures) and by laws (such as sumptuary laws or laws concerning "decency" and "public morality").[11] Nevertheless, the transvestite gesture signals the possibility that the social body is as fluid as the private body's drapery and that the gender definitions regulating the social order may shift and mutate.

The anatomically ambiguous individual is even more subversive and threatening. Hermaphrodites have historically posed epistemological challenges to definitions of natural boundaries and to the very notion of gender clarity itself. One mid-nineteenth-century treatise on teratology (the study of medical "monsters" into which hermaphrodites have traditionally been fit) framed the challenge this way:

> It is necessary to note that from infancy, therefore well before hermaphroditism has imprinted its mark of ambiguity originating in the genital apparatus on the total physical constitution, the subject already evinces in its inclinations, tendencies, tastes, humor an instability that is the expression of its sexual anomalousness.[12]

The "mark of ambiguity" in this formulation rests on instability itself. Ambiguous genitalia represent the site of a culturally fraught contest for social place that relies on clear gender differentiation and rejects social mutability.

In antiquity and the early Middle Ages, hermaphrodites resided in the realm of divine signification—and were frequently put to death. They came to be considered as naturally deviant embryogenic sexual anomalies in the sixteenth, seventeenth, and early eighteenth centuries, when they emerged as problems for canon and civil law. Later, they were transferred to the scientific arena of medical phenomena, where they have been classified under the ideologically charged terminologies of late nineteenth-century sexology. Currently, intersexed conditions are referred to embryologists, endocrinologists, and surgeons (usually urologists). The hermaphrodite may serve as a foundational test case for an analysis of normative constructions of gender, because intersexuality questions social organization in basic ways.

Law and medicine take very different approaches to how sex is construed, and nowhere is this better exposed than by the ways in which each has traditionally classified hermaphrodites. The tension between these approaches demonstrates how this extreme challenge to a hierarchical

and heterosexual social order has been radically marginalized and expelled from a sex/gender system whose rigid binarism is crucial to its operation. The scientific recognition of hermaphroditism as a natural biological possibility confounds cultural investments in sexual difference as an absolute and invariable binary opposition. These cultural investments turn out to be the products of a reactionary fear of the threat of homosexuality. Before returning to the operative power of this fear, I shall examine the legal status of hermaphrodites, the progressive medicalization of their bodies, and the unfolding of several cases of hermaphroditism.

AMBIGUOUS SEX AND MEDICAL JURISPRUDENCE

Hermaphrodites pose a particularly unsettling problem for medical jurisprudence. The law assumes a precise contrariety between two sexes, whereas medical science has for several centuries understood sex determination to involve a complex and indefinite mechanism that results in a spectrum of human sexual types rather than in a set of mutually exclusive categories.[13] The state has several reasons for requiring that newborns be registered with a name and a sex designation at the time of their birth: to establish a means of social organization and to prevent fraud; to regulate the granting of different privileges and responsibilities according to sex; and, most crucially, to regulate morality and family life by prohibiting sex acts and marriages involving persons of the same sex. Prohibitions against "deviant sexual practices" or "sexual perversion" echo this centrally organizing concern to bar same-sex alliance because such terms virtually always refer to homosexual acts.[14] Changes in sex designation can be made only if the reason for the change is sufficient "to overcome or safeguard society's interests in reliable identification and in public morality."[15] "Public morality" here again means the maintenance of a taboo against homosexuality.

Thus, biological indeterminacy—the fuzzy boundary line around the human body—has legally been erased in the service of social regulation and cultural taboo. What is the state's interest in the absoluteness of sex categories? What kind of civil disorder results if ambiguously sexed individuals are permitted to decide on their own sexual identification and gender behavior, or to reject gender roles altogether, or to move from one gender to another? Medicolegal treatises refer to "scandal" and to

problems for "public order" and "public morality" that may result if the state neglects its interest and right to intervene and to constrain individual freedom of choice in these cases.[16] The difficulty, of course, always returns to marriage, a mutually consensual legal bond that is founded on the certainty that the consenting individuals are of different sexes. The taboo, the circumscribed and disruptive possibility that must be eradicated, always resides in the union of same sexes.

In his work on jurisprudence, Pierre Jacques Brillon (1671–1736) noted that the charge of sodomy might be brought against hermaphrodites who lived in the male sex and then performed the female role in sexual intercourse. Brillon cited a 1603 case in which a young hermaphrodite was condemned to death by hanging and afterwards burned for this offense.[17] However, because they frequently do not state this fundamental injunction against homosexual alliances, later medicolegal treatises sometimes contradict themselves when they discuss hermaphroditism. In his 1778 *Elements of Medical Jurisprudence*, for example, Samuel Farr classified hermaphrodites as monsters but suggested that "were it not that such beings often fly from society, lead sedentary lives, and are deprived of some wholesome exercises to the human constitution, life might be enjoyed by them, and to as great an extent as by any other persons."[18] He argued that

> as these are living beings, and sometimes capable of all the functions of society, such distinctions ought to be made relating to them, as will place their situation in the most proper light, and the most favorable to their happiness. They are great objects of our pity and complacency, for they are not only deprived of the common pleasures of mankind, but are subject to disorders which are painful, uncomfortable, and inconvenient. (p. 20)

For Farr, the key legal issues with respect to hermaphrodites concerned their impotence, their right to marry, and the possibility of changing their sex. On marriage, he was empathetically liberal—it depended on the first question, of impotence, but should be "left to their own choice." But on the subject of "Whether change of the sexes might be allowed?" Farr replied, "This is certainly contradicted in the terms, and will admit of no dispute" (p. 23), a view that effectively proscribed the legalization of marriages involving hermaphrodites and answered the indeterminacy of hermaphroditic sex and sexuality with its own ambiguity. Indeed, in the disposition of an 1849 case involving an ambiguously sexed 3-year-old child (this case is discussed in some detail below), the surgeon justi-

fied his castration of the child by arguing the necessity to coerce celiba-
cy by removing all potential for sexual desire and thereby eliminating the
subject's inclination to marry.

Medicolegal texts vary widely in their application of biological
knowledge to the law. Charles Meymott Tidy, for example, in the 1882
edition of his *Legal Medicine*, followed precedent for determining ques-
tions of inheritance, succession to title, eligibility for certain professions,
"tenancy by courtesy," legitimacy and paternity challenges, and divorce
by invoking the notion that hermaphrodites must be treated legally
"according to the kind of sex which doth prevail,"[19] a notion that was in
operation, as we shall see, by the sixteenth century and that can be found
in codified form in both civil and ecclesiastical law compilations.[20] It is
important to note that it was examination by medical experts recognized
by the courts that determined the "prevailing" sex, not a free choice by
the intersexed individual.[21] Tidy readily admitted, however, the difficul-
ty posed by "sexless beings" in whom neither sex prevails. He resolved
that there is only one clearly "distinctive sexual characteristic" and "that
is the *genital gland*. This is *the* reliable—and, we may add, the *only* reli-
able—test of sex," although he leaves unspecified what precisely he means
by "gland" (p. 282).[22] Tidy wanted consideration for nongenital data as
well but cautioned against overestimating "inclinations and desires"
because of the influence of upbringing. Here, like Farr, he contradicted
himself, in a classic example of expediency:

> The sexual inclinations, the habits and tastes, and the general conformation
> of the body should in all cases be considered. If they support the conclu-
> sions based on the principles laid down in the preceding paragraphs they
> may be regarded as valuable confirming evidence. But if, on the contrary,
> they fail to confirm, or even appear at variance with such conclusions, they
> may then be entirely disregarded. (p. 291)

In order to fit the requirements of a given argument, sex categorization
on this model uses or discards the subjective experience of living inside
an ambiguous body.

Most recent legal challenges to the irreversibility of sex designations
at birth have come from transsexuals wishing to alter their civil status fol-
lowing sex reassignment surgery. In the United States, birth certificates
themselves establish only the fact of birth and carry no evidential or pro-
bative value, but they do affect draft status, government security clear-
ances, and the acquisition of passports. In most states, a court order can
alter civil status, and this alteration may then be appended to the origi-

nal birth certificate. Nevertheless, this differs from the filing of a new birth certificate altogether. In Illinois, a law intended for cases of newborns with ambiguous genitalia has been used by transsexuals to acquire new birth certificates. The Illinois law holds that if a physician files an affidavit that a person's sex designation should be changed by reason of a surgical procedure, such a change may be made. In cases in which "corrective" surgery is not at issue, the legal waters become even muddier, but the Illinois law at least allows that biological sex does not always fully reveal itself at birth, and that medicolegal mistakes can therefore be made.

However, in 1966, the Committee on Public Health of the New York Academy of Medicine stated two reasons for their recommendation against sex changes on birth certificates in cases of surgical sex reassignment. First, transsexuals remain chromosomally in their original sex.[23] Second, the Committee questioned whether the law should be changed "to help psychologically ill persons in their social adaptation." The fundamental concern, however, was revealed in the report's final sentence: "The desire of concealment of a change of sex by the transsexual is outweighed by the public interest for protection against fraud."[24] The question of fraud is tightly bound to questions of sexual acts and to proscriptions against homosexuality. It is in this domain that the transsexual's predicament resembles that of the hermaphrodite. However, the transsexual's civil and social status is uncannily lucid in comparison with the legal limbo awaiting the hermaphrodite who refuses surgery and wishes to maintain a sexually ambiguous body.

THE MEDICALIZATION OF AMBIGUOUS SEX

"There is no legal or medical definition of sex," claims a medical textbook published in 1964. This text goes on to differentiate between chromosomal sex, gonadal sex ("It is the histological structure and not the naked eye appearance which determines the sex of the gonad"), "*apparent* sex" (my italics), and psychological sex or sexual behavior ("the psychological sexual libido between the sexes, the sexual attraction of man for woman, and vice versa, which leads to heterosexual intercourse"). This textbook argues that the "normal female" represents "the neutral or basic sex" and points out that "the law stipulates that a human being *must* be either a male or a female and makes no provision for the category of intersex."[25] This lack of legal provision is odd, given that "intersexuality rests on the fact that *genetically* there is no pure male or female constitu-

tion, but rather a balance between two types of genes."[26] A well-known late nineteenth-century medical volume, Gould and Pyle's *Anomalies and Curiosities of Medicine*, ignored this notion of balance by classifying intersexuality or hermaphroditism with "Major Terata" as a part of the study of monsters, but its authors also recognized "a type of hermaphroditism in which the sex cannot be definitely declared, and sometimes dissection does not definitely indicate the predominating sex."[27]

"After the discovery of the chromosomal mechanism of genic sex determination at the beginning of the present century," several endocrinologists have reported, "possibly the most surprising outcome of research in this field is the realization that, given the male or the female chromosomal constitution, any individual still may develop into either a male or a female."[28] A 1959 medicolegal handbook cautions that "genet-

	Terminology	Sex Chromatin	Structure of Gonads				Sex Differentiation		
			Form	Germ Cells	Cortical Elements	Medullary Elements	External Genitalia	Genital Ducts	Secondary Sex Development
Gonadal Dysgenesis	Gonadal hypoplasia	♀ ?	streak ?	absent or scanty	scanty	vestiges	female	female	absent
	Gonadal aplasia	♂ or ♀	streak	absent	absent	vestiges	female	female	absent
	Gonadal dysplasin	♂ or ♀ ?	streak	absent	absent	Leydig cells rete tubules	phallic enlargement	female	absent, exc. sex hair
	Testicular hypoplasia	♂ or ♀	small oval	absent	absent	primitive tubules	ambiguous	male	absent
	Testes with germinal aplasia	♂ or ♀	small	absent	absent	tubules with Sertoli cells; Leydig cells	male	male	male
	Testes with tubular fibrosis	♀ or ♂	small testes	absent or scanty	absent or defect	tubules with fibrosis; Leydig cells	male	male	male, sometimes gynecomastia
	True hermaphrodite with ovotestes	♀ or ♂	ovotestes	absent or scanty ?	present	present	male or female	mixed male or female	male or female
	True hermaphrodite with testis and ovary	♀ or ♂	testis and ovary	?	present	present	male or female	male or female	male or female
Male Pseudohermaphrodites	Male pseudohermaphrodites A. Simulating ♀ or ambiguous	♂	testes abdomin. or inguin.	usually absent	vestiges	well developed tubules well formed Leydig cells	ambiguous or male	predom. male predom.	male or female
	B. Simulating ♀	♂				present	female	female	female
Female Pseudo-hermaphrodites	Female pseudohermaphrodites A. Without adrenal hyperplasia	♀	ovaries	present	normal	normal	male or ambig.	female	female
	B. With adrenal hyperplasia	♀	ovaries	present	normal	normal	ambiguous or male	female	male, precocious

Figure 5: Types of Abnormal Sex Differentiation.

This grid correlates types of congenital gender disorders (e.g. malformations in gonadal development; male and female pseudohermaphroditism) with chromosomal identity (sex chromatin); internal gonad structure (note: Leydig cells are interstitial cells of the testis, whereas Sertoli cells are elongated cells in the seminiferous tubules to which spermatids are attached during spermiogenesis); and sexual differentiation in relation to external genital development and secondary sex characteristics. [From "The Criteria of Sex: The Nomenclature and Classification of Hermaphroditism," in Howard W. Jones and William Wallace Scott, *Hermaphroditism, Genital Abnormalities and Related Endocrine Disorders* (Baltimore: Williams & Wilkins, 1958): 52. Used by permission.]

ic sex as determined by sex chromatin patterns, cannot be employed as an invariable governor of social sex," even though juridical categories do not permit this duality.[29] By inventing categories of psychological and social sex, these texts assume the normativity of heterosexuality and argue insidiously against the naturalness of homosexuality. Homosexuals, in these terms, are those whose affectional and sexual behavior contradicts their biological sex.

In the face of juridical rigidity on sex differentiation, there exists a wide variety of types of sexual ambiguity classified medically under the general rubric "pseudohermaphroditism."[30] Figure 5 shows the range of abnormal sex differentiation that may occur in human sexual development, with resulting abnormalities in gonad structure, external genitalia, and secondary sexual characteristics. Figure 6 charts types of hermaph-

Etiologic Factors	Criteria of Sex / Groups of hermaphrodites	Chromosomal Pattern	Gonadal Structure	Morphology of External Genitalia	Morphology of Internal Genitalia	Hormonal Dominance	Usual Sex of Rearing	Usual Gender Role
Gonad and chromosome discrepancy	Gonadal aplasia and dysplasia	male or female	0	feminine*	feminine	0	as women	as women
	Klinefelter's syndrome (testicular hypoplasia, testes with tubular fibrosis)	male or female	masculine	masculine	masculine	mixed	as men	as men
	Hermaphroditismus verus	male or female	mixed	mixed	mixed	insuff. data	either	either
Etiology obscure	Male hermaphroditism	male	masculine	mixed	mixed	masculinizing or feminizing	either but mostly as women	either but mostly as women
Adrenal hyperplasia	Female hermaphroditism with virilization	female	feminine	mixed	feminine	masculinizing	either but mostly as women	either but mostly as women
Etiology obscure	Female hermaphroditism without virilization	female	feminine	mixed	feminine	feminizing	either	either

*May have enlarged clitoris.

Figure 6: Classification of Hermaphroditism.

This table correlates the causes (etiologic factors) of some types of hermaphroditism with some of the categories in Fig.5, and adds a column for hormonal dominance. The last two columns are curious, in that they distinguish between "normal sex of rearing" and "usual gender role" in an implicit admission that these need not always overlap, but in all cases here they coincide. [From "The Criteria of Sex: The Nomenclature and Classification of Hermaphroditism," in Howard W. Jones and William Wallace Scott, *Hermaphroditism, Genital Abnormalities and Related Endocrine Disorders* (Baltimore: Williams & Wilkins, 1958): 53.] Used by permission.]

roditism and the patterns they follow, and includes the "usual" sex of rearing and gender role. These figures are taken from a 1958 textbook that remains one of the standard authorities on its subject.[31] Both figures rely on dichotomous sex labeling that misleadingly assigns genders to their content and that is deconstructed within the schemas with the use of the designation "mixed" and the notion of "predominance." As we now know that chromosome combinations such as XO, XXX, and XXY exist, the effort to schematize is self-defeating. Such schemas could not have been produced before hermaphroditism became fully medicalized. Whereas medicalization began in the sixteenth century and was nearly completed by the nineteenth, its power did not alter the social condition of hermaphrodites until the availability of surgical and pharmacological interventions could control or create a public sexual identity for these individuals. In mandating binary sex differentiation for legal purposes, medical jurisprudence has, then, imposed a clear-cut distinction, even though in biomedical terms such a distinction has long been known not to exist.[32]

The disjunction between medical knowledge and its social assimilation has a long history with respect to hermaphrodites, though certain early writers admitted the basic humanity of sexually ambiguous beings. In a section of *De civitate dei* [*City of God*] titled "Whether certain monstrous races of men are derived from the stock of Adam or Noah's sons," Saint Augustine twice refers to those of "a double sex" and "persons of sex so doubtful, that it remains uncertain from which sex they take their name." Augustine concluded of these individuals that "whosoever is anywhere born a man, no matter what unusual appearance he presents in colour, movement, sound, nor how peculiar he is in some power, part, or quality of his nature, no Christian can doubt that he springs from that one protoplast."[33] In his *De generatione animalium* [*On the Generation of Animals*], Aristotle considered hermaphroditic individuals to be produced by natural causes and offered explanations based on embryological development and pathophysiology,[34] but not until the eighteenth century was there a return to this scientific approach to explanations of ambiguous sex.

Aristotle and Augustine were expansive in their ideas of humankind and its variations. There is, however, evidence that in antiquity and through the Middle Ages intersexed individuals could not be assimilated into conceptions of the natural and were often put to death, usually by drowning.[35] Belief in supernatural and astrological origins for hermaph-

roditism is evident in the terminology used to designate monsters: *lusus naturae* (this term was coined in the Renaissance; the modern terms *Naturspiel* and *jeu de nature* derive from it) and the words "monstrum" and "teras." There is some debate about the etymology of "monster," but it comes either from *monere*, to warn, or *monstrare*, to show forth or demonstrate, and *teras* also means to show forth. Both words, then, refer to portents and signs as well as to defective births and malformations. All of these meanings point to the importance of the semeiotics of the monstrous, and hermaphrodites were taken to signify divine wrath.[36]

The question of monstrosity also raises contradictions in the way hermaphrodites have been denied moral status. Brillon's *Dictionnaire des arrêts* reported that although fathers were permitted to put to death their monstrous offspring, such offspring nevertheless counted among a family's children for purposes of establishing the father's privileges and exemptions, even though they could not inherit property or succeed to titles.[37] Ernest Martin, in a history of monsters published in 1880, wrote:

> In effect, from the moment the use of the law allows the principle of impunity for the sacrifice of a monster, at the same time and by reciprocity it admits the innocence of this monster in the event that it commits a crime. A law cannot claim to exercise any punishment with regard to someone it does not protect without pain of committing an inconsistency and a flagrant violation of justice.[38]

If monsters were to be sacrificed as nonhuman threats to humanity, they also retained a fundamental innocence before human civil laws.

The beginnings of a shift away from this excision of sexual ambiguity from the social body occurred as a result of growing interest in natural history, an interest that yielded the refinement of biological classification systems, yet at the same time left space for anomalous or ambiguous cases.[39] This shift was inaugurated in the sixteenth century with Ambroise Paré's controversial 1573 *Des monstres et prodiges* [*On Monsters and Marvels*] which began the process of naturalizing and medicalizing gender disorders and other anomalies. Paré was the first to attempt a systematic classification of congenital malformations, though his system is shot through with superstition in its understanding of embryology. Paré declared medical practitioners to be the authorities of choice on the issue of placing hermaphrodites in their appropriate niche. "The most expert and well-informed physicians and surgeons," he argued, "can recognize whether hermaphrodites are more apt at performing with and using one set of organs than another, or both, or none

at all." He went on to make clear that cultural ideas about sex-appropriate behavior have equal importance with observations of genitalia in making decisions in these cases: "Whether the whole disposition of the body is robust or effeminate; whether they are bold or fearful, and other actions like those of males or of females."[40]

Paré's contemporary Michel de Montaigne expressed the change from the monstrous to the natural, or naturally anomalous, in an essay on a monstrous child ("D'un enfant monstrueux") that harks back to Augustine's view of basic human commonality:

> What we call monsters are not so to God, who sees in the immensity of his work the infinity of forms that he has comprised in it; and it is for us to believe that this figure that astonishes us is related and linked to some other figure of the same kind unknown to man. From his infinite wisdom there proceeds nothing but that is good and ordinary and regular; but we do not see its arrangement and relationship. What he sees often, he does not wonder at, even if he does not know why it is. If something happens which he has not seen before, he thinks it is a prodigy [Cicero].

> We call contrary to nature what happens contrary to custom; nothing is anything but according to nature, whatever it may be. Let this universal and natural reason drive out of us the error and astonishment that novelty brings us.[41]

Montaigne clearly saw through the flawed alliance of nature and custom, or, as we might now put it, between biological and social determinism.

A number of prominent cases of hermaphroditism became publicly contested at the turn of the seventeenth century. The interrogation of issues of civil status for these individuals began in this period, most notably with Paul Zacchias (1584-1659), who coined the term "medicolegal" and classified hermaphrodites as beings without sex, "des ambigus" ("the ambiguous ones"), in a work titled *Quaestionum medico-legalium*.[42] In 1599, Antide Collas of Dôle was imprisoned and tortured; she was accused of having produced her abnormal bodily conformation as the result of illicit commerce with the devil, and under pain of torture she confessed to having had criminal relations with Satan, a crime for which she was burned alive. In 1603, in a case documented by Brillon, two hermaphrodites were condemned to death and executed for having sexual relations with each other. The specific crime was sodomy: they were both determined to be predominantly male and were hanged and then burned.

The most controversial case and the best known came to light in 1601 when the parliament of Rouen tried a defendant named Marie/Marin le Marcis. Having lived as a woman for twenty-one years, Marie took on the name Marin, put on men's clothing, and registered a wish to marry a woman named Jeane le Febvre (who was also imprisoned). Marin le Marcis was enjoined to wear women's clothing and to remain celibate, but the initially imposed penalty of life imprisonment was ultimately relaxed. This case ultimately turned into a contest that called into question the reputation of monastic orders and involved moral theologians who fault-ed Plato's assertion that the first human beings were androgynes; they countered contentions of Adam's androgyny by citing *Genesis*: "*Deus fecit illos marem et feminam.*" In an important treatise by Jacques Duval called *Des Hermaphrodits* [*Of Hermaphrodites*] that was published in 1612 and recounts this case at length, Duval provided an overview of ancient opin-ions, cited Augustine, offered astrological explanations concerning the relative positions of Mercury and Venus, and included several other case reports.[43]

In an essay in which he reads Shakespeare's *Twelfth Night* as a play that participated in the Renaissance delight in individual transformations and sex change, literary critic Stephen Greenblatt discusses Duval's book on the Marie/Marin le Marcis case. Greenblatt highlights the importance of the idea that "the transformation of gender identity figures the emergence of an individual out of a twinned sexual nature" and argues for "the per-sistent doubleness, the inherent twinship, of all individuals."[44] This emphasis on doubling began earlier, at least with Augustine's reference to "a double sex," and it was borne out in the visual representations of her-maphrodites, not only in the Renaissance but in later texts on hermaph-roditism as well. Caspar (Gaspard) Bauhin's *De Hermaphroditorum* (1614), for example, represents several figures, one of conjoined twins, each with doubled genitalia in mirror image (Fig. 7) and another with doubled male and female genitalia (Fig. 8).[45] Ulisse Aldrovandi's 1642 *Monstrorum Historia* depicts a highly muscled androgyne with side-by-side doubled sexual organs (Fig. 9) and a hermaphrodite with vertically doubled gen-italia and a tear-shaped opening that reveals internal structures (Bauhin had also included this image, with a caption that refers to the uselessness of the sexual organs)(Fig. 10).[46] Figure 7 is especially intriguing, as the doubling of the individual bodies in conjoined twinship multiplies the twinship or doubleness of sexual identity.[47] An eighteenth-century text

Figure 7: Twin hermaphrodites. Heidelberg, 1486.

[From Casparus Bauhinus, *De Hermaphroditorum monstrosorumque, partuum natura* . . . (Frankfurt: Oppenheim, 1614): Figure II.] Courtesy of the Historical Collections, College of Physicians of Philadelphia.

Figure 8: Hermaphrodite with horizontally doubled external genitalia.

[From Casparus Bauhinus, *De Hermaphroditorum monstrosorumque, partuum natura . . .* (Frankfurt: Oppenheim, 1614): Figure I.] Courtesy of the Historical Collections, College of Physicians of Philadelphia.

Figure 9: Androgyne.

[From Ulisse Aldrovandi, *Monstrorum historia* (Bononia, Italy: N. Tebaldini, 1642): 42.] Courtesy of the Historical Collections, College of Physicians of Philadelphia.

Figure 10: Hermaphrodite with vertically doubled external genitalia.

[From Ulisse Aldrovandi, *Monstrorum historia* (Bononia, Italy: N. Tebaldini, 1642): 517.] Courtesy of the Historical Collections, College of Physicians of Philadelphia.

Figure 11: Hermaphrodites.

[*Hermaphroditen* (Strassburg: Umand König, 1777): Plate I.] Courtesy of the
Historical Collections, College of Physicians of Philadelphia.

Figure 12: Hermaphrodites.

[From Georg Arnaud, *Anatomisch-Chirurgische Abhandlung über die Hermaphroditen* (Strassburg: Umand König, 1777): Plate II.] Courtesy of the Historical Collections, College of Physicians of Philadelphia.

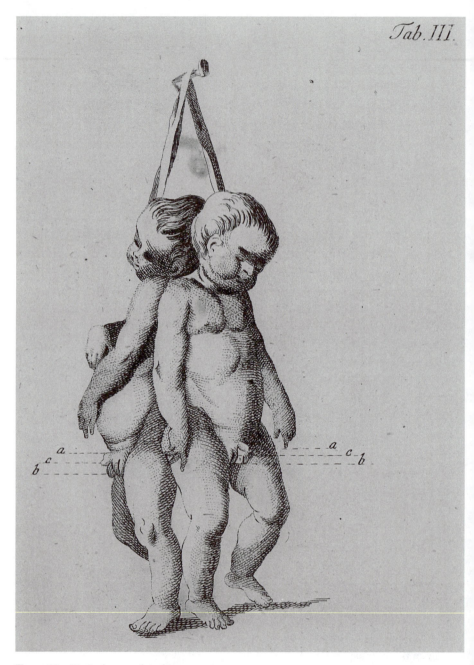

Figure 13: Twin hermaphrodites.

[From Georg Arnaud, *Anatomisch-Chirurgische Abhandlung über die Hermaphroditen* (Strassburg: Umand König, 1777): Plate III.] Courtesy of the Historical Collections, College of Physicians of Philadelphia.

by Georges Arnaud de Ronsil also plays with genital pluralism in its representations of hermaphrodites. Figure 11 depicts two reclining bodies with multiple genital identities; Figure 12 pairs two ambiguous bodies in a configuration that makes them appear to be a romantic couple, with the standing figure apparently offering consolation while both fix their gaze on the genitalia of the seated figure. The twinned children in Figure 13 bear doubled external genitalia, and their back-to-back hanging from one hook echoes in an eerie fashion the fate of earlier hermaphrodites.[48]

These early modern representations of the hermaphroditic predicament demonstrate that the sexually ambiguous individual moves from monstrous sign to natural (mal)formation. This move questions the very notion of what can be classifed as anomalous. This movement continued in the eighteenth century with the science of generation, the forerunner of the modern science of embryology and the twentieth-century biomedical subspecialty of endocrinology. Early physiological explanations were "seminal." Galen believed that each testis produced one sex and that hermaphrodites occurred when seminal fluid from both testes combined. Avicenna thought that seminal fluid deposited on the left side of the womb created a female, on the right a male, and in the middle a hermaphrodite. The work of eighteenth-century experimenters John Hunter (1728-1793), Albrecht von Haller (1708-1777—he published *De Monstrorum origine mechanica* in 1745), and Caspar Friedrich Wolff (1733-1794) prepared the way for new approaches to generation and congenital developmental deformations. Jacob Ackermann (1765-1815) wrote two treatises on sex differences in embryonic development and on genital structures in hermaphrodites.[49] Not until the work of father and son Etienne and Isidore Geoffroy Saint-Hilaire, however, did teratology (a word coined by Isidore) become a science of the study and classification of monstrosities and abnormalities.[50]

Isidore Geoffroy Saint-Hilaire's important three-volume work, *Histoire générale et particulière des anomalies de l'organisation* (1832-1837), offers the first systematization of teratology as a science in its own right. Geoffroy Saint-Hilaire's defense of his father's project is helpful:

> I have sought and I believe I have succeeded in demonstrating that the whole of our knowledge of anomalies, or, to use from here on the term I have given it in this work, teratology, cannot any longer be considered as a section of pathological anatomy. . . . I will show how its laws and relations are in themselves none other than corollaries of more general laws of organization; how, among recently proposed theories, all those that are not applicable to anomalies are not applicable to normal facts either, and must

be relegated to the rank of systems; how, on the contrary, several princi-
ples, established on not too solid ground through the study of normal facts,
find their complete demonstration in the study of anomalies.[51]

In this passage, Geoffroy Saint-Hilaire argued for an understanding of the
close relation between the anomalous and the normal. Later, he proposed
a number of terms, but preferred "anomaly," defined as "any deviation
from species type, or, in other words, any organic particularity."[52] He
reserved "monstrosity" only for severe anomalies such as anencephalous
(headless) births. Geoffroy Saint-Hilaire put hermaphrodites in a class of
their own (see Fig.14) because none of the formations in themselves are
*mal*formations; rather, it is the combination and association of certain
characteristics that normally exist only separately and are only anomalous
in relation to sex.[53] "It is therefore with hermaphrodisms as with other
anomalies," he concluded, "to the extent that we get near them, the mar-
vellous disappears; but their scientific interest grows" (my translation).[54]

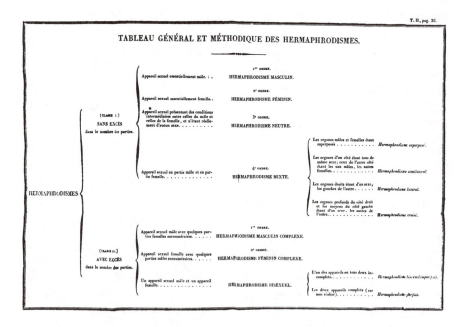

Figure 14: General and Methodical Table of Hermaphrodisms.

This table shows the preendocrinological understanding of classifications for varying types
of pseudohermaphroditism. [From Isidore Geoffroy Saint-Hilaire, *Histoire générale et partic-
ulière des anomalies de l'organisation chez l'homme et les animaux . . . ou Traité de Tératologie*
(Paris: J.-B. Baillière, 1832-1837): II, between pages 178-179.] Courtesy of the Historical
Collections, College of Physicians of Philadelphia.

It was, then, toward the end of the eighteenth century that scientific researchers began to question theories of preformation and to pay attention to internal structures.[55] This work grew out of earlier commentaries on the role of the male and female seed in reproduction.[56] Thomas Laqueur has argued that by the end of the eighteenth century the female orgasm ceased to be viewed as necessary for generation, and that this shift signaled the replacement of hierarchical explanations of sexual difference with what Laqueur calls "a biology of incommensurability." Nineteenth-century advances in embryology (for example, germ layer theory) then reproduced at the embryonic level the by-then challenged Galenic notion of homologies between the sexes (the same structures, one external and one inverted internally): Developmentally, the sexual organs of the male and female fetus share common origins (see Fig. 15).[57] Developmental commonalities between male and female sex organs have been thematized in gendered terms by some clinical researchers. For example, a 1966 article uses the language of warfare—struggle and dominance—to describe embryonic sexual differentiation:

> The "battle of the sexes" begins early in intrauterine life. Gestation takes place in a maternal estrogenic environment. Thus it becomes necessary, in dealing with male embryos, to have some factor(s) to counteract this influence, else all individuals, irrespective of genotype, would be born as female phenotypes.[58]

On this account, the conquering testis must invade and subdue the disruptively dominant influence of maternal estrogens.

This historical trajectory in the understanding of developmental anatomy culminates in the relatively recent science of endocrinology, which began with the work of Charles Edouard Brown-Séquard as early as 1865 and whose pioneering work with respect to sex was Frank R. Lillie's 1932 textbook *Sex and Internal Secretions*.[59] Reproductive endocrinology derives from the 1905 discovery of hormones, and it is largely to pediatric endocrinologists that the medical community turns today for the treatment of newborns with ambiguous genitalia.[60] Current treatment of patients with ambiguous sexual characteristics depends on the patient's age at the time of clinical intervention. When this intervention occurs at or after puberty, the primary concern is to maintain sex assignment whenever possible. In cases of ambiguous external genitalia at birth, there is a larger range of options, depending on the causes of the ambiguity. Causes for female pseudohermaphroditism (karyotype

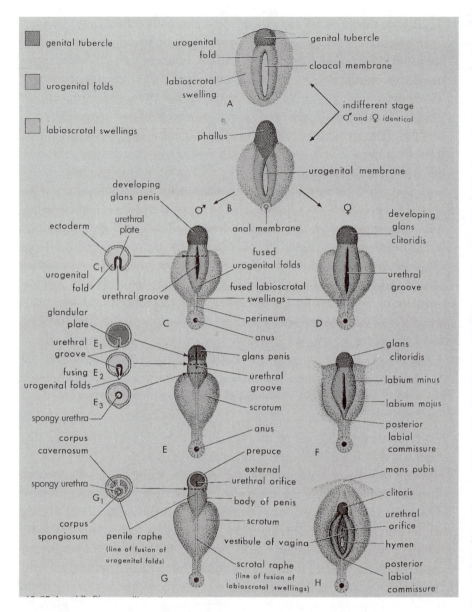

Figure 15: Development of the external genitalia from the indifferent stage to 12 weeks. [From Keith L. Moore, *The Developing Human: Clinically Oriented Embryology*, 4th ed. (Philadelphia: W.B. Saunders Co., 1988): 272.] Used by permission.

[chromosome pattern] 46, XX) include androgen excess (three types of congenital adrenal hyperplasia), virilizing tumors in the mother, or the mother's contact with androgenic drugs. Causes of male pseudohermaphroditism (karyotype 46, XY) include defects in testosterone synthesis or androgen action, whereas abnormal karyotypes may be due to mixed gonadal dysgenesis (defective embryological development).[61]

Medical explanations to families of patients emphasize a continuum of sexual differentiation, focus on the bipotentiality of early "neutral gonads," and use terms such as "variation" in preference to "abnormality." For example, at the Johns Hopkins Hospital's Psychohormonal and Pediatric Endocrine Clinics, when karyotyping first became available, "[it was] felt that there was little to be gained by disclosing . . . chromosomal information" to patients and their families in cases of Androgen Insensitivity Syndrome (these children have XY chromatin patterns and normal androgen levels, but the target tissues are insensitive to androgens; they appear to be female at birth and are reared as females[62]), but "it was rapidly realized that the assumption that records could be kept confidential in a hospital environment was naive and certainly incorrect."[63] Chromosomal studies are now considered necessary for a firm diagnosis.

Diagnosis and management of sexually ambiguous births are complicated by social and psychological investments in the sex of a newborn: the first thing everyone wants to know is, "is it a boy or a girl?" One pediatric endocrinologist urges that these births constitute an "emergency."[64] Enormous pressure is exerted on obstetricians to "commit" immediately to a sex in a situation in which, as we have seen, nothing "in between" or "mostly" is available from a social and legal perspective. Feminist critiques of biology use the gender assumptions and frequent stereotyping found within the literature on sexual ambiguity to demonstrate flaws in certain kinds of gender arguments based on biology, but the existence of a range of "intersexes" does not otherwise figure in this debate.[65] It is clear that whereas medical science now has a sophisticated understanding of sexual developmental anomalies, this understanding has not been translated into a changed social understanding of sex differentiation and gender identity.

It comes as no surprise that hermaphrodites initially challenged the way we conceive of the natural world and its component parts. Gender ambiguity was merely one kind of irregularity that could be characterized as supernatural, demonic, or monstrous. In this context, to achieve any kind of status as natural—albeit rare, peculiar, anomalous—was to

make progress. Deviation from a norm cannot be achieved until access to the norm is made available. The paradox of ambiguous sex is that it partakes of two norms in such a way as to transcend normativity altogether; that is, it is the true hermaphrodite who should be the norm from which all unambiguous females and males are seen to deviate. In fact, embryology recognizes that all embryos begin as female (see Fig. 15).

Thus, the new eighteenth-century attention to natural history taxonomies powered the move of gender disorders from the realm of the monstrous into the realm of the natural. This represented a crucial epistemological move,[66] in that it prepared the way for the medicalization of gender disorders across the next several centuries. However, I have tried to demonstrate that we arrive in the twentieth century at a point apparently far distant from Ovid's myth of the union into one body of Salmacis and Hermaphroditus in Book IV of the *Metamorphoses*. In Ovid's story, Hermaphroditus, son of Hermes and Aphrodite, is "unmanned" by Salmacis' powerful obsession, which results in "Their cleaving bodies mix: both have one face"; they "are now but one, with double forme indew'd./No longer he a Boy, nor she a maid;/But neither, and yet either, might be said."[67] We have also moved far away from ancient and medieval demonology to enter the technological and pharmacological arenas of embryology, endocrinology, and genito-urinary surgery. But in a curious way, the results of total medicalization return us to the semiotics of teratology. Individuals with gender disorders are permitted to live, but the interesting consequence of that permission is that the disorders themselves are rendered invisible, are seen as social stigmata to be excised in the operating room. Difference, again, is erased.

FIVE CASE HISTORIES

I turn now to five cases that postdate the medicalization of ambiguous sex. All of these cases were treated within the framework of understanding natural phenomena to be available for scientific study. By the early eighteenth century, the canon of prodigies had been replaced by a scientific fascination with anomalous births, despite a continued belief in the ominous meanings and supernatural production of deformed progeny (discussed in the next chapter). As a result, the birth of hermaphrodites no longer was part of a mythological or supernatural framework. In the

eighteenth century, hermaphroditism was taxonomized as a natural anatomical anomaly that posed particular ecclesiastical and civil juridical problems.

In recounting these cases, my use of gendered pronouns is, of necessity, idiosyncratic. I use the gender in which the persons were living at the time in question; I also try to respect the gender to which they wished to belong when I am aware of this wish. Those writers who refer to hermaphrodites as "it" or "the being" tend to be least humane in their approach to the subject. The neuter pronoun dehumanizes as well as neutralizes.

In November 1732, Anne Grandjean was born in Grenoble. When she was 14, she confided to her father that she experienced "*un instinct de plaisir dont elle ignorait la cause*" ["an instinct of pleasure of which she did not know the cause"] when she was with her female companions, but that the presence of men "*la laissait froide et tranquille*" ["left her cold and calm"]. Her father advised her to see her confessor, who suggested that she could not remain "*sans crime*" ["without crime"] in women's clothing and that she must dress herself in clothes "*convenable au sexe dominant chez elle*" ["appropriate to the sex that dominated in her"]. Her father renamed her "Jean-Baptiste" and she acquired a new identity with her new wardrobe, "*sans autre forme de juridiction*" ["without other form of jurisdiction"]. Jean-Baptiste's first love was a woman named Françoise Legrand, but this liaison did not endure. He then became romantically involved with Françoise Lambert, and they were married at Chambéry. Before the marriage, apparently, there were "*familiarités*" ["intimacies"]; Grandjean's spouse-to-be knew in advance "*tout ce que Grandjean pouvait être et Grandjean lui paraissait être tout ce qu'il fallait*" ["all that Grandjean could be and Grandjean appeared to her to be all that was required"]. As nothing formal had been done earlier to effect a change of civil status and Grandjean had been baptised with the name Anne, his father now "emancipated" him before a judge in Grenoble and officially changed his name to Jean-Baptiste. The newly married couple lived for a year in Chambéry, then moved to Lyons in order to establish themselves in business. They boarded with a silk merchant there for three years.

Then the trouble began. Grandjean's wife encountered Françoise Legrand, who fomented a scandal when she learned of the marriage by telling people that Grandjean was a hermaphrodite. Grandjean's wife went to see her confessor, who advised her to terminate sexual relations

with her husband. Grandjean resisted, and proposed finally to his wife that they go to see the Grand-Vicaire, recount their history, and follow his advice. The Procureur Général of Lyons and then the Procureur du Roi learned about the case, and Grandjean was arrested and imprisoned in irons "*pour le maintient des moeurs*" ["for the maintenance of morality"]. Surgeons were called to examine him and determined him to be "predominantly" female. Following the law that enjoined hermaphrodites to marry in accordance with the sex medically determined to "dominate" in them,[68] Grandjean was indicted for the crime of profaning the sacrament of marriage and condemned to be attached to a "*carcan*" [iron collar], to be whipped by the executioner, and to be banished in perpetuity. He was transferred to the Conciergerie du Palais and placed in solitary confinement with the explanation that he could not be placed either with men or with women as he was "*ni homme, ni femme, ou . . . tous les deux à la fois*" ["not man, not woman, or . . . both at once"]. In 1765, Grandjean's marriage was declared "*abusif*" ["abusive"], the sentence of profanation reduced, and Grandjean put "*hors de cour*" ["outside the court's jurisdiction]. He was ordered to wear women's clothing and forbidden to see his wife or to consort with other members of the female sex. Information about Grandjean comes from a text printed in Paris and distributed by his defenders. It is not known what became of him after 1765.[69]

The "*mémoire*" or "*requête*" that survives of this case is filled with euphemism on the subject of Grandjean's actual anatomic and physiologic condition and of his intimate relations. In an 1845 account of the case in a wildly racist popular treatise on procreation and monstrosity, Grandjean was alleged "*se faisait passer publiquement pour homme et femme à la fois*" ["to have passed himself off publicly as a man and as a woman simultaneously"] and to have been "*une femme, dont les parties offraient un prolongement anormal, comme autrefois les femmes de Lesbos*" ["a woman whose organs were abnormally elongated, as was the case in antiquity with the women of Lesbos"]. It is not clear what it would mean to be a man and at the same time a woman, and the analogy to the women of Lesbos elucidates this writer's assumption of homosexuality as well as the understood scurrilousness of lesbianism in the European moral hierarchy.[70]

A number of conclusions can be drawn about the institutional treatment of sex ambiguity from the case of Anne/Jean–Baptiste Grandjean, despite the fact that these conclusions are in part speculative. First, there was no mention of sexual orientation: An attraction to women and an

indifference to the company of men by itself indicated to Grandjean's confessor and to his father that he was male, as the other issues that may have disquieted 14-year old Anne Grandjean—the physiology of her responses—were suppressed. For one female to desire or derive sexual pleasure from another is a "crime" in the priest's terms, or perhaps he meant to suggest that Grandjean's covert male presence among females would create a criminal atmosphere. Second, Grandjean was prosecuted in consequence not of his malformed anatomy but of his marriage. A study of women in eighteenth-century England who "passed" as men shows that they were virtually never prosecuted except when they married or attempted to marry other women, and then the charge was fraud, not lesbianism.[71] Grandjean's condemnation was for profaning a sacrament, in effect also a charge of fraud. Fraud here consists of a usurpation of maleness and thereby of male power. Third, even though anatomic difference was at issue, the legal resolution entailed an injunction concerning costume, an imposition of outward signs thought to conform to a predominating gender identity that must be maintained outwardly—even if under drapery the anatomy could not be altered or controlled. Finally, it is clear that Grandjean was not free to choose his own gender and could not choose to be uncategorizable or "intersexual" (a late nineteenth-century coinage). There must be a dominant sex determinable by medical examination, and only Grandjean's marriage and the subsequent charge of fraud produced the terms for such an examination.

A century later, the case of Levi Suydam, a 23-year old inhabitant of Salisbury, Connecticut, also turned on a medical examination. In March of 1843, Suydam was presented by the Whigs of Salisbury to the town's board of Selectmen to be declared eligible to vote in a controversial local election. The opposition party challenged this presentation on the grounds that Levi Suydam was more female than male and was therefore not entitled to the status of freeman. William James Barry was called to examine Suydam and published an account of this "Case of Doubtful Sex." On first examination, Dr. Barry pronounced Suydam to be a male citizen and, therefore, entitled to all the privileges of a freeman. On election day, Suydam's admission to vote was challenged by a Dr. Ticknor. Dr. Barry stated his findings and invited Dr. Ticknor to examine Suydam. This done, Dr. Ticknor concurred, and Suydam voted. The Whig ticket was elected by a majority of one.

Several days later, Dr. Barry learned that Suydam menstruated regularly and began to investigate further. Suydam's sister, who did his laun-

dry, corroborated this new information, and Suydam unwillingly con-
fessed. Drs. Barry and Ticknor reexamined Suydam and discovered more
complicated anatomic evidence than their first external examination had
elicited—a vaginal opening was located. In addition, they determined
that he was "decidedly of a sanguineous temperament, [with] narrow
shoulders, and broad hips." Barry's case report included the information
that "he had amorous desires, and . . . at such times, his inclination was
for the male sex: his feminine propensities, such as a fondness for gay col-
ors, for pieces of calico, comparing and placing them together, and an
aversion for bodily labor, and an inability to perform the same, were
remarked by many."[72] Whether the election results were reversed is not
recorded.

Several nineteenth-century manuals of medical jurisprudence
reported on this case and all agreed on three points. First, the law con-
tinued to hold that one sex always predominates and that it was, there-
fore, possible in every case, though sometimes very difficult, to make a
medical sex determination. Second, the only legal reason to be concerned
with hermaphroditic individuals was for the purpose of determining the
ownership and descent of property where primogeniture prevailed or
entailed inheritance was at issue, for justifying divorce, or for imputing
the illegitimacy of children claiming these individuals as their parents.[73]
The goal was to decide on a predominant sex and thenceforward to
adhere strictly to this decision in clothing, social role, and legal privilege
(including suffrage).[74] Third, a critical form of evidence valuation
occurred: The presence or absence of certain gender-coded sociosexual
behaviors carried the same status as the presence or absence of certain
anatomic and physiologic characteristics. To have a vagina and to enjoy
piecing calico carried equivalent weight as evidence, and in this case, as
with Anne/Jean-Baptiste Grandjean, the emphasis of the investigation
rested on making sure that those judged to be predominantly female were
barred from the usurpation of male privilege.

In reporting on the Suydam case in his *Manual of Medical Jurisprudence*,
Alfred Swaine Taylor (1806-1880) remarked:

> This was certainly an embarrassing case—one to which Lord Coke's [Sir
> Edward Coke (1552-1634)] rule for a decision, i.e., the prevalence of either
> sex, is hardly applicable. The presence of a penis and one testicle referred
> the being to the male, while the bodily configuration, and still more strong-
> ly the periodical menstrual discharge, referred him to the female sex. The
> right of voting might have been fairly objected to, because, while the female

characters were decided, the organs indicative of the male sex are described as having been imperfectly developed.[75]

The right to vote, on this account, depended on the possession of perfectly developed male sexual organs.

Taylor went on to recount a case involving the important American surgeon Samuel D. Gross. Gross examined a 3-year-old child "regarded as a girl," but who had begun "to evince the taste, disposition, and feelings of the other sex" at the age of 2, an "evincing" determined because "she rejected dolls and similar articles of amusement, and became fond of boyish sports."[76] Gross's examination revealed a small cul-de-sac vagina without "aperture, or inlet"(p. 387) and well-formed testicles in the labia, as well as a small clitoris. The child was declared an androgyne produced as the result of arrested male development with, in Taylor's words, "no intermixture of the sexes" (p. 677). Taylor reported what followed:

> Dr. Gross considered that for the child's future welfare and happiness, it would be better that it should have no testicles at all, than that it should retain them under such an imperfect development of the other organs. He therefore removed them by operation from the labia or divided scrotum, and had the dissatisfaction to find that they were perfectly formed in every respect, and that the spermatic cords were quite natural. The operation was performed in July, 1849, and three years subsequently (in 1852) it was found that emasculation was complete, for the disposition and habits of the being had materially changed, and were those of a girl; she was found to take great delight in sewing and housework, and she no longer indulged in riding sticks, and other boyish exercises. (p. 677)

The surgeon's "dissatisfaction" was Taylor's addition. Gross's own testimony stated his lack of regret and his continuing sense that his actions were not only the right ones but should serve as a model on which to treat such cases. As in the Suydam case, anatomic and social data intersect: To sew is to be emasculated. Taylor compared this case to that of Levi Suydam because "this being was deprived of the rights and privileges of a *male* by the removal of the testicles" (p. 677), and he introduced the case with reference to Gross's "attempt . . . to destroy all sexuality, and thereby all rights of citizenship" (p. 676). Here Taylor was incorrect on the subject of American citizenship, which has never been coextensive with the right of suffrage. It may be that he was less worried about Suydam as a *woman*, because she would have fewer rights in any case. Nevertheless, in Taylor's formulation, male privilege resides in the testicles.

Taylor's account of this castration differed markedly from Gross's own report in the 1852 *American Journal of the Medical Sciences*. Gross's concern,

couched in humane terms but disturbing in its conclusions, was to use surgery to neutralize the threat of genital ambiguity:

> [T]he question occurred whether anything could or ought to be done to deprive the poor child of that portion of the genital apparatus [testicles] which, if permitted to remain until the age of puberty, would be sure to be followed by sexual desire, and which might thus conduce to the establishment of a matrimonial connection. Such an alliance, it was evident, could eventuate only in chagrin and disappointment, if not in disgrace, ruin of character, or even loss of life. (p. 387)

Gross elected to remove "an appendage of so useless a nature; one that might, if allowed to proceed in its development, ultimately lead to the ruin of her character and peace of mind" (pp. 387-388). The key, for Gross, was to cut away not gender identity so much as sexual desire, to use surgery as a means to discourage matrimony and to ensure celibacy.

Gross's description of the castration was followed by a long meditation on the history of hermaphrodites and the prejudices against them, and again he focused on marriage:

> A defective organization of the external genitals is one of the most dreadful misfortunes that can possibly befall any human being. There is nothing that exerts so baneful an influence over his moral and social feelings, which carries with it such a sense of self-abasement and mental degradation, or which so thoroughly 'maketh the heart sick,' as the conviction of such an individual that he is forever debarred from the joys and pleasures of married life, an outcast from society, hated and despised, and reviled and persecuted by the world. (pp. 388-389)

But this debarring, in the case of Gross's patient, was deliberately produced surgically. Even the journal editor felt compelled to add a note disagreeing with the author and comparing his conclusions to a decision to administer "prussic acid to terminate the sufferings of those afflicted with malignant disease, or who have received severe and irremediable injuries" (p. 390). And, indeed, Gross's final sentence is chilling:

> [E]very suggestion, calculated to ameliorate the condition of this unfortunate class of beings, by depriving them of their only incentives to matrimony, and thereby dooming them to everlasting celibacy, should be hailed as a valuable contribution to the science and humanity of the present age. (p. 390)

Gross focused on the threat of ambiguously sexed individuals' entering into sanctioned social relations, whereas Taylor used the case to illustrate the connections between gender identity and legal privilege.

In his 1891 treatise on hermaphroditism, Charles Debierre extended these concerns about sex-dependent privilege and legal alliance in a way characteristic of the later nineteenth century. He alleged the possibility of criminal degeneracy in persons of doubtful sex and suggested that whole families might be destroyed by neuropathies, hysteria, epilepsy, and madness. Following Debierre's lead, A.-B. de Lip Tay, a later popularizer, concluded a book entitled *La Vie sexuelle des monstres* [*The Sexual Life of Monsters*] with the argument that the hermaphrodite cases he had recounted

> demonstrate . . . that from a physiological point of view the hermaphrodite, far from enjoying a double generative power, is, on the contrary, as Debierre says so well, a degenerate being, and more or less impotent, and almost always infertile, a being warped even in its inclinations and its psychosis, by reason of its poorly established and perverted sexuality. Before the social laws this is an unhappy person dangerous to others and against whom Debierre cautions society.[77]

This argument collapses on itself. If the hermaphrodite is impotent, infertile, and incapable of sexual pleasure, then how is hermaphroditic sexuality—here erased—perverted and dangerous? Lip Tay first debunked the threat of a supersexuality, then suggested that its absence or dysfunctionality could be equally dangerous.

Debierre's worries were different. "Imagine one of these men-women admitted to a seminary, in a congregation, in a monastery, in a school," he wrote. "Think that a woman-man can end up in a convent or a girls' boarding school, and you will convince yourself that article 57 of the civil Code is not farsighted enough."[78] Debierre's solution for preventing these outrageous possibilities was surprisingly humane, given his rhetoric: The civil code was wrong to permit only two categories of persons, he argued, because, rare though it is, he argued that indeed there are three categories—men, women, and those who are neither.[79] Debierre did not consider the possibility of admitting both sexes, the *"ni homme, ni femme, ou . . . tous les deux à la fois"* ["not man, not woman, or . . . both at once"] alleged of Grandjean. He insisted on "neither," on an absence of gender, rather than permitting the more threatening protean possibility of "both." He proposed an examination at birth, a reexamination between the ages of 15 and 18, and the establishment of a category called *"Sexe Douteux"* ["Doubtful Sex"].[80]

A now well-known nineteenth-century case played out Debierre's horror of what could happen should an indeterminate individual live in

a sex-segregated institution. This was precisely the situation of Herculine Barbin, whose memoirs were published in 1872 with commentaries by the legal medicine specialist Auguste-Ambroise Tardieu. (Michel Foucault published a modern edition, with medical, legal, and journalistic appendices, in 1980.) Barbin was raised as a girl, boarded at convent schools, and became a teacher at such a school. When she began a romantic liaison with another woman, she initiated efforts to confront her body's differences and sought out confessors and physicians. These efforts at length resulted in an official decree altering her civil status from female to male and changing her name from Adélaïde Herculine (Alexina) to Abel. However, the decree did not, as he had hoped, result in marriage to his lover. In the aftermath of these changes, Barbin lived alone in Paris, worked for a time for the railroad, and committed suicide at the age of 30, in February 1868, eight years after the court order had designated him a man.

The Barbin materials add to the history of gender disorders a well-documented case in which we have three utterly differing versions. The memoirs themselves represent a species of romantic autobiography, filled with highly rhetorical sentiment (*"J'ai beaucoup souffert, et j'ai souffert seul! seul! abandonné de tous!"*[81] ["I have suffered much, and I have suffered alone! Alone! Forsaken by everyone!"[82]]. In many ways, the most shocking aspect of the materials Foucault collected in his edition comes in the cacophonous clash between the gushing effusions and exclamation points of Barbin, the cold anatomic catalogue of the physicians' reports, and the dry juridical language of the civil status proceedings.[83] Three different "bodies" emerge from these texts. Reconciling them—reintegrating them—is both the problem of analyzing the clashes and in some sense a metaphor for what must have been Barbin's lived experience of residing not just outside appropriate social boundaries but beyond the conception of such boundaries.[84]

Barbin's memoirs were found at the time of his suicide in 1868 and referred to in the manuscript as *"la tâche que je me suis imposée"* ["the task that I have imposed upon myself"]. This task was particularly difficult because, Barbin wrote, *"J'ai à parler de choses qui, pour plusieurs, ne seront que d'incroyables absurdités; car elles dépassent, en effet, les limites du possible"* (p. 75) ["I have to speak of things that, for a number of people, will be nothing but incredible nonsense because, in fact, they *go beyond the limits of what is possible*"] (p. 15, my italics). This question of limits is echoed in the focus on a conflation of anatomic sex and social place in the Barbin dossier.

Goujon's autopsy report in the *Journal de l'anatomie et de la physiologie de l'homme* [*Journal of Human Anatomy and Physiology*] (1869), for example, stated that examination of Barbin's corpse "*a permis de rectifier le premier jugement qui avait été porter sur son sexe pendant la plus grande partie de sa vie, et de confirmer l'exactitude du diagnostic qui l'avait en dernier lieu remis à sa véritable place dans la société*"[85] ["permitted a rectification of the first judgment, which had determined his sexual identity during the greater part of his life, and a confirmation of the exactness of the diagnosis that in the end had *assigned him to his true place in society*" (p. 131, my italics)]. Goujon went on to suggest that "*des penchants et des habitudes qui sont ceux de leur véritable sexe, et dont l'observation aiderait considérablement à marquer leur place dans la société, si l'état des organes génitaux et de leur différentes fonctions n'était pas suffisant pour arriver à ce but*" (p. 611) ["inclinations and habits of their true sex are revealed in people who have been victims of an error, and observing these traits would help considerably in marking out their place in society, if the state of the genital organs and their different functions were not sufficient for attaining this end" (pp. 138-139)]. This reminds us of the propensity for brightly colored fabrics noted by those who observed Levi Suydam. Barbin himself noted these traits—the gender-coded behaviors of physical activity and intellectual pursuit—and spoke of place: "*Ai-je coupable, criminel, parce qu'une erreur grossière m'avait assigné dans le monde une place qui n'aurait dû être la mienne?*" (p. 112) ["Was I guilty, criminal, because a gross mistake had assigned me a place in the world that should not have been mine?"] (p. 54).

A newspaper account at the time of the legal proceedings and attendant publicity in 1860 reported on "an extraordinary metamorphosis in medical physiology" and described Barbin as a pious and modest schoolgirl who lived "until today in ignorance of herself, that is to say, with the belief that she was what she appeared to be in everybody's opinion" (p. 144, *L'Echo Rochelais*). In these accounts, self-knowledge, social niche, and genitalia represent analogous ways of knowing and analogous layers in the social definition of individual human beings.

The Grandjean, Suydam, and Barbin cases inscribe themselves in the history of social ideology as challenges to sex-defined privilege. To marry, to vote, to teach, to love—the activities of ordinary social relations involve boundary-crossing when practiced by these individuals. Social boundaries depend on difference and hierarchy. When these attempts to exist in a social world are uncovered as usurpations of male power and

privilege by individuals judged to be "predominantly" female or "imper-
fectly" male, they become most threatening. The accusation of fraud
brought against hermaphrodites, as it was brought against women who
cross-dressed in order to be accepted into male occupations, to travel
freely and without harassment, and especially to marry other women, is
an accusation of usurpation, of illicitly gaining access to powers meant to
be denied to them.

Even the language of medicolegal treatises confirms this. For exam-
ple, Tardieu speaks of a person named Valmont as *"une femme réconnue
telle seulement après sa mort, ayant vécu dans les liens d'un mariage où elle avait
usurpé le rôle de l'homme"* ["a woman recognized as such only after her
death, having lived in the bonds of a marriage in which she usurped the
role of the man"].[86] Most of the early modern hermaphrodites whose
punishments were especially severe were registered as female at birth,
and their development of ambiguous but suspiciously male sexual char-
acteristics after puberty posed a problem for the status quo of power
hierarchies. Hermaphrodites highlight the privilege differential between
male and female precisely because they cannot participate neatly in it.
In addition, their illicit "usurpation" of a gender not theirs by birth reg-
istration always raises the specter of homosexuality. In the preface to his
Lexicon Physico-Medicum: or, A New Physical Dictionary . . . (1719), for
example, John Quincy proposed this definition of the predicament of
intersexuality:

> Hermaphrodite, is generally understood to be a Person where there is a
> Confusion of Sexes, by a Participation of the genital Parts of both. But there
> seems no more of Truth in this, than that some Females have their Clitoris
> of an uncommon size; and which frequently happens from lascivious
> Titillations, and Frictions, as in the notorious Instance of the two Nuns at
> Rome.[87]

Natural history from Aristotle forward clearly reveals that there is no
absolute distinction between the sexes in either animal world or human,
but instead simply variations on a continuum whose midpoints are less
densely populated than its outer edges. The poignance of Barbin's mem-
oirs comes in part from the cultural pressure exerted on him to erase these
midpoints. Declaring herself "shaken" upon a youthful reading of Ovid's
Metamorphoses, Barbin also reports that at the age of 17 *"[m]on état, sans
présenter d'inquiétudes, n'était plus naturel"* (p. 78) ["[m]y condition,
although it did not present any anxieties, was no longer natural" (p. 19)].
Barbin's language itself reflects ambiguity and indecision, as the original

French uses linguistic gender markers alternately, so that the subject speaks sometimes in the masculine and sometimes in the feminine voice, a gesture of written indeterminacy untranslatable into English. Barbin's language also becomes increasingly legal as the memoirs progress, referring to herself as *"proscrit"* (p. 159) ["outlawed" (p. 98)] and as someone who *"renverse toutes les lois de la nature et de l'humanité"* (p. 160) ["overturns all the laws of nature and humanity" (p. 99)]. And finally Barbin's self-references grow slipperier, as it becomes clear that the change of civil status has clarified nothing, until he is *"un déshérité . . . un être sans nom"* (p. 161) ["a disinherited creature, a being without a name" (p. 100)].

The subject's own account of her/himself is missing from the other cases, so that the Barbin autobiography provides a rare glimpse into the experience of living on a boundary in a world in which the insistence on choosing sides drives all social and institutional action. Even today, when gender is recognized as socially and culturally constructed, and therefore its codes are available for analysis, the status and cultural uses of binary opposition itself go unchallenged. Certainly, the hegemony of binary sex designations was at least as strong in early modern Europe. The problem was succinctly stated by James Parsons in his 1741 treatise *A Mechanical and Critical Enquiry into the Nature of Hermaphrodites*: "If there was not so absolute a law with respect to the being of only one sex in one body," Parsons wrote, "we might then indeed expect to find every day many preposterous digressions from our present standard."[88] Such "preposterous digressions" were precisely what later troubled Charles Debierre. The result is a sexually ambiguous individual such as Barbin growing up and then teaching in a girls' school, seducing one of her intimates, then changing gender status as in a masquerade. The "digression" is to homosexuality.

Through the mid-nineteenth century, there was no possibility of extensive surgical participation in the decision on a predominant sex in ambiguous cases. Arnold Davidson has argued that this was not solely because genito-urinary surgical techniques were not yet adequately advanced, but that in addition, the notion of a "sex-change operation" was conceptually impossible until after the work of Freud and of sexologists such as Richard von Krafft-Ebing and Havelock Ellis. Earlier, Davidson proposes, no such thing as "sexuality" existed. Only after having constructed the notion of a sexuality could we set about solving the problem of how to regulate it. Davidson uses the Barbin case to illustrate this argument.[89] There are many flaws with this view and with Davidson's

dismissal of the coincidence of sexological ideas with the surgical ability to alter sexual anatomy, but certainly the treatment of hermaphrodites in the twentieth century differs from their treatment earlier. Surgery is routinely and nearly automatically performed along with other medical interventions. The result is a new invisibility, but some of the same issues about the constructions of gender recur in muted form.

Or perhaps they recur in heightened form. It could be argued that the availability of hormonal and surgical technologies to alter anatomic sex does two things. It expunges intersex from the category of disabilities to which individuals accommodate themselves and makes of intersexed conditions something akin to a harelip or a supernumerary toe, something to be fixed and then forgotten. Because of its ability to produce the simulacra of sex, to reconstruct the sexual body, medical technology has also created the category of transsex.[90] The irony here cannot be understated. Intersexed bodies that occur "naturally" are erased as "unnatural," whereas "normal" bodies are resexed in a complex enactment of gender construction that relies on the finality of sex as a binary opposition. You can change, albeit with great difficulty and at great cost, from one sex to the other, but you cannot straddle the two.

A 1960 case report in the *Lancet*, Britain's leading medical journal, illustrates how surgical thinking affects gender construction. The case concerns a boy who presented with penile hypospadias (misplaced urethral opening) at age 11; his problem was surgically repaired, and he was discharged a year later.[91] At age 14, he reappeared, this time with bilateral gynecomastia (enlarged breasts). He was diagnosed as having Klinefelter's Syndrome, a gender disorder produced by an XXY chromosomal pattern. A bilateral mastectomy was performed, and he underwent a battery of laboratory studies. As a consequence of these studies, a new diagnosis emerged: The patient did not in fact have a Y chromosome at all but was a chromosomal female. Exploratory laparotomy (incision through the abdominal wall) was undertaken, resulting in the finding of an intraabdominal left gonad with ovarian tissue. Extensive surgery followed: A uterus, an ovary, and a thickened cord were removed; a testis and external male genitalia were left intact; and a course of testosterone was initiated. The report is murky on the role of the patient and his family in therapeutic decision making: "Before his discharge from hospital, the father was told exactly what had been found and what had been done." But the surgeons decided their plan in advance: "We all agreed that if female internal genitalia and an ovary

were found [on laparotomy], as we expected, then they should be removed in their entirety."[92]

It needs to be underscored that this child's problems were social rather than functional or medical the second time he presented himself to the medical system.[93] The final paragraph of the *Lancet* case report states clearly the social theory that underlay the surgeons' agreement on a course of action and merits extensive citation:

> It could be safely argued that this child was more female than male in that his sex-chromosome pattern was XX, his ovary was a much more adequately functioning organ than his testis, he had some uterine tissue, and he had pronounced breast development. On the other hand, he was physically a male in general appearance and his external genitalia were masculine. He had not even a vestigial vagina. Most important of all, he was psychologically oriented as a male, and it has been strongly recommended ... that in these cases of intersex where the individual is not completely of either sex the patients should be brought up in the sex to which they have been accustomed and to which, superficially, they appear to belong. In order to achieve this, it is necessary to remove the evidence of the other sex, so as to avoid embarrassment later on and, as far as possible, to leave the evidence of the obvious sex intact. Since the whole future of the child is at stake, it is exceedingly important to make a firm decision at the time the child is under investigation and treatment . . . to carry out the treatment radically at the time and then to send the patient out into the world with the greatest possible security and confidence. As with so many other things, it is doubts that may lead to trouble, and in the patient's mind these should be reduced as far as possible.[94]

The term "doubtful sex," employed frequently in the second half of the nineteenth century, emphasizes the dangers of doubt. This case returns to the allegation about Barbin that she was "in ignorance of herself" and produces precisely a question of self-knowledge, of the matching up of the epistemology of the external, "the obvious sex," with the epistemology of the hidden, internal "other sex."

Cuthbert E. Dukes, a pathologist, makes a similar argument, even echoing the language of this patient's physicians, though from a slightly different perspective. "The recent discovery that some of the so-called 'inter-sex' anomalies may be directly related to abnormalities in chromosomes is certainly of surgical interest," Dukes writes, "because it is generally agreed that 'inter-sex' patients, whether true hermaphrodites or pseudo-hermaphrodites, should be brought up in the sex to which they have been accustomed and to which superficially they appear to belong. In order to achieve this it may be necessary for the surgeon to

remove evidence of the other sex. In the future, therefore," Dukes argues, "the geneticist may be called in to 'give evidence' when surgical treatment is to be considered."[95] A similar argument had been made a few years earlier by Sheldon J. Segal and Warren O. Nelson who held that, although their view "in no way intended to imply that genetic sex need be the primary consideration in deciding social sex," nevertheless "in all other cases of ambisexuality, the ultimate decision as to sex of rearing should depend on the particular physical situation in each case, but knowledge of the genetic sex should be available to the responsible clinician."[96] Genetic sex was overridden in the case related here. In the recent past, as we saw earlier, some endocrinologists advocated withholding chromatin information from patients in cases in which the sex of rearing was to be in conflict with chromosomal sex. Echoes of the case seen by Samuel D. Gross and reported by Alfred Swaine Taylor recur here—that the child in question, reared as a female after surgery, would likely have been chromosomally male.

The child in the 1960 *Lancet* report was "physically a male in general appearance," and "superficially" he "appears to belong to the male sex." The report does not take up the issue of the patient's affective choices or his potential for sexual function or pleasure or for reproduction (intersex individuals are virtually always sterile). The overriding concern was to keep this child in the sex in which he had been raised, a sensible-seeming approach. He was socialized and comfortable as a boy—why should he have become anything else? The historical issue to note here is that this "sensible" approach has only recently become available. It requires extensive surgery and hormonal treatment, the *excision* of the other and artificial bolstering of the "obvious" or "predominant" so that the latter can reign and doubts can be expunged. Anne Grandjean and Herculine Barbin presented not with anatomic symptoms, which remained hidden under the then compensatorily important drapery of gender-coded clothing, but with "doubts."

AMBIGUOUS SEX AND SOCIAL IDEOLOGY

Despite the availability of the medical category of "intersex," from antiquity to the present, only Charles Debierre—who believed in the criminal propensities of hermaphrodites—and more recently Anne Fausto-Sterling[97] have seriously proposed an addition to our two gender

classifications.[98] The legal and medical literature does not contain challenges to the neat contrariety of those classifications or of our understanding of the "normal" in sexual identity.[99] There are a number of ways to classify sex definitions, but there is no clear hierarchy that can negotiate across chromosomal or genetic criteria to internal and external reproductive characteristics and from there to the sex of rearing, or to social and legal gender designation (see Fig.16). It is this last designation that

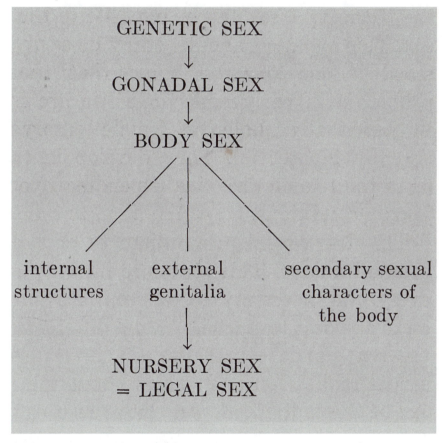

Figure 16: Chain of events in morphologic sex differentiation.

[From Alfred Jost, "Embryonic Sexual Differentiation (Morphology, Physiology, Abnormalities)," in Howard W. Jones and William Wallace Scott, *Hermaphroditism, Genital Abnormalities and Related Endocrine Disorders* (Baltimore: Williams & Wilkins, 1958): 16.] Used by permission.

determines an individual's social and civil identity. Isidore Geoffroy Saint-Hilaire clearly stated the stakes of this identity in 1836:

> The laws of all nations admit, among the members of society they rule, two great classes of individuals based on the difference of the sexes. To one of these classes are imposed duties of which the other is exempt, but also accorded rights of which the other is deprived. The destiny of each new-born, from the moment his sex is known or declared known, is thus ruled in advance for the principal circumstances of life: he is placed in one or the other of these two great classes to which belong functions not only different, but nearly inverse in the family as well as in society. In this regard, no intermediaries; our laws do not admit their existence, do not foresee the possibility.[100]]

Medical jurisprudence has, indeed, focused on ways of determining predominant sex for legal purposes, although it has long been concluded that "the division of mankind into male and female is imperfect, because *there exists a set of beings absolutely neuter*, who have no claim to any sex save that which is appropriated to them on the decision of ill-informed medical jurists."[101]

Gender is a historically and culturally relative category, and medical science has recognized the enormous plasticity of both sexual identification and gender. Anatomical markers are not always determining. Although medicine recognizes the flexibility of the continuum along which sexual differentiation occurs, that recognition has not resulted, as one might have postulated, in a necessary juridical accommodation of those who occupy minority spaces (ironically, its midpoints) on the continuum. On the contrary, medicine has also developed a technology for removing ambiguities with surgical and hormonal intervention, so that the basic principle of bimodal distribution can be maintained. That development has also permitted the maintenance of a legal fiction of binary gender as an absolute. To whatever extent jurisprudence was pushed between the seventeenth and the nineteenth centuries to take account of an understanding of gender as a fluid category without clearcut boundaries, it is no longer required to do so.[102]

The juridical invention of the notion of medical "predominance" has met, albeit imperfectly, the need to categorize all individuals as either male or female. When "predominance" itself becomes difficult for physicians to pin down, as was the case with Levi Suydam, then the key is to avoid mistakes that would accord wrongful privilege—such as the right to vote or to marry—to indeterminately gendered individuals. How then are these individuals to be categorized, and what social and legal privi-

lege may they be accorded? What is to be classified as anomaly or defor-
mation, and what merely as variation on the range of the normal?
Medicine and the biological sciences constitute sex differently from the
law. The relation between the operation of discordant professional dis-
courses on the one hand, and juridical categories and the cultural uses of
binary oppositions on the other, suggests that human taxonomies—the
tagging and classification of every person—underlie all social organiza-
tion.

When efforts at taxonomy yield ambiguity, they fail. Ambiguity must
be officially erased in order to defeat the threat of rule-breaking, bound-
ary-crossing, and anarchy that occurs if gender-indeterminate individu-
als are permitted to marry at their own discretion, to form legal bonds in
which the sexes of the partners may be the same or ambiguous and, there-
fore, potentially the same. The threat here comes from all sides. If we
digress from the absoluteness of the binary gender opposition, we will
have a state in which normative heterosexual social organization is threat-
ened because homosexuality may claim sanctions. Social and legal con-
trol over the body—both social and anatomic—will thereby be surren-
dered.[103] Heterosexual marriage would no longer be the only model for
legal alliance. The threatening nature of sexual ambiguity as anarchy is
even embedded in a rock song by The Kinks, "Lola," whose male speak-
er, besotted with a physically powerful and sexually ambiguous figure,
comments on the ubiquity of sexual confusion.[104] These lyrics resemble
in some respects Richard Thompson's "Woman or a Man?" although the
speaker of "Lola" is far more obsessed.

I have tried to suggest that ambiguous sex, most visible recently in
popular song lyrics and in entertainment figures such as David Bowie,
Boy George, k.d. lang, and Ru Paul, at the same time requires, upholds,
and retaliates against the mechanisms of social legitimation in which gen-
der participates. These mechanisms rely on control of sexuality as one of
the underpinnings for social order. We now recognize how such control
over women historically equated female physiological processes and
reproductive functions with intellectual and moral weakness, an equation
especially powerful in the second half of the nineteenth century, in part
because of the work of European sexologists and the repressive uses to
which it was put. Carroll Smith-Rosenberg has described this as "the
nineteenth century's obsession with categorizing the physical, and espe-
cially the sexual, with describing the abnormal, and with defining the
legitimate."[105] Such an obsession, as I have tried to show, had its origins

much earlier in Western culture as a drive to regularize and control sexual behavior through rigidly oppositional gender taxonomies.

As monsters, hermaphrodites were put to death. As ambiguous participants in the social realm, they have been constrained by legal definitions to take on or throw off particular sexes as befitted the juridical sex categories of their time. Today, surgical and medical intervention renders invisible any individuals born with intersexual characteristics. Far from being reversed by our liberal progression from "monstrosity" to "anomaly," the repression of the double-sexed in earlier centuries has now been completed by the triumphant strategies of medical intervention in the service of civil taxonomizing. Suppression achieves its perfect form in "excision," and the potential of the monster-outsider for subversive social arrangements is eradicated altogether.[106] The varying approaches to ambiguous sex I have traced suggest that the assignment of a place in or the expulsion from legitimate social enmeshment represents an ideological project, a particular and paradigmatic instance of the cultural construction of sex and one that reveals the powerful operations of homophobia in social practice.

The threat of hierarchies challenged and overturned continues to loom over us, but with a difference. Ambiguous sex does more than merely turn the world upside down, a gesture that, after all, fundamentally maintains the notion of hierarchy even when it reverses it. Sexual ambiguity threatens the possibility of gender contrariety as the basis for social order and thereby threatens the hegemony of heterosexuality. Its history demonstrates that this threat has been met with the heaviest artillery available to the professional discourses of medicine and jurisprudence that establish human definitions and boundaries.

5. *Dangerous Wombs*

*As thou knowest not what is the way of the Spirit, nor how the bones
do grow in the Womb of her that is with Child: even so thou knowest
not the works of God, who maketh all things.*

> Ecclesiastes 9.5
> Epigraph to John Locke's
> *Essay Concerning Human Understanding*[1]

In early modern Europe, both physicians and jurists recognized that their
respective professions were governed by different epistemological stan-
dards. Vicq d'Azyr, secretary to the Royal Society of Medicine in France,
articulated this view. He held that whereas lawyers were required to make
unyielding decisions based on conflicting laws, customs, and decrees,
physicians were permitted more space for uncertainty.[2] The competing
historical and cultural understandings of intersexed bodies examined in
Chapter 4 make clear that medicine and the law construe bodily truths
from differing knowledge bases. Jurists rely virtually entirely on medical
testimony to analyze biological data, and medical professionals do not
usually take into account the legal ramifications of their diagnoses. New
medical technologies have contributed to realigning the ethical dilemmas
facing medicolegal jurisprudence, but the terms of this epistemological
gap still hold even though Western medicine and law remain inextrica-
bly entwined. This chapter contextualizes a fascinating medical debate
that took place during the eighteenth century in Europe over whether
the mental activity of a pregnant woman could cause her fetus to become
misshapen. That debate might appear to be an odd historical footnote to
folk beliefs about the human body. It has never completely disappeared,
however. Looking at the way this debate unfolded in Enlightenment
Europe opens up some broad paths to an investigation of a more modern

problem, the very recent trend toward criminalizing the behavior or status of pregnant women on behalf of their gestating fetuses.

The authority of women to voice and explain their own experience of pregnancy and childbirth before and during the eighteenth century contrasts powerfully with the twentieth century's reliance on medicolegal decisions to define that experience. In the eighteenth century, a woman only became officially and publicly pregnant when she felt her fetus "quicken," or move inside her, and she alone could ascertain and report the occurrence of quickening. In 1765, William Blackstone's *Commentaries on the Laws of England* concluded that life "begins in the contemplation of law as soon as an infant is able to stir in the mother's womb."[3] To be pregnant today, in contrast, almost always entails certification by a medical professional and is verifiable through a number of tactile, laboratory, and visual interventions into a woman's body, from palpation to chemical analysis to ultrasonagraphy. In a sense, female interiority has been made public at the same time that women's bodily exterior has attained juridical and moral privacy rights.[4]

In early modern Europe, however, pregnancy and childbirth remained the domains of women. It was not that men had not always participated to one degree or another in some aspects of obstetrics; but female midwives had greater professional authority, and physicians who did obstetrical work held low status among their colleagues. Male involvement in such work was thought to be vaguely unsavory. Even as new imaging technologies—microscopy, anatomical injections, dissection—began to erode the credence given to women's testimony, women continued to control information, experience, and beliefs concerning reproduction. A pregnancy did not exist until there was quickening, as announced by the pregnant woman, and a child did not exist until it was born alive. Focus on the fetus as an entity that is available to medical and legal professionals for pronouncement and intervention and that can be discussed separately from the womb that contains it is very much a modern phenomenon.[5]

▼ ▼ ▼

In 1991, Jennifer Clarice Johnson was prosecuted in a Florida appellate court under a Florida statute that criminalizes delivery of controlled substances to minors. Her newborn infant had tested positive for cocaine. Johnson was convicted for "gestational substance abuse" and sentenced to drug rehabilitation and fifteen years probation. The court found that

Johnson had passed crack cocaine to her fetus through the umbilical cord. Its opinion signaled the first successful prosecution of a pregnant woman in the United States for prenatal damage to a fetus.[6] On appeal the following year, the Florida State Supreme Court unanimously overturned the conviction, declining "the State's invitation to walk down a path that the law, public policy, reason and common sense forbid it to tread."[7] By mid-1992, more than 160 women had been similarly prosecuted for substance use during pregnancy, though so far there are no state or federal laws in the United States that specifically criminalize prenatal maternal behavior. Most of the women who have faced prosecution have been women of color living in poverty. Many have pleaded guilty or accepted plea bargains, but all twenty-three women who challenged their prosecutions have won their cases on grounds that they were unconstitutional or without legal basis.[8]

Jennifer Johnson, twenty-three years old, poor, and African-American, became the first pregnant woman in the United States to be convicted of delivering drugs to her fetus *in utero*.[9] Crucial to this prosecution was the fact that Johnson was not convicted of *using* drugs, only of exposing her fetus to drugs. Had she aborted her pregnancy, the prosecution would never have taken place. The charges brought against Johnson concerned drug *exposure* rather than *harm*. No evidence was introduced to prove that Johnson's drug use adversely affected her children; on the contrary, there was testimony that Johnson's children were healthy and normal. Law professor Dorothy E. Roberts has argued that race and class figured prominently in the Johnson prosecution, and figure in the state's choice in general to punish rather than to help pregnant drug addicts, who are primarily poor African-American women. "These women are not punished simply because they may harm their unborn children," Roberts asserts. "They are punished because the combination of their poverty, race, and drug addiction is seen to make them unworthy of procreating."[10]

Criminal cases such as the one brought against Jennifer Johnson have profound repercussions for ideas about women's bodies, pregnancy, and fetuses. These prosecutions necessarily vest fetuses with the status of persons whose rights can be asserted against the rights of their mothers, thereby creating an adversarial relation between pregnant women and the contents of their wombs. The legal notion of fetal personhood is relatively new and, ironically, results in part from the 1973 United States Supreme Court decision on abortion in *Roe* v. *Wade*. The Court held that "the

unborn have never been recognized in the law as persons in the whole sense," and that "the word 'person,' as used in the Fourteenth Amendment, does not include the unborn."[11] However, the trimester division that defined viability in *Roe* also paradoxically produced an argument for determining a certain moment at which a fetus becomes an entity separate and separable in law from its mother.[12] Fetal *viability* as a concept inherits much of the power of quickening but with the crucial difference that it is decided by physicians and jurists rather than by pregnant women.

In early modern Europe, the responsibility for prenatal care fell to the pregnant woman, because pregnancy was not the medicalized condition it has become. That period's advice literature tended to be written by and for women and included counsel on nutrition, exercise, and travel as well as recipes for abortifacients, often described as mixtures to bring on menstruation or to remove false pregnancies.[13] Pregnant women were advised not to travel in carriages or ride horseback, not to consume strong liquor, and to avoid spicy foods. Explanations for some of this advice differ from their equivalents today. Wine, for example, was often recommended during pregnancy. Consuming strong drink while pregnant or lactating, on the other hand, was thought to cause childhood rickets. The traditional diet in England during the seventeenth century was highly salted and included a consumption of alcohol that we would find alarming, estimated by Robert Fogel at between 3 and 9 ounces of absolute alcohol daily.[14] Although women kept private medical books that urged them to cut down on strong drink while pregnant, nothing existed that bore any resemblance to our current ideas about, for example, the etiology of fetal-alcohol syndrome.

Prosecutions of pregnant women in early modern Europe for crimes related to their pregnancies were confined to those who conceived out of wedlock. The rate of prosecutions for prenuptial pregnancy varied. In addition, laws concerning bastards made unwed motherhood extremely difficult. The child could not inherit, and poor women had few means to force the fathers to marry them. Concern was more for the cost of maintaining such children than for sexual immorality, but adultery and fornication were also prosecutable offenses for women. It is important to note that throughout the eighteenth century, it was believed in Western Europe that female orgasm was required for conception. Therefore, a woman was in no position to claim rape if she became pregnant, because pleasure was assumed and was seen as implying consent.[15]

In 1884, Justice Oliver Wendell Holmes denied cause for wrongful death in the case of a fetus born dead prematurely after its mother had fallen. In *Dietrich v. Northampton*, Holmes argued that the fetus is part of the mother and is not owed a separate duty of care.[16] Courts in the United States followed Holmes' precedent concerning prenatal injuries until 1946, when a District of Columbia Court recognized a fetus as a "distinct individual."[17] Thus, the concept of fetal personhood in law is a post-World-War II phenomenon. A long history predates recent challenges to maternal autonomy in decision-making about pregnancy and in blame for its outcome. The move toward criminalizing the conduct of pregnant women, though radically new in United States jurisprudence, harks back to an ancient tradition of searching for explanations for birth malformations in the minds and bodies of pregnant women.

"At all stages of pregnancy," reproductive rights attorney Lynn M. Paltrow has written, "the fetus is completely dependent on the woman—everything she does could affect it. . . . Recognizing 'fetal abuse' moves us toward criminalizing pregnancy itself because no woman can provide the perfect womb." Paltrow argues that we face a slippery slope. If cocaine, an illegal substance, is prohibited, what about alcohol and tobacco, strenuous exercise or poor nutrition, or driving a car or riding in an airplane or owning a gun?[18] To understand the prehistory of this predicament, we need to ask some less obvious questions about the activities of pregnant women: What about nightmares? phobias? emotional shocks? religious practices? sexual acts? aversions? obsessions? cravings? The imperfect womb, while not until now the object of legal sanctions, has been targeted for centuries as the source and foundation for birth disabilities and malformations. I shall return to the current trend toward increased criminalization of the conduct of pregnant women after an excursion into the eighteenth-century debate concerning maternal desire and the imprinting of fetuses in the womb.

▼ ▼ ▼

During the eighteenth century, physiologists, philosophers, and medical commentators engaged in a heated debate about whether imaginative activity in the minds of pregnant women could explain birthmarks and birth malformations. Seventeenth- and eighteenth-century developments in embryology and in neurophysiology were crucial for the unfolding of this quarrel about pregnancy and the power of mind. The contestatory and internally conflicting discourses that participated in this debate grew

out of a range of cultural beliefs about the human body and about women and mothering that are embedded in eighteenth-century medical writings and have not diminished in importance.

It was a complicated business to demarcate bodily borders in the eighteenth century.[19] Although the physical body was known to have a skin, that surface material represented not only a boundary but also a fluid surface on which interior life revealed itself.[20] Inside and outside, body/self and external world operated in a process of continual exchange. Earlier in the century, women did not "reproduce" when they bore children, rather they participated in *generatio*, or "fruitfulness." The term "reproduction" itself was not used in relation to the propagation of mammals until well into the eighteenth century, eventually replacing the term "generation" with its connotations of divine creation. Earlier, reproduction meant what we now mean by *re*generation, and was first used to describe the capacity of polyps to regenerate lost appendages.[21] Although physicians and anatomists engaged widely and intensively in the study of sexual anatomy, the reproductive apparatus of a woman's body that we classify and study today under the medical rubrics of obstetrics and gynecology did not exist as a unit of clinical knowledge or medical practice in the early eighteenth century. Fetuses were nourished and developed by women, whose anatomical structures were far better understood than their functions, though sexual and generative function was the subject of urgent concern.[22]

Enlightenment Europeans also insisted on the relationality of bodies as classificatory systems, a concern inherited from the history of monsters discussed in Chapter 4. Categories of the body delimited both sensory experience and human notions of autonomy and aesthetics. The female body contained a particular potential to invoke the monstrous, because the body's capacity for monstrosity was tied to its capacity for generation.[23] By the middle of the nineteenth century, representations of women's bodies were more often subsumed into an etherealized domestic ideal. In contrast, early eighteenth-century images of women derived from the threat of an unsocialized, willful, and appetitive female sexuality.[24] In Enlightenment Europe, anatomic entities and selves were understood to produce ideas in physical manifestation across the bodies of pregnant women. The eighteenth-century debates about the maternal imagination were crucial not only for the cultural representation and medical analysis of women's bodies but also for the ability of women to control their own lives.

In a medical treatise published in London in 1714, called *De Morbis Cutaneis. A Treatise of Diseases Incident to the Skin*, English surgeon Daniel Turner defined what he called "that Faculty of the sensitive Soul called Phansy or Imagination" as a physiological power that resided in the brain. It operated, he argued, by irradiating nervous fluid inward in response to impressions received by the external organs. This definition was admittedly vague. Turner's brief treatise was important for the history of medicine because it stands as the first English dermatology text, but its fame rests on the vehement debate it initiated. That this debate grew out of the nascent specialty of dermatology underlines the eighteenth-century's preoccupations with surfaces and appearances, and with the idea of stigmata, a preoccupation fueled in large measure by the scourge of smallpox and the controversy surrounding the practice of inoculation. As Barbara Maria Stafford has written, "Cutaneous pathology was the heart of darkness in the Enlightenment."[25]

Turner needed to define the imagination in his treatise on diseases of the skin because he made a controversial claim in his chapter about the causes of birthmarks. That chapter carried a typically long-winded eighteenth-century title: "Of Spots and Marks of a diverse Resemblance, imprest upon the Skin of the *Foetus*, by the Force of the Mother's Fancy; with some Things premis'd, of the strange and almost incredible Power of Imagination, more especially in pregnant Women."[26] Turner could not explain his claim. In fact, he wrote: "how these strange Alterations should be wrought, or the *Foetus* cut, wounded and maimed, as if the same were really done with a Weapon, whilst the Mother is unhurt, and merely by the Force of her Imagination, is, I must confess ingenuously . . . *Supra Captum*, *i.e.* above my Understanding" but nevertheless undeniable (pp. 116-117). That Turner asserted the occurrence of maternal impressions but admitted to not knowing why this should be so underscores an important fact of early eighteenth-century medicine: The notion of professional expertise not only did not exist in this period, but physicians were frequently the butt of jokes. Physician consultations were at the same time desired and feared.[27] James Augustus Blondel, a Parisian educated at the University of Leiden and a noted member of the College of Physicians of London, as was Turner, responded virulently to Turner's assertion. Blondel asked, "What can be more scandalous, and provoking, than to suppose, that those whom God Almighty has endow'd, not only with so many charms, but also with an extraordinary Love and Tenderness for

their Children, instead of answering the End they are made for, do bread [sic] *Monsters* by the Wantonness of their Imagination?"[28]

Turner's theory of the maternal imagination, or maternal impressions, embraced two quite separate ideas. First, a pregnant woman's longings, if ungratified, were understood to *mark* her fetus. Hence, if an overwhelming desire for strawberries could not be satisfied, the infant would be born with a strawberry mark.[29] Cravings (or aversions) of this sort did not always involve food. They might also pertain to religious or sexual activities, or to obsessive acts or thoughts. Yet it is telling that the vast majority of examples of the first type of maternal impression involve a pregnant woman's uncontrollable appetite for fruit. The physician-theologian Nicholas Malebranche, a central influence on Turner, had written in his 1674 *De la recherche de la vérité* [*In Search of Truth*] that the mother's desire for fruit caused the fetus to imagine and desire the fruit as well, so that "these unfortunate infants thus become like the things they desire too ardently." Both Alain Grosrichard and Marie-Hélène Huet point out the theological analogy between monstrous offspring and forbidden fruit.[30]

Second, the pregnant woman needed to avoid disturbing experiences at all costs, on the theory that if, for example, she was startled on the street by the sight of a beggar missing the fingers of one hand, her infant would be born lacking the fingers of the corresponding hand. The pseudonymous early eighteenth-century midwifery handbook, *Aristotle's Compleat and Experienc'd Midwife*, contained this advice: "Let none present any strange and unwholesome Thing to her, nor so much as name it, lest she should desire it, and not be able to get it, and so either cause her to Miscarry, or the Child to have some Deformity on that Account."[31] John Maubray went further in his popular 1724 *The Female Physician, Containing all the Diseases incident to that Sex in Virgins, Wives, and Widows*. Maubray placed responsibility for these misadventures onto the pregnant woman herself. "She ought discreetly," Maubray wrote, "to suppress all *Anger, Passion*, and other *Perturbations* of Mind, and avoid entertaining too *serious* or *melancholick Thoughts*; since all *such* tend to impress a *Depravity* of Nature upon the Infant's *Mind*, and *Deformity* on its *Body*." In addition, pregnant women were to maintain domestic harmony in their households and marriages. According to Maubray, "There never ought so much as a *Cloud* to appear in [her] *Conjugal Society*; since all such unhappy *Accidents* strongly affect the growing *Infant*."[32]

What, then, did these explanations look like in action? In 1566 in England, a woman gave birth to an infant born with a "ruffed" neck. A

manuscript in the British Library called *The True Description of a Childe with Ruffes* contains the following verse:

> And ye O England whose womankinde
> in ruffes do walk so oft
> Parsuade them stil to bere in minde,
> This childe with ruffes so soft.[33]

Blame for this malformation was placed on the mother's vanity—she had too closely followed the clothing fashions of the day without regard for her developing fetus. The best-known maternal imagination case in England was actually a fraud. Mary Tofts of Godalming in Surrey, commonly referred to as the "rabbet woman," in 1726 contrived a hoax aimed at gaining fortune by claiming to have given birth to a litter of 17 rabbits after seeing and becoming obsessed with a rabbit while working in the fields.[34] In 1746, the *Gentleman's Magazine*, a politically moderate English monthly that covered a wide range of medical topics, published a typical report of a malformed birth ascribed to the maternal imagination:

> The wife of one Rich. Haynes of Chelsea, aged 35 and mother of 16 fine children, was deliver'd of a monster, with nose and eyes like a lyon, no palate to the mouth, hair on the shoulders, claws like a lion instead of fingers, no breast-bone, something surprising out of the navel as big as an egg, and one foot longer than the other.—She had been to see the lions in the Tower, where she was much terrify'd with the old lion's noise.[35]

Another example demonstrates the extent to which families took seriously the desires of pregnant women and the need to satisfy them. When his pregnant wife told the botanist Camerarius that she felt overwhelmed by the wish to smash a dozen eggs in his face, he obligingly submitted to her desire.[36]

Barbara Stafford intriguingly describes the process by which it was thought the senses could contaminate the brain of a pregnant woman and make her fetus susceptible to a transmitted contagion of desire or fear:

> In a sort of pre-Freudian fetal psychology, the infant took on the literal shape of the trauma, or the experience that had left a profound negative or positive groove in [the mother's] psyche. Hence offspring visibilized concealed or surrogate passions on their surfaces. Like a blank sheet of paper, the skin became marbled by pathos, mottled by an alien pattern of interiority.[37]

This kind of ahistorical psychologizing bypasses the complex neurophysiology of eighteenth-century concepts of nervous communication.

Nevertheless, the point holds: The birth of a defective infant unveiled the secret passions of its mother just as the birth of an addicted baby today opens fissures in the autonomy of its mother, as the very term "crack baby" implies. It is not surprising, then, that the birth of a "monster" called into question, above all, the legitimacy of its parentage.

As a consequence, malformed births represented a major problem in early modern Europe. A monstrous birth lacked legitimacy in a fundamental way. Such an infant failed to resemble its (or any) father; hence, in a social order ruled by the laws of primogeniture and patrilineage, a malformed birth stood for social disruption of a basic sort. Before the sixteenth century, a monstrous birth signified the opposite of its father's stamp. It was a portent, a sign of the wrath of God.[38] Edward Stillingfleet regarded it difficult to distinguish between acts of the divine spirit and impressions of fancy, and in his Boyle lectures of 1705, Samuel Clarke said "what Men commonly call the *Course of Nature*, or the *Power of Nature*" is actually the "*Will of God.*"[39] Conflicts arose between the ecclesiastical interest in the immortal soul of the infant and the secular authority's concern for determining property rights, inheritance, and legitimacy. Both interests applied pressure to midwives, who were responsible for determining whether a live birth had taken place, and for baptizing moribund newborns.

It is pertinent to point out here that the notion of fetal personhood necessary to underwrite a case such as *Johnson* v. *Florida* in 1991 was inconceivable in the eighteenth century. A newborn did not legally exist unless it was born alive, and the conflicts now familiar to us between saving the life of the mother and preserving the product of her labor were not at issue in early modern Europe. The mother's health and survival unequivocally came first, as it was the pregnant woman who was being delivered, not the fetus. This clear hierarchy of concern underlay the midwifery practice of manual version and the more often male surgical practices of craniotomy and embryotomy as means of removing a dead fetus from a living woman.[40]

▼ ▼ ▼

The subject Turner and Blondel became so vituperative about was not by any means new either to the eighteenth century or to Europe. The belief that the maternal mental state influences fetal development is ancient and can be found in Hindu medical treatises that predate Western Hippocratic medicine by many centuries.[41] Ayurvedic texts argued that prenatal beings

were sentient and environmentally responsive. The *Garbha Upanishad* and the *Susruta-samhita*, for example, claimed that the fetus expressed its desires through the longings of the mother, hence such longings must be gratified, whereas the *Caraka-samhita* provided a guide for pregnant women that equated certain eating habits (excessive sweets or fish) or behaviors (sleepwalking, sexual promiscuity) with character traits in the unborn child.[42] The Judeo–Christian tradition also offers a notable example of the theory that maternal sense impressions mark offspring—the story of Jacob placing rods before his flock in order that they bear speckled and spotted cattle (*Genesis* 30:31-43).

Nor have these beliefs ever fully disappeared. In an essay written between 1572 and 1574 on the power of the imagination, Michel de Montaigne asserted that "women transmit marks of their fancies to the bodies of the children they carry in their womb."[43] In 1674, Malebranche narrated the tale of a child who had been born exactly resembling a portrait of Saint Pius on the feast of his canonization, with the face of an old man, almost no forehead (because in the portrait the image of the saint turns his gaze heavenward), and the shape of an inverted mitre on his shoulders. This malformation was explained as a sign of the power of the mother's imagination, because she had attended too carefully to the portrait during her pregnancy, a suggestion first proposed in a lost work attributed to Empedocles.[44] James I of England was thought to panic at the sight of a drawn sword because his mother Mary Stuart witnessed the brutal murder of David Rizzio while pregnant with him, an interpretation recounted by Malebranche and repeated in Sir Walter Scott's 1822 historical novel, *The Fortunes of Nigel.*

In 1653, William Harvey's *Anatomical Excitations* sketched the theory behind these views about the power of the maternal imagination. Harvey described the womb as "a principal part, which doth easily draw the *Whole body* into consent with it. No man . . . is ignorant, what grievous *Symptomes,* the Rising, Bearing down, and Perversion, and Convulsion of the *Womb* do excite; what horrid extravagancies of minde, what Phrensies, Melancholy Distempers, and Outragiousness, the *praeternatural Diseases* of the womb do induce, as if the affected Persons were inchanted."[45] Similarly, in his essay "*Sur les femmes*" ["On Women"], Denis Diderot remarked that "Woman carries inside herself an organ susceptible of terrible spasms, keeping her at its disposal, and arousing in her imagination ghosts of all sorts. It is in hysterical delirium that she comes back to the past, that she springs toward the future, that all times are present to her. It

is from the organ particular to the sex that come all of her extraordinary ideas."[46]

Nineteenth-century medical texts continued to refer to the impact of the maternal imagination. Thomas Bull's 1842 *Hints to Mothers for the Management of Health During the Period of Pregnancy* commented on the prevalence of belief in the power of the maternal imagination, though Bull refuted its validity.[47] An 1888 article in the *Journal of the American Medical Association* entitled "Monstrosities and Maternal Impressions" detailed the case of a woman who gave birth to an anencephaloid infant ("frog-child") after she caught a frog while fishing, was unable to extract the hook, and had to crush the frog's head with a stick. Indeed, this article begins with the declaration that "[w]hether maternal impressions do or do not influence foetal development, is a question still before the profession."[48] Even the 22nd edition of *Stedman's Medical Dictionary* (1972) contains an entry for "maternal impressions," though it treats the subject as wrongheaded folklore. The entry reads: "a strong emotion or shock, experienced by a pregnant woman, popularly supposed to be the cause of a malformation or surface marking of the fetus, also the lesion or malformation supposed to result from the mental impression of the mother. This concept is not based on fact. There are no nervous communications between mother and fetus."[49] The more standard current medical approach to this subject can be found in *Index Medicus* under the rubric "Maternal-Fetal Exchange," though there is also a subject heading for "Maternal Behavior." Abnormal food cravings have been medicalized under the term *pica*, which in the eighteenth century referred only to a condition of pregnant women but today is more commonly used in pediatrics to designate an eating disorder of children.[50]

The two separate ideas that together form the concept of the maternal imagination are quite different. Though both types are involuntary on the part of the pregnant woman, cravings or obsessions are active, whereas witnessing unsettling persons or events or representations amounts to a passive, usually visual taking in of experience that is imposed from without. This distinction between passive and active mental states, however, did not always hold up. In his 1651 *Directory for Midwives*, for example, which by the early eighteenth century had become an enormously popular midwifery guide, Nicholas Culpeper described maternal impressions by combining the two types: "Sometimes there is an extraordinary cause, as imagination, when the Mother is frighted, or imagineth strange things, or longeth vehemently for some meat which if she have not, the child hath a mark of the colour or shape of what she desired."[51]

Both types of maternal impression ultimately raise questions about the formulation of theories concerning female desire and its location in the generative female body. Interestingly, the first idea, of cravings, is the one that persists both as folklore and in obstetric textbooks today—the pickles-and-ice-cream (or, in the 1959 Disney animated classic "Lady and the Tramp," watermelon-and-chop-suey) takeover of the pregnant woman's appetites.[52] But in their early modern formulation, the maternal imagination debates proposed a continuum between the passive reception of sensory experience from outside and the active production of desire. The maternal imagination debaters took the Lockean concept of the primacy of sensory experience and from it derived, if not quite a coherent theory of female desire, then as close as we get in the seventeenth and eighteenth centuries to a notion of what women want. It is worth noting here that Locke himself may have been unsure about the place of women and generation in his empirical philosophy, as evidenced in the epigraph to his *Essay* that also serves as my epigraph to this chapter, a willingness to admit ignorance that was typical of physicians around 1700 in Europe. In the theories of the period, women's desires remained involuntary, unintentional, beyond a woman's control. As Marie-Hélène Huet writes, "Imagination translates the mother's desires in a way that escapes her will, her wishes, or her own understanding; it cannot even produce an aesthetic effect."[53]

In 1668, François Mauriceau described pregnancy as "a rough Sea" and urged pregnant women "to be careful to overcome and moderate her Passions, as not to be excessive angry; and above all, that she be not afrighted; nor that any melancholy news be suddenly told her" because she might miscarry or harm her fetus. He wrote that pregnant women "have so great loathings, and so many different longings, and strong passions for strange things," hence it was difficult to prescribe a proper diet for them. He also cited the case of his then 50-year-old cousin whose hands still trembled because when his mother was 8 months pregnant with him, her husband was killed with a sword and she was told of the event in a sudden manner and trembled violently.[54] Figure 18, from Mauriceau's *The Diseases of Women with Child, and in Child-bed*, "represents the natural scituation of the Womb" and provides a view into the interior of a woman's abdomen and pelvis. It is remarkable for a number of reasons: the oddly stylized breasts; the representation of external genitalia, odd for the period; the curious scale in which the drawing depicts a kind of maternal spaciousness; and the interior design itself, with the mesentery, flanked by the kid-

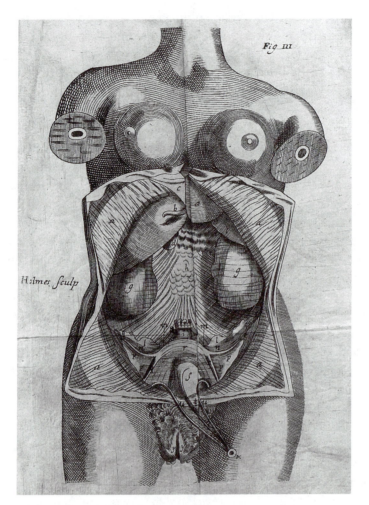

Figure 18: The Womb. London, 1683.

Legend: A.A.A.A. The Muscles of the Belly, and the Peritoneum turned outwards. a.a. The Liver. b. The Umbilical Vein. c. The suspending Ligament of the Liver. d. The Bladder of the Gall. e. The Pancreas, or Sweet-bread. f. Part of the Spleen. g.g. The Reigns. h. The place where the Mensentary was fastened. i. The right Gut. l.l. The Testicles. m.m. The Ejaculatory Vessels, which comes immediately from the Testicles to the Womb. n.n. The Vessels, ordinarily taken for the true Ejaculatories. o.o. A production of the broad Ligament, which seems to be ragged. p.p.p.p. The broad Ligaments. q.q. The round Ligaments. r. The Womb. s. The Bladder. t. The Urachus, by which the Urin of the Child passeth into the Bladder of the Mother. u.u. The Umbilical Arteries. x. The Navel, where is fastened the two Umbilical Arteries, and the Urachus, with which the Umbilical Vein serves only after the Birth for suspensoirs for the Bladder and Liver. y. The two great Lips of the Privy Parts, between which appears the great Crevice, or Notch. [From François Mauriceau, *The Diseases of Women with Child and in Child-bed*, trans. Hugh Chamberlen (London: John Darby, 1683): Figure III, 12-13.] Courtesy of the Historical Collections, College of Physicians of Philadelphia.

neys, not only covering the intestines but also appearing as a heavenly overseer of the womb and ovaries.

In addition to the array of thinkers on generation from Heliodorus and Empedocles to the father and son founders of teratology, Etienne and Isidore Geoffroy Saint-Hilaire, dozens of writers participated in the Enlightenment installment of the debate about maternal impressions. Responding to the ideas of Daniel Turner, Blondel published *The Strength of Imagination in Pregnant Women Examin'd: and the Opinion that Marks and Deformities in Children arise from thence, Demonstrated to be a Vulgar Error* in 1727. Turner countered in 1730 with *The Force of the Mother's Imagination upon her Foetus in Utero.* Blondel's work appeared under the title *Dissertation physique sur la force de l'imagination des femmes enceintes sur le foetus* in Leiden in 1737. Turner's *De morbis cutaneis* was translated into French as *Traité des maladies de la peau* in 1743. In the meantime, Malebranche's *De la recherche de la vérité* went through five editions between 1721 and 1772. Henry Bracken's 1737 *The Midwife's Companion* sided with Turner. Bracken cited the example mentioned earlier of the fingerless beggar and demonstrated the sociopolitical implications of these ideas: "Indeed, such Objects as these [the beggar] should be driven out of every Town, by express Order of the Magistrate: For it is not hardly credible the Number of Children who are born monstrous on such Accounts."

A French argument in support of Blondel appeared in 1745 when Bordeaux physician Isaac Bellet published his *Lettres sur le pouvoir de l'imagination des femmes enceintes. Où l'on combat le préjugé qui attribue à l'imagination des Mères le pouvoir d'imprimer sur le corps des enfans renfermés dans leur sein la figure des objets qui les ont frappés* [*Letters on the power of the imagination of pregnant women. In which is combatted the prejudice that attributes to the imagination of mothers the power to imprint on the bodies of the children enclosed in their wombs the mark of objects that have struck them*]. Bellet argued against maternal impressions, as is clear from his title, but he also reported that this wrong-headed prejudice destroyed the repose and health of pregnant women because they were made anxious or alarmed by the smallest events and lived in fear of experiencing or thinking something that would hurt their infants. This situation was so dreadful, according to Bellet, that he argued in a circle, asserting that imaginary maladies became real ones and affected the infant in the womb.[55] Later in the century, in her 1797 *The Pupil of Nature; or Candid Advice to the Fair Sex*, Martha Mears presented the same circular argument about maternal passions. Mears wrote that there was no circulatory communication between mother and fetus, but

that "[i]t is of the utmost moment to root out of the mind those fatal apprehensions; or they will often produce the very evils to which they are so tremblingly alive." Disease during pregnancy may result, or difficulty in delivery, and even "a puny, or distorted infant is sometimes brought forth—the victim of its mother's terrors."[56]

A line-by-line refutation of Blondel's 1727 treatise was published in 1747 by John Henry Mauclerc: *Dr. Blondel confuted: or, the Ladies vindicated, with Regard to the Power of Imagination in Pregnant Women: Together with a Circular and General Address to the Ladies, on this Occasion*. Mauclerc's subtitle—*the Ladies Vindicated*—reveals the underlying problem of the status of pregnant women as rational beings that was involved in these quarrels. Jean Astruc's well-known *Traité des maladies des femmes* [*Treatise on the Diseases of Women*] exhorted women to control their emotions in order to protect their fetuses:

> Passions of the soul, such as choler, regret, fear, sorrow, can harm the conservation of the embryo, and often cause miscarriage in the beginning of the pregnancy if one gives in to them too actively. It is therefore necessary to exhort the pregnant woman to contain herself, and what is more certain, to avoid all occasions that could affect her strongly.[57]

That a pregnant woman must contain herself, *se contenir*, represents the key phrase in Astruc's discussion, making clear both the locus of responsibility for the pregnancy and the nature of female interiority as potential excess that must be policed. Figures 18, 19, and 20 come from Astruc's text: Figure 19 illustrates a kind of floral vision of fetal development in its earliest stages; Figure 20 suggests the degree to which the womb was understood as a container, but also shows the fetus floating free of its surroundings; and Figure 21 represents a peculiarly stylized view of the fetus, whose final appearance holding the umbilical cord seems to represent a sovereignty over its maternal dependency at the moment of birth, a moment figured as the appearance of a minature adult. The Abbé Dinouart's *Abrégé de l'embryologie sacré, ou Du traité du devoir des Prêtres, des médecins & autres, sur le salut éternel des enfans qui sont dans le ventre de leur mère* [*Abridgement of Sacred Embryology, or Of a Treatise on the Duty of Priests, Doctors and Others, concerning the Eternal Salvation of Children Who are in the Belly of their Mother*] urged priests and doctors to beware of the factors that could harm a fetus: abusive husbands, inattention to health or intemperance, and women who had the impudence or temerity to travel or carry heavy burdens while pregnant. Dinouart also warned against quarrels, anger, sadness, and other

Figure 19. A Human Embryo. Paris, 1765.

[From Jean Astruc, *Traité des maladies des femmes*, 3 vols (Paris: Guillaume Cavelier, 1765): 3: Plate II.] Courtesy of the Historical Collections, College of Physicians of Philadelphia.

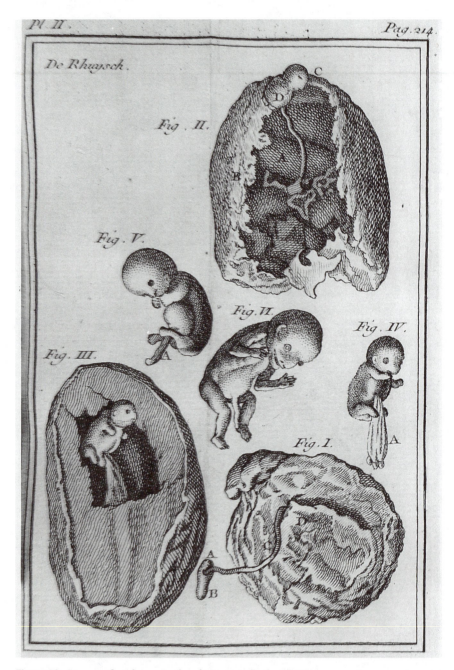

Figure 20. Stages of embryonic development. Paris, 1765.

Legend: A. The head of the embryo. B. The body of the embryo with no appearance of arms or legs. C. The umbilical cord. D. The placenta. (My translation.) [From Jean Astruc, *Traité des maladies des femmes*, 3 vols (Paris: Guillaume Cavelier, 1765): 3: Plate I.] Courtesy of the Historical Collections, College of Physicians of Philadelphia.

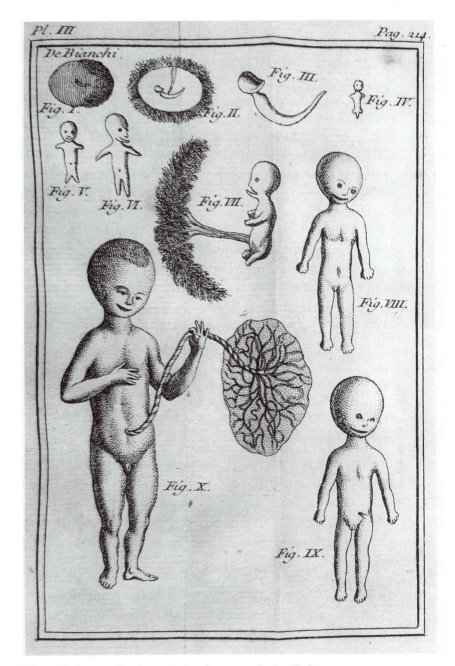

Figure 21. Stages of embryonic development. Paris, 1765.

[From Jean Astruc, *Traité des maladies des femmes*, 3 vols. (Paris: Guillaume Cavelier, 1765): 3: Plate III.] Courtesy of the Historical Collections, College of Physicians of Philadelphia.

passions that could have grievous effects on developing fetuses, and urged pregnant women to come to church to pray every day.[58]

The controversy continued throughout the second half of the eighteenth century and into the nineteenth. In 1756, the German scientist Theodore Eller argued against Turner in "*Recherches sur la force de l'imagination des femmes enceintes sur le foetus*" in the *Mémoires de l'Académie Royale de Prusse.*[59] Diderot and d'Alembert's *Encyclopédie* contained an entry refuting the power of pregnant women's imaginations, holding that the child in the womb is in this regard as independent of the mother who carries him, as the egg is independant of the hen that lays it.[60] In 1788, a pro-impressions treatise was published in Paris by the hygienist and king's physician Benjamin Bablot under the title *Dissertation sur le pouvoir de l'imagination des femmes enceintes* [*Dissertation on the Power of the Imagination of Pregnant Women*]. Johann Caspar Lavater's 1792 *Essays on Physiognomy* contained an essay called "Observations on the Marks which Children Bring into the World upon Them—On Monsters, Giants, and Dwarfs." Lavater commented on the marking powers of the maternal imagination:

> When the imagination is powerfully agitated by desire, love, or hatred, a single instant is sufficient for it to create or annihilate, to enlarge or contract, to form giants or dwarfs, to determine beauty or ugliness: it impregnates the organic fetus, with a germ of growth or diminution, or wisdom or folly, of proportion or disproportion . . . and this germ afterwards unfolds itself only at a certain time, and in given circumstances.[61]

In 1807 Jean-Baptiste Demangeon attempted a reasoned study of the issue, entitled *Considérations physiologiques sur le pouvoir de l'imagination maternelle durant la grossesse, et sur les autres causes, prétendues ou réelles, des difformités et des variétés naturelles* [*Physiologic Considerations on the Power of the Maternal Imagination during Pregnancy, and on the other causes, assumed or real, of deformities and natural variation*]. He concluded that the jury was still out. The debate gradually died out, its ideas subsumed in some measure into the science of teratology by the early nineteenth century. Importantly, no definitive conclusion to the quarrel ever resolved it, and belief in the power of the maternal imagination remains with us in folk beliefs within a variety of cultures.

▼ ▼ ▼

The language of the original medical treatises in this debate made clear the issues that were, and remain, at stake. In his 1730 response to Blondel,

Turner presented an extraordinary description of the physiology of imagination, and it bears quotation at length in order to understand the nature of the quarrel:

> The Fancy once excited at the Appearance of the Object, presently stirs up the Appetite. . . .
>
> If it be desirable the whole Bent of the Soul is carried forth to court and embrace it, earnestly endeavouring to be united thereunto, she is . . . stretched forth in Pleasure to the utmost Irradiation, while the animal Spirits in a kind of Ovation being carried within the Brain, are constantly exciting the most pleasing Ideas of the same, and livelily [sic] acting [sic] the nervous System, cause the Eyes, Face, Hands, and all the Members to shine and leap for Joy; farther, more fully also shaking the Praecordia by the Influence of the Brain, delivered by Means of the Nerves, they thrust forth the Blood more rapidly, and as a Flame more brightly inkindled, pour forth the same with Vigour into all Parts of the Body.
>
> On the contrary, if it appear dreadful or grievous to the Imagination, whilst the Soul sinks down contracted into a narrower Space, the Spirits inhabiting the Brain, as if struck down by Flight and troubled, put on only sad and fearful Looks . . . and hence the Countenance is dejected or cast down, the Limbs grow feeble, and the Praecordia being contracted and bound together, by Reason of the Nerves carrying the same Affection from the Brain, restrain the Blood from its due Excursion . . . which being thus heaped up in the same Place. . . brings on a troublesome Oppression at the Heart; whilst in the mean Time the exterior Parts, deprived of their wonted Influx, languish and grow disordered: So that the Changes and Alterations wrought upon our Bodies . . . by this Power of Imagination, are almost incredible. . . .[62]

This is a striking description, and one that was echoed almost verbatim in Dr. Robert James' *Medicinal Dictionary* (1743-1745). Turner presented a *tour de force* of interior and sexualized motion, so that it seemed that if women's imaginations kicked in at all, they risked becoming seasick as well as uncontrollably libidinous. Turner described a dancing and singing embodiment, with choral ovations for the images before us and a balletic *jouissance*; "desirable" images produce a kind of evangelical ecstacy. On the other hand, "dreadful or grievous" images contract rather than expand our capacity to feel, and cramp us with blockages and oppressions. It is clear from this passage that Turner's subject was much larger than the influence of the maternal imagination on fetal development. This debate was about passion and power with respect to the early modern understanding of the body as an envelope, a coating for the soul, a receptacle whose corporeality was allegorical as well as physical.

Blondel's counterargument conceded the power of maternal experience to influence fetal development. He granted, for example, the following:

> 1. That the Child may suffer by the Distempers of the Mother, by several Accidents, as great Falls, and Blows she receives, by the Irregularity of her Diet, and of her Actions, by Dancing, Running, Jumping, Riding, Excess of Laughing, frequent Sneezing, and all other Agitations of her Body.

> 2. That a sudden Surprise, a violent Passion of Anger, an extraordinary Grief, or an Apprehension of Danger may be the Cause of a Miscarriage.

> 3. That the Uterus, and the Muscles of the Abdomen, being in a strong Convulsion, may knead the tender Body of the Child, bruise it in several Parts, and cause either a Mutilation, or a Dislocation.

> Lastly, that the Disappointment of what the Mother longs for, making her uneasy and pine away, the Child may be depriv'd of sufficient Nourishment, grow feeble and weak, and at last, lose its Life.

But having made these concessions, Blondel cut to the chase:

> All this is not in dispute; but what I deny, is, That the strong Attention of the Mother's Mind to a Determined Object, can cause a Determined Impression upon the Body of the Child.[63]

Blondel asserted that women who gave birth to marked or malformed children were hounded into making confessions after the fact, and he seemed to be challenging the honesty of mothers in these cases.

The eighteenth-century understanding of the physiology of pregnancy undergirded the quarrel between Turner and Blondel. How did these physicians think material from the pregnant woman's imagination was getting, literally, impressed onto the flesh of their fetuses? Prior to Turner and his choral ode to the maternal imagination, Malebranche had devoted a long section of his *De la recherche de la vérité* to the subject of maternal-fetal relations. Malebranche argued that mothers could "imprint" their infants with their passions, and that the fetus shared blood, spirits, sensations, and passions with its mother:

> Children in their Mother's Womb, whose Bodies are not yet compleatly form'd, and who are of themselves in a State of the greatest Weakness, Impotency, and Want, that can possibly be conceiv'd, ought to be united likewise to their Mothers in the strictest manner imaginable. And though their Soul be separate from that of their Mothers, yet since their Body is not loos'd, and disengaged from her's, it ought to be concluded, they have the same Sentiments and the same Passions; in a word, all the same Thoughts

as are excited in the Soul, on occasion of the Motions which are produc'd in the Body.[64]

The relation Malebranche described is one of absolute dependency. One case he recounted in particular presented a full-blown theory of the physiology of maternal impressions. This case involved a child born mentally deficient, with his "whole Body broken in the same places that Malefactors are broken on the wheel." The child's mother had gone to see an execution during her pregnancy. Here is Malebranche's description of what happened:

> All the blows which were given to the Condemned, struck violently the Imagination of the Mother; and by a kind of Repercussive blow, the tender and delicate Brain of her Infant. The Fibres of the Infant's Brain not being able to resist the furious torrent of these Spirits, were broke and shattered all to pieces. And the havock was violent enough to make him lose his Intellect for ever. This is the Reason why he come into the World deprived of Sense. (p. 56)

That is Malebranche's theory of the child's mental deficiency. On his physical disabilities, he continued:

> At the Sight of this Execution, so capable of dismaying a timorous Woman, the violent course of the Animal Spirits of the Mother, made a forcible descent from her Brain, towards all the Members of her Body, which were Analogous to those of the Criminal, and the same thing happened to the Infant. But because the Bones of the Mother were capable of withstanding the violent Impression of these Spirits, they receiv'd no dammage by them. . . . But the rapid course of the Spirits was capable of bursting the soft and tender parts of the Infant's Bones. (p. 56)

Although Malebranche saw a natural efficacy to the intimate interaction between mother and fetus, he also commented that "we ought not to measure the Power of GOD by our weak Imagination; and we are ignorant of the Reasons, which might have determined Him in the Construction of his Work" (p. 57). Malebranche conflated theological beliefs and embryological ideas. "From the time of our Formation in our Mother's Belly," he wrote, "we are under Sin, and stain'd with the Corruption of our Parents" (p. 58). But he also concluded that "all those Spurious Traces which Mothers imprint in the Brain of their Children, adulterate their Minds, and corrupt their Imaginations" (p. 60). Children remained the products and the embodiment of forbidden fruit.

William Smellie's 1760 midwifery treatise also subscribed to the power of the maternal imagination to affect the fetus *in utero*. In a section

on "Monstrous Births" in his *Treatise on the Theory and Practice of Midwifery*, Smellie described a mother's explanation for an infant who was born missing the top part of his skull:

> Upon the ninth of April 1747, when she was near two months gone with child, she was grievously frightened with thinking on Lord Lovatt, who was that day to be beheaded. Her husband was gone to see the execution amongst the crowd on Tower-Hill, and when the news came to her hearing, that a scaffold was fallen down, by which accident many people were hurt, and some killed on the spot, she immediately feared that her husband might be of the number, and was greatly affected. While she was under this dread and apprehension, an officious idle woman came to her and said, that a friend of hers, for whom she had a great regard, was killed on the spot, and that she saw his brains on the ground; upon this the poor woman put both her hands on her head in great agony, and immediately fainted away.[65]

Smellie's account is reminiscent of Malebranche's account of a pregnant woman who witnessed an execution, but this time the "impression" was mediated through its narrative account. It was the pregnant woman's imagination, not her eyes, that "saw."

▼ ▼ ▼

Ideas of conception and generation did not move very far in Western thought from Aristotle's *On the Generation of Animals* to William Harvey's *De Generatione Animalium* in 1651, and embryology did not emerge as a separate medical discipline until the second half of the sixteenth century. The Turner-Blondel contribution to ideas of generation appeared at the height of discussions about embryological *preformation*. This was the view that the whole human structure exists in miniature prior to conception. Preformationist views came in a variety of degrees and flavors and were not an eighteenth-century invention, though they tended to be presented less extremely in earlier periods.[66] Preformationist arguments did not achieve any universal consensus in the medical community, but they began to appear in great numbers in medical literature around the end of the seventeenth century and are important for understanding the stakes in the debates about the maternal imagination.

The usual version of preformation was called *animalculism*. It held that the preformed human being inhabited the male seed. With an improved microscope, Antoni van Leuwenhoek first observed spermatazoa in 1677 and thought the sperm contained a miniature human being. There was an interesting controversy concerning why, if animalculist versions of pre-

formation had validity, children often looked like their mothers. One explanation involved the maternal imagination: Vain pregnant women looked at their own likenesses in the glass, and their image then became imprinted on the fetus they were carrying.

There was also a strain of preformationism called *ovism* that saw the female egg as the repository for the homunculus, a view that seemed to be shored up by Regnier de Graaf's discovery of the ovarian follicle in 1672. In 1675, Marcello Malpighi studied what he thought were unfertilized hen's eggs and observed embryos; hence, he put forward the hypothesis that the egg contained a miniature chick. The Swiss anatomist Albrecht von Haller also became partial to ovism after earlier opposing preformation, but following the announcement in the 1670s by Leeuwenhoek and Nicolas Hartsoeker that semen contained millions of little animalcules, animalculism, or spermaticism, became by far more common. The most extreme version of preformationist belief was the notion of *emboîtement* or encasement. Haller offered an ovist explanation of that all-inclusive view: "It follows that the ovary of an ancestress will contain not only her daughter but also her granddaughter, her great-granddaughter and her greatgreatgranddaughter, and if it is once proved that an ovary can contain many generations, there is no absurdity in saying that it contains them all."[67] In other words, all potential human beings have existed from the moment of divine creation.

The animalculist preformationists challenged the view inherited in the West from Aristotle that the male seed contributed the sentient soul of a human being and that the woman contributed formless matter.[68] Scientists such as Leeuwenhoek and Hartsoeker argued that these miniature beings were placed there directly by God at the time of creation, providing for the continuation of the species into eternity. In 1759, Kaspar Friedrich Wolff observed unfertilized hen's eggs without seeing embryos and proposed the "layer concept" of cell production in his *Theoria Generationes*. This observation provided the foundation for *epigenesis*—the belief that the embryo develops structurally and sequentially *in utero* through the growth and differentiation of specialized cells. When Lazzaro Spallanzani's experiments in 1775, which included the artificial insemination of dogs, showed that both egg and sperm were required for the production of an embryo, preformationist ideas began to fade. Epigenesis did not fully shake preformation believers of various stripes, however, until the end of the eighteenth century.

Yet, animalculism so incarnated the comforts of an entrenched gender ideology in embryological theory that, even though it had always been a minority view, it persisted well past the point at which biological knowledge made it obsolete. In 1762, for example, James Cooke wrote in his *New Theory of Generation* that sperm "are no less than his [the father's] little Pupilla, Images, or Pictures in Parvo, wrapt up very securely, Insect like, in a fine exterior Bag, covering, or Wrapper" and that animalculism is "confirmed."[69] Both ovism and animalculism, of course—or, for that matter, any kind of preformation theory—presupposed parthenogenic reproduction. (I use the term "parthenogenesis" here anachronistically; it was not coined until 1849 by the comparative anatomist Richard Owen.) Of course, what occurred in a preformationist view was not "reproduction"; nothing got produced, strictly speaking, because it already existed. It is also useful to remember that not until the development of cell theory and microscopic staining could Oskar Hertwig demonstrate, in 1876, that the sperm actually penetrates the egg and that their nuclei join to produce fertilization.[70]

Animalculist preformationism was the view Blondel espoused. "By what Right," he asked, "has the Mother's Fancy any Influence upon the Body of the *Foetus*, which comes from the *Semen virile*, and which is, in respect to her, but a *Passenger*, who has taken there his Lodging for a short time?" "If the Father," Blondel continued, "could not cause, by the Strength of Imagination, any change in the Animalcule which was originally in his Body; I desire to know, why the Mother should plead that Priviledge in Exclusion to the Father?" (p. 47). Blondel understood the fetus to be entirely unrelated to its mother-vessel, denying any circulation of blood or nervous impulses between mother and fetus (though in 1543, Vesalius had presented the first description of fetal-placental anatomy[71]). He did not deny the imagination as a powerful human faculty but, he said, "All our Faculties are limited; there are certain Bounds, beyond which they can't exert their Strength; let our Passions be never so violent, yet they are confined within the Sphere of the Mind, and of the Body. By what Magick, then, is the Imagination of one Being, capable to affect another, which is wholly and entirely a different *Individuum*?" (pp. 74–75).

In contrast, Turner proposed that there was a continuity between fetal and maternal blood vessels and he followed an epigenetic view that the fetus was molded into the form of its parents by the maternal organism during gestation.[72] This debate, therefore, embraced a central paradox in

early modern thinking about fetal development: Turner was relatively accurate about maternal-fetal relations *in utero* but superstitious about the mental stability of pregnant women, whereas Blondel was medically inaccurate in his knowledge of gestational physiology but rejected the prevailing folk beliefs about female irrationality and uncontrollability during pregnancy. What is most striking is that both Turner's imaginationist view, which attributed responsibility for monstrous births to maternal impressions, and Blondel's preformationist view, which argued that the maternal role in gestation was merely to house the fetus as it increased in size, similarly negated the agency of pregnant women. For preformationists, the mother remained entirely passive and useless except as a vessel; for imaginationists, the maternal imagination operated wholly beyond the will of the mother, who could not shape it or impose meaning on it.[73]

So we are right back in a dilemma. The imaginationists gave women an active role in the development of their fetuses and believed their stories, but at a price—in this view, women were held accountable for any birth not entirely normal. The preformationists (including the ovists) denied women any role in gestation other than as pack animals but absolved them of blame for the birth that ensued. Paul-Gabriel Boucé has pointed out that "the implicit discourse of the Enlightenment might be analysed as one of the insidious assimilation of the pregnant woman with an abnormal creature, potentially sick both in her body and mind, and subject to uncontrollable picas, dreams and fantasies, so potent that they will, through her highly conductive body and essentially plastic mind, leave their monstrous impressions on the foetus."[74]

Preformation/epigenesis discussions and the maternal imagination debates also bore relations to a larger question—the mind/body dichotomy. Epigenesis offered a developmental theory of the fetus as self-made rather than manufactured from without.[75] This internalization of the generative process raises questions about the distinction in the West between *psyche* and *soma*, a distinction that can be traced to Hippocrates and Galen.[76] For Descartes, the material body was distinct from the mind because it could lack consciousness:

> It is indeed possible (or rather, as I shall say later on, it is certain) that I have a body closely bound up with myself; but at the same time I have, on the one hand, a clear and distinct idea of myself taken simply as a conscious, not an extended being; and, on the other hand, a distinct idea of body, taken simply as an extended, not a conscious being; so it is certain that I am really distinct from my body, and could exist without it.

Descartes' formulation of the mind/body split also repudiated the person as born of woman by radically separating biology and consciousness. Descartes argued that his parents did not "in any way even make me, in so far as I am a conscious being; they merely induced certain dispositions in the matter in which I have hitherto held that I inhere—that is, that my mind inheres."[77]

The Cartesian duality between mind and body and the search for a *seat* in the body for the mind (the pineal gland, the *medulla oblongata*) or for a seat for the soul (in the amorphously neurologic *sensorium commune*) took some sharp turns during the eighteenth century.[78] It was not until the 1830s that the work of the English physician Marshall Hall and the German physiologist Johannes Müller, working independently, formally explained the spinal system of central nerves and elucidated the modern reflex concept. Hall and Müller were building on the Bell–Magendie law, the dramatic discovery in the 1820s that located sensory and motor functions in the spinal nerve roots and provided a model for understanding the psychology of sensation and motor response.

The distinctive feature of eighteenth-century discourses concerning the physiology of perception was their focus on the *sensorium*. In the sensualist account, ideas and objects operated as intermediaries between the consciousness and the external world. The *sensorium*, a complex idea in itself, filled the conceptual gap between mind and body because it was simultaneously a philosophical and a physiological category. The understanding of this process of mediation grew out of the emergence of the nervous system in the eighteenth century, seen as the mechanism through which mind and body communicated, and prompted an infiltration of physiology into philosophy and into empiricist psychology. The nervous system came to be seen not just as a transportation network for the senses but as a unifying principle between mind and body. Even so, as late as 1811, Charles Bell could write in his *Idea of a New Anatomy of the Brain* that "the whole brain is a common sensorium. . . . [I]mpressions . . . are carried along the nerves to the sensorium, and presented to the mind; and . . . the mind, by the same nerves which receive sensation, sends out the mandate of the will to the many parts of the body."[79]

Related to the sensorium, the concept of *sympathy* worked in ways that render it remarkably similar to eighteenth-century notions of imaginative power. J.B. Monfalcon defined *sympathy* this way: "One says that there is *sympathy* when one part which is irritated acts on one or more other parts with greater force than on other systems or organs of the ani-

mal economy. When analyzed, all sympathy can be defined as follows: the affection of one organ is felt by one or more organs more or less remote."[80] In effect, the idea of sympathy argued that there existed a species of *consent* between disparate parts of the body, so that changes in one part produced corresponding changes in the other. Both the concepts of reflex action and of sympathy implicated the physical organism of the human body in functional relations with its environment.[81]

My interest in the thorny mind/body problem is quite specific with respect to the imaginationist controversy. Not how or why do mind and body, brain and nerves, interact, but what specific physical effects did eighteenth-century physicians believe that interaction could have on a gestating fetus? I would argue that there can be no theory of the imagination in this period without a parallel theory of neurophysiology. The imagination itself was interestingly described as a faculty of the mind that specially impinged on the body—and that operated involuntarily.[82] Throughout the century, literary writers and medical thinkers produced theories of the relations between mind and body.[83] Samuel Johnson called the imagination "a licentious and vagrant faculty, unsusceptible of limitations, and impatient of restraint." The faculty of imagination, Johnson continued, "has always endeavored to baffle the logician, to perplex the confines of distinction, and burst the enclosures of regularity."[84] Imagination is not willed and cannot be controlled, making it a faculty particularly susceptible to being associated with women, and specifically with mothers.

The maternal imagination debates in the eighteenth century, I have suggested, can be inserted rather seamlessly into similar Enlightenment debates in the areas of embryology and the physiology of mind and perception. In studying the seventeenth and eighteenth centuries, scholars ignore physiology at their peril if they wish to understand the development of these disciplines. But in the area of generation and reproduction, I would argue, the ideological stakes were especially high. Assigning responsibility for the horror of defective or malformed births affected inheritance, social organization, and political power. In a social system dependent on male lineage, it was more than just ideologically convenient to displace this responsibility onto the bodies and minds of women.

▼ ▼ ▼

The conflicting explanatory narratives during the Enlightenment that purported to fix the etiology of, and thus the blame for, the birth of

"imperfect" infants represent more than just a quirky footnote to the history of embryology. Their underlying significance involves the legacy of mother-blame for the appearance and behavior of children. Mother-blame serves to justify a wide range of strategies for containing women's minds by containing women's bodies. Regulatory discourses concerning the physiology and reproductive roles of women have a long social history. In the eighteenth century, physicians debated the power of a pregnant woman's mental state to influence the development of her fetus. In the nineteenth century, medical practitioners in the United States led an anti-abortion campaign intended to establish medicine as a scientific profession and to regulate reproduction. The nineteenth century campaign to criminalize abortion sought to replace the testimony of a pregnant woman about her pregnancy with an externally imposed medical authority. This campaign had the effect of claiming for physicians "a special competence to mediate between a woman and the state," an effect that continues to be important.[85] In the nineteenth century as in the eighteenth, assumptions about maternal duty dictated attitudes concerning the behavior of pregnant women.

In a passage that makes these assumptions clear, Philadelphia physician Hugh Lenox Hodge attacked pregnant women for disobeying medical advice: "They eat and drink, they walk and ride, they will practice no self restrainment, but will indulge every caprice, every passion, utterly regardless of the unseen and unloved embryo."[86] The specter of unbridled appetites reappears in this passage. Such views permitted physicians to step in and "restrain" women who were unwilling or unable to restrain themselves. Both eighteenth century discourses that located fetal malformations in maternal mental activity, and nineteenth century regulations concerning pregnant women, medical authority, and abortion, served to make women's role in reproduction conform to prevailing ideas about women's social place. As legal historian Reva Siegel notes, "Regulations governing the conditions in which women conceive, gestate, and nurture children express social attitudes about sexuality and motherhood and, in turn, shape women's experience of sexuality and motherhood."[87]

The Enlightenment debates bear striking similarities to the current ethical discussions that stem from the legal battles pitting pregnant women and fetuses against each other. In a provocative article entitled "'Fetal Rights': A New Assault on Feminism" in the March 26, 1990, issue of *The Nation*, Katha Pollitt asked, "How have we come to see women as the major threat to the health of their newborns, and the womb as the most

dangerous place a child will ever inhabit?"[88] That turns out not to be a new question. Women in the United States who use drugs, especially cocaine, during pregnancy now may face prosecution as criminals for a variety of offenses, from drug trafficking to criminal child abuse to assault with a deadly weapon. At the same time, many drug treatment centers routinely turn away pregnant addicts, few have obstetricians on their staffs, and pregnant users avoid even basic prenatal care for fear of being reported. Thirty-seven thousand babies are born in the United States each year to drug-addicted women; fetal-alcohol syndrome affects one of every 1000 U.S. births; and 1.5% of newborns in New York City are HIV positive.[89]

Yet, at the time of the initial trial of Jennifer Johnson in 1989, for example, there were approximately 4500 drug-addicted pregnant women in Florida, 2000 of whom were on waiting lists for the only 135 drug treatment beds available statewide for pregnant women.[90] Carol E. Tracy, who was then executive director of the Philadelphia Mayor's Commission for Women, noted in 1990 that only 11% of the pregnant women who need substance-abuse treatment get it. Tracy wrote, "We live in a society that romanticizes motherhood but provides virtually no structural supports for mothers."[91] (Since 1990, the situation has begun to improve—now about 75% of drug treatment programs accept pregnant users.) And more broadly, Justice William Brennan remarked in a dissent to the *Gilbert* decision, which struck down the EEOC guidelines requiring employers to provide maternity benefits under their disability programs, that "the United States is the only industrialized country in the world with no universal legal and social provisions for maternity."[92]

In the United States, the overwhelming response to the tragedies of teenage pregnancy, women and young children with AIDS, single-mother households living below poverty, inner city crime and drive-by shootings, and homelessness has been to criminalize acts of desperation such as drug use rather than to provide services to prevent it, to create jobs programs for inner city youth, or to devise a system for regulating firearms. To assert that a person represents a "danger to self or others" constitutes the legal justification for curtailing an individual's civil rights. This justification fuels discussion of mandatory drug treatment for pregnant women but it has not led the courts, for example, to impose drug treatment for all intravenous drug users, or, for that matter, to mandate medical treatment for others kinds of untreated disease.[93] In addition, following the path of increasing "fetal rights" will inevitably lead to permitting lawsuits for prenatal injuries to be brought by children against their mothers. *Roe* v. *Wade*

does not prevent tort actions for previable fetuses. At the same time, a maternal duty to utilize prenatal technologies has been emerging. The medicolegal system in the United States, defined as it is by adversarial relations and contests, cannot adequately grapple with the problem of establishing a reasonable standard of care for pregnant women.[94]

It is deceptively easy to conclude that eighteenth-century embryology was not advanced enough to come up with more scientific explanations for "monsters." But the question is, can we learn anything from these early medical debates that might illuminate the complicated social, ethical, medical, and legal issues we currently face?[95] In prosecuting women for drug use during pregnancy, for example, is the state again displacing the systemic socioeconomic problems of unemployment, poverty, and despair onto the bodies of women, and taking over control of those bodies because women allegedly lack "self-control"? When jurists try to translate the moral expectation that a pregnant woman will make every attempt to ensure the healthy development of her unborn fetus into an idea of enforceable legal duty, they cannot help but subordinate a woman's rights to privacy and to autonomy to a codification of the state's interest in protecting her fetus from harm.[96] In a 1988 Illinois ruling in a case involving a mother sued for prenatal injuries that occurred during an automobile accident when she was 5 months pregnant, the court summarized the situation that arises with the notion that fetuses have a cognizable "legal right to begin life with a sound mind and body." The decision in *Stallman* v. *Youngquist* contains this passage:

> It is the firmly held belief of some that a woman should subordinate her right to control her life when she decides to become pregnant or does become pregnant: anything which might possibly harm the developing fetus should be prohibited and all things which might positively affect the developing fetus should be mandated under the penalty of law be it criminal or civil.[97]

The court found for the mother in this case, and so far such cases have not withstood judicial scrutiny.

A number of feminist legal scholars have offered compelling critiques of the idea of fetal rights—and necessarily of the notion of fetal personhood itself that such rights must presuppose. Conceiving and bearing children has never been risk-free, and women have always made, and have been expected to make, sacrifices during pregnancy. However, if a pregnant woman does not have a different relation to her fetus than do others, including the state, women's ownership of their own bodies is challenged

and pregnant women are punished for social ills such as poverty, unemployment, malnutrition, and unequal access to education and to health care. In juridical terms, there is no "bright line" at which this location of responsibility might stop. "Until the child is brought forth from the woman's body," writes Janet Gallagher, "our relationship with it must be mediated by her. The alternative adopts a brutally coercive stance toward pregnant women, viewing them as means to an end which may be denied the bodily integrity and self-determination specific to human dignity."[98]

The crux of this dilemma can be located in the language of rights itself. A focus on rights grounds the discussion in privacy law, which becomes meaningless if the contents of a pregnant woman's womb can be severed from her person and granted separate interests. The constitutional right of privacy detailed in *Griswold* v. *Connecticut*, a 1965 case protecting privacy rights in contraceptive practice and on which *Roe* v. *Wade* is largely based, was affirmed, with qualifications, for pregnant women in the *Roe* decision in 1973. That right of decisional privacy has begun to yield its place to the rights of fetuses, pitting a pregnant woman not just against the product of her own body but against her very body itself.[99] Writing for the majority in the *Roe* decision, Justice Harry Blackmun remarked that "a pregnant woman cannot be isolated in her privacy."[100]

In *Eisenstadt* v. *Baird*, a 1972 case that struck down on equal protection grounds a Massachusetts statute prohibiting the distribution of contraceptives to unmarried persons, the court held, "If the right of privacy means anything, it is the right of the individual . . . to be free from unwarranted intrusion."[101] Privacy rights in law are not monolithic; they include the right to be left alone, to refuse medical treatment, to have possession of and power over one's own person.[102] Christyne L. Neff persuasively argues that the doctrine of bodily integrity serves women's interests in reproductive freedom better than does privacy law. Bodily integrity doctrine underpins legal notions of assault and battery, search and seizure, informed consent, and the right to refuse medical treatment. Separating the fetus from a pregnant woman, Neff asserts, pursues "an analysis that views the pregnant woman as a duality [and] is itself a violation of woman's bodily integrity."[103] Privacy rights in their multiple forms cannot be opposed quite this neatly to the legal notion of bodily integrity, since the concept of privacy in some ways includes ideas about the body as a refuge, a space set apart from state intrusion.[104] A version of such an idea of bodily integrity, indeed, seems to have existed for early modern European thinkers, a complex irony given the arguments I have been making. At

the same time, the embeddedness of pregnancy within a network of social practices and individual interests may have been more clearly delineated in earlier historical periods than it is in the United States today.

The eighteenth-century debates about the maternal imagination were intricate from both biological and philosophical perspectives. To contend that the maternal imagination was impotent, physicians subscribed to pre-formationism and used the physiologically wrong-headed argument that the fetus shared no circulatory or nervous communication with its mother and, thus, as a fully independent being could not respond to her mental or sensual experiences. In contrast, writers who upheld the power of the maternal imagination chastised those who impugned the honesty of women concerning their experiences of pregnancy. This eighteenth-century controversy, then, radically questioned the ontologic relation between pregnant women and fetuses and did so in unexpected ways.

That ontologic relation continues to be vexing. One twentieth-century writer examining the problem of environmental and workplace toxins proposes that "the more that is learned about these insidious dangers, the more remarkable it becomes that any fetus navigates the perilous voyage from conception to birth healthy and intact."[105] The eighteenth-century maternal imagination controversy demonstrates that female reproductive capabilities have always opened a space for women to be viewed as actual or potential containers. In response, women themselves have been subject to a wide variety of strategies of containment.

6. *Explaining* AIDS

This disease will be the end of many of us, but not nearly all, and the dead will be commemorated and will struggle on with the living, and we are not going away. We won't die secret deaths anymore. The world only spins forward. We will all be citizens. The time has come.

> Prior Walter
> Epilogue
> *Angels in America*[1]

In 1973, the year the United States Supreme Court announced its *Roe* v. *Wade* decision, a commission of the National Institutes of Health issued a regulation designed to protect fetuses. The group decided that "the human fetus is a research subject that should be treated in every respect like a child." The regulation requires that when federal funds are used for fetal research, the father as well as the mother must give permission to participate. Having gone unnoticed for nearly two decades, the regulation gained attention in 1991 when research was proposed to study the effects of the drug AZT on pregnant women infected with human immunodeficiency virus (HIV). Under the regulation, pregnant women by themselves may not authorize their own participation in such a study. Ethicist and pediatrician Norman Fost pointed out the irony that this regulation was issued in the same year as the *Roe* decision: "One branch of the Government said women could kill fetuses for any reason and another branch said that women could not consent to even trivial research on their fetuses without the father's permission."[2] The 1973 NIH regulation illustrates the distance we have traversed since the early eighteenth century, when women exercised certain kinds of authority over their reproductive bodies. In the late twentieth century, fetuses and pregnant women have changed places. Fetuses now frequently take legal precedence over their mothers.

It is no accident that the 18-year obscurity of the NIH regulation should have been broken in a study concerning the transmission of HIV. Women with HIV infection or acquired immunodeficiency syndrome (AIDS), especially pregnant women, reside at a very low point on the hierarchy of social authority.[3] The movement to criminalize drug use by pregnant women and to make drug treatment mandatory has been prompted by concern for the health of fetuses, with little or no pretense of concern for pregnant women. Even though injection drug use entails a high risk of contracting or transmitting HIV, few efforts have been made to provide drug treatment programs for nonpregnant drug users.[4] If women have increasingly become pack animals for fetuses, then women are expendable altogether with respect to HIV and AIDS. It took years for women with HIV to arrive on the public-health agenda at all, and years more for the most common conditions of HIV-infected women to be included in the official government definition of AIDS.[5] The word "epidemic" in its Greek origin, *epidêmos*, signifies the arrival of a foreigner. Women circulate dangerously but do not settle down and belong.[6]

Foreignness can also take on other odd contexts in this age of epidemic. In the early spring of 1993, I overheard a striking conversation while browsing in the AIDS and Health section of Giovanni's Room, a gay and feminist bookstore in Philadelphia. Two men evidently searching for a book to give a friend were flipping through several titles. "Here's one," one man remarked to the other, "that talks about loss in general, no matter *what* from." His voice had an edge of near-incredulity, as though the idea of death and loss from anything other than AIDS struck him as completely alien. Surely, his tone conveyed, loss is inseparable from the idea of AIDS, one unimaginable without the other. "Gee, yeah," his companion replied, also a bit taken aback, "I guess she could use something like that, too." In addition, perhaps, to a guide about the rage-tinged sorrows of the plague years. How tense and tightly woven, how specialized, our grieving has become, I thought. This chapter attempts to grasp and recontextualize this free-floating grief.[7]

Human immunodeficiency virus infection invades and colonizes the body, as Donna Haraway points out in her expansionist analysis of immune system discourses.[8] In addition to being jammed with what Stephen S. Morse calls "viral traffic,"[9] the body infected by HIV has also been penetrated by a set of politically and socially hostile notions of contagion, pollution, and threatening communicability. These are precisely the notions that have characterized homophobia and white racism in the

age of AIDS. Reports of the epidemic in the West continue to speak about "leakage" from the initially identified "risk groups" of homosexuals, Haitians, heroin addicts, and later hemophiliacs into an amorphously defined but clearly white, middle-class, suburban, "decent," and, above all, heterosexual "general population," a population that is carefully delimited *against* the transgressive otherness of same-sex desire, racial difference, injection drug use, and illness.[10] The AIDS epidemic is rarely discussed as a tragedy within the groups it most affects.[11] A report issued in February 1993 and prepared by the National Research Council, an affiliate of the National Academy of Sciences, made an inverse but essentially parallel argument. The Council argued, controversially, that AIDS would now remain a problem only for people of color in impoverished inner cities and for gay men, and hence it would disappear because for all practical purposes it would become invisible. Or, as a *Philadelphia Inquirer* editorial put it in response to the report, "The plague is still concentrated in particular zip codes" where "gays, druggies [sic], and their straight sex partners . . . live in disproportionate numbers."[12] The cultural production of categories of visibility and invisibility, speakability and unspeakability, point toward a global strategy of containment that is also a strategy of denial. To put it another way, if the epidemic can be contained by denying those who suffer and die from AIDS, AIDS *as* an epidemic—an invasion of and by those who are perverse and foreign—will cease to exist.

Paul Monette's powerful poetic elegies for his lover Roger Horwitz, who died in October 1986, capture a more sympathetic aspect of the sense that infection requires us to contain ourselves and others, to shore up barriers, to do vigilant housekeeping. In "The Worrying," Monette writes:

> my rags and vitamins dumb as leeches how did
> the meningitis get in where did I slip up
> what didn't I scour I'd have swathed the city
> in gauze to cushion you no man who hasn't
> watched his cruelest worry come true in a room
> with no door can ever know what doesn't
> die because they lie who say it's over[13]

Scrubbing cloths; protecting potions; sucking leeches: Still the room has no door, not even a camphor-soaked curtain. Monette's searing poems, in a collection tellingly entitled *Love Alone*,[14] limn the walls of a permeable trap. These lines open the first elegy, "Here":

everything extraneous has burned away
this is how burning feels in the fall
of the final year not like leaves in a blue
October but as if the skin were a paper lantern
full of trapped moths beating their fired wings (3)

Monette's image of the transparent insubstantiality of the mourner's skin—
of life forever ambushed by infirmity—suggests my contention in this
chapter. I want to argue that HIV infection and AIDS have catalysed an
ancient discourse about the human body as a bounded material entity, a
container that must itself be contained.

▼ ▼ ▼

Rock Hudson's media-saturated illness and death in 1985 represented a
turning point in the popular imagination of HIV infection in the United
States.[15] An explosion of articles in mass-circulation magazines blared
headlines such as "Now No One Is Safe" (June 1985 cover of *Life*),
"AFRAIDS" (*New Republic*, October 14, 1985), and "AIDS Fear May Cause
Less Kissing Under the Mistletoe" (*Jet*, December 23, 1985). Appallingly
little public attention had been paid to the growing disaster of the epidemic
since its first inside-page appearance in the *New York Times* in 1981 as a
strange cancer affecting gay men.[16] The revelation that Hudson was ill and
the accompanying photographs of a sex object gone to seed struck a nerve.

Rock Hudson's ordeal stood for the definitive moment of leakage
from Them to Us, representing, of course, a neat paradox. Because in this
renewed moment of public attention to a faded (and now disintegrating)
Hollywood sex object came the discovery that one of America's favorite
loverboys next door was gay. This exemplary member of Us turned out all
along to have been one of Them. Hudson's off-screen sexual orientation
might have been expected, therefore, to produce a different popular
response, a suggestion that anyone at all, whatever his public heterosexual
credentials, might turn out to be bisexual or gay. The family man next
door might be having sex with other men; we might all simply be *passing*
as "normal," that is, as heterosexual. Cindy Patton offers this analysis of the
Hudson phenomenon:

> Rock Hudson epitomized the fear of fluid sexuality which epidemiological
> risk categories were supposed to shore up. Rock Hudson, the closet
> gay/screen heterosexual personified the fearful paradox: AIDS was a gay dis-
> ease and anyone could get AIDS. Neatly sidestepping the obvious conclusion
> that anyone might be gay (or bisexual), Rock Hudson's death proved what

everyone knew: despite public hysteria about casual contagion, 'getting AIDS' required a private act, required 'taking it,' required feminization.[17]

Patton's argument is compelling, especially in her yoking of a weakened immune system to a passivity defined in opposition to manliness. But this "obvious conclusion" also produced another threat—the threat of homo- sexuality—that apparently loomed even larger than the threat of HIV infec- tion. Hudson's AIDS diagnosis might have been used to confirm the Moral Majority/New Right's reading of the epidemic as a punishment for moral perversity, a sign that we must all redouble our guard against moral con- tagion, because even the seemingly average bourgeois denizen of House Beautiful could be injecting drugs or engaging in receptive anal sex before coming home to his wife and children. This reading occurred to a certain extent. But these responses were not predominant, because they would have required a focus on Rock Hudson as a gay man.

Such a focus did not—apparently could not—occur. Curiously, Hudson continued in his screen role as handsome heterosexual heartthrob even in his illness and death, even in the literal wasting away of a body that exemplified heterosexual desirability. As Hudson's body became gay through publicity about his medical condition, it was also deteriorating and attenuating before our eyes in a stream of before and after, then and now magazine spreads. This is not to say that Hudson's homosexuality was ignored, or even especially downplayed. Some of the headlines, for exam- ple, trumpeted judgments such as "The Hunk Who Lived a Lie." But it was precisely Hudson's proven talent for dissembling, his *acting* ability and his status as an actor, that signaled his betrayal. In an essay called "Rock Hudson's Body," Richard Meyer points out that the stage name itself— the Rock of Gibraltar and the Hudson River—referred to a larger-than- life body often displayed as a squeaky-clean participant in rituals of bodi- ly cleansing and alluded to "an expansive landscape of the masculine."[18] Hudson's studio-produced *masculinity* was the lie. Meyer cites an article called "The Gay Decades" by theater critic Frank Rich in the November 1987 issue of *Esquire*. Rich located the sense of betrayal engaged by Hudson's diagnosis in his "skill at playing a heterosexual":

> I suspect that most Americans believed that Hudson, who seemed so nat- ural on screen, was playing himself, which means that many of our funda- mental, conventional images of heterosexuality were instilled in us (and not for the first time) by a homosexual.[19]

Hudson's body, Meyer argues convincingly, represented a fantasy of mas- culinity. A recent documentary called "Rock Hudson's Home Movies"

juxtaposes a series of clips from the Hudson filmography to argue quite effectively that this studio production of masculinity was carried out with a wink. In his romantic comedies, Hudson was frequently positioned in emasculating situations—in bed with Tony Randall, playing at being sexually inept with Doris Day—positions that other studio he-men such as Gary Cooper and John Wayne were never forced to take. Hudson's homosexuality, however officially closeted and even covered publicly by a brief marriage, was always in full view for those who were able to see it.[20] And if, as was implied in most of the media coverage, Hudson's AIDS was caused by his homosexuality, it was still only the HIV infection that could leak out of his deteriorating body, not the sexual practice. His homosexuality, after all, had already been contained for the uninitiated by the Hollywood closet of the 1950s and 1960s.[21]

Hudson remained, therefore, the clean-cut all-American boy; hence, the hysterical headlines about heterosexual AIDS. If Rock Hudson, pillowboy to Doris Day and rescuer of Jane Wyman, legatee of Errol Flynn, Clark Gable, Gary Cooper, and John Wayne as an elder statesman of male heterosex objects, could die of AIDS, then anybody might contract the infection. Ronald Bayer refers to late 1985 as "the height of a wave of social anxiety and conflict about AIDS."[22] A typical remark heralded this watershed moment in the epidemic when, at the International Conference on AIDS held in Atlanta in April 1985, then Secretary of Health and Human Services Margaret Heckler announced the importance of finding a way to "stop the spread of AIDS before it hits the heterosexual community." "We have a very strong public interest," Heckler went on to say, "in stopping AIDS before it spreads outside the risk groups, before it becomes an overwhelming problem."[23]

Of course, there was already an overwhelming and global problem well before 1985. Nevertheless, through the summer of 1985 and into the fall, photo essays of Rock Hudson juxtaposed the "before" of robust heterosexual health with the "after" of emaciated, sterile homosexuality. The fear hidden behind the articulated concern about HIV *leakage* masked a deeper fear that to contract AIDS is to be homosexualized. "The dead were marching into our lives like an occupying army," the narrator of Allen Barnett's short story "The *Times* As It Knows Us" tells us.[24] In a speech delivered on February 4, 1993 concerning the ban on homosexuals in the military, Senator Jesse Helms of North Carolina put this another way when he condemned President Bill Clinton for being "bound and deter-

mined to allow the followers of ACT UP and Queer Nation to invade the United States."[25] Barnett and Helms, of course, make strange bedfellows. Barnett's character speaks of an invasion *of* the gay community, Helms of an invasion *by* what he perceives to be the gay community. But "community" boundaries and the anxieties they inspire do not stand as absolute markers either for identity or for behavior. Demarcated categories in the HIV epidemic remain both culturally specific and highly labile.

The 1993 National Research Council report defined only certain categorizable "at risk" bodies as, in effect, inescapably orifice-laden, whereas the rest of "us" have smooth and inviolable body surfaces. In the industrialized West, the "no one is safe" argument gets closed off in this account. Along with poverty, street crime, injection drug use, welfare, teenage pregnancy, drive-by shootings, and other disasters of urban anomie, inner city ghettoes and gay gathering places now *contain* HIV. The rest of "us" just have to stay out of the wrong neighborhoods, the wrong bars, and the wrong beds. Implanted in the Western narrative of AIDS is the notion that the groups first affected by HIV are to blame for not containing the virus within their already otherwise-tainted communities of deviants and criminals. So when Rock Hudson became ill enough to go to Paris for treatment, his iconic fame—his exemplary status as a desirable love object for women—caused his fictional public heterosexual screen image to occlude his private membership in a gay subculture. Although his "outing" was widely disseminated through the media, Hudson more importantly represented viral leakage. The threat to Hudson's body was a threat to all heterosexual desire. Hudson's Hollywood career had worked precisely because it maintained heterosexuality as a fiction, a story, fantasized and kept in circulation by a set of cultural needs to solidify the foundations of heterosexual hegemony. Rock Hudson's body *was* heterosexual desirability in the flesh, and it was marked by disease. After his death, when a lawsuit by a former lover attracted media interest, this changed. Posthumously, Hudson became more homosexual than HIV-infected. While alive, he was just a sick man with a secret.[26]

Secrecy forms a crucial idiom for AIDS, because even when looked on "merely" as a medical phenomenon, AIDS itself is a syndrome with a set of dispersed definitions. The "empiric criteria" for AIDS classification have been altered from time to time by the Centers for Disease Control in Atlanta, as new populations of the infected gain official recognition. The multipage U.S. government definition of AIDS in itself suggests a multiva-

lent, spacious, even overdetermined conception of what constitutes the syndrome. Although identity markers have come to seem causally identical with AIDS, the syndrome's effects disperse across tissues and organ systems.[27] It is as though the addictiveness of drug use and homosexual sex has affixed itself onto individual bodies, which then become addicted to their own infectiousness. HIV may move from skin to lungs to eyes to brain, but it can never leave the system altogether.[28] Indeed, much of the laboratory research for AIDS treatments has focused not on killing the virus but rather on blocking it from penetrating healthy cells, in a sort of viral-condom approach to disease prevention.[29] Most recently, a set of infections that affect HIV–positive women have been added to the roster of afflictions that "count," quite literally in epidemiologic terms, as AIDS.

Susan Sontag refers to this situation in her argument that "AIDS does not have, as it were, natural borders," and she points out that empiric determinations of the presence of the disease mingle with surveillance criteria.[30] This slipperiness affects a range of responses to the epidemic, from health insurance eligibility to self-labeling by persons infected with HIV. Concerning the problem of categorizing AIDS, Paula Treichler argues that there can never be a single unchallenged account of the AIDS epidemic, especially with respect to "First World" accounts of the disease in the "Third World." "AIDS continually escapes the boundaries placed on it by positivist medical science," Treichler writes, "and its meanings mutate on a parallel with the virus itself."[31] In an especially chilling development, a distinction is now being made between "natural infection" and "vaccine-induced infection" for the purpose of sparing the subjects of experimental vaccines from discrimination. When these subjects encounter a problem getting health insurance or clearance from the Peace Corps, the Immigration and Naturalization Service or the Reserve Officer Training Corps, their troubles are smoothed by a letter from the government. Researchers worry that they may not be able to claim to "do no harm" if their subjects experience discrimination.[32] It has apparently not occurred to these researchers to join the argument that discrimination against *anyone* with HIV infection should be made illegal.

In the face of the suffering and death wrought by the global epidemic of HIV infection and AIDS, it appears not only odd but, at first glance anyway, apparently virtually inhumane to talk about the cultural representations and the language of this catastrophe. But as Treichler, Douglas Crimp, and others have demonstrated, crucial aspects of the medical tragedy of AIDS have been culturally constructed.[33] One of the epidemic's

most damaging by-products—the deployment of pollution narratives—
can only be understood by looking at HIV infection and AIDS as ideologi-
cally situated diseases of cultures and societies. Medical historian Charles
Rosenberg has argued that "a disease is no absolute physical entity but a
complex intellectual construct, an amalgam of biological state and social
definition."[34] "AIDS," Treichler writes, "is also a complex and contradic-
tory *construction* of culture."[35] The immune system breakdown and oppor-
tunistic infections characteristic of HIV disease can each be understood as
biological entities, but the AIDS epidemic designates a social phenomenon.
The *stigma* that has come to be attached to AIDS conditions is produced in
a situated fashion.[36]

Treichler makes a compelling argument that Western constructions of
AIDS have produced a sense of the ailment's mystery that corresponds to
the mysteriousness (to the West) of the incomprehensible "dark conti-
nent" of Africa, always figured monolithically, with which it is associated.
Just as we assume that infectious diseases will become knowable and,
therefore, tameable through professional medical expertise, so we imag-
ine that experts can decode the mysteries of alien cultures. Treichler
argues that "the metaphors of mystery and otherness produce the desire
for control, which is in turn fulfilled and justified by the metaphors of oth-
erness and mystery."[37] People with HIV infection and AIDS evoke the cul-
tural construction of the foreign, as the very idea of a collapsing immune
system challenges the fixity of established boundaries between ideologi-
cal categories of the normal and the abnormal, creating what social
philosopher Iris Marion Young calls "border anxiety"[38] and literary and
cultural critic Marjorie Garber calls "category crisis." These terms denote
permeability, the blurring of distinctions and definitions, and the possi-
bility of boundary crossings. They indicate, according to Garber, "the
ground of culture itself."[39] Examining the anxiety produced by cross-
dressing, which she interprets as a paradigmatic "third term," Garber
describes category crisis as a cultural delimitation of the space of possibil-
ity through disruption and cultural dissonance. Anne Fausto-Sterling
makes a similar argument concerning the binary opposition of sex deter-
mination.[40]

The ambiguous social position of the person with HIV infection—at
the same time pitiable, marginalized as disposable, and charged with dan-
ger—triggers threats to the borders of individuals who look on this ambi-
guity with a normalizing gaze. But HIV embodiment should not be under-
stood as static. As Judith Butler has argued, "the body is not a self-identical

or merely factic materiality; it is a materiality that bears meaning, if nothing else, and the manner of this bearing is fundamentally dramatic. . . . [t]he body is not merely matter but a continual and incessant materializing of possibilities."[41] HIV infection and AIDS pose a threat to systems of guarding not only the physical boundaries of the body, but also the borders of social and moral categories as they are fixed, in the West, in transgressive notions of sexuality and human desire.[42]

Some kinds of border anxiety are more threatening than others. Young suggests, for example, that the aversive responses of whites to Asians or Latinos or African-Americans, however subtle or complex, do not include a fear that the white person might be transformed into a member of another racial group, as racial constructions of Otherness are based on genealogy and the physical body surface. In contrast, aversive reactions of bodily distancing or avoidance in interactions with disabled or older people represent a more fundamental fear: this person could be me if I had been less lucky, might very well be me in a few years. Still more paradigmatically, according to Young, a powerful kind of border anxiety characterizes homophobia because the borders between straight and gay are so hard to read and so porous. Her analysis is useful for understanding the profound anxieties unleashed by the idea of permitting openly gay or lesbian people in the United States armed forces, an organization precisely defined by its commitment to the policing of borders.[43]

To the extent that lesbian and gay rights groups have been successful in combating nineteenth-century descriptions of homosexuality and "inversion" as forms of moral and physical degeneracy, and in deobjectifying alternative sexual orientations, the identity boundaries between homosexuality and heterosexuality have become increasingly permeable. Anyone at all can be lesbian or gay, and homosexual practice can occur in private even while heterosexual status is maintained in public. The same kind of cultural imperialism that fuels other forms of group oppression fuels social and political manifestations of homophobia. One might argue that the Rock Hudson phenomenon supervalidates the threatening aspect of this paradox of difference in sameness. But in addition, the internalized conflicts implicit in the psychiatric term "homosexual panic" make homophobia a fear of contagion as well as a form of bigotry.

Lesbians and gay men are acceptable to progressive liberals who profess to abhor discrimination only insofar as we agree to make ourselves invisible through public "discretion," but in this invisibility we are also marked out and stereotyped. This is the logic that underlies the debate in

the United States about lifting the ban on gays in the military. Gay men and lesbians, everyone admits, are already enlisted in the armed forces and have always served (there is even an organization for gay veterans, the Alexander Hamilton American Legion Post). The opposition to making this absent presence a present presence rests precisely on the idea that homosexuality is acceptable only under cover of its presumed nonexistence, only so long as it remains unspoken; or, it can be classified as unspeakable only insofar as it *is* unspoken. The specter of permissible homosexuality elicits a set of panic fantasies of seduction in showers, bunks, and foxholes, the claustrophobic and inescapable "close quarters" of military camaraderie and military "discipline" (and the latter's resemblance to a not-so-sublimated sadomasochism).

What would have been classified as sinful in previous centuries now finds itself classified under the relatively modern rubric of the sexually perverse.[44] Indeed, homosexuality itself was "discovered" as a disease category in the late nineteenth century (the first medical case report appeared in Berlin in 1869), and then underwent revision in the form of removal from the diagnostic category of "mental disorder" in a 1974 ruling of the American Psychiatric Association. Two consequences of this history are pertinent here. First, homosexuality shifted from a form of sexual practice or behavior—that is, from a classification of sex acts—to an essence or condition, a way of being in the world.[45] Acts can be changed or suppressed, but essences cannot. Second, less than a decade after homosexuality was demedicalized in the psychiatric literature, the new disease of AIDS that became associated with gay male sexual practices functioned in effect to remedicalize homosexuality itself, both as a behavior and as an essence. Into this nuanced status of homosexuality as the last enduring taboo, AIDS inserted its epidemic social as well as medical scourge.[46] Even societies that claim an ethos of tolerance and attention to human and civil rights have succumbed to the politics of difference. In another time, those who are HIV-positive would be wearing the leper's bell, the Jew's yellow star, or the homosexual's pink triangle as symbols of outsiderhood and its attendant and contagious depravity.

The failure to repress sexuality, to suppress hedonistic impulses, and to regulate bodily functions and pleasures has been blamed for the spread of AIDS, and the sexual body as such has been labeled dangerous and insurrectional. In this analysis, the complexly motivated socioeconomics of injection drug use have been occluded by the subsumption of drug use into the category of the pleasurable and the forbidden. Injection drug use,

it needs to be said, finds its explanations in class and race oppression rather than in pleasure. In addition, sexual practice, pleasure notwithstanding, represents only a piece of homosexual identity claims. Social inequalities, and difference in general, have been congealed into fixed identity categories. In the West, this labeling has ironically taken the form of an aggravated and virulent homophobia—an attack on sexual practices seen as "unnatural" yet somehow, or even therefore, contagious, addictive, and ineradicable.

My discussion thus far has emphasized male homosexual practices over other acts associated with HIV infection. In this discussion, gender, race, and class have been subsumed under the sign of sex. A few things need to be said about the lability of these categories with respect to HIV and AIDS, as well as about the calculus of social transgression that compels me to insist on same-sex desire as the culturally targeted culprit in this epidemic. Most new cases of HIV seropositivity in the United States are occurring in women, and for several years more than half the diagnoses of HIV-positive individuals and people living with AIDS in this country have been among African-Americans and Latinos. All of these categories overlap, and it apparently does not go without saying that, among many imaginable permutations of identity and behavior, there are gay men and lesbians who inject drugs; African-Americans and Latinos who are lesbian or gay; lesbians who sleep with men who are injection drug users and/or bisexual; women injection drug users with bisexual sex partners; poor homosexuals and wealthy injection drug users. There has been no coherent category for "women" in AIDS discourses, and the epidemiological studies have themselves given priority to homosexuality over drug use in classifying cases with multiple possible transmission routes.[47]

It is foolish to believe that HIV infection is *contained* in urban ghettoes or gay cruising areas, since these very activities—drug dealing and same-sex pick-ups—flourish precisely because they attract people from the suburbs, and because cities, in general, beckon as havens of anonymity and the availability of the illicit. In Philadelphia, for example, we need to ask who are the people who buy cocaine on street corners in Spring Garden, or purchase the services of young male hustlers in Kensington or prostitutes at 13th and Locust? Despite the blurriness, mutability, and multiple laminations of the identity boxes delineated by the terms class, race, and sexual practice, I would argue that same-sex desire remains, nevertheless, the transgressive category *par excellence* because it exists in the public imagination either purely under the signs of volition and pleasure, or under the

sign of a disease that invites the multiplication and proliferation of other diseases, one of which is always nonprocreative sex itself.

A homophobic trashing of sex as disgusting yet fascinating, repellent yet impossible to resist, appears alongside a sexualized white racism that merges African-American and Latino intravenous drug users with a notion of the undifferentiated and monolithic "African" as "primitive" and bestial. As AIDS activist Simon Watney has asserted, "AIDS has been widely harnessed to the interests of a new hygienic politics of moral purity" in which we have "demonized" the virus as "primitive" in our racist characterizations of "Africa" as a single culture and reified the virus as a sign of the "unnatural" in our Western homophobia.[48]

Both cases—sex-trashing and contempt for intravenous drug use—involve condemnations of pleasure. Sexual and substance practices that are condemned are also seen as profoundly seductive: One touch, one toke, one hit, one taste, and you'll be hooked. Sexual practices and substance use alike are understood to be *chosen*; the circumstances in which these practices occur have been erased. Stigmatizing explanatory narratives have been deployed largely to reassure the artificially invented "general population" that they are "safe" from taint as long as they resist such chosen pleasures, and thereby to justify a refusal to examine the underlying decay of social infrastructure. Epidemiologic patterns of HIV infection correlate with the inequitable economics of health care, and the relations between poverty, unemployment, educational ghettoization, urban despair, and family dispersement.[49]

AIDS is by no means the first disease to elicit a rhetoric of blame, pollution, and stigma, or the first epidemic that has infringed on human and civil rights.[50] Jews were accused of spreading bubonic plague in Rome in 1656, just as African-Americans were held responsible for syphilis in the United States in the 1930s.[51] A poor section of lower Manhattan in New York City was blamed for the 1832 cholera outbreak, and ethnic minorities and the poor were seen as the culprits in the polio epidemic of 1916. We could find the same doling out of blame to the disenfranchised in other outbreaks of these and other diseases—leprosy, yellow fever, typhoid, cholera, tuberculosis, influenza.[52] Of the polio epidemic, Thomas J. Riley asked these revealing questions in an article in *Survey* in July, 1916:

> Is not infantile paralysis one of the health problems arising among the same
> people and in the same conditions as give us our problems of tuberculosis

and other contagious or infectious diseases, of poverty, ignorance, defor-
mities and defects? Perhaps one could include also delinquency and drunk-
enness. . . . Must we forever have these plague spots and these ill-favored
folks?[53]

The stitching together of infection, disability, social disadvantage, and
crime is noteworthy here. To be poor and uneducated is to be an infec-
tious agent as well as to be at fault for one's own ills.

The notion of individual responsibility for disease transmission has
far-reaching implications for the professional medical system, the public
health, and the legal status of infected individuals.[54] Responses to the 1853
outbreak of yellow fever in New Orleans, for example, bore an uncanny
resemblance to the mid-1980s fear of AIDS in heterosexual North
America. In August of 1853, the New Orleans *Weekly Picayune* ran a
scolding editorial whose language demonstrates the complex political lay-
ering of class oppression and professional authority with which the city
galvanized itself:

> We every day hear complaints from physicians of the manner in which their
> treatment of persons suffering from the prevailing fever is thwarted and nul-
> lified by the inconsiderate conduct . . . of their patients. . . . These com-
> plaints, it is true, generally respect the emigrants and foreigners among us.
> But this is precisely the class among which the ravages of the disease and its
> mortality are greatest. We are told that patients of this class often refuse to
> take the prescriptions of the physician, and are perpetually disregarding his
> most positive instructions, when upon the most implicit observation of
> these depends absolutely their lives.

A fear of lower-class incursions on the middle-class populace emerges
from the newspaper's chiding of reprobate patients. This fear resembles the
current language of homosexual "leakage" and represents a sanctimonious
hope in the authoritative reins of the physicians.

Passages such as those from the *Survey* article and the *Weekly
Picayune* editorial demonstrate the assertion that "epidemics constitute a
transverse section through society, reflecting in that cross-sectional per-
spective a particular configuration of institutional forms and cultural
assumptions."[55] By the early twentieth century, the atmospheric theories
of disease causation traceable to the Corpus Hippocraticum that held sway
through much of the nineteenth century yielded to a newly deployed
(though not a new) ideology: that individuals must take responsibility
both for their own well-being and for the public health, that behaviors
and ways of life can harbor and promote disease. This individualist expla-

nation proposed that disease could be caused and/or exacerbated by deviant behavior, and such behavior could also result from the disease process—a lose-lose proposition, because deviance would make you sick but at the same time meant that you were already sick.[56] Sexual promiscuity, poverty, racial or ethnic identity,[57] alcoholism, homosexuality, addictions, criminality itself—these could explain disease and could be simultaneously explained by disease, leaving a chicken and egg problem with conflicted social implications.[58] At the same time, discovery of microbial causes of cholera, tuberculosis, leprosy (Hansen's disease), typhoid, and diphtheria led to the possibility of treatments and cures (not fully realizable until the 1940s and the advent of antibiotics). The medical profession became more powerful as a consequence, and in particular the public was struck by the ability of medicine to *explain*.[59] We want to be reassured, and we need to create meanings if they cannot be provided, as Judith Williamson forcefully argues.[60] Our meaning-making is differential and defensive; or, as Stephen Schecter writes, "Stories are our protection against the thingness of the world, against identification with facts, against this guise death assumes."[61]

A less medicalized view characterizes the response to diseases whose mechanisms are not yet fully understood, such as cancer and AIDS. For these diseases, explanatory fictions are constructed to impose meaning: cancer strikes individuals who are chronically depressed; heart disease signifies a weak will and can be prevented through diet and exercise; AIDS is a divine punishment for unnatural acts or a sign of individual moral collapse. When disease causation can be located, institutional control of the disease moves to the medical profession, though medicine also always serves to reinforce social norms.[62] When such causation is only imperfectly understood, there is a wider canvas on which to paint hegemonic social assumptions and assert a normative notion of "compliance." In New Orleans, for example, those suffering from yellow fever were accused of "inconsiderate conduct" toward their physicians, instead of obedience (*Weekly Picayune*, 1853). But the social notion of AIDS has a unique plasticity, due in part to the gap between who is understood to be at risk and who actually "has it." So although it shares uncertain, and even grimmer, prognoses with cancer and heart disease, it cannot be homologized with these more acceptable, less communicable ailments of modernity.

Thus, AIDS is only the most recent in a long line of transmissable diseases that have been blamed on undesirable elements of society, though historians of medicine have begun to treat the chronicity of AIDS as super-

seding its status as an epidemic and to analogize it more with cancer than with plague.[63] (Both syphilis and AIDS, it should be noted, go under cover of long periods of latency, a factor that needs to be added to chronicity as defining these diseases.) Gay men, IV drug users, poor Latinos, all Haitians, the rural and urban poor in central Africa, sex workers in Thailand and, indeed, everywhere: These groups were already stigmatized in North America and Europe before their association with HIV infection. Paradoxically, all of these groups have become more visible, and as a consequence less mystified, because of their identification with AIDS. They have also become more threatening and more contagious, as "carriers" both of infectious agents and of insurrectional forms of social and sexual disruption. Indeed, one gay activist in Germany has ironically deplored the gradual elimination of the homosexual from discourses on AIDS and argues that gays need to take back and embrace the disease. As soon as homosexuals become invisible in relation to AIDS, this writer argues, governments will be able to apply repressive measures to gays and lesbians without backlash.[64]

Before his own death from AIDS, Thomas Yingling wrote that "AIDS has required a continual vigilance against secrecy, shame, and repression, the hallmarks of that same (perhaps bourgeois) privacy that polices homoerotic desire."[65] To the extent that Yingling was right—that etiological explanations have leapt to the conclusion that same-sex desire itself *causes* AIDS—homoeroticism has come to be seen as a form of social pollution, a fundamental transgression of the symbolic order. Sex acts are, on a model drawn from Mary Douglas' delineation of pollution strategies in *Purity and Danger*, sacred;[66] that is, sexual practice invokes power and submission, penetration and invasion, holiness and filth. Sexual intimacy is separate from all other social practice, walled off and protected, but also infectious. It represents, in other words, a bodily system that leaks, and no amount of caulking seals it up or off.[67]

Gay men (and to a much lesser extent lesbians, who are also often figured as sexually repressed, or even asexual) have been depicted as people who cannot control their desires, who cannot "help themselves." Thus state apparatuses must be brought in to stand sentinel over people who become identical with their alleged inability to restrain their appetites, and hence with those appetites themselves as reified demons. If left alone as free agents within sanctioned social systems, the sexually suspect with their seductive power will not go underground but will actively recruit "normals" to join our ranks. Thus, only to the extent that the infectious can

be rendered Other or foreign, outside the borders of the normal, can they be regulated and repressed by the processes of social immunity. Once seropositive individuals are marked and separated from "the general population" of the as-yet uninfected, they can be subject to external control, and the threat to their individual bodies will no longer also threaten the body politic.[68] In Cuba, outright quarantine has been in effect for those who test positive for HIV (and the tests are mandatory), though some have argued that quarantine results in greater access to amenities, including health care, for seropositive Cubans than is available to the Cuban population as a whole.[69]

Injection drug users receive an opposite configuration as people who can and should control themselves but willfully choose not to do so. This willfulness separates drug users from gay men in the mythologies of the AIDS epidemic in the United States. Both groups endanger others by leaking bodily fluids, and both have a kind of seductive potential to turn no into yes. Their seductive powers correlate directly to the odiousness of their transgressions. In a public-health strategy dependent on the politics of repression, fixing categories of immorality and criminality has an irresistible appeal.

Despite the social pervasiveness of the idea that individual behaviors and "life-styles" or "life ways" cause disease and, therefore, that individual behavioral change can prevent disease, the overwhelming lesson of the history of public-health education during outbreaks of epidemic disease has been that, as Gregg Meyer argues, "simple repression of high-risk behaviors is an unrealistic and irresponsible approach to controlling sexually transmitted diseases."[70] Policing disease does not work any better than does policing desire,[71] even though we continue to classify sexually transmitted diseases as a systemic sign of moral decay in a culture as a whole and as a sign of moral failure—or at least moral vulnerability for individual persons. We seek isolatable microbes that behave randomly to explain disease processes. At the same time—especially in the absence of such particularizable disease entities—we also accuse people who are ill of having infected themselves. The same (il)logic holds in the homophobia surrounding AIDS more generally. As Judith Butler has written, "throughout the media's hysterical and homophobic response to the illness there is a tactical construction of a continuity between the polluted status of the homosexual by virtue of the boundary-trespass that *is* homosexuality and the disease as a specific modality of homosexual pollution."[72]

The strife that has surrounded both needle exchange programs in

inner cities and the making available of condoms in high schools exemplifies a polarization between individual responsibility for behaviors and the societal project of upholding a particular moral agenda. Groups that have opposed these programs argue that they condone illegal drug use and sanction sexual activity among teenagers (invariably referred to as "children" by these groups) who should be taught at home and in their health classes to abstain, to "just say no."[73] Instead of providing clean needles and condoms, these groups advocate preaching abstinence. Students are not required to take or use the condoms made available through AIDS prevention programs in high schools, and indeed most programs permit parents to stipulate that students not be permitted to participate (these are availability rather than distribution programs). So condom acquisition, never mind use, is not enforced. Groups opposed to needle exchange programs and to condom availability in schools have an ideological investment in denying the deployment of forms of inner city crisis and of teenage sexuality that they feel symbolically inhere in needles and condoms themselves.[74]

Supporters of needle exchange programs and of condom availability counterargue that the denial/abstinence approach is unrealistic. Such an approach withholds protection from disease and pregnancy from the young and the poor because they are denied information about and the means to protect themselves from disease. No matter how much they hear the gospel of abstinence, young people and the disadvantaged who live in urban poverty cannot be counted on to heed it when it competes with peer and social pressures, mores in their neighborhoods, sexual desire, and the simple physical need for solace, closeness, and a means to numb anxiety in a world of poverty and family dislocation. Large and growing numbers of people become infected with HIV through contaminated needles and they pass this infection on to their sexual partners and the children they conceive. Statistics suggest that large numbers of teenagers have unprotected sex, especially in poor urban and minority communities, where AIDS currently presents the greatest risk in the United States. We cannot afford to ignore the reality, or to pretend that this reality can be changed meaningfully by social preaching. Preaching about immorality has never led to changes in the socioeconomic conditions that lead people to behave in ways that endanger them. Public institutions have never been able to restrain drug use or sexuality. Indeed, Michel Foucault has argued that it is precisely institutions such as prisons and schools that fos-

ter and even celebrate covert sexual practices.[75] The "normative" and the "transgressive" in our sense of our bodies, our sexual activities, and our erotic desires exist within and are in some ways authorized by the institutional discourses that shape and enforce them. AIDS has catalyzed a renewed institutional surveillance over the plural and elastic potential of human embodiment.[76]

Cultural analysts of the social framing of the AIDS epidemic go to some lengths to make clear that they are not denying the brutal bodily and psychic damage of AIDS-related illnesses, even though they and others (most notably the protest group ACT UP) have been criticized for "tainting" the fight against AIDS "with the faddish argot of postmodernism."[77] The academic and cultural critique of HIV infection and AIDS has its uses, but certainly by itself it does not alter the fact that on the street, people are experiencing the pain, messiness, fear, and fatigue of opportunistic infections, of pneumocystis carinii pneumonia and thrush and pelvic inflammatory disease and Kaposi's sarcoma and cytomegalovirus. How do we reconcile this suffering with the language that has been used to taunt, bracket off, and dismiss people living with AIDS? It is not so easy to detach infection, fatigue, stress, pain, grief, anger, frustration, and the debilitations of the body and the heart that characterize HIV infection, from the way our bodies, and in particular our sexual practices, are *read* in a culture that is profoundly sex-averse and pleasure-averse, and which has become positively galvanized in these aversions in response to HIV seropositivity.

Our collective aversion to the pleasures and dangers of the body has led well beyond the needle and condom debates to what activist and filmmaker Amber Hollibaugh calls "the second epidemic" of discrimination:[78] children denied access to schooling; gay men denied insurance coverage and housing; the prosecution of ACT UP workers who make available clean needles and bleach, whereas intravenous drug users cannot find spaces in drug treatment programs; individuals denied visas (the debacle concerning Haitians in Guantanamo Bay made this issue particularly vivid); and the protracted but finally losing battle of some residents in the otherwise progressive West Mt. Airy section of Philadelphia, and in other neighborhoods in other cities, to keep an AIDS hospice from opening in their midst.[79]

One of the AIDS dramas that challenged our notions of behavioral responsibility and collective guilt involved the long, publicly enacted, and bitter dying of Kimberly Bergalis, a 23-year old who claimed to have been

one of six patients infected with HIV by Florida dentist David Acer, who himself died of AIDS in September 1990. An investigation by the Centers for Disease Control in Atlanta implicated Acer, determining that improper instrument sterilization was the probable cause of transmission, rather than contact with the dentist himself. The Bergalis case prompted an outpouring of public compassion that was tied to Bergalis's status as an "innocent victim." She presented herself not only as a virgin, but as a complete sexual innocent. This portrait was questioned in a CBS "60 Minutes" report on June 19, 1994. CBS' Mike Wallace reported evidence that all the patients allegedly infected by Acer, including Bergalis, had significant risk factors for HIV infection that were unrelated to the dentist. In a videotaped interview aired in the program, Bergalis confessed to sexual activity. She had also been diagnosed with human papilloma virus.

Nevertheless, Bergalis responded to her diagnosis with a crusade, supported by Congressman William Dannemeyer, to require mandatory HIV testing for all health-care workers, an unnecessary and impossibly expensive idea because hospitals and clinics had already instituted "universal precautions."[80] *Washington Post* writer Malcolm Gladwell reported that Bergalis was so shunned by gay rights and AIDS activist groups for her stance that New York's Lambda Legal Defense Fund called her the "HIV version of Willie Horton."[81] A pariah among AIDS activists, Bergalis became a martyr elsewhere, depicted as a chaste sufferer whose body was wracked by pain and debility. As Katharine Park points out in an essay on the meaning of the Bergalis case, the mythical "open sores" on the corrupt body of the frightening and evil gay doctor become marks of sanctity on the body of the Christian martyr.[82] The rabid desire that grew around Bergalis to ascribe blame and exact revenge for her predicament, however understandable in emotional terms, polarized the AIDS community.

But Congress went beyond Bergalis' demands. On July 18, 1991, Senator Jesse Helms introduced a bill that would have required the imprisonment of health-care workers who treat patients without informing them of the worker's positive serostatus. It passed the Senate resoundingly. Then the Senate passed a "compromise" bill to require mandatory testing of all health-care workers and notification of patients prior to surgery, but removed the prison proviso. Health-care workers, who face exposure to HIV on a daily basis from needle sticks and other routine mishaps, now also have to fear criminal charges and professional disaster if they become infected. Other incidents concerning health-care workers had already taken place: In August 1990, a licensed practical nurse in Louisiana lost an

appeal to the Fifth Circuit Court of Appeals after having been fired for failing to report his positive HIV-antibody status to his employer; in April 1991, the New Jersey Superior Court ruled that an HIV-positive physician who had been required by the Princeton Medical Center to inform his patients of his status had not been discriminated against. On the other hand, the Pennsylvania Health Department determined that the patients of a Pittsburgh neurologist who died of AIDS were not at risk, and the New York State Division of Human Rights reinstated a pharmacist who had been fired after his HIV test results were disclosed.[83] More case law will be required before anything resembling a consensus on the mutual risks of patients and health-care providers becomes clear. In the meantime, the "universal precautions" that stipulate treating everyone as though they were infectious makes all of us potential attackers and potential targets.

Because HIV infection compromises the body's immunity, it is precisely the question of bodily boundaries, of border anxiety and trespass, of the construction of a walled apparatus of diffentiation between the immune and the compromised that has come into play in the ideological deployments of discrimination in relation to HIV and its pollution narratives of normality and transgression. In every country with an AIDS epidemic, that epidemic is culturally specific, and particular "patterns of disease transmission are socially and culturally produced."[84] We have invented, edited, and endlessly revised tales of green monkeys in Africa, government conspiracies, "perverted" birth control methods, divine scourge, anal penetration, bad mothering, criminality, race, and drugs. We have demonized the pleasures of the body in every way, by constructing wild scenarios of homicidal lust and homicidal revenge as well as by rendering the sexual body repugnant. The medical syndrome of AIDS itself is viral, and for now, incurable, but the epidemic is historically specific and the moral stances it has imposed and the judgments it has wrought are reparable. We need to fight the virus, instead of working so hard to categorize the people infected with it. Although monitoring our narratives is only one place to start, the pollution stories that have been assigned to contain people living with AIDS within policed borders must be rewritten almost as urgently as we need to eradicate the virus itself. For the story to end differently, its interpretations must change.

A proliferation of novels, short fiction, plays, and poetry in response to the epidemic has begun the task of reinterpreting the AIDS story, or at least of creating new mythologies from the zone of battle itself.[85] Sarah Schulman's 1990 novel *People in Trouble* constructs a particularly stark

vision of Greenwich Village in the grip of epidemic. Schulman's distanced narrator uses a staccato prose style that assaults the reader even when its images are lyrical. The novel intertwines the efforts of its three central characters to define themselves sexually, to make political interventions in their world, and to render themselves comfortable with an urban landscape of trash, drug dealing, homelessness, pollution, and corporate greed. The novel opens with these lines:

> It was the beginning of the end of the world but not everyone noticed right away. Some people were dying. Some people were busy. Some people were cleaning their houses while the war movie played on television.[86]

In *People in Trouble*, AIDS occurs from a place located as elsewhere, as a media event. Several of the central episodes in the novel are depicted through the filter of television news reports. One of these is a political protest consisting of an occupation of "Ronald Horne's Castle in midtown Manhattan" (p. 123), a hotel decorated in "Early Modern Colonialism" where the staff wear loincloths and chains hanging from their wrists and ankles (p. 119). While watching the protest on television in a neighborhood bar, Peter realizes that his wife, who has cut her hair into a crewcut and taken to wearing a suit and tie, is one of the participants. The climactic scene, involving the burning of an art installation that causes the death of Ronald Horne, also takes place as much on television as in the streets and is reported in the novel's parody of fragmentary style:

> Good evening. In the news tonight, Ronald Horne murdered in Forty-second Street melee. Congress approves new Contra aid plan. Mayor goes to bat for the peanut butter bagel and Masters and Johnson warn heterosexuals: New threat from AIDS. But first, Susie? (p. 224)

The irony and power of the novel finally come from the sense that these fragments might be capable of being shaped into an aesthetic if not meaningful mosaic. As one character thinks while walking down a crowded sidewalk, "There were tiny jewels and particular human treasures in different spots along the way, but each one was surrounded by something very difficult and fearful" (p. 114).

Tony Kushner's monument to the AIDS epidemic, the two-part *Angels in America*, dramatizes exactly that ability to see tiny beads of light in the darkness. Its hero, Prior Walter, suffers from AIDS, fears his own death, and rages at the lover who first abandons him and then wants to return. Still, Prior is able to speak the final lines of the play with resounding defiance.

One of the play's brilliant achievements is its creation of a fictional Roy Cohn as he dies of AIDS. When his doctor diagnoses him, Cohn responds with a tirade on the inappropriateness of the label "Homosexual" when applied to him:

> Like all labels they tell you one thing and one thing only: where does an individual so identified fit in the food chain, in the pecking order? Not ideology, or sexual taste, but something much simpler: clout. Not who I fuck or who fucks me, but who will pick up the phone when I call, who owes me favors. This is what a label refers to.[87]

And homosexuals do not have clout; they are people "who in fifteen years of trying cannot get a pissant antidiscrimination bill through City Council" (p. 45). Because he has clout, by his own logic Cohn cannot be labeled as a homosexual, no matter who he sleeps with. As he says:

> I have sex with men. But unlike nearly every other man of whom this is true, I bring the guy I'm screwing to the White House and President Reagan smiles at us and shakes his hand. Because what I am is defined entirely by who I am. Roy Cohn is not a homosexual. Roy Cohn is a heterosexual man, Henry, who fucks around with guys. (p. 46)

When Henry repeats that Roy has AIDS, he retorts: "No, Henry, no. AIDS is what homosexuals have. I have liver cancer" (p. 46).

Cohn's repudiation of the "gay disease" contrasts sharply with the embrace of AIDS Prior Walter achieves. Prior and Belize, the former drag queen and registered nurse who cares for him, like the members of an ACT UP-like activist group in Schulman's *People in Trouble*, own and own up to HIV and AIDS. Although their ownership cannot be said to empower them, it does allow them to arrive at a kind of self-acceptance. They do not need the public masks of a Roy Cohn or a Ronald Horne, the embodiments of power in each text. *People in Trouble* ends with a realistic appraisal of the epidemic's toll: "Suffering can be stopped," one character says, "But it can never be avenged. . . . We are a people in trouble" (p. 228). *Part Two: Perestroika* of *Angels in America* ends with the poignant lines— "Nothing's lost forever. In this world, there is a kind of painful progress. Longing for what we've left behind, and dreaming ahead"—and with Prior's affirmation— "More life. The Great Work begins."[88]

The AIDS epidemic and HIV infection have focused social concerns on the

human body as a carrier of culture, values, and morality. Such a focus has occurred despite, or perhaps *because of,* the body's literal incorporation of contagion. This is not a coincidence. Recently, a critic writing about Jean-François Lyotard's formulation of the postmodern condition hypothesized that the physical (and especially the sexual, one might add) human body has become a site of cultural critique because, "given our suspicion of metadiscourses and transcendental subjects, our postmodern sensibility desires to make contact with some ground, with the physical stripped of metaphysical pretensions. This physical ground would be the body." This critic goes on to demonstrate a profound paradox in postmodern thought. The body is valorized as a positive locus of materialization, and at the same time revealed to be an institutional product of discourses. According to Lyotard, the body is "a product which must constantly be produced through operations, manipulations, excisions, severings and suturings, grafts, occlusions, and derivations performed upon the labyrinthine libidinal band."[89] The work of philosophers, historians, and theorists such as Lyotard, Foucault, Kristeva, Garber, Elaine Scarry, Thomas Laqueur, Linda Singer, Emily Martin[90] and others has repeatedly pointed to the crucial role of the body in hierarchies and taxonomies of power—human bodies are pinned down and controlled through the classification systems of race, gender, marital status, and the cheap photographic replications that "identify" in order to maintain and enforce social categories.[91]

By the careful classification of "AIDS bodies" into marginalized subcultures (of the invisible, according to the National Research Council report)—those who are "protected" only by the anonymity of HIV clinics—we are "pitting ancient emblems of stigma and taboo against modern concepts of pluralism and the prerogatives of identity."[92] "AIDS has provided a pretext," writes Steven Seidman, "to reinsert homosexuality within a symbolic drama of pollution and purity."[93] Ascribing AIDS to particular "risk groups" rather than "risk behaviors" requires a corresponding segregation of behaviors by group and classification of groups by alleged sexual practices. It has been one of the primary goals of AIDS activists to make this crucial conceptual shift from "group" to "behavior." Risk groups have been identified by definition as "not us." In this way, stigma can be affixed and contained and the marginalization and continued disenfranchisement of these groups ("not us") can be justified. Hence, the denial that married, white, middle-class heterosexuals ever engage in anal or oral sex or are promiscuous or visit prostitutes or inject drugs—

despite all clear knowledge to the contrary.[94] In consequence, Simon Watney writes, we must "contest and refute the heavily over-determined picture of 'normal' sexuality and 'abnormal' sexual acts that so massively informs AIDS ideology" and "insist that in all its variant forms, human sexuality is much of a muchness."[95]

People living with AIDS know they are menacing the boundaries of the socially acceptable and literally embodying the metaphorical connections between the physical body and the social body. Hence, the emphasis on disciplining and regulating the physical body, in arenas from the gym to the courts. The Gay Games in 1994, scheduled to coincide with the 25th anniversary of the Stonewall uprising and the New York City Gay Pride parades, had the effect of presenting an enacted counterargument to the idea that homosexuality is a sickness. The Games literally played out the athleticism and health of the gay and lesbian body in sport. That counterargument was necessary because AIDS has surfaced at a time when the conditioned, muscular, flat-bellied, tightly contoured body in vogue is the body under surveillance, punished, regimented, in and under control, contained, and intact. Such a body produces no secretions, transmits no viruses, takes in no bodily fluids, and engages in safe, dry, regulated sex if it engages in sex at all.[96]

The AIDS epidemic has calcified a range of social and cultural ideologies. Threats to well-being and to distinctions between groups always do that by underscoring asymmetries in social power and inequities that result in systematic exclusions from social space. Many people have pointed out the social ironies surrounding AIDS. At the height of a sexual revolution, in which varying forms of sexual expression had for over a decade been gaining mainstream acceptance, comes a virus transmitted by this very expression, thus catapulting Western societies back into a revamped reinvention of the social hygiene movements of the 1890s or "traditional family values" of the 1950s that have been repackaged by the New Right "as a prophylactic social device."[97] A virus that has decimated a generation of gay men in their prime has also brought a new visibility and legitimacy to gay politics.[98] Linda Singer deftly analyzes these paradoxes as deriving from a logic of panic, and she reads as well the entrepreneurial advantages of body panic:

> Epidemic sexuality has been constructed not coincidentally as a window of opportunity for capital, a period of growth, producing new and enlarged mechanisms for commodifying the sexual body, erotic and reproductive,

and for profit by the fact that in catastrophic conditions which place the sexual body in question, value is intensified.[99]

The proliferation of condom and (safer) sex boutiques in the wake of what Singer calls "sexual epidemic" illustrates this relation between AIDS and the marketing of sex.

The often conflicting ideologies brought into play by AIDS invariably concern sexual practice. The understanding of bodily conditions arguably amounts to what Thomas Laqueur calls "making sex." Ending his book of that title with an analysis of Freud, who "showed how difficult it is for culture to make the body fit into the categories necessary for biological and thus cultural reproduction," Laqueur concludes:

> The ways in which sexual difference have been imagined in the past are largely unconstrained by what was actually known about this or that bit of anatomy, this or that physiological process, and derive instead from the rhetorical exigencies of the moment. Of course the specific language changes over time . . . and so does the cultural setting. But basically the content of talk about sexual difference is unfettered by fact, and is as free as mind's play.[100]

The production of pollution narratives concerning HIV infection and AIDS has not been "as free as mind's play" but rather has been conditioned by "the [*ideological*] exigencies of the moment." AIDS has devastated the Western population of gay men and decimated huge populations of the poor in central Africa. HIV infection is spreading with frightening speed in Thailand, in India, and in the urban ghettos of the United States.[101] The early Western narratives of divine punishment were recounted in a kind of triumph: Those "unnatural" and godless and sterile practices were leading to death and damnation, as the religious right had always predicted. But the damned quite literally refused to contain themselves. They donated blood, they had sex, they conceived children—in short, they went on with their lives, often without realizing they were infected. And now the saved are in apocalyptic jeopardy, too. Like Kimberly Bergalis, they are angry. Unlike North American and European gays and lesbians, or Haitian farm workers or central Africans, they have not begun to attend funerals every week, and they are not yet chastened. The enormous irony in pollution narratives about HIV-positive bodies as containers that need to be contained is that they presuppose the inevitability of contact with the Other.

Whereas fear by itself has justified unconscionable treatment of people living with AIDS, the threatening *presence* of the HIV infected on the

public terrain of social prejudice has far outweighed the actual threat. How convenient that the stricken are primarily gay men, African-Americans, and Latinos, and that the highest mortality rates have occurred in Haiti, Zaire, and Uganda. Thus, it has been possible to continue to figure AIDS as a disease of Otherness, a disease of gays and people of color. And gay men bear the greatest burden of blame, because they hold up the threat of dissolving boundaries, of self-pollution, of the body as always harboring within itself the seeds of its own dissolution. Social fears can be kept in check only by their displacement onto the "ever available" bodies of gays and lesbians and bisexuals, the Others who are all of us.

Epilogue

If I come to you with a torch and a notebook, a medical diagram and a cloth to mop up the mess, I'll have you bagged neat and tidy. I'll store you in plastic like chicken livers. Womb, gut, brain, neatly labelled and returned. Is that how to know another human being?
> Jeanette Winterson
> *Written on the Body*[1]

Writing on the body, then sealing it up in plastic for storage, for safe-keeping, seem apt ideas with which to end *Altered Conditions*. Medicine takes notes on the human body, maps it in anatomical atlases, labels its parts. Winterson's narrative irony proposes that we are not only the sum of those parts. However, what we are in addition—the mind/self married to the body—remains less threatening than its physical partner. I have tried to show that social, political, and cultural interests co-opt medical and legal categories for the purposes of containing the human body.

The presumed social need to restrain the anarchic potential of the human body, to delimit bodily borders and the legal rights that go with knowing where I stop and you begin, is related to the need to reinforce political borders, a need increasingly under stress. Borders produce, it is thought, clarity and autonomy. Yet their current splintering under demographic, environmental, and political pressures make cartography appear to be an outmoded skill. In an article in the *Atlantic Monthly*, Robert D. Kaplan analyzes the stresses that have led people in many parts of the world to "redefin[e] their identities in terms of religion and tribal ethnicity which do not coincide with the borders of existing states." Kaplan explains his own "healthy skepticism toward maps, which—create a conceptual barrier that prevents us from comprehending the political crack-up just beginning to occur worldwide." He argues that "the classificatory grid of nation-states is going to be replaced by a jagged-glass pattern of city-states, shanty-states, nebulous and anarchic regionalisms" as over-

lapping and competing sediments of various kinds of identities topple any notion of map-making.[2]

Nation-states as we know them came into being at about the same time that clinical practice was solidifying into an organized medical profession. Both systems are experiencing stress as they become increasingly subspecialized—each group with its own claimed enclave, each organ system with its own trained consultant. The fear fueling the calcification of these subspecialized spaces is that leakage will occur. In medicine, the explosion of scientific knowledge and the availability of new technological interventions prompt practitioner insecurity, especially in the face of the growing medicolegal industry. The economics of reimbursement policies and the political necessity of marking out a territory and asserting expertise over it add to the instability confronted by health-care workers. The team approach of Rehabilitation Medicine discussed in Chapter 1 remains a minority approach in a profession organized around discrete specialist consultations. An equivalent territoriality characterizes political strife in the late twentieth century, in which the boundaries around nation-states do not match the identification strategies of those who live within them.

It is contagion of the Other we fear, and this fear stokes the repressive fires of body languages and body politics. Not surprisingly, sexual practices are at the center of this repression. I have traced in *Altered Conditions* a history of stories about the human body and the ways clinical practitioners use interpretive storytelling—case-taking and case history writing—to organize their diagnostic processes. It seems more than coincidental that the diagnoses I have looked at closely—hermaphroditism, birth malformations, and AIDS—engage issues of sexuality and gender and thereby crucially unsettle this storytelling process. Stories also draw lines and limits around the human body with their narrative authority and with their beginnings, middles, and ends. Once we have a story to explain the unknown, the foreign, the alien, then we can be reassured that it will remain safely unknown, foreign, alien, and that our bodies will continue to serve as containers and as fortresses.

Notes

Introduction

1. Naguib Mahfouz, "The Ditch," in *The Time and the Place and Other Stories*, trans. Denys Johnson-Davies (New York: Doubleday Anchor, 1991): 48. I would like to thank Kaye Edwards for sending me this story.

2. For an interesting discussion of this, see Naomi Schneider, "Matters of Life and Death," *Women's Review of Books* 11(4) (1994): 13, a review of Juliet Wittman's *Breast Cancer Journal* (Golden, CO: Fulcrum Publishing Company, 1993), Musa Mayer's *Examining Myself* (Winchester, MA: Faber & Faber, 1993), and Marianne A. Paget's *A Complex Sorrow: Reflections on Cancer and an Abbreviated Life* (Philadelphia: Temple University Press, 1993).

3. A good summary of this understanding can be found in Arthur Kleinman, *The Illness Narratives: Suffering, Healing and the Human Condition* (New York: Basic Books, 1988).

4. Suzy Menkes, "Fetish or Fashion: Body piercing has moved into the mainstream, but why?" *New York Times*, November 21, 1993, Section 9: 1, 9. For a theoretical discussion of tattooing and body-piercing, see David Curry, "Decorating the Body Politic," *New Formations* 19 (1993): 68-82.

5. Margalit Fox, "A Portrait in Skin and Bone," *New York Times*, November 21, 1993, Section 9: 8.

6. Donna Haraway, "A Manifesto for Cyborgs: Science, Technology, and Socialist Feminism in the 1980s," *Socialist Review* 80 (1985): 65-107; reprinted in *Feminism/Postmodernism*, ed. Linda J. Nicholson (New York: Routledge, 1990): 190-233. Citations are from the Nicholson edition: 191, 205, 219.

7. Rita Charon offers an analysis of body ideals in the construction of medical norms in an excellent essay, "To Build a Case: Medical Histories as Traditions in Conflict," *Literature and Medicine* 11(1) (1992): 115-132.

8. The editors of *The Nation* refer to "this fissiparous post-cold-war world" to express the problem in "On Intervention," *The Nation* 257(21) (December 20, 1993): 751. In the same issue, see Richard Falk, "Intervention Revisited: Hard Choices and Tragic Dilemmas," 755-764. See also Michael Ignatieff, *Blood and Belonging: Journeys into the New Nationalism* (New York: Farrar, Straus & Giroux, 1994).

9. Ernesto Laclau and Chantal Mouffe speak of this new radical politics of identity in *Hegemony and Social Strategy* (London: Verso, 1985). See also Evelyn Reid, "Redefining Cultural Identities," in *Off-Centre: Feminism and Cultural Studies*, ed. Sarah Franklin, Celia Lury, and Jackie Stacey (London: HarperCollinsAcademic, 1991): 274-283. Kirstie

McClure also discusses unsettling boundaries and disorder in "The Issue of Foundations: Scientized Politics, Politicized Science, and Feminist Critical Practice," in *Feminists Theorize the Political*, ed. Judith Butler and Joan W. Scott (New York: Routledge, 1992): 341-368. The outcome of the Russian parliamentary elections on December 12, 1993, in which the ultranationalist Liberal Democratic Party headed by Vladimir V. Zhirinovsky won the most votes, may suggest a distressing move to reinstate and clarify cultural identities.

10. Jane Flax discusses the collapse of rationalist Enlightenment certainties in a section called "Twentieth-Century Nightmares: The Centers Will Not Hold" of her essay "The End of Innocence," in *Feminists Theorize the Political*, pp. 445-463.

11. "The State of the World's Refugees—the Challenge of Protection," Sadako Ogata, United Nations High Commissioner for Refugees. Recent mass exoduses in Burundi, Afghanistan, Mozambigue, Iraq, and Rwanda have swelled these numbers. See Paul Lewis, "Stoked by Ethnic Fighting, Refugee Numbers Grow," *New York Times*, November 10, 1993, A1. Places as far apart as Ukraine, Québec, and Staten Island have demanded secession from larger political entities as well. For accounts of the implications of particular ethnic conflicts, see Henry Kamm, "In New Eastern Europe, An Old Anti-Gypsy Bias," *New York Times*, November 17, 1993, A6, Barbara Demick, "Anti-Gypsy Pogroms Rampant in Romania," *Philadelphia Inquirer*, November 29, 1993, A1, A8 on the Roma people, and Donatella Lorch, "Burundi After Mutiny: Horror Stories Everywhere," *New York Times*, November 21, 1993, A3. As I write in January 1994, an indigenous peasant uprising has begun in the Chiapas region of southern Mexico. On the complicated goals of a politics of diversity, see Stuart Hall, "New Ethnicities," in *Black Film British Cinema*, Institute of Contemporary Arts Document 7 (London: Institute of Contemporary Arts, 1988): 27-30.

1. *Defining Disease*

1. "Krankheiten nichts für sich Bestehendes, in sich Abgeschossenes, keine autonomischen Organismen, keine in den Körper eingedrungene Wesen, noch auf ihm wurzelnde Parasiten sind ... sie nur den Ablauf der Lebens erscheinungen unter veränderten Bedingungen darstellen"; "die normalen Bedingungen des Lebens"; "setzt daher die Kenntniss des normalen Verlaufes der Lebenserscheinungen und der Bedingungen, unter welchen derselbe möglich ist." "Über die Standpunkte in der wissenschaftlichen Medicin," *Archiv für pathologische Anatomie und Physiologie und für klinische Medicin* 1 (1847): 3-4. English translations are cited from *Disease, Life, and Man: Selected Essays by Rudolf Virchow*, trans. Lelland J. Rather (Stanford: Stanford University Press, 1958): 26-27. Virchow citations come from this translation. The original German will be given in the Notes.

2. *"Alle pathologischen Formen sind entweder Rückund Umbildungen oder Wiederholungen typischer, physiologischer Gebilde"*; "die Physiologie mit Hindernissen, des Kranke Leben nichts, als das durch allerlei äussere und innere Einwirkungen gehemmte gesunde"; "alle Krankheiten lösen sich zuletzt auf in active oder passive Störungen": Rudolf Virchow, "Cellular-Pathologie," *Archiv für pathologische Anatomie und Physiologie und für klinische Medicin* 8(1) (1855): 14, 15, 38.

3. See Rudolf Virchow, "Die Stellung der Pathologie unter den biologischen Wissenschaften," *Berliner klinische Wochenschrift* 30(321) (1893); "The Place of Pathology Among the Biological Sciences" in *Disease, Life, and Man*, 151-169.

4. See the entry for "Health and Disease" in *Dictionary of the History of Science*, ed. W.F. Bynum, E.J. Browne, and Roy Porter (Princeton: Princeton University Press, 1981): 176.

5. Useful discussions can be found in Audrey L. Meaney, "The Anglo-Saxon View of the Causes of Illness," in *Health, Disease and Healing in Medieval Culture*, ed. Sheila Campbell, Bert Hull, and David Klausner (New York: St. Martin's Press, 1992): 12-33, and Danielle Jacquart, "The Introduction of Arabic Medicine into the West: The Question of Etiology," in the same volume, pp. 186-193.

6. For historical discussions, see Knud Faber, *Nosography: The Evolution of Clinical Medicine in Modern Times* (New York: P.B. Hoeber, 1930); F.K. Taylor, *The Concepts of Illness, Disease and Morbus* (Cambridge: Cambridge University Press, 1979); and Owsei Temkin, "Health and Disease," in *The Double Face of Janus* (Baltimore: The Johns Hopkins University Press, 1977): 419-440.

7. For discussions of this seventeenth-century development, see Peter Dear, "Narratives, Anecdotes, and Experiments: Turning Experience into Science in the Seventeenth Century," in *The Literary Structure of Scientific Argument: Historical Studies*, ed. Peter Dear (Philadelphia: University of Pennsylvania Press, 1991): 135-163, and Steven Shapin and Simon Schaffer, *Leviathan and the Air-Pump: Hobbes, Boyle, and the Experimental Life* (Princeton: Princeton University Press, 1985).

8. "Ist die Krankheit nur die gesetzmässige Manifestation bestimmter (an sich normaler) Lebenserscheinungen unter ungewöhnlichen Bedingungen und mit einfach quantitativen Abweichungen, so muss sich alles Heilverfahren wesentlich gegen die veränderten Bedingungen richten." "Die naturwissenschaftliche Methode und die Standpunkte in der Therapie," *Archiv für pathologische Anatomie und Physiologie und für klinische Medicin* 2 (1849): 9; *Disease, Life, and Man*, p. 59. I would like to thank Kathryn Montgomery Hunter for prompting me to read Virchow's essays.

9. For further discussions of the context of Virchow's ideas, see Lelland J. Rather's introduction to *Disease, Life, and Man*, "Harvey, Virchow, Bernard, and the Methodology of Science," 1-25, and Erwin H. Ackerknecht's *Rudolf Virchow: Doctor, Statesman, Anthropologist* (Madison: University of Wisconsin Press, 1953).

10. See Kurt Goldstein, "Disease, Health and Therapy," in *Jubilee Volume, 100th Anniversary, Rudolf Virchow Medical Society*, ed. Joseph Berberich, Henry Lax, and Rudolf Stern (Basel: Karger, 1960): 180-191.

11. Lester L. King, "What Is Disease?" *Philosophy of Science* 21 (1945): 197.

12. Joseph Margolis, "The Concept of Disease," *Journal of Medicine and Philosophy* 1 (1976): 253.

13. Harold Merskey, "Variable Meanings for the Definition of Disease," *Journal of Medicine and Philosophy* 11 (1986): 229. See also F. Kräupl Taylor, "A Logical Analysis of the Medico-Psychological Concepts of Disease," *Psychological Medicine* 1 (1971): 356-364, and "A Logical Analysis of Disease Concepts," *Comprehensive Psychiatry*

24(1) (1983): 35–48. Another interesting essay on this subject (on which there is a vast bibliography) is E.J.M. Campbell, J.G. Scadding, and R.S. Roberts, "The Concept of Disease," *British Medical Journal* 2 (1979): 757–762. George L. Engel offers a systems approach to clinical care that integrates the whole person and her or his environment in "The Clinical Application of the Biopsychosocial Model," *American Journal of Psychiatry* 137(5) (1980): 535–544. Engel's work in this field is widely cited.

14. See Samuel A. Cartwright, "Report on the Diseases and Physical Peculiarities of the Negro Race," *The New Orleans Medical and Surgical Journal* 7 (May 1851): 707–709. In the seventeenth century, teething was understood to be a disease (anyone who has been up in the middle of the night with a child cutting a molar will appreciate this categorization). See Brian K. Nance, "Determining the Patient's Temperament: An Excursion into Seventeenth-Century Medical Semeiology," *Bulletin of the History of Medicine* 67(3) (1993): 417–438.

15. Emily Martin, "Histories of Immune Systems," *Culture, Medicine, and Psychiatry* 17(1) (1993): 67. Emily Martin's larger project, *Flexible Bodies: Tracking Immunity in American Culture from the Days of Polio to the Age of AIDS* (Boston: Beacon Press, 1994), appeared after *Altered Conditions* went to press. I do not want to discount the utility of medical norms. Rita Charon expresses this utility with brilliant clarity: "One cannot argue that a serum potassium of 7.5 is as good as a serum potassium of 3.8. Anyone with a squamous-cell carcinoma in his or her chest would rather it not be there. No one would prefer atrial fibrillation to normal sinus rhythm" ["To Build a Case: Medical Histories as Traditions in Conflict," *Literature and Medicine* 11(1) (1992): 126].

16. H. Tristram Engelhardt, Jr., "The Concepts of Health and Disease," in *Concepts of Health and Disease: Interdisciplinary Perspectives*, ed. Arthur L. Caplan, H. Tristram Engelhardt, Jr., and James J. McCartney (Reading, MA: Addison-Wesley Publishing Co., 1981): 32. This useful volume contains many of the most important essays on the concept of disease in the West, including Sir Henry Cohen's "The Evolution of the Concept of Disease" (pp. 209–219), Ilza Veith's "Historical Reflections on the Changing Concepts of Disease" (pp. 221–230), and Owsei Temkin's "The Scientific Approach to Disease: Specific Entity and Individual Sickness" (pp. 247–266). Other helpful discussions of the history of definitions of disease include Walther Riese's *The Conception of Disease, its History, its Versions and its Nature* (New York: Philosophical Library, 1953), and L.J. Rather, "Towards a Philosophical Study of the Idea of Disease," in *The Historical Development of Physiological Thought*, ed. Chandler Mc'. Brooks and Paul F. Cranefield (New York: Hafner Publishing Co., 1959): 351–373.

17. Scott L. Montgomery's work analyzes what he calls "biomilitarism." See, especially, "Of Codes and Combat: Images of Disease in Biomedical Discourse," *Science as Culture* 12 (1991): 55–73, and "Illness and Image in Holistic Discourse: How Alternative Is 'Alternative'?" *Cultural Critique* 25 (1993): 65–89. See also Michael S. Sherry, "The Language of War in AIDS Discourse," in *Writing AIDS: Gay Literature, Language, and Analysis*, ed. Timothy F. Murphy and Suzanne Poirier (New York: Columbia University Press, 1993): 39–53.

18. *Harrison's Principles of Internal Medicine*, 12th ed., ed. Jean D. Wilson, Eugene

Braunwald, Kurt J. Isselbacher, Robert G. Petersdorf, Joseph B. Martin, Anthony S. Fauci, and Richard K. Root (New York: McGraw-Hill Book Co., 1991): 447-451. See also *Principles and Practice of Infectious Diseases*, 3rd ed., ed. Gerald L. Mandell, R. Gordon Douglas, Jr., and John E. Bennett (New York: Churchill Livingstone, 1990), and *Infectious Diseases and Medical Microbiology*, 2nd ed., ed. Abraham I. Braude, Charles E. Davis, and Joshua Fierer (Philadelphia: W.B. Saunders, 1986) for discussions of virulence factors and clinical definitions of terms such as "infection," "disease," "colonization," and "carrier."

19. Microbiologists, unlike physicians, are more likely to term the distinction I am tracking here as one between infection and disease rather than between colonization and infection.

20. For an analysis of rhetorical strategies in scientific naming, see John Lyne, "Bio-Rhetorics: Moralizing the Life Sciences," in *The Rhetorical Turn: Invention and Persuasion in the Conduct of Inquiry*, ed. Herbert W. Simons (Chicago: University of Chicago Press, 1990): 35-57.

21. Katharine Park makes a compelling and provocative argument against this comparison in "Kimberly Bergalis, AIDS, and the Plague Metaphor," in *Media Spectacles*, ed. Marjorie Garber, Jann Matlock, and Rebecca L. Walkowitz (New York: Routledge, 1993): 232-253. Park points out that English conflates the two meanings of "plague" into one term to designate both the biblical idea of scourge and the specific disease of *pestis*.

22. The 1992 Kenneth Branagh film "Peter's Friends" exemplifies the way HIV revelations and individual HIV exposures can be melodramatized.

23. D. Duckworth, "The Need for a Standard Terminology and Classification of Disablement," in *Functional Assessment in Rehabilitation Medicine*, ed. Carl V. Granger and Glen E. Gresham (Baltimore: Williams and Wilkins, 1984): 1-13.

24. See also P.H.N. Wood, "The Language of Disablement: A Glossary Relating to Disease and its Consequences," *International Rehabilitation Medicine* 2 (1980): 86-92, and S.Z. Nagi, *Disability and Rehabilitation* (Columbus: The Ohio State University Press, 1965).

25. Carl V. Granger and Glen E. Gresham, "Functional Assessment in Rehabilitation," in *New Developments in Functional Assessment*, ed. C.V. Granger and G.E. Gresham, *Physical Medicine and Rehabilitation Clinics of North America* 4(3) (1993): 418.

26. World Health Organization definitions; cited by Rolland P. Erickson and Malcolm C. McPhee, "Clinical Evaluation," in *Rehabilitation Medicine: Principles and Practice*, ed. Joel A. DeLisa (Philadelphia: J.B. Lippincott, 1988): 25.

27. For a useful discussion of categories of stigma with respect to the normal, see Joan Susman, "Disability, Stigma, and Deviance," *Social Science and Medicine* 38(1) (1994): 15-22.

28. *Research Plan for the National Center for Medical Rehabilitation Research*, U.S. Department of Health and Human Services, National Institutes of Health, NIH

Publication No. 93-3509 (March 1993): 31. I am indebted to M. Elizabeth Sandel, M.D., Director of Neurorehabilitation at the Hospital of the University of Pennsylvania, for guidance on rehabilitation terminologies.

29. Paul Morrison presents a compelling account of what he calls "somatic out-ing"—the physical exposure of inner depravity. He compares AIDS to the smallpox that ravages Madame de Merteuil at the end of Choderlos de Laclos' 1784 novel *Les Liaisons dangereuses* (it is perhaps not coincidental that several film versions of this novel appeared in the 1980s). Smallpox turns Madame de Merteuil inside out, reveal-ing her true soul on her disfigured face. See Paul Morrison, "End Pleasure," *GLQ: A Journal of Lesbian and Gay Studies* 1(1) (1993): 53-78.

30. Stephen F. Levinson and Paul G. O'Connell, "Rehabilitation Dimensions of AIDS: A Review," *Archives of Physical Medicine and Rehabilitation* 72(9) (1991): 690. This is a useful if diffuse article that offers clinically helpful and humane interventions for disabled AIDS patients in hospital settings and argues for the importance of reha-bilitation services for the HIV-infected and AIDS patient populations. My reading of its opening sentence notwithstanding, I applaud the article's suggestions and its sub-tle articulation of an argument against clinical biases holding that HIV-infected per-sons are not good candidates for rehabilitation therapies.

31. Rehabilitation medicine has begun increasingly to pay attention to the needs of HIV and AIDS patients. For an overview of the field, see *HIV-Related Disability: Assessment and Management, Physical Medicine and Rehabilitation: State of the Art Reviews* 7, ed. Michael W. O'Dell (Philadelphia: Hanley & Belfus, 1993), especially O'Dell's first chapter, "Rehabilitation in HIV Infection: New Applications for Current Knowledge," 1-8.

32. Michael Callen and Richard Berkowitz, in *New York Native*, November 8-21, 1982, p. 29.

33. Robert May, interview with Bob Edwards on National Public Radio's "Morning Edition," August 15, 1991.

34. Don C. Des Jarlais and Samuel R. Friedman, "HIV-1 Infection Among Intravenous Drug Users in Manhattan, New York City, from 1977 through 1987," *Journal of the American Medical Association* 261(7) (1989): 1008-1012. See also Don C. Des Jarlais, "Stages in the Response of the Drug Treatment System to the AIDS Epidemic in New York City," *Journal of Drug Issues* 20 (1990): 335-347, and Don C. Des Jarlais, John Henston, and Samuel R. Friedman, "Implications of the Revised Surveillance Definition: AIDS Among New York City Drug Users," *American Journal of Public Health* 82 (1992): 1531-1533.

35. In the United States Senate in July 1991, Senator Jesse Helms of North Carolina introduced a bill mandating prison sentences for health-care workers who test posi-tive for HIV and continue to treat patients without informing them of their serosta-tus. The bill passed overwhelmingly in the Senate. At that time, the Pennsylvania Health Department estimated that in Pennsylvania alone it would cost $32 million a year to test all health workers in the state, more than the state and federal govern-ments spend on all AIDS prevention programs combined. See Scott Burris, "The Senate Flips Over AIDS," *Philadelphia Inquirer*, July 22, 1991, and Kelvyn Anderson

and Shannon Duffy, "Invasive Procedure: Doctors, AIDS and the Law," *Philadelphia City Paper*, August 16-23, 1991: 14-15.

36. See Paul Farmer, *AIDS and Accusation: Haiti and the Geography of Blame* (Berkeley: University of California Press, 1992).

37. For a very different analysis of the somatization of desire, see Peter Brooks, *Body Works: Objects of Desire in Modern Narrative* (Cambridge, MA: Harvard University Press, 1993).

38. Ronald Bayer, *Private Acts, Public Consequences: AIDS and the Politics of Public Health* (New Brunswick, NJ: Rutgers University Press, 1989): 17. Bayer argues that had AIDS first appeared among African-American and Latino heroin users and their sexual partners, discussions of privacy and the legitimacy of the state's public-health prerogatives would have been substantially different.

39. Sandra Harding, *Whose Science? Whose Knowledge?: Thinking from Women's Lives* (Ithaca, NY: Cornell University Press, 1991): 12, 74.

40. Audre Lorde makes a powerful argument for women who have had mastectomies to "come out" one-breasted in public in *The Cancer Journals* (San Francisco: Spinsters Ink, 1978).

41. I mention Multiple Personality Disorder (MPD) and eating disorders in particular because interesting work has recently been done proposing cultural readings of these diagnoses. In addition, these diagnoses raise questions concerning self and body very close to my concerns in this book. On MPD, see Nicholas Humphrey and Daniel C. Dennett, "Speaking for Ourselves: An Assessment of Multiple Personality Disorder," *Raritan* 9(1) (1989): 68-98; Ian Hacking, "Two Souls in One Body," *Critical Inquiry* 17 (1991): 838-867, and "Multiple Personality Disorder and its Hosts," *History of the Human Sciences* 5(2) (1992): 3-31; Ruth Leys, "The Real Miss Beauchamp: Gender and the Subject of Imitation," in *Feminists Theorize the Political*, ed. Judith Butler and Joan W. Scott (New York: Routledge, 1992): 167-214; John P. Lizza, "Multiple Personality and Personal Identity Revisited," *British Journal of the Philosophy of Science* 44 (1993): 263-274; and James M. Glass, *Shattered Selves: Multiple Personality in a Postmodern World* (Ithaca, NY: Cornell University Press, 1993). On eating disorders (on which there is a vast literature), see especially Joan Jacobs Blumberg, *Fasting Girls: The Emergence of Anorexia Nervosa as a Modern Disease* (Cambridge, MA: Harvard University Press, 1988); Matra Robertson, *Starving in the Silences: An Exploration of Anorexia Nervosa* (New York: New York University Press, 1993); and Susan Bordo's excellent collection of essays, *Unbearable Weight: Feminism, Western Culture, and the Body* (Berkeley: University of California Press, 1993). The invention of Premenstrual Syndrome and its legal uses offer another intriguing medicocultural diagnosis. See Mary Brown Parlee, "The Social Construction of Premenstrual Condition," in *The Good Body: Asceticism in Contemporary Culture*, ed. Mary G. Winkler and Letha A. Cole (New Haven, CT: Yale University Press, 1994): 91-107. Another example of a medicocultural diagnosis is discussed in Chris Feudtner, "'Minds the Dead Have Ravished': Shell Shock, History, and the Ecology of Disease Systems," *History of Science* 31 (December 1993): 377-420.

PRODUCING CASE HISTORIES

1. "Reconstructing Clinical Activities: Patient Records in Medical History," *Social History of Medicine* 5(2) (1992): 183-205.

2. See Michael Holquist, "From Body-Talk to Biography: The Chronobiological Bases of Narrative," *Yale Journal of Criticism* 3 (1989): 31. In "Clinical Judgment and the Rationality of the Human Sciences," *Journal of Medicine and Philosophy* 11 (1986): 167-178, Eugenie Gatens-Robinson argues that medical "facts" are such only within the context of a story. See also Richard Baron, "Bridging Clinical Distance: An Empathic Rediscovery of the Known," *Journal of Medicine and Philosophy* 6(1) (1981): 5-23.

3. The most recent study of this kind is Kathryn Montgomery Hunter's excellent *Doctors' Stories: The Narrative Structure of Medical Knowledge* (Princeton: Princeton University Press, 1991). In addition, see Steven L. Daniel, "The Patient as Text: A Model of Clinical Hermeneutics," *Theoretical Medicine* 7 (1986): 195-210; Edward L. Gogel and James S. Terry, "Medicine as Interpretation: The Uses of Literary Metaphors and Methods," *Journal of Medicine and Philosophy* 12 (1987): 205-217; Rita Charon, "Doctor-Patient/Reader-Writer: Learning to Find the Text," *Soundings* 72 (1989): 137-152; and Howard Brody, *Stories of Sickness* (New Haven, CT: Yale University Press, 1988).

4. In *The Care of Strangers: The Rise of America's Hospital System* (New York: Basic Books, 1988), 382, Charles E. Rosenberg remarks on the need for a study of the history of medical records. In addition to the important essay of Stanley Joel Reiser, "Creating Form Out of Mass: The Development of the Medical Record," in *Transformation and Tradition in the Sciences: Essays in Honor of I. Bernard Cohen*, ed. Everett Mendelsohn (Cambridge: Cambridge University Press, 1984): 303-316, see Guenter Risse, *Hospital Life in Enlightenment Scotland: Care and Teaching at the Royal Infirmary of Edinburgh* (Cambridge: Cambridge University Press, 1986), and John Harley Warner, *The Therapeutic Perspective: Medical Practice, Knowledge, and Identity in America, 1820-1885* (Cambridge, MA: Harvard University Press, 1986). For other partial histories of diagnostic reasoning, history-taking, and record-keeping, see V.-P. Comiti, "Histoire des maladies et diagnostic médical historique," *Gazette Médicale de France* 88(21) (June 5, 1981): 3087-3090; R.H. Kampmeier, "Medicine as an Art: The History and Physical Examination," *Southern Medical Journal* 75 (1982): 203-210; Charles Newman, "Diagnostic Investigation before Laënnec," *Medical History* 4 (1960): 322-329; Christian Probst, "Das Krankenexamen: Methodologie der Klinik bei Boerhaave und in der ersten Wiener Schule," *Hippokrates* 39 (1968): 820-825; Johannes Steudel, "Anamnesis through the Ages," *Ciba Symposium* 5 (1958): 178-184; John D. Stoeckle and J. Andrew Billings, "A History of History-Taking: The Medical Interview," *Journal of General Internal Medicine* 2(2) (1987): 119-127; Antoine Thivel, "Diagnostic et pronostic à l'époque d'Hippocrate et à la notre," *Gesnerus* 42 (1985): 479-497; and Raymond Villey, Claude Mandonnet, and Pascal Campbell, *Histoire du diagnostic médical* (Paris: Masson, 1976). Helpful analyses of the processes of medical reasoning are considered in *Clinical Judgment: A Critical Appraisal,*

Proceedings of the Fifth Trans-Disciplinary Symposium on Philosophy and Medicine, Los Angeles, April 14-16, 1977, ed. H. Tristram Engelhardt, Jr., Stuart F. Spicker, and Bernard Towers (Dordrecht: D. Reidel Publishing Co., 1979).

2. *Story, History, and Diagnosis*

1. George L. Engel, "The Deficiencies of the Case Presentation as a Method of Clinical Teaching," *New England Journal of Medicine* 284(1) (January 7, 1971): 22. Engel also published an earlier article that is useful for my argument here: "Clinical Observation: The Neglected Basic Method of Medicine," *Journal of the American Medical Association* 192(10) (June 7, 1965): 157-160.

2. Engel, "Deficiencies," 22.

3. See Michel Foucault, *The Birth of the Clinic: An Archaeology of Medical Perception* (New York: Vintage Books, 1973), and David Armstrong, "The Doctor-Patient Relationship: 1930-80," in *The Problem of Medical Knowledge: Examining the Social Construction of Medicine*, ed. Peter Wright and Andrew Treacher (Edinburgh: Edinburgh University Press, 1982): 109-122. From the perspective of psychological anthropology, Thomas J. Csordas argues that the body is the subject of culture rather than an object to be studied in *Embodiment and Experience: The Existential Ground of Culture and Self* (Cambridge: Cambridge University Press, 1994).

4. Robert Hooper, *Dr. Hooper's Physician's Vade-Mecum: or, A Manual of the Principles and Practice of Physic* (New York: Harper & Brothers, 1846): 19.

5. See Knud Faber, *Nosography in Modern Internal Medicine* (New York: Paul B. Hocker, Inc., 1923), and Russell Maulitz, *Morbid Appearances: The Anatomy of Pathology in the Early Nineteenth Century* (Cambridge: Cambridge University Press, 1987).

6. For an example of a symptom evaluation schema, see Francis Warner, "The Clinical Study of Subjective Symptoms," *Birmingham [England] Medical Review* 5 (1976): 115-125.

7. On the other hand, a recent textbook contains this sentence: "Think of it [the history of present illness] rather as a short story or a mystery story in which positive and negative clues contribute to a total understanding of the sequential events that have led to the patients' coming to you" [*Clinical Diagnosis*, 5th ed., ed. Richard D. Judge, George D. Zuidema, and Faith T. Fitzgerald (Boston: Little, Brown, 1989): 23]. Shifts in medical authority have been traced by Norman Jewson in "The Disappearance of the Sick Man from Medical Cosmology, 1770-1870," *Sociology* 10 (1976): 225-240, and "Medical Knowledge and the Patronage System in Eighteenth-Century England," *Sociology* 8 (1974): 369-385.

8. H. Tristram Engelhardt, Jr., in "Explanatory Models in Medicine: Facts, Theories, and Values," *Texas Reports on Biology and Medicine* 32(1) (1974): 226, discusses disease as "a relational concept." See also Horacio Fabrega, Jr., "The Function

of Medical-Care Systems: A Logical Analysis," *Perspectives in Biology and Medicine* 20 (1976): 108–119. Nosologies can be seen, one philosopher of medicine would have it, as "ultimately a description of the limitations of the innate adaptive resources of the human organism" [Dana D. Copeland, "Concepts of Disease and Diagnosis," *Perspectives in Biology and Medicine* 20 (1977): 538].

9. Susan Bordo, *Unbearable Weight: Feminism, Western Culture, and the Body* (Berkeley: University of California Press, 1993): 74.

10. Thomas W. Laqueur, "Bodies, Details, and the Humanitarian Narrative," in *The New Cultural History*, ed. Lynn Hunt (Berkeley: University of California Press, 1989): 176–204.

11. Laqueur, "Bodies, Details, and the Humanitarian Narrative," p. 183. See also Hermann Boerhaave, "Description of Another Dreadful and Unusual Disease," trans. Maria Wilkins Smith, *Journal of the History of Medicine and Allied Sciences* 23 (1968): 331–348, and "Hermann Boerhaave's *Atrocis, nec descripti prius, morbi historia*: the first translation of the classic case report of rupture of the esophagus, with annotations [History of a grievous disease not previously described]," *Bulletin of the Medical Library Association* 43 (1955): 217–240.

12. My discussion here has profited from the analysis of narrative conventions in history in Wallace Martin, *Recent Theories of Narrative* (Ithaca, NY: Cornell University Press, 1986). See also Paul Veyne, *Comment on écrit l'histoire* (Paris: Editions du Seuil, 1978).

13. Carl Hempel, "The Function of General Laws in History," in *Aspects of Scientific Explanation and Other Essays in the Philosophy of Science* (New York: The Free Press, 1942): 231–243.

14. W.B. Gallie, *Philosophy and Historical Understanding* (New York: Schocken Books, 1964); Arthur Danto, *Analytical Philosophy of History* (Cambridge: Cambridge University Press, 1965); W.H. Dray, "On the Nature and Role of Narrative in Historiography," *History and Theory* 10 (1971): 153–171.

15. Paul Ricoeur, "The Narrative Function," in *Hermeneutics and the Human Sciences*, ed. John B. Thompson (Cambridge: Cambridge University Press, 1981): 291. See also Paul Ricoeur, "Time and Narrative: Threefold *Mimesis*," in *Time and Narrative*, vol. 1, trans. Kathleen McLaughlin and David Pellauer (Chicago: University of Chicago Press, 1984): 52–87.

16. A useful analysis of the difficulties this entails can be found in Hans Kellner, *Language and Historical Representation: Getting the Story Crooked* (Madison: University of Wisconsin Press, 1989). The work of historians Hayden White and Dominick LaCapra best exemplifies the yield of a literary focus on historical writing. On their work, see Lloyd S. Kramer, "Literature, Criticism, and Historical Imagination: The Literary Challenge of Hayden White and Dominick LaCapra," in *The New Cultural History*, ed. Lynn Hunt (Berkeley: University of California Press, 1989): 97–128. For other helpful discussions of historiographical theory, see Lionel Gossman, "History and Literature: Reproduction or Signification," in *The Writing of History: Literary Form and Historical Understanding*, ed. Robert Canary and Henry Kosicki (Madison:

University of Wisconsin Press, 1978): 3-23; Louis O. Mink, "Narrative Form as a Cognitive Instrument," in *The Writing of History*, pp. 129-149; Nancy F. Partner, "Making Up Lost Time: Writing on the Writing of History," *Speculum* 61 (1986): 90-117; and Robert F. Berkhofer, Jr., "The Challenge of Poetics to (Normal) Historical Practice," *Poetics Today* 9(2) (1988): 435-452.

17. The significance of these three kinds of information has shifted, so that now data produced by sophisticated technological diagnostic tools far outweigh in importance (and in credibility) the patient's narrative. For a useful commentary, see Paul B. Beeson and Russell C. Maulitz, "The Inner History of Internal Medicine," in *Grand Rounds: One Hundred Years of Internal Medicine*, ed. Russell C. Maulitz and Diana E. Long (Philadelphia: University of Pennsylvania Press, 1988): 33-35. In the same volume, Stephen J. Kunitz analyzes the shifting functions of diagnoses in "Classifications in Medicine," 279-296.

18. For an exposition of this approach, see Lawrence L. Weed, *Medical Records, Medical Education, and Patient Care: The Problem-Oriented Record as a Basic Tool* (Cleveland: Press of Case Western Reserve University, 1969), and L.L. Weed, "Medical Records, Patient Care, and Medical Education," *Irish Journal of Medical Science* 6 (1964): 271-282; "Medical Records that Guide and Teach," *New England Journal of Medicine* 278 (1968): 593-600, 652-657; and "What Physicians Worry About: How to Organize Care of Multiple Problem Patients," *Modern Hospital* 110 (1968): 90-94. Richard E. Easton also discusses this system in *Problem-Oriented Medical Record Concepts* (New York: Appleton-Century-Crofts, 1974), and William J. Donnelly and Daniel J. Brauner offer a critique in "Why SOAP Is Bad for the Medical Record," *Archives of Internal Medicine* 152(3) (1992): 481-484.

19. Three modern textbooks present this teaching particularly lucidly: *Harrison's Principles of Internal Medicine*, 8th edition (New York: McGraw-Hill, 1977): 1-12; Elmer L. and Richard L. DeGowin, *Bedside Diagnostic Examination*, 3rd ed. (New York: Macmillan Publishing Co., 1976): 11-32; and Paul Cutler, *Problem Solving in Clinical Medicine: From Data to Diagnosis* (Baltimore: Williams & Wilkins Company, 1979): 10-11.

20. These ideas are discussed in André Arsenault, "Mutations du discours thérapeutique," in *Traité d'anthropologie médicale: L'Institution de la santé et de la maladie*, ed. Jacques Dufresne, Fernand Dumont, and Yves Martin (Québec: Presses Universitaires de Québec, 1985): 75-84.

21. For a history of narrative history, see Georg G. Iggers, *New Directions in European Historiography*, rev. ed. (Middletown, CT: Wesleyan University Press, 1975).

22 Hans Kellner usefully discusses the dilemma of history-writing and its insincerities in *Language and Historical Representation: Getting the Story Crooked* (Madison: University of Wisconsin Press, 1989). Kellner's notes also provide a helpful bibliography of historiographical scholarship.

23. For commentary on "narrativist" history, see Maurice Mandelbaum, "A Note on History as Narrative," *History and Theory* 6 (1967): 413-419; Richard G. Ely, Rolf Gruner, and William H. Dray, "Mandelbaum on Historical Narrative: A

Discussion," *History and Theory* 8 (1969): 54–70; W.H. Dray, "On the Nature and Role of Narrative in Historiography," *History and Theory* 10 (1971): 153–171; and David L. Hull, "Central Subjects and Historical Narratives," *History and Theory* 14 (1975): 253–274. Louis O. Mink, in "History and Fiction as Modes of Comprehension," *New Literary History* 1 (1970): 541–558, also discusses the relation of narrative form to theories of historical knowledge. See also Maurice Mandelbaum, *The Anatomy of Historical Knowledge* (Baltimore: The Johns Hopkins University Press, 1977); Arthur C. Danto, *Narration and Knowledge* (New York: Columbia University Press, 1985); David Carr, *Time, Narrative, and History* (Bloomington: Indiana University Press, 1986); and Paul A. Roth, "Narrative Explanations: The Case of History," *History and Theory* 27 (1988): 1–13.

24. Hayden White, "The Question of Narrative in Contemporary Historical Theory," *History and Theory* 23 (1984): 1. This essay is included in White's collection of essays, *The Content of the Form: Narrative Discourse and Historical Representation* (Baltimore: The Johns Hopkins University Press, 1987).

25. Louis O. Mink, "The Autonomy of Historical Understanding," in *Philosophical Analysis and History*, ed. William H. Dray (New York, 1968; reprinted Westport, CT: Greenwood Press, 1978): 180–181; cited by Roger G. Seamon, "Narrative Practice and the Theoretical Distinction between History and Fiction," *Genre* 16 (1983): 203.

26. Steven Marcus, *Freud and the Culture of Psychoanalysis: Studies in the Transition from Victorian Humanism to Modernity* (Boston: George Allen & Unwin, 1984): 61. This notion has since been challenged, and Freud's text of Dora has become as overdetermined as its subject in a proliferation of literary analyses. See especially *In Dora's Case: Freud—Hysteria—Feminism*, ed. Charles Bernheimer and Claire Kahane (New York: Columbia University Press, 1985).

27. The term "clinical parsimony" comes from an illuminating discussion in Donald P. Spence, *Narrative Truth and Historical Truth: Meaning and Interpretation in Psychoanalysis* (New York: W.W. Norton & Co., Inc., 1982): 144–145.

28. See Sande Cohen, *Historical Culture: On the Recoding of an Academic Discipline* (Berkeley: University of California Press, 1986): 72, 100, 323. See also Claude Bremond, *Logique du récit* (Paris: Editions du Seuil, 1973); Seymour Chatman, *Story and Discourse: Narrative Structure in Fiction and Film* (Ithaca, NY: Cornell University Press, 1978); and Mieke Bal, *Narratology: Introduction to the Theory of Narrative* (Toronto: University of Toronto Press, 1985).

29. Edward Gibbon, *The History of the Decline and Fall of the Roman Empire*, ed. J.B. Bury, 7 vols. (London: Methuen and Co., 1909-1914): III, 373, n. 184.

30. Henry Fielding, *The History of Tom Jones, a Foundling*, 2 vols., ed. Fredson Bowers with commentary by Martin C. Battestin (Middletown: Wesleyan University Press, 1975): I, 43. The passage reads: "Reader, take care, I have unadvisedly led thee to the Top of as high a Hill as Mr. *Allworthy's*, and how to get thee down without breaking thy Neck, I do not well know" (I, pp. 43–44). This kind of interruption is typical of Fielding's narrative strategy. Elsewhere, he writes, "We warn thee not too

hastily to condemn any of the Incidents in this our History, as impertinent and foreign to our main Design, because thou dost not immediately conceive in what Manner such Incident may conduce to that Design" (II, p. 524). Laurence Sterne, of course, also indulges in this sort of rhetorical reader tongue-lashing in *Tristram Shandy.*

31. Cited as his epigraph by Leo Braudy, *Narrative Form in History and Fiction: Hume, Fielding, and Gibbon* (Princeton: Princeton University Press, 1970): 3.

32. See Roland Barthes, "Le discours de l'histoire," in *Le Bruissement de la langue: essais critiques IV* (Paris: Editions du Seuil, 1984): 153–166; and Georg G. Iggers, *New Directions in European Historiography* (Middletown: Wesleyan University Press, 1975): 23-24.

33. Erwin H. Ackerknecht remarks on the contemporaneity of votive inscriptions and the *Corpus Hippocraticum* in *A Short History of Medicine* (Baltimore: The Johns Hopkins University Press, 1982): 49.

34. For an eighteenth-century analysis of Hippocratic case-writing, see Sir John Floyer, *A Comment on Forty Two Histories Discribed* [sic] *by Hippocrates in the First and Third Book of his Epidemics* (London: J. Isted, 1726). On Floyer's career, see Gary L. Townshend, "Sir John Floyer (1649-1734) and His Study of Pulse and Respiration," *Journal of the History of Medicine* 22 (1967): 286-316. For discussions of Greek diagnostics, see William Arthur Heidel, *Hippocratic Medicine: Its Spirit and Method* (New York: Columbia University Press, 1941); W.H.S. Jones, "'Hippocrates' and the *Corpus Hippocraticum*," reprinted from the *Proceedings of the British Academy* 31 (1945): Pamphlet 1505, Historical Collections, College of Physicians of Philadelphia; Rudolph E. Siegel, "Clinical Observation in Hippocrates: An Essay on the Evolution of the Diagnostic Art," *Journal of the Mount Sinai Hospital* 31(4) (1964): 285-303; Walther Riese, "The Structure of Galen's Diagnostic Reasoning," *Bulletin of the New York Academy of Medicine* 44 (1968): 778-791; and Owsei Temkin, *Hippocrates in a World of Pagans and Christians* (Baltimore: The Johns Hopkins University Press, 1991).

35. See Gordon L. Miller's excellent study of the relation between the case history and medical epistemology in Greek medicine, "Literacy and the Hippocratic Art: Reading, Writing, and Epistemology in Ancient Greek Medicine," *Journal of the History of Medicine and Allied Sciences* 45 (1990): 11-40.

36. For a discussion of bedside precepting and its Italian origins in Padua in the sixteenth century, see Carlo M. Cipolla, *Public Health and the Medical Profession in the Renaissance* (New York: Cambridge University Press, 1976); Jerome J. Bylebyl, "The School of Padua: Humanistic Medicine in the Sixteenth Century," in *Health, Medicine and Mortality in the Sixteenth Century*, ed. Charles Webster (New York: Cambridge University Press, 1979); and Bylebyl, "Commentary," in *A Celebration of Medical History*, ed. Lloyd G. Stevenson (Baltimore: The Johns Hopkins University Press, 1982): 200-209. On precepting in Vienna, see Erna Lesky, "The Development of Bedside Teaching at the Vienna Medical School from Scholastic Times to Special Clinics," in *The History of Medical Education*, ed. Charles D. O'Malley (Berkeley:

University of California Press, 1970). I am indebted to Jerome Bylebyl and Gert Brieger for suggestions on this subject.

37. An introduction to the range of medical records can be found in the British Records Association, *Catalogue of an Exhibition of Medical Records in the Library of the Royal College of Physicians of London* (London: British Records Association, 1958).

38. Théophile Bonet, *A Guide to the Practical Physician: Shewing, from the most approved Authors, both Ancient and Modern, the Truest and Safest Way of Curing all Diseases, Internal and External, Whether by Medicine, Surgery, or Diet. To which is added, An Appendix Concerning the Office of a Physician* (London: Thomas Flesher, 1684): 853–868.

39. Peter Shaw, *A New Practice of Physic; wherein the various Diseases incident to the human Body are orderly described, Their Causes assign'd, Their Diagnostics and Prognostics enumerated, and the Regimen proper in each deliver'd* . . . , 2 vols. (London: J.Osborn and T. Longman, 1726). Throughout the eighteenth century, debates flourished concerning the merits of empiricism as opposed to the creation of principles, theories, and systems on which to base all medical practice. Two representative examples are, in England, John Barker's *An Essay on the Agreement Betwixt Ancient and Modern Physicians: or a Comparison Between the Practice of Hippocrates, Galen, Sydenham, and Boerhaave, in Acute Diseases. Intended to shew, What the Practice of Physick, in such Distempers, ought to be* (London: G. Hawkins, 1747), and in North America, Peter Middleton's *A Medical Discourse, or an Historical Inquiry into the Ancient and Present State of Medicine* (New York: Hugh Gaine, 1769). For some of these polemical writers, record-keeping in itself signaled an antitheoretical move, a move toward therapeutic and disease specificity. See, for example, James Sims' *A Discourse on the Best Method of Prosecuting Medical Enquiries*, 2nd ed. (London: J. Johnson, D. Wilson and G. Nichold, and C. Parker, 1774).

40. A representative example is David MacBride, *A Methodical Introduction to the Theory and Practice of Physic* (London: W. Strahan and T. Cadell; Edinburgh: A. Kincaid, W. Creech and J. Balfour, 1772). The term "anamnesis" to refer to a clinical history is particularly rich. Literally, an anamnesis is a calling to mind or recollection; its usage for the case history was common in the eighteenth and nineteenth centuries, though it has now become archaic. The relationship between memory and historical reconstruction is crucial for the argument I wish to make about the narrative functions of the history.

41. Hermann Boerhaave, *A Method of Studying Physick* (London: C. Rivington, 1719): 274-275.

42. George Baglivi, *The Practice of Physick, reduc'd to the Ancient Way of Observations containing a just Parallel between the Wisdom and Experience of the Ancients, and the Hypothesis's of Modern Physicians. Intermix'd with many Practical Remarks upon most Distempers* (London: Andrew Bell, 1704): 51. Baglivi was participating in a controversy of the period concerning scientific language and style, and he sounded very much like Thomas Sprat in his 1667 *History of the Royal Society*, where Sprat attacks "this Trick of Metaphor, this volubility of Tongue."

43. Owsei Temkin, "Studien zum 'Sinn'-Begriff in der Medizin," *Kyklos* 2 (1929): 45, 51. In his important call for attention to the practice of ordinary physicians as well as to the thought of elitist medical writers, Erwin H. Ackerknecht remarked that Temkin's history of the case history had "found no successors." See Ackerknecht, "A Plea for a 'Behaviorist' Approach in Writing the History of Medicine," *Journal of the History of Medicine* 22 (1967): 213.

44. Jean Devaux, *L'Art de Faire les Raports en Chirurgie, où l'on enseigne la Pratique, les Formules & le Stile le plus en usage parmi les Chirurgiens commis aux Raports; Avec un extrait des Arrests, Statuts & Reglemens faits en consequence* (Paris: Laurent d'Houry, 1703).

45. John Bellers, *An Essay Towards the Improvement of Physick. In Twelve Proposals. By which the Lives of many Thousands of the Rich, as well as of the Poor, may be Saved Yearly. With an Essay for Imploying the Poor; By which the Riches of the Kingdom may be greatly Increased* (London: J. Sowle, 1714): 7.

46. Jerome Bylebyl suggests that "in an age when the routine practice of medicine depended heavily upon verbal skills, no clear distinction could be made between the internal process of reasoning from manifest symptoms to diagnostic, prognostic, and therapeutic conclusions, and the external process of consultation in which the observations and deductions were set forth in a formal speech." In Bylebyl, "Commentary," in *A Celebration of Medical History*, ed. Lloyd G. Stevenson (Baltimore: The Johns Hopkins University Press, 1982): 207.

47. Thomas Sydenham, *The Whole Works of that Excellent Practical Physician Dr. Thomas Sydenham, wherein Not only the History and Cures of Acute Diseases are treated of after a New and Accurate Method; But also the Shortest and Safest Way of Curing most Chronical Diseases*, trans. from Latin by John Pechy (London: Richard Wellington and Edward Castle, 1696): preface (unpaginated). This work went through ten editions by 1742.

48. Francis Clifton, *The State of Physick, Ancient and Modern, briefly consider'd: with a plan for the improvement of it* (London: W. Bowyer for John Nourse, 1732): A7. Clifton was also, in this period, participating in the long-standing debate between the ancients and the moderns, as his title suggests, whose literary participants included Boileau, Corneille, Dryden, Swift, and Pope. This debate was sometimes referred to as the Battle of the Books. Clifton made no secret of his vehement stand on the side of the old guard Ancients, and the struggles concerning theory and empiricism in medicine echo this debate.

49. Guenter Risse, *Hospital Life in Enlightenment Scotland: Care and Teaching at the Royal Infirmary of Edinburgh* (Cambridge: Cambridge University Press, 1986): 2, 45. See also Guenter Risse, "Hospital History: New Sources and Methods," in *Problems and Methods in the History of Medicine*, ed. Roy Porter and Andrew Wear (London: Croom Helm, 1987): 175-203. Irvine Loudon also comments on some of these developments in *Medical Care and the General Practitioner, 1750-1850* (Oxford: Clarendon Press, 1986): 1-48.

50. The French journal *Annales* was founded in 1929 by historians Lucien Febvre and Marc Bloch. See Toby Gelfand, "The *Annales* and Medical Historiography: *Bilan*

et Perspectives," in *Problems and Methods in the History of Medicine,* ed. Roy Porter and Andrew Wear (London: Croom Helm, 1987): 15-39, for an analysis of the medical history articles in this journal.

51. For a different angle on this subject, see Terence D. Murphy, "Medical Knowledge and Statistical Methods in Early Nineteenth-Century France," *Medical History* 25 (1981): 301-319. Murphy discusses medicine's heightened confidence in analytical methods as it developed in the second half of the eighteenth century.

52. C.B. McCullagh, "Narrative and Explanation in History," *Mind* 78 (1969): 258.

53. He cites particularly Michael Oakeshott, *Experience and Its Modes* (Cambridge: Cambridge University Press, 1933); W.H. Dray, *Laws and Explanation in History* (Oxford: Oxford University Press, 1957); and Arthur C. Danto, *Analytical Philosophy of History* (Cambridge: Cambridge University Press, 1965). This debate has flourished recently in the work of historians such as Hayden White and in the journal *History and Theory.*

54. See Richard Harrison Shryock, *The Development of Modern Medicine: An Interpretation of the Social and Scientific Factors Involved* (London: Victor Gollancz Ltd., 1948); David Riesman, "The Rise and Early History of Clinical Teaching," *Annals of Medical History* 2 (1919): 136-147; and David M. Vess, *Medical Revolution in France, 1789-1796* (Gainesville: University Presses of Florida, 1975).

55. "Eloge de Foubert," in Antoine Louis, *Eloges lus dans les séances publiques de l'Académie Royale de Chirurgie de 1750 à 1792,* ed. E.-Frédéric Dubois (Paris, 1859): 124-125. Cited by Toby Gelfand, *Professionalizing Modern Medicine: Paris Surgeons and Medical Science and Institutions in the 18th Century* (Westport, CT: Greenwood Press, 1980): 105.

56. Toby Gelfand, *Professionalizing Modern Medicine,* 134.

57. See Erwin H. Ackerknecht, *Medicine at the Paris Hospital, 1794-1848* (Baltimore: The Johns Hopkins University Press, 1967): 198-201.

58. The development of Linnaean systems of nosology in the eighteenth century was related to this new kind of taxonomizing in medicine.

59. Philippe Pinel, "Mémoire sur cette question proposée sur sujet d'un prix par la Société de médecine: *Déterminer quelle est la meilleure manière d'enseigner la médecine pratique dans un hôpital*" (1793), edited and translated in Philippe Pinel, *The Clinical Training of Doctors. An Essay of 1793,* ed. Dora B. Weiner (Baltimore: The Johns Hopkins University Press, 1980): 35, 73, 55, 90.

60. Edward Foster, *An Essay on Hospitals, Or, Succinct Directions for the Situation, Construction, & Administration of Country Hospitals. With an Appendix, wherein the Present Scheme for establishing Public County Hospitals in Ireland, is impartially considered* (Dublin: W.G. Jones, 1768): 54-55. Institutional concerns also began to take center stage around this period. Hospitals depended on private philanthropy for funds, and they needed to be able to document cure rates and community service in a systematic fashion if their patrons were to continue to support them.

61. This is, of course, Michel Foucault's thesis in *The Birth of the Clinic: An Archaeology of Medical Perception*, trans. A.M. Sheridan Smith (New York: Vintage Books, 1973). For a modification, see Toby Gelfand, "Gestation of the Clinic," *Medical History* 25 (1981): 169-180. See also David Michael Levin and George F. Solomon, "The Discursive Formation of the Body in the History of Medicine," *Journal of Medicine and Philosophy* 15 (1990): 515-537, and Thomas Osborne, "Medicine and Epistemology: Michel Foucault and the Liberality of Clinical Reason," *History of the Human Sciences* 5(2) (1992): 63-93.

62. This history is outlined in more detail in Othmar Keel, "The Politics of Health and the Institutionalization of Clinical Practices in Europe in the Second Half of the Eighteenth Century," in *William Hunter and the Eighteenth-Century Medical World*, eds. W.F. Bynum and Roy Porter (Cambridge: Cambridge University Press, 1985): 207-256.

63. Francis Home, *Clinical Experiments, Histories, and Dissections*, 3rd ed. (London: J. Murray and Edinburgh: William Creech, 1783): vi-viii. See also J.F. Enders, "Francis Home and His Experimental Approach to Medicine," *Bulletin of the History of Medicine* 38 (1964): 101-112. The importance of the analogy to "experiment" will come up again later, in my discussion of a twentieth-century textbook on differential diagnosis.

64. John Ferriar, *Medical Histories and Reflections*, 3 vols. (London: Cadell and Davies, 1810): I, xxiv-xxv. This is a republication of the 1793 edition.

65. On the other hand, as Barbara Bates pointed out to me, Ferriar's suggestion can be read as an atheoretical method of accumulating data about which the clinician will think. As such it would be analogous to the Subjective, Objective sections of the SOAP protocol, with the clinician following with Assessment.

66. For two further examples, see David Hosack, *An Introductory Lecture on Medical Education* (New York: T. and J. Swords, 1801), and Philippe Pinel, *La Médecine clinique rendue plus précise et plus exacte par l'application de l'analyse, ou Receuil et résultat d'observations sur les maladies aigues, faites à la Salpêtrière*, 2nd ed. (Paris: J.A. Brosson, 1804).

67. Alfred Aspland, Clinical Report Society of Guy's Hospital, "Directions for Case-Taking" (St. George's Fields: Philanthropic Society, 1837).

68. William Augustus Guy, "On the Best Method of Collecting and Arranging Facts, with a proposed new Plan of Commonplace Book," *Quarterly Journal of the Statistical Society of London* (January 1841), Historical Collections, College of Physicians of Philadelphia.

69. H.M. Bullitt, "The art of Observing, or the proper Method of Examining Patients, with a view to correct Diagnosis," *Western Lancet* 3 (January 1845): 397-409.

70. Samuel Crompton, *Medical Reporting; or, Case-Taking: Being an attempt to prove that it is necessary for the medical attendants or families to record the particulars of their patients' illnesses, and the peculiarities of their constitutions; in order to treat their illnesses with due care: with suggestions for overcoming the difficulties which have hitherto prevented medical case-taking from becoming general* (London: Isaac Pitman, 1847); London Medical Society of

Observation, *What to Observe at the Bed-Side and After Death in Medical Cases* (Philadelphia: Blanchard and Lea, 1853); Robert S. Powell, "What to Observe at the Bedside," *Virginia Medical and Surgical Journal* 12 (1859): 388–390.

71. John Southey Warter, *Observation in Medicine or the Art of Case-Taking* (London: Longmans, Green, and Co., 1865).

72. Alfred K. Hills, "Instructions to Patients, How to Communicate their Cases to a Physician by Letter" (1870), Historical Collections, College of Physicians of Philadelphia. During the eighteenth century, it was not uncommon for diagnosis and treatment to take place by correspondence.

73. W.H. Allchin, *Scheme for Case Reporting* (London: H.K. Lewis, 1887): 3–4.

74. An example is James C. Howden, *Index Pathologicus for the Registration of the Lesions Recorded in Pathological Records or Case-Books of Hospitals and Asylums* (London: J. & A. Churchill, 1894).

75. See James H. Cassedy, "Medicine and the Rise of Statistics," in *Medicine in Seventeenth-Century England*, ed. Allen G. Debus (Berkeley: University of California Press, 1974): 283–312, and Major Greenwood, *Medical Statistics from Graunt to Farr* (Cambridge: Cambridge University Press, 1948).

76. A useful single-volume compendium of Farr's writings can be found in *Vital Statistics: A Memorial Volume of Selections from the Reports and Writings of William Farr*, ed. Noel A. Humphreys (London: Office of the Sanitary Institute of Great Britain, 1885). For discussions, see John M. Eyler, *Victorian Social Medicine: The Ideas and Methods of William Farr* (Baltimore, MD: The Johns Hopkins University Press, 1979), and M.J. Cullen, *The Statistical Movement in Early Victorian Britain: The Foundations of Empirical Social Research* (New York: Barnes & Noble, 1975).

77. See Erwin H. Ackerknecht, "Some Remarks Concerning Bureaucracy and Medicine," *Gesnerus* 42 (1985): 221–228, and Jean-Pierre Goubert, "The Art of Healing: Learned Medicine and Popular Medicine in the France of 1790," in *Medicine and Society in France: Selections from the "Annales: Economies, Sociétés, Civilisations,"* ed. Robert Forster and Orest Ranum, trans. Elborg Forster and Patricia M. Ranum (Baltimore: The Johns Hopkins University Press, 1980): 1–23. See also Mary Poovey, "Figures of Arithmetic, Figures of Speech: The Discourse of Statistics in the 1830s," *Critical Inquiry* 19 (Winter 1993): 256–276.

78. See Emanuel Hayt and Jonathan Hayt, *Legal Aspects of Medical Records* (Berwyn, IL: Physicians' Record Library, 1964).

79. In "Machines and Medicine: Technology Transforms the American Hospital," in *The American General Hospital: Communities and Social Contexts*, ed. Diana Elizabeth Long and Janet Golden (Ithaca, NY: Cornell University Press, 1989): 109–134, Joel D. Howell examines the impact of "objective" machine measurements on the form and structure of patient-care records using Pennsylvania Hospital records from 1897 to 1927. Edward T. Morman discusses the participation of the pathology laboratory in diagnostic procedures in "Clinical Pathology in America, 1865–1915: Philadelphia as a Test Case," *Bulletin of the History of Medicine* 58 (1984): 198–214. For two more extensive accounts, see Audrey B. Davis, *Medicine and Its Technology: An Introduction*

to the History of Medical Instrumentation (Westport, CT: Greenwood Press, 1981), and Stanley Joel Reiser, Medicine and the Reign of Technology (Cambridge: Cambridge University Press, 1978).

80. John Harley Warner, The Therapeutic Perspective: Medical Practice, Knowledge, and Identity in America, 1820-1885 (Cambridge, MA: Harvard University Press, 1986): 107.

81. Robert Hutchinson and Harry Rainy, Clinical Methods: A Guide to the Practical Study of Medicine (London: Cassell and Co., 1897). The fifteenth edition of Hutchinson's Clinical Methods was revised by Donald Hunter and R.R. Bomford with David G. Penington (Philadelphia: J.B. Lippincott Co., 1968). Authors for the sixteenth edition were R.R. Bomford, Stuart Mason, and Michael Swash (London: Baillière Tindall, 1975).

82. Richard C. Cabot and F. Dennette Adams, Physical Diagnosis, 12th ed. (Baltimore: Wm. Wood and Co., 1938): 2.

83. Barbara Bates, A Guide to Physical Examination and History Taking, 4th ed. (Philadelphia: J.B. Lippincott Co., 1987). The first edition appeared in 1974, the second in 1979, the third in 1983, and the fifth in 1990. Earlier editions contained a section on recording the physical examination but did not emphasize history-taking, although Dr. Bates, who graciously read and commented on an early version of this chapter, told me that this lack reflected circumstances rather than concept. A lengthy discussion of the history opens Clinical Diagnosis, 5th ed., ed. Richard D. Judge, George D. Zuidema, and Faith T. Fitzgerald (Boston: Little, Brown, 1989).

84. W.B. Cannon, "The Case Method of Teaching Systematic Medicine," Boston Medical and Surgical Journal 142(2) (January 11, 1900): 31-36. Cannon cited the introduction by Langdell of the case method at Harvard Law School in the early 1870s as precedent. This had been a controversial development in the teaching of law and it created some controversy in medicine as well. C.W. Eliot responded to Cannon's suggestions in "The Inductive Method Applied to Medicine," Boston Medical and Surgical Journal 142(22) (May 24, 1900): 557-558, and the idea was taken up most importantly in a textbook by Richard C. Cabot, Case Teaching in Medicine: A Series of Graduated Exercises in the Differential Diagnosis, Prognosis and Treatment of Actual Cases of Disease (Boston: D.C. Heath & Co., 1906). For an account of these developments, see Kenneth M. Ludmerer, "Reform at Harvard Medical School, 1869-1909," Bulletin of the History of Medicine 55 (1981): 343-370, and Kenneth M. Ludmerer, Learning to Heal: The Development of American Medical Education (New York: Basic Books, 1985). The method still receives some debate. See George L. Engel, "The Deficiencies of the Case Presentation as a Method of Clinical Teaching," New England Journal of Medicine 284(1) (January 7, 1971): 20-24.

85. See Ernest A. Codman, "Case-records and Their Value," Bulletin of the American College of Surgeons 3(2) (1917): 24-27; "Standard of Efficiency for the First Hospital Survey of the College," Bulletin of the American College of Surgeons 3(3) (March 1918), case records are discussed on pp. 2-4; and John G. Bowman, "Case Records and Their Use," Bulletin of the American College of Surgeons 4(1) (January 1919): 1-14. The American College of Surgeons was founded in 1913, and the materials cited here are

part of the Hospital Standardization Series that emerged from the Conference on Hospital Standardization, Joint Session of Committees on Standards, held in Chicago in 1917. For sample record forms, see Vol. 4 (1919) and Vol. 5 (1921) of the *Bulletin of the American College of Surgeons*. The latter contains 19 forms and a bibliography of materials concerning case records. Later developments are discussed in Dorothy L. Kurtz, *Unit Medical Records in Hospital and Clinic* (New York: Columbia University Press, 1943). See also Chapter XVIII, "Records," in Michael M. Davis, *Clinics, Hospitals and Health Centers* (New York: Harper & Bros., 1927), and Raymond Peal, "Modern Methods in Handling Hospital Statistics," *Bulletin of the Johns Hopkins Hospital* 32 (1921): 187-188.

86. These shifts did not occur without controversy in Europe. For an example, see Toby Gelfand, "A Confrontation over Clinical Instruction at the Hôtel-Dieu of Paris during the French Revolution," *Journal of the History of Medicine* 28 (1973): 268-282.

87. See Terence D. Murphy, "Medical Knowledge and Statistical Methods," *Medical History* 25 (1981): 301-319, on Condorcet's social mathematics, Laplace's work on the calculus of probabilities, and Philippe Pinel's important 1807 essay, "Résultats d'observations et construction des tables pour servir à déterminer le degré de probabilité de la guérison des aliénés."

88. See Owsei Temkin, "The Double Face of Janus" and "An Essay on the Usefulness of Medical History for Medicine" in *The Double Face of Janus and Other Essays in the History of Medicine* (Baltimore: The Johns Hopkins University Press, 1977): 14-15, 84.

89. See Arthur Kleinman, *The Illness Narratives: Suffering, Healing and the Human Condition* (New York: Basic Books, Inc., 1988).

90. Walther Riese, "The Structure of the Clinical History," *Bulletin of the History of Medicine* 16 (1944): 442.

91. See Owsei Temkin, "The Scientific Approach to Disease: Specific Entity and Individual Sickness," in *The Double Face of Janus* (Baltimore: The Johns Hopkins University Press, 1977): 441-455; John G. Bruhn, "The Diagnosis of Normality," *Texas Reports on Biology and Medicine* 32 (1974): 241-248; and Alain Rousseau, "Une Révolution dans la sémiologie médicale: le concept de spécificité lésionnelle, " *Clio Medica* 5 (1970): 123-131.

92. Michael T. Taussig, "Reification and the Consciousness of the Patient," *Social Science and Medicine* 14B (1980): 9.

93. See W.W. Stead, A. Heyman, H.K. Thompson, and W.E. Hammond, "Computer-Assisted Interview of Patients with Functional Headache," *Archives of Internal Medicine* 129 (1972): 950, and Stephen G. Pauker, G. Anthony Gorry, Jerome P. Kassirer, and William B. Schwartz, "Towards the Simulation of Clinical Cognition: Taking a Present Illness by Computer," *American Journal of Medicine* 60 (June 1976): 981-996. For an argument about the inadequacy of algorithms in medical diagnosis, see Marx W. Wartofsky, "Clinical Judgment, Expert Programs, and Cognitive Style: A Counter-Essay in the Logic of Diagnosis," *Journal of Medicine and Philosophy* 11 (1986): 81-92.

94. For a useful history of the use of computers for clinical records, see William W. Stead, "A Quarter-Century of Computer-Based Medical Records," *M.D. Computing* 6(2) (1989): 75-81. In "The Misinformation Era: The Fall of the Medical Record," *Annals of Internal Medicine* 110(6) (1989): 482-484, John F. Burnum proposes that medical record information has become increasingly unreliable despite electronic informatics due to concerns about confidentiality, cost-control regulations, and reimbursement standards. I would like to thank Peter Bradley for bringing this article to my attention. On the subject of computer-assisted history-taking, see Stephen G. Pauker, G. Anthony Gorry, Jerome P. Kassirer, and William B. Schwartz, "Towards the Simulation of Clinical Cognition: Taking a Present Illness by Computer," *American Journal of Medicine* 60 (1976): 981-996. Stanley Joel Reiser discusses the erosion of subjectivity in "The Decline of the Clinical Dialogue," *Journal of Medicine and Philosophy* 3 (1978): 305-13. See also Arthur Kleinman and Everett Mendelsohn, "Systems of Medical Knowledge: A Comparative Approach," *Journal of Medicine and Philosophy* 3 (1978): 314-330; Arthur Kleinman, "The Cognitive Structure of Traditional Medical Systems," *Ethnomedicine* 3 (1974): 27-49, and *The Illness Narratives: Suffering, Healing and the Human Condition* (New York: Basic Books, 1988); Jeremiah A. Barondess, "The Clinical Transaction: Themes and Descants," *Perspectives in Biology and Medicine* 27 (1983): 25-38; William J. Donnelly, "Righting the Medical Record: Chronicle into Story," *Journal of the American Medical Association* 260(12) (August 12, 1988): 823-825; and *The Clinical Encounter: The Moral Fabric of the Patient-Physician Relationship*, ed. Earl E. Shelp (Dordrecht: D. Reidel Publishing Co., 1983).

95. See Raymond Villey, *Histoire du secret médical* (Paris: Seghers, 1986). For a discussion of the functions of sign production, interpretation, and coding in medicine, see John F. Burnum, "Medical Diagnosis through Semiotics: Giving Meaning to the Sign," *Annals of Internal Medicine* 119(9) (November 1, 1993): 939-943, and Kathryn Vance Staiano, *Interpreting Signs of Illness: A Case Study of Medical Semiotics* (Berlin: Mouton de Gruyter, 1986). Another discussion of the hermeneutic strategies and knowledge production of medical language can be found in Tullio Maranhão, *Therapeutic Discourse and Socratic Dialogue* (Madison: University of Wisconsin Press, 1986).

96. George Devereux, *From Anxiety to Method in the Social Sciences* (The Hague: Mouton & Co., 1967). See also Robert F. Berkhofer, Jr., "The Challenge of Poetics to (Normal) Historical Practice," *Poetics Today* 9 (1988): 435-452.

97. "[I]l y aura dans chaque observation de la tendance à lui faire prouver tel point doctrinal plutôt que tel autre." Antonio Mattei, *Considérations sur l'Observation médicale en générale. Analyse, Synthèse, Induction clinique, Vitalisme. Organicisme, Empirisme, Eclecticisme, et leurs Applications pratiques* (Paris: L. Martinet, 1856): 25.

98. A. McGehee Harvey, James Bordley III, and Jeremiah A. Barondess, *Differential Diagnosis: The Interpretation of Clinical Evidence*, 3rd ed. (Philadelphia: W.B. Saunders Co., 1979). The first edition was published in 1955. Also pertinent is Lawrence B. McCullough, "Particularism in Medicine," *Criticism* 22 (1990): 361-370.

3. Case History and Case Fiction

1. Hugh Lenox Hodge, Case Book No. 5, Case 96 (Philadelphia, 1817): 54–56. Manuscript in the archives of the Historical Collections of the Library of the College of Physicians of Philadelphia.

2. Hodge, Case Book No. 5, Case 103, 94–98.

3. See A.M. Aron, J.M. Freeman, and S. Carter, "The Natural History of Sydenham's Chorea," *American Journal of Medicine* 38 (1965): 83, and John N. Walton, ed. *Brain's Diseases of the Nervous System*, 8th ed. (Oxford: Oxford University Press, 1977): 614–619, for detailed accounts of Saint Vitus' Dance.

4. This term has been popularized by Oliver Sacks in *The Man Who Mistook His Wife for a Hat and Other Clinical Tales* (New York: Summit Books, 1985) and in "Clinical Tales," *Literature and Medicine* 5 ((1986): 16–23. Harold L. Klawans also uses this formal concept in *Toscanini's Fumble and Other Tales of Clinical Neurology* (Chicago: Contemporary Books, Inc., 1988). In addition, see a sequence of essays in *Literature and Medicine* 5 (1986): Joanne Trautmann Banks, "A Controversy about Clinical Form," 24–26; David Barnard, "A Case of Amyotrophic Lateral Sclerosis," 27–42; Eric Rabkin, "A Case of Self Defense," 43–53; David H. Smith, "The Limits of Narrative," 54–57. In "'A Case of Amyotrophic Lateral Sclerosis': A Reprise and a Reply," *Literature and Medicine* 11(1) (1992): 133–146, David Barnard replied to the controversy sparked by his earlier article. *Literature and Medicine* 11(1) (1992) comprises a special issue on "The Art of the Clinical Case History," edited by Joanne Trautmann Banks and Ann Hunsaker Hawkins. The April 1994 issue of *Literature and Medicine*, which I was not able to see before this book went to press, concerns "Narrative and Medical Knowledge." The notion of a relation between stories and bodies is also discussed in Philip Mosley, "The Healthy Text," *Literature and Medicine* 6 (1987): 35–42; Larry R. Churchill and Sandra W. Churchill, "Storytelling in Medical Arenas: the Art of Self-Determination," *Literature and Medicine* 1 (1982): 73–79; and James Hillman, "The Fiction of Case History: A Round," in *Religion as Story*, ed. James B. Wiggins (New York: Harper & Row, 1975): 123–173. The psychoanalytic narrative raises different though theoretically related kinds of questions. For especially useful accounts, see Roy Schafer, "Narration in the Psychoanalytic Dialogue," *Critical Inquiry* 7 (1980): 29–53, and Donald P. Spence, *Narrative Truth and Historical Truth: Meaning and Interpretation in Psychoanalysis* (New York: W.W. Norton & Co., 1982). See also James Walkup, "Narrative in Psychoanalysis: Truth? Consequences?" in *Narrative Thought and Narrative Language,* ed. Bruce K. Britton and Anthony D. Pellegrini (Hillsdale, NJ: Lawrence Erlbaum Associates, 1990): 237–267.

5. For theoretical discussions of these questions, see Frank Kermode, *The Sense of an Ending* (New York: Oxford University Press, 1968), and Terry Eagleton, "Ideology, Fiction, Narrative," *Social Text* 2 (1979): 62–80. Discussions of history-writing and medical documents occur in several essays in the *Yale Journal of Criticism* 5(2) (1992): Natalie Zemon Davis, "Stories and the Hunger to Know," 159–163; Carlo Ginzburg, "Fiction as Historical Evidence: A Dialogue in Paris, 1646," 165–178; and J. Hillis Miller, "Response," 182–187. See also Carlo Ginzburg, *Clues,*

Myths, and the Historical Method, trans. John and Anne C. Tedeschi (Baltimore, MD: The Johns Hopkins University Press, 1989).

6. Approaching medicine as a "text" with its own special discourse and scrutinizing the role language plays in medical knowledge have become accepted practices, from F.G. Crookshank's "The Importance of a Theory of Signs and a Critique of Language in the Study of Medicine," in *The Meaning of Meaning*, ed. C.K. Ogden and I.A. Richards (New York: Harcourt, Brace and Co., 1930): 337-355 to G.S. Rousseau's call to articulate an adequate methodology for the discipline of "Literature and Medicine" in "Literature and Medicine: Towards a Simultaneity of Theory and Practice," *Literature and Medicine* 5 (1986): 152-181. For a particular application of the notion of "the patient as text," see Kathryn Montgomery Hunter's comment on the Barnard-Rabkin debate cited in note 2, "Making a Case," *Literature and Medicine* 7 (1988): 66-79, and her book, *Doctors' Stories: The Narrative Structure of Medical Knowledge* (Princeton, NJ: Princeton University Press, 1991).

7. In a discussion of Boerhaave's case-writing, historian Thomas Laqueur relates the evolution of truth claims in early medical case reporting to the development of other quintessentially eighteenth-century literary forms—the novel, the parliamentary inquiry, and the autopsy report. See Thomas W. Laqueur, "Bodies, Details, and the Humanitarian Narrative," in *The New Cultural History,* ed. Lynn Hunt (Berkeley: University of California Press, 1989): 176-204.

8. See Roy Porter, "Lay Medical Knowledge in the Eighteenth Century: The Evidence of the Gentleman's Magazine," *Medical History* 29 (1985): 138-168. See also W.F. Bynum, Stephen Lock, and Roy Porter, eds., *Medical Journals and Medical Knowledge: Historical Essays* (London: Routledge, 1992), the first systematic study of medical journalism. A useful discussion of patient-physician relations from the patient's perspective in this period can be found in Dorothy Porter and Roy Porter, *Patient's Progress: Doctors and Doctoring in Eighteenth-Century England* (Stanford: Stanford University Press, 1989). The "Introduction" to Carol Houlihan Flynn's *The Body in Swift and Pope* (Cambridge: Cambridge University Press, 1990), entitled " 'The Dearness of things' the body as matter for text" (pp. 1-7), discusses the problem of the body's materiality as a central eighteenth-century concern.

9. This is Norman Jewson's widely accepted theory; see Norman Jewson, "The Disappearance of the Sick Man from Medical Cosmology, 1770-1870," *Sociology* 10 (1976): 225-240, and Norman Jewson, "Medical Knowledge and the Patronage System in Eighteenth Century England," *Sociology* 8 (1974): 369-385.

10. For a discussion of these ideas as they held sway in an earlier period, see Andrew Wear, "Puritan Perceptions of Illness in Seventeenth-Century England," in *Patients and Practitioners: Lay Perceptions of Medicine in Pre-Industrial England,* ed. Roy Porter (Cambridge: Cambridge University Press, 1985): 55-99. See also Lucinda McCray Beier, Sufferers & Healers: The Experience of Illness in *Seventeenth-Century England* (London: Routledge & Kegan Paul, 1987).

11. *The Genuine Works of Hippocrates,* 2 vols., trans. Francis Adams (London: The Sydenham Society, 1849): I, 416. Further references are given parenthetically in the text.

12. Sir John Floyer, *A Comment on Forty two Histories Discribed [sic] by Hippocrates in the First and Third Books of his Epidemics* (London: J. Isted, 1726): 116-117.

13. John Coakley Lettsom, *Medical Memoirs of the General Dispensary in London, for Part of the Years 1773 and 1774* (London: E. and C. Dilly, 1774): 139-142.

14. Frances Burney, *Memoirs of Doctor Burney*, 3 vols. (London: Edward Moxon, 1832): II, 86-100.

15. *The Early Diary of Frances Burney, 1768-1778,* ed. Annie Raine Ellis, 2 vols. (London: George Bell and Sons, 1889): II, 154.

16. James Boswell, *Life of Johnson,* ed. R.W. Chapman (London: Oxford University Press, 1970): 68.

17. James Boswell, *Boswell's Journal of a Tour to the Hebrides with Samuel Johnson,* ed. Frederick A. Pottle and Charles H. Bennett (New York: The Literary Guild, Inc., 1936): 8.

18. Boswell, *Life of Johnson,* 105.

19. Boswell, *Life of Johnson,* 106.

20. Boswell, *Life of Johnson,* 107. George Cheyne was physician to Richardson, who also suffered from nervous disorders thought to affect his writing.

21. See Peter Pineo Chase, "The Ailments and Physicians of Dr. Johnson," *Yale Journal of Biology and Medicine* 23 (1950-1951): 370-379; Sir Humphry Rolleston, "Samuel Johnson's Medical Experiences," *Annals of Medical History* n.s. 1 (1929): 540-552; and John Wiltshire, *Samuel Johnson in the Medical World: The Doctor and the Patient* (Cambridge: Cambridge University Press, 1991).

22. Walter Jackson Bate, *Samuel Johnson* (New York: Harcourt Brace Jovanovich, 1977): 125, 126. Katherine C. Balderston also proposes a psychological model to explain Johnson's behavior, citing in particular his "unrecognized erotic thoughts," in her essay "Johnson's Vile Melancholy" in *The Age of Johnson,* ed. F.W. Hilles and W. S. Lewis. (New Haven: Yale University Press, 1949): 3-14.

23. On Tourette Syndrome, see Arthur K. Shapiro and Elaine Shapiro, "Tourette Syndrome: History and Present Status," and T.J. Murray, "Dr. Samuel Johnson's Abnormal Movements," in *Gilles de la Tourette Syndrome,* Volume 35 of *Advances in Neurology,* ed. Arnold J. Friedhoff amd Thomas N. Chase (New York: Raven Press, 1982): 17-23, 25-30. For other discussions of Johnson's chorea, see L.C. McHenry, Jr., "Samuel Johnson's Tics and Gesticulations," *Journal of the History of Medicine* 22 (1967): 152-168, and T.J. Murray, "Dr. Johnson's Movement Disorders," *British Medical Journal* 1 (1979): 1610-1614.

24. "Witty Ticcy Ray," in *The Man Who Mistook His Wife for a Hat and Other Clinical Tales* (New York: Summit Books, 1985): 87. See also Oliver Sacks, "Tics," *New York Review of Books,* January 29, 1987.

25. Indeed, the first mention of this neurologic affliction in the West occurs in the *Malleus Maleficarum,* and the novel and film *The Exorcist* are based on an exaggerated case of Tourette Syndrome. In the summer of 1993, because of the success of

the Philadelphia Phillies major league baseball team and their appearance in the World Series, Tourette Syndrome gained a nationally recognized spokesman in the person of Jim Eisenreich, a Phillies outfielder who left baseball for a time while he tried to control the disease.

26. The term "pathography" has been borrowed from Freud's psychoanalytic histories. For discussions, see the work of Anne Hunsaker Hawkins, "Two Pathographies: A Study in Illness and Literature," *Journal of Medicine and Philosophy* 9 (1984): 231-252, and *Reconstructing Illness: Studies in Pathography* (West Lafayette, IN: Purdue University Press, 1993).

27. Identifying information withheld to protect the patient.

28. *Paradise Lost*: *VIII*, 188-197. Cited from *John Milton, Complete Poems and Major Prose,* ed. Merritt Y. Hughes (Indianapolis: The Odyssey Press, Inc., 1957): 367.

29. Letter to Mrs. Thrale in Bath dated June 19, 1783. *James Boswell, Life of Johnson,* ed. R.W. Chapman (London: Oxford University Press, 1970): 1241-1242.

30. For discussions, see Macdonald Critchley, "Dr. Samuel Johnson's Aphasia," *Medical History* 6 (1962): 27-44, as well as Sir Humphry Rolleston, "Samuel Johnson's Medical Experiences," *Annals of Medical History* n.s. 1 (1929): 540-552, and Peter Pineo Chase, "The Ailments and Physicians of Dr. Johnson," *Yale Journal of Biology and Medicine* 23 (1950-1951): 370-379.

31. Heberden wrote his case notes, entitled Index Historiae Morborum, in Latin: "vox subito perit in viro nato LXXIV, mente et membris illasis; quae intra paucos dies fere restituitur. 17 Jun 1783." Cited by Lawrence C. McHenry, Jr., "Medical Case Notes on Samuel Johnson in the Heberden Manuscripts," *The New Rambler: Journal of the Johnson Society of London* Serial B.XV (June 1964) and reprinted in the *Journal of the American Medical Association* 195(3) (January 17, 1966): 89-90 (quoted material appears on p. 89). McHenry wrote extensively on Johnson's various maladies and his interest in medicine. See also "Mark Akenside, M.D. and a Note on Dr. Johnson's Asthma," *New England Journal of Medicine* 266 (April 5, 1962): 717-718; "Samuel Johnson's 'The Life of Dr. Sydenham'" *Medical History* 8 (1964): 181-187; "Doctors Afield: Louis Morin, M.D., Botanist, and Dr. Johnson," *New England Journal of Medicine* 273 (August 5, 1965): 323-324; with Ronald MacKeith, "Samuel Johnson's Childhood Illnesses and the King's Evil," *Medical History* 10 (1966): 386-399; "Samuel Johnson's Tics and Gesticulations," *Journal of the History of Medicine and Allied Sciences* 22 (1967): 152-168; "Dr. Samuel Johnson's Emphysema," *Archives of Internal Medicine* 119 (January 1967): 98-105; "Art and Medicine: Dr. Johnson's Dropsy," *Journal of the American Medical Association* 206 (December 9, 1968): 2507-2509; "Samuel Johnson: A Medical Portrait," *Jefferson Medical College Alumni Bulletin* 18(2)(1969): 2-9.

32. A. Brodal, "Self-Observations and Neuro-Anatomical Considerations after Stroke," *Brain* 96 (1973): 675.

33. Elizabeth A. Kolin, "Stroke: A Sudden Discontinuation of Self," paper delivered in Kansas City, Missouri, on October 2, 1985, to the American Academy of Physical Medicine and Rehabilitation. May Sarton, *After the Stroke: A Journal* (New

York: W.W. Norton and Co., Inc., 1988), and Ilza Vieth, *Can You Hear the Clapping of One Hand? Learning to Live with a Stroke* (Berkeley: University of California Press, 1988); both comment on this experience.

34. John W. Stakes and Raymond A. Sobel, "A 55-Year-Old Woman with a Progressive Neurologic Disorder," Case Records of the Massachusetts General Hospital, Case 22-1986, *The New England Journal of Medicine* 314 (June 5, 1986): 1498. Subsequent references come from this page of the case.

35. Elaine Scarry, *The Body in Pain: The Making and Unmaking of the World* (New York: Oxford University Press, 1985). David B. Morris analyzes Scarry's book helpfully in "How to Read The Body in Pain," *Literature and Medicine* 6 (1987): 139-155. See also Julia L. Epstein, "Writing the Unspeakable: Fanny Burney's Mastectomy and the Fictive Body," *Representations* 16 (1986): 131-166.

36. Montaigne cites this proposal in his essay "De l'expérience" ("On Experience"):

> Ainsi Platon avait raison de dire que, pour être vrai médecin, il serait nécessaire que celui qui l'entreprenait eût passé par toutes les maladies qu'il veut guérir & par tous les accidents & circonstances de quoi il doit juger. C'est raison qu'ils prennent la vérole s'ils la veulent savoir panser.

Essais de Michel de Montaigne, 5 vols. (Paris: Imprimerie Nationale, 1963): V, 283.

> So Plato was right in saying that to become a true doctor, the candidate must have passed through all the illnesses that he wants to cure and all the accidents and circumstances that he is to diagnose. It is reasonable that he should catch the pox if he wants to know how to treat it.

The Complete Works of Montaigne, trans. Donald M. Frame (Stanford: Stanford University Press, 1958): 827.

37. Cindy Patton comments on this phenomemon in *Inventing AIDS* (New York: Routledge, 1991). Although gay men are sometimes the subjects of these articles, they tend to favor the "victim" figure as "innocent": those who purportedly came into contact with HIV through transfusions or accident.

38. Jean Starobinski, "The Body's Moment," *Yale French Studies* 64 (1983): 276.

39. See Jacalyn M. Duffin, "Sick Doctors: Bayle and Laennec on Their Own Phthisis," *Journal of the History of Medicine* 43 (1988): 165-182, and *When Doctors Get Sick*, ed. Harvey N. Mandell and Howard M. Spiro (New York: Plenum, 1987).

40. George Cheyne, *The English Malady* (London: G. Strahan, 1733): 259. Subsequent references are given parenthetically in the text.

41. Clifford Geertz, "Thick Description: Toward an Interpretive Theory of Culture," in *The Interpretation of Cultures* (New York: Basic Books, 1973): 3-30. Page references are given parenthetically in the text. This notion of ethnography as a kind of cultural code-breaking, and an interrogation of systems of meaning appears throughout an important collection of essays on ethnographic practice, *Writing Culture: The Poetics and Politics of Ethnography*, ed. James Clifford and George E.

Marcus (Berkeley: University of California Press, 1986).

42. Geertz, "Ideology as a Cultural System," in *The Interpretation of Cultures,* 204.

4. *Ambiguous Sex*

1. Robert Edgerton cites a statistic of 2% to 3% in "Pokot Intersexuality: An East African Example of the Resolution of Sexual Incongruity," *American Anthropologist* 66 (1964): 1289. Dr. Iraj Rezvani of St. Christopher's Hospital for Children in Philadelphia believes this estimate to be too high. Public ignorance of the existence of intersexes was demonstrated in a television talk show featuring interviews with Dr. John Money and three hermaphrodites: "Geraldo," Geraldo Rivera, NBC, July 27, 1989. The show was broadcast with the revealing title "Hermaphrodites: The Sexually Unfinished."

2. In a *New York Times* article headlined "Who Is Female? Science Can't Say" (January 16, 1992:E6), Gina Kolata cites Dr. Maria New, head of pediatrics at New York Hospital–Cornell Medical Center, who uses the 1 in 13,000 figure for "little girls with normal sex chromosomes who have male-muscle patterns and masculinized genitals." This article discusses the International Athletic Federation's recommendations that examining an athlete's genitals be substituted for chromosomal testing using buccal smears. Only female athletes are tested. The 1 in 25,000 estimate in current births has been proposed by Keith L. Moore in *The Developing Human: Clinically Oriented Embryology*, 3rd ed. (Philadelphia: W.B. Saunders, 1982): 283-290, a standard medical textbook. Suzanne J. Kessler remarks on the difficulty of getting accurate statistics on the frequency of intersexed births; the physicians she interviewed declined to estimate frequency rates. See her article, "The Medical Construction of Gender: Case Management of Intersexed Infants," *Signs* 16(1)(1990): 4. Any attempt at calculating frequency rates needs to make clear which conditions it includes. Hypospadias, the placement of the urethral opening in a male on the undersurface of the penis, which is often underdeveloped and curved downward, occurs in 1 in about every 300 males, according to Moore. This relatively common condition is sometimes considered an aspect of intersexuality.

3. In "The Medical Construction of Gender," Suzanne Kessler makes this argument very cogently in her conclusion (pp. 24-26). Ethnographic studies of patients and their families are needed to complement Kessler's study of physicians who discover, assign, announce, and construct the sex of infants. But Kessler makes a strong case that medical teams manage intersexed children and ultimately control the conversion of biological sex into cultural gender. For a historical view of the medical hegemony over sex assignment in ambiguous cases, see Lorraine Daston and Katharine Park, "Hermaphrodites in Renaissance France," *Critical Matrix* (Princeton Working Papers in Women's Studies) 1(5) (1985): 1-19.

4. This is not the case in all cultures, nor was it always the case in earlier historical periods, where sex changes later in life occur. See Note 98.

5. Lynda Hart, "Karen Finley's Dirty Work: Censorship, Homophobia, and the NEA," *Genders* 14 (1992): 5. Terry Castle analyzes the eighteenth-century transvestite Mary Hamilton, alias George, and the play Henry Fielding wrote about her story as existing on "a symbolic margin—at once present and absent, notorious and unmentionable, sublime and taboo." Castle reads the subject of Fielding's *The Female Husband* as "a violation of categories"; "It [Fielding's play] sets out to represent a human paradox, that which shouldn't exist but does, a 'monster of perversity.'" See Castle, "Matters Not Fit to be Mentioned: Fielding's *The Female Husband*," ELH 49(3)(1982): 602, 603. For a discussion of the particular taxonomic response to sexual differentiation in eighteenth-century Europe, see Londa Schiebinger, "The Anatomy of Difference: Race and Sex in Eighteenth-Century Science," *Eighteenth-Century Studies* 23(4)(1990): 387–405.

6. Richard Thompson/Island Music BMI. Recorded on Thompson's *Small Town Romance*, Hannibal Records 1316, 1984, and on "Michael Doucet and Cajun Brew," Rounder Records 6017, 1988. Cited by permission.

7. The 1620 pamphlets *Hic Mulier: Or the Man Woman* and *Haec-Vir: Or the Womanish Man* are reprinted in *Half Humankind: Contexts and Texts of the Controversy about Women in England, 1540-1640*, ed. Katherine Usher Henderson and Barbara F. McManus (Chicago: University of Chicago Press, 1985): 264-289. For accounts, see Lisa Jardine, *Still Harping on Daughters: Women and Drama in the Age of Shakespeare* (Brighton, U.K.: Harvester, 1983): 158-162, and Linda Woodbridge, *Women and the English Renaissance: Literature and the Nature of Womankind, 1540-1620* (Urbana: University of Illinois Press, 1984): 139-151. Jean Howard discusses how cross-dressing threatened hierarchical social structures and the subordination of women in "Crossdressing, the Theatre, and Gender Struggle in Early Modern England," *Shakespeare Quarterly* 39 (1988): 418-440. Jonathan Dollimore analyzes some of the same material in "Subjectivity, Sexuality, and Transgression: The Jacobean Connection," *Renaissance Drama*, n.s. 17 (1987): 53-81. The *Oxford English Dictionary* dates the term "transvestite" to 1652. See also *Rewriting the Renaissance: The Discourses of Sexual Difference in Early Modern Europe*, ed. Margaret W. Ferguson, Maureen Quilligan, and Nancy Vickers (Chicago: University of Chicago Press, 1986). Stuart Clark comments on the language of contraries employed in the Renaissance to delineate extreme and antithetical poles of the moral universe in "Inversion, Misrule and the Meaning of Witchcraft," *Past & Present* 87 (1980): 98-127. Phyllis Rackin argues that gender difference in the Renaissance was grounded in theological and historical discourses rather than in the biological sciences, in "Historical Difference/Sexual Difference," paper discussed at the Seminar on the Diversity of Language and the Structure of Power, Program for the Assessment and Revitalization of the Social Sciences, University of Pennsylvania, May 1991.

8. Edward Ward's 1709 *History of London Clubs* was the first to use this term. For discussions of transvestism and homosexuality in the eighteenth century, see Lynne Friedli, "'Passing Women': A Study of Gender Boundaries in the Eighteenth Century," in *Sexual Underworlds of the Enlightenment*, ed. G.S. Rousseau and Roy Porter (Chapel Hill: University of North Carolina Press, 1988): 234-260; Terry

Castle, "The Culture of Travesty: Sexuality and Masquerade in Eighteenth-Century England," in *Sexual Underworlds of the Enlightenment*, 156-180; Laurence Senelick, "Mollies or Men of Mode? Sodomy and the Eighteenth-Century London Stage," *Journal of the History of Sexuality* 1(1) (1990): 33-67; and five essays by Randolph Trumbach, "London's Sodomites: Homosexual Behavior and Western Culture in the Eighteenth Century," *Journal of Social History* 11 (1977): 1-33; "Sodomitical Subcultures, Sodomitical Roles, and the Gender Revolution in the Eighteenth Century: The Recent Historiography," in *Unauthorized Sexual Behavior during the Enlightenment*, ed. Robert P. Maccubbin, special issue of *Eighteenth-Century Life* 9 (1985): 109-121; "Sodomy Transformed: Aristocratic Libertinage, Public Reputation and the Gender Revolution of the 18th Century," *Journal of Homosexuality* 19(2) (1990): 105-124; "The Birth of the Queen: Sodomy and the Emergence of Gender Equality in Modern Culture, 1660-1750," in *Hidden from History: Reclaiming the Gay and Lesbian Past*, ed. Martin Bauml Duberman, Martha Vicinus, and George Chauncey, Jr. (New York: NAL Books, 1989): 129-140; and "London's Sapphists: From Three Sexes to Four Genders in the Making of Modern Culture," in *Body Guards: The Cultural Politics of Gender Ambiguity*, ed. Julia Epstein and Kristina Straub (New York: Routledge, 1991): 112-141. In *Sexual Suspects: Eighteenth-Century Players and Sexual Ideology* (Princeton: Princeton University Press, 1992), Kristina Straub analyzes the ideological implications of cross-dressing in eighteenth-century theatrical life in England. Aphra Behn's playful 1688 lyric, "To the Fair Clarinda, Who Made Love to Me, Imagined More than Woman," presents one view of sexual mutability in this period: "For who that gathers fairest flowers believes/ A snake lies hid beneath the fragrant leaves." Less work has thus far been done to recover the history of lesbianism in early modern Europe, though several recent publications address the question of lesbianism. See Terry Castle, *The Apparitional Lesbian: Female Homosexuality and Modern Culture* (New York: Columbia University Press, 1993), Emma Donoghue, *Passions Between Women: British Lesbian Culture, 1668-1801* (London: Scarlet Press, 1993); and Martha Vicinus, "'They Wonder to Which Sex I Belong': The Historical Roots of the Modern Lesbian Identity," *Feminist Studies* 18(3)(1992): 467-497.

9. For a variety of discussions of cross-dressing in different periods of theater history, see, in addition to Howard and Dollimore (Note 7) Froma I. Zeitlin, "Travesties of Gender and Genre in Aristophanes' *Thesmophoriazousae*," *Critical Inquiry* 8 (1981): 301-328; Phyllis Rackin, "Androgyny, Mimesis, and the Marriage of the Boy Heroine on the English Renaissance Stage," *PMLA* 102 (1987): 29-41; Laura Levine, "Men in Women's Clothing: Antitheatricality and Effeminization from 1579 to 1642," *Criticism* 28 (1986): 121-143; Stephen Orgel, "Nobody's Perfect: Or Why Did the English Stage Take Boys for Women," *South Atlantic Quarterly* 88 (1989): 7-29; Catherine Belsey, "Disrupting Sexual Difference: Meaning and Gender in the Comedies," in *Alternative Shakespeares*, ed. John Drakakis (London: Methuen, 1985): 166-190; Pat Rogers, "The Breeches Part," in *Sexuality in Eighteenth-Century Britain*, ed. Paul-Gabriel Boucé (Manchester, U.K.: Manchester University Press, 1982): 244-258. Sandra M. Gilbert's "Costumes of the Mind: Transvestism as Metaphor in Modern Literature," *Critical Inquiry* 7 (1980): 391-417,

is not concerned with drama but raises many of the same issues that emerge in theater history and criticism. On performance, sex, and gender identity more generally, see Judith Butler, *Bodies That Matter: On the Discursive Limits of 'Sex'* (New York: Routledge, 1994), especially Chapter 4, "Gender Is Burning: Questions of Appropriation and Subversion": 122-140; Sue-Ellen Case, ed., *Performing Feminisms: Feminist Critical Theory and Theatre* (Baltimore: The Johns Hopkins University Press, 1990); Jennifer Robertson, "Gender-Bending in Paradise: Doing 'Female' and 'Male' in Japan," *Genders* 5 (Summer 1989): 50-69; and Kath Weston, "Do Clothes Make the Woman? Gender, Performance Theory, and Lesbian Eroticism," *Genders* 17 (Fall 1993): 1-21.

10. A rich literature on cross-dressing has emerged from cultural studies. See most notably Marjorie Garber, *Vested Interests: Cross-Dressing and Cultural Anxiety* (New York: Routledge, 1992). See also Peter Ackroyd, *Dressing Up: Transvestism and Drag: The History of an Obsession* (New York: Simon and Schuster, 1979); Anne Hermann, "'Passing' Women, Performing Men," in *The Female Body: Figures, Styles, Speculations*, ed. Laurence Goldstein (Ann Arbor: University of Michigan Press, 1991): 178-189; Esther Newton, *Mother Camp: Female Impersonators in America* (Chicago: University of Chicago Press, 1972); and Annie Woodhouse, *Fantastic Women: Sex, Gender and Transvestism* (New Brunswick: Rutgers University Press, 1989).

11. Natalie Zemon Davis, in a classic account of sexual inversion in popular festivals and ordinary life, remarks that "sexual symbolism is . . . always available for use in making statements about social experience and in reflecting (or concealing) contradictions within it." See her "Women on Top: Symbolic Sexual Inversion and Political Disorder in Early Modern Europe," in *The Reversible World: Symbolic Inversion in Art and Society*, ed. Barbara A. Babcock (Ithaca, NY: Cornell University Press, 1978): 147-190, 150 (reprinted from Natalie Zemon Davis, *Society and Culture in Early Modern France* [Stanford: Stanford University Press, 1975]: 124-151). In the same volume, in an essay on Indonesian transvestites, James L. Peacock asserts the following general principle concerning symbolic reversals: "the classificatory world view, which emphasizes the subsuming of symbols within a frame, nourishes and is nourished by symbols of reversal; the instrumental world view, which emphasizes the sequential harnessing of means to an end, threatens and is threatened by such symbols." See James L. Peacock, "Symbolic Reversal and Social History: Transvestites and Clowns of Java," in *The Reversible World*: 221-222.

12. My translation. "Il faut remarquer que dès l'enfance, bien longtemps par conséquent avant que l'hermaphrodisme ait imprimé à l'ensemble de la constitution physique ce cachet d'ambiguité qui a son point de départ dans l'appareil génital, le sujet offre déjà dans ses inclinations, ses penchants, ses goûts, son humeur, une instabilité qui est l'expression de son anomalie sexuelle." Dr. Caufeynon, *Les Monstres humains* (Paris: Librairie de la Nouvelle France, 1850): 90. Caufeynon reports that many hermaphrodites succumb to alcoholism, and in a section on the sexual instinct of hermaphrodites, he claims that their genital deformations (in particular, clitoral hypertrophy) produce "venereal pleasures."

13. For discussions, see Roger Ormrod, "The Medico-Legal Aspects of Sex Determination," *The Medico-Legal Journal* 40 (1972): 78-88; Donna Lea Hawley, "The Legal Problems of Sex Determination," *Alberta Law Review* 15 (1977): 122-141; Katherine O'Donovan, *Sexual Divisions in Law* (London: Weidenfeld and Nicolson, 1985); and Paul Robertshaw, "Contemporary Legal Constitution of Women: Categories, Classification, Dichotomy," *Oxford Literary Review* 8 (1986): 198-207. Most case law in this area involves petitions for divorce based on accusations of hermaphroditism [*Peipho* v. *Peipho*, *Illinois Reports of Cases at Law and in Chancery* 88 (1878): 438-40; *Kirschbaum* v. *Kirschbaum*, Court of Chancery of New Jersey, *The Atlantic Reporter* 111 (1921): 697-701] or of transsexuality [see Jeannine S. Haag and Tami L. Sullinger, "Is He or Isn't She? Transsexualism: Legal Impediments to Integrating a Product of Medical Definition and Technology," *Washburn Law Journal* 21 (1982): 342-372, and Katherine O'Donovan, "Transsexual Troubles: The Discrepancy Between Legal and Social Categories," in *Gender, Sex and the Law*, ed. Susan Edwards (London: Croom Helm, 1985): 9-27]. I am grateful to Laura Rivkin for help with legal research.

14. A useful discussion about medieval versions of this can be found in James A. Brundage, *Law, Sex, and Christian Society in Medieval Europe* (Chicago: University of Chicago Press, 1987): 108.

15. Alexander Morgan Capron and Richard D'Avino, "Legal Implications of Intersexuality," in *The Intersex Child*, ed. Nathalie Josso, Vol. 8 of *Pediatric and Adolescent Endocrinology* (Basel: S. Karger, 1981): 221.

16. For one example, see Ernest Martin, *Histoire des monstres depuis l'antiquité jusqu'à nos jours* (Paris: C. Reinwald, 1880): 196.

17. Pierre Jacques Brillon, *Dictionnaire des Arrêts, ou Jurisprudence Universelle des Parlemens de France, et autres tribunaux. Contenant par ordre alphabétique les matières beneficiales, civiles, et criminelles; les maximes du droit ecclésiastique, du droit romain, du droit public, des coutumes, ordonnances, édits, et déclarations*, new ed., 6 vols. (Paris: Guillaume Cavalier et al., 1727): III, 604.

18. Samuel Farr, *Elements of Medical Jurisprudence: or, a succinct and compendious Description of such Tokens in the Human Body as are requisite to determine the Judgment of a Coroner, and of Courts of Law, in Cases of Divorce, Rape, Murder, & c. To which are added, Directions for Preserving the Public Health* (London: T. Becket, 1788): 19. Further references are given parenthetically in the text. Farr's text is based on Johann Friedrich Fuseli's *Elementa Medicinae Forensis* (1767).

19. Charles Meymott Tidy, *Legal Medicine*, 2 vols. (New York: William Wood & Co., 1882): I, 275-276. Further references appear parenthetically in the text. Tidy includes the case of Levi Suydam, discussed as one of the cases in this chapter.

20. See Pierre Jacques Brillon, *Dictionnaire des arrêts*, articles on "Hermaphrodites," "Eunuque," and "Monstre." Jean Domat, who lived from 1625 to 1696, compiled a folio volume of civil laws, *Les Loix civiles dans leur ordre naturel, le droit public, et legum delectus*, new ed. by Louis de Héricourt (Paris: Durard, 1777), 10 in which hermaphrodites were defined as "ceux qui ont les marques des deux sexes, & ils sont

réputés de celui qui prévaut en eux" ["those who have the marks of both sexes, and they are reputed to be that sex which prevails in them" (my translation)]. This definition appeared in a section called "De l'État des personnes par la nature" ["Of the state of persons by nature"]; distinctions were founded on sex, birth, and age, and "le double sexe dans les hermaphrodits" ["the double sex in hermaphrodites"] was classified as one of those "défauts ou vices de conformation qu'on a de naissance" ["defects or vices of conformation that one has from birth"] (p. 9). The standard reference work for canon law was compiled by Louis de Héricourt [du Vatier] (1687–1752), Domat's editor and a parliamentary lawyer ("avocat du Parlement"). See Louis de Héricourt, *Les Lois ecclésiastiques de France dans leur ordre naturel et une analyse des livres du droit canonique*, new ed. (Neufchâtel: Chez la Société Typographique, 1774). The definition here was similar and echoed Brillon's article on hermaphrodites: "On appelle hermaphrodites ceux qui ont les signes des deux sexes. S'il y en a quelques-uns, ils doivent en se mariant suivre le sexe qui dommine [sic] en leur personne" ["We call hermaphrodites those who have the signs of two sexes. If there are several [signs], they must follow the sex that dominates in their person when they marry"]: III, 47. This text noted two cases, one from 1603 and one from 1765, that are discussed in the case section of this chapter.

21. Lorraine Daston and Katharine Park make this point convincingly, refuting the idea of choice as Michel Foucault presents it in his Introduction to the memoirs of Herculine Barbin (cited in note 82). Daston and Park focus on the case of Marie/Marin le Marcis. See their "Hermaphrodites in Renaissance France," *Critical Matrix* 1(5)(1985): 1–19.

22. It is interesting to note that after decades of high-tech excursions into chromosomal testing through buccal smears, the International Athletic Federation recommended in 1992 that its doctors go back to simply looking at the genitals of female athletes. The International Olympic Committee still does genetic testing. See Gina Kolata, "Who Is Female? Science Can't Tell," *New York Times* (January 16, 1992): E6.

23. This is also true, however, of newborns with XY chromosomal sex but who have Androgen Insensitivity Syndrome; these children are now virtually always raised as girls, with surgical construction of a vagina and hormonal therapy.

24. "Change of Sex on Birth Certificates for Transsexuals," Report by the Committee on Public Health, New York Academy of Medicine, *Bulletin of the New York Academy of Medicine* 42 (1966): 724. For other discussions of transsexuals, see Janice Raymond, *The Transsexual Empire: The Making of the She-Male* (Boston: Beacon Press, 1979); L.M. Lothstein, "Sex Reassignment Surgery: Historical, Bioethical and Theoretical Issues," *American Journal of Psychiatry* 139 (1982): 417–426; Judith Shapiro, "Transsexualism: Reflections on the Persistence of Gender and the Mutability of Sex" and Sandy Stone, "The *Empire* Strikes Back: A Post-Transsexual Manifesto," both in *Body Guards The Cultural Politics of Gender Ambiguity*, ed. Julia Epstein and Kristina Straub (New York: Routledge, 1991):248–279, 280–304; Marjorie Garber, "Spare Parts: The Surgical Construction of Gender," *differences* 1(3)(1989): 137–159; Bernice L. Hausman, "Demanding Subjectivity: Transsexualism, Medicine, and the Technologies of Gender," *Journal of the History of*

Sexuality 3(2)(1992): 270-302, and the discussion that followed it in the *Journal of the History of Sexuality* 4(2)(1993): 288-292; Janice Irvine, *Disorders of Desire: Sex and Gender in Modern American Sexology* (Philadelphia: Temple University Press, 1990); and Carole-Anne Tyler, "The Supreme Sacrifice? TV, 'TV,' and the Renee Richards Story," *differences* 1(3)(1989): 160-186.

25. C.N. Armstrong, "Intersexuality in Man," in *Intersexuality in Vertebrates Including Man*, ed. C.N. Armstrong and A.J. Marshall (London and New York: Academic Press, 1964): 349, 356, 350. See also R.V. Short, "An Introduction to Some of the Problems of Intersexuality," *Journal of Reproduction and Fertility* 7 (1969): 1-8 and Suzanne J. Kessler, "The Medical Construction of Gender: Case Management of Intersexed Infants," *Signs* 16 (1990): 3-26.

26. Joyce Bruner-Lorard, "Intersexuality in Mammals," in *Intersexuality*, 343.

27. George M. Gould and Walter L. Pyle, *Anomalies and Curiosities of Medicine* (Philadelphia: W.B. Saunders, 1897): 211-212. Interesting but less useful studies are Martin Howard, *Victorian Grotesque: An Illustrated Excursion into Medical Curiosities, Freaks and Abnormalities—Principally of the Victorian Age* (London: Jupiter Books, 1977) and Leslie Fiedler, *Freaks: Myths and Images of the Secret Self* (New York: Simon and Schuster, 1978).

28. E. Witschi, W.O. Nelson, and S.J. Segal, "Genetic, Developmental and Hormonal Aspects of Gonadal Dysgenesis and Sex Inversion in Man," *Journal of Clinical Endocrinology and Metabolism* 17 (1957): 750.

29. Fred A. Mettler, *The Medical Sourcebook: A Reference Handbook for Legal, Legislative and Administrative Personnel* (Boston: Little, Brown and Co., 1959): 641.

30. The question of terminology is complicated and politically charged. I have referred to "indeterminacy" and "ambiguity" in this chapter in a search for the most neutral possible terms. The term "intersexuality" was not coined until the nineteenth century; from "monster" to "anomaly" to "congenital malformation," all the available terms have been charged. The literature I cite variously refers to "imperfect development," "defective formation," "ambisexuality," "abnormal sexual development," and "malformation," in addition to the terms I have already mentioned. See John Money and Anke A. Ehrhardt, *Man & Woman, Boy & Girl: The Differentiation and Dimorphism of Gender Identity from Conception to Maturity* (Baltimore: Johns Hopkins University Press, 1972), John Money, *Sex Errors of the Body and Related Syndromes: A Guide to Counseling Children, Adolescents, and Their Families*, 2nd ed. (Baltimore; Paul H. Brookes Publishing Co., 1994), and Keith L. Moore, *The Developing Human: Clinically Oriented Embryology*, 4th edition (Philadelphia: W.B. Saunders Co., 1988).

31. Howard W. Jones and William Wallace Scott, *Hermaphroditism, Genital Abnormalities and Related Endocrine Disorders* (Baltimore: Williams & Wilkins, 1958): 52, 53.

32. The biological model of human sexuality has been criticized, especially by feminist researchers, most notably Ruth Bleier, in *Science and Gender: A Critique of Biology and Its Theories on Women* (New York: Pergamon Press, 1984). Thomas Ford Hoult

argues that evidence does not yet compellingly demonstrate that human sexuality is directly related to biology, in "Human Sexuality in Biological Perspective: Theoretical and Methodological Considerations," *Journal of Homosexuality* 9 (1984): 137-155.

33. Saint Augustine, *The City of God*, trans. Marcus Dods (New York: Random House, 1950): 530, 531.

34. Aristotle, *On the Generation of Animals*, trans. A.L. Peck (Cambridge, MA: Harvard University Press, 1953).

35. Pliny reports this practice in his *Natural History*, though he goes on to say that it no longer occurs. "Individuals are occasionally born, who belong to both sexes; such persons we call by the name of hermaphrodites; they were formerly called Androgyni, and were looked upon as monsters, but at the present day they are employed for sensual purposes": *The Natural History of Pliny*, 6 vols., trans. and ed. John Bostock and H.T. Riley (London: Henry G. Bohn, 1855-1857): II, 136. The editors cite Livy for accounts of hermaphrodites thrown into the sea. For histories of the early periods, see W. Dieke, "Die antiken Hermaphroditen," *Zentralblatt für Gynäkologie* 78 (1956): 889-927; Maurice Garçon, "Les tribulations des hermaphrodites," *Histoire de la médecine* 12 (1962): 15-26; R. Keller, "Historical and Cultural Aspects of Hermaphroditism," *Ciba Symposium* 2 (June 1940): 466-470; Johanna M. Tamm and G.A. Hauser, "Geistesgeschichtliche und medizinische Aspekte der Hermaphroditen," *Praxis* 50 (1961): 86-91; and Franz Ludwig von Neugebeuer, *Hermaphrodismus beim Menschen* (Leipzig: Werner Klinkhardt, 1908).The von Neugebeuer volume is a comprehensive treatise on "Zwitterbildung" and contains numerous case reports.

36. James Romm discusses the question of semiotics in ancient writings on the monstrous in "The Edges of the Earth in Ancient Thought: Distance and the Literary Imagination" (Ph.D. Dissertation, Princeton University, 1987), especially Chapter 3, "'Men of Different Form': Teratology and Biology in the Distant World," 101-51. I would like to thank him for sharing his work with me and for help with ancient terms and references. For an important and useful account of the situation in the Middle Ages, see John B. Friedman, *The Monstrous Races in Medieval Art and Thought* (Cambridge, MA: Harvard University Press, 1981). Jean Céard offers a history of ideas about monsters in *La Nature et les prodiges: l'insolite au XVIe siècle* (Geneva: Droz, 1977), as does Jurgis Baltrusaitis in *Réveils et prodiges* (Paris: Armand Colin, 1960). In "Sur l'origine des monstres," *Concours Médical* 77 (4)(1955): 305-306, Marcel Sendrail meditates on ancient examples of monstrous births and their treatment and suggests that the impulse to put to death infants with birth defects came from the semiotic power of the monstrous: "En annulant le signe, elle espérait abolir le fait signifié" (p. 305). See also C.J.S. Thompson, *The Mystery and Lore of Monsters, with Accounts of some Giants, Dwarfs and Prodigies* (New York: Bell Books, 1968); Friedrich Ahlfeld, *Die Missbildungen des Menschen: Eine Systematische Darstellung dar beim Menschen Angeboren Vorkommenden Missbildungen und Erklärung ihrer Entstehungsweise*, 2 vols. (Leipzig: Verlag Grunow, 1882); Jean-François Béchet, *Essai sur les monstruosités humaines ou vices congénitaux de conformation* (Paris: Didot le Jeune, 1829); and Etienne Chauvin, *Précis de Tératologie* (Paris: Masson, 1920).

37. Pierre Jacques Brillon, *Dictionnaire des arrêts*: IV, 435.

38. My translation. "En effet, du moment où une disposition du code consacrerait le principe de l'impunité laissée au sacrifice d'un monstre, elle consacrerait en même temps, et par réciprocité, l'innocence de ce monstre, dans le cas où il viendrait à commettre un crime. Une loi ne peut prétendre exercer un châtiment quelconque envers celui qu'elle ne protège pas, sans peine de commettre une inconséquence et une violation flagrante de la justice." Ernest Martin, *Histoire des monstres depuis l'antiquité jusqu'à nos jours* (Paris: C. Reinwald, 1880): 183.

39. For useful discussions of social and legal taxonomies in the Renaissance understanding of sex difference, see Ian Maclean, *The Renaissance Notion of Woman: A Study in the Fortunes of Scholasticism and Medical Science in European Intellectual Life* (Cambridge: Cambridge University Press, 1980). Maclean moves from Aristotle's attribution of related opposites to Pythagoras, to the argument that a parallel exists between legal functions and sex difference, pointing out, "Difference in law consists of contraries (married/unmarried) or opposites of privation (able to succeed to a title/unable to succeed). There is little room for the 'species relativa' which has its place in medicine and ethics" (p. 81). In "Hermaphrodites in Renaissance France," [*Critical Matrix* 1(5)(1985): 1–19], Lorraine Daston and Katharine Park point out the negative views of homosexuality and lesbianism in the Renaissance. See also Lorraine Daston, "Marvelous Facts and Miraculous Evidence in Early Modern Europe," *Critical Inquiry* 18(1)(1991): 93–124; Marie-Hélène Huet, "Monstrous Imagination: Progeny as Art in French Classicism," *Critical Inquiry* 17(4)(1991): 718–737; and Ann Rosalind Jones and Peter Stallybrass, "Fetishizing Gender: Constructing the Hermaphrodite in Renaissance Europe," in *Body Guards: The Cultural Politics of Gender Ambiguity*, ed. Julia Epstein and Kristina Straub (New York: Routledge, 1992): 80–111.

40. Ambroise Paré, *On Monsters and Marvels*, ed. Janis L. Pallister (Chicago: University of Chicago Press, 1982): 27–28. "Les Medecins et Chirurgiens bien experts et advisez peuvent cognoistre si les hermafrodites sont plus aptes à tenir et user de l'un que de l'autre sexe, ou des deux, ou du tout rien." "Si toute l'habitude du corps est robuste ou effeminee, s'ils sont hardis ou craintifs, et autres actions semblables aux masles ou aux femelles." Ambroise Paré, *Des Monstres et prodiges*, ed. Jean Céard (Geneva: Librairie Droz, 1971): 25–26. This work was first published by André Wechel in Paris in 1573. It contains a chapter titled "Des Hermafrodites ou Androgynes, c'est à dire, Qui en un mesme Corps ont Deux Sexes." Céard's introduction contains a useful historical background. See also Albert Sonderegger, *Missgeburten und Wundergestalten in Einblattdrucken und Handzeichnungen des 16. Jahrhunderts* (Zurich: Orell Füssli, 1927).

41. Translation from *The Complete Essays of Montaigne*, trans. Donald M. Frame (Stanford: Stanford University Press, 1958): 539.

> Ce que nous appelons monstres ne le sont pas à Dieu, qui voit en l'immensité de son ouvrage l'infinité des formes qu'il y a comprises; et est à croire que cette figure qui nous estonne, se rapporte et tient à quelque autre figure de mesme

genre inconnu à l'homme. De sa toute sagesse il ne part rien que bon et commun et reglé; mais nous n'en voyons pas l'assortiment et la relation.

"Quod crebo videt, non miratur, etiam si cur fiat nescit. Quod ante non vidit, id, si everit, ostentum esse censet." [Cicero, De divinatione]

Nous appelons contre nature ce qui advient contre le coustume; rien n'est que selon elle, quel qu'il soit. Que cette raison universelle et naturelle chasse de nous l'erreur et l'estonnement que la nouvelleté nous apporte.

Michel de Montaigne, *Essais*, 2 vols., ed. Maurice Rat (Paris: Garnier Frères, 1962): II, 118. Using more philosophical examples, Montaigne also discusses confusions of nature in the essay "Nous ne goustons rien de pur," II, 76–80.

42. Paulus Zacchias, *Quaestionum medico-legalium, a variis mendis purgata passimque interpolata, et novis recentiorum authorum inventis ac observationibus aucta*, new ed. (Frankfurt: Schînwetteri, 1666). See also M. Jacob Müller, *Discursus juridico-philologicus de Hermaphroditis* (Frankfurt: Christoph. Andreae Zeitler, 1692).

43. Jacques Duval, *Des Hermaphrodits, accouchemens des femmes, et traitement qui est requis pour les relever en santé & bien élever les enfans* (Rouen: Geuffroy, 1612). Duval's work participated in a heated debate over the case of Marin le Marcis; the other important work is Jean Riolan, *Discours sur les hermaphrodits où il est démontré contre l'opinion commune qu'il n'y a point de vrays hermaphrodits* (Paris: Pierre Ramier, 1614). For brief discussions, see Christos S. Bartsocas, "Goiters, Dwarfs, Giants and Hermaphrodites," in *Endocrine Genetics and Genetics of Growth*, ed. Costas J. Papadatos and Christos S. Bartsocas (New York: Alan R. Liss, 1985): 1-18, and Katharine Park and Lorraine J. Daston, "Unnatural Conceptions: The Study of Monsters in Sixteenth- and Seventeenth-Century England," *Past & Present* 92 (1981): 20-54. Park and Daston use Bacon to demonstrate the shift from concerns about delineating breaks between nature and the supernatural to concerns about distinguishing the natural from the artificial. See also Caroline Bingham, "Seventeenth-Century Attitudes Toward Deviant Sex," *Journal of Interdisciplinary History* 1 (1971): 447-468. For accounts of ambiguous sex in sixteenth-century Spain, see Michèle Escamilla, "A Propos d'un dossier inquisitorial des environs de 1590: les étranges amours d'un hermaphrodite," in *Amours légitimes, amours illégitimes en Espagne (XVIe-XVIIe siècles)*, ed. Augustin Redondo (Paris: Publications de la Sorbonne, 1985): 167-182 and Israel Burshatin, "Elena/Eleno; Performing Gender and Race in Sixteenth-Century Spain," unpublished paper. Patricia Parker discusses the case of Marie Germain in "Gender Ideology, Gender Change: The Case of Marie Germain," *Critical Inquiry* 19(2)(1993): 337-364.

44. Stephen Greenblatt, *Shakespearean Negotiations: The Circulation of Social Energy in Renaissance England* (Berkeley: University of California Press, 1988): 91, 79. Greenblatt relies entirely on Duval's text for his account, without reference to Duval's debate with Riolan, and he accepts the continuing sway of the Galenic notion of sexual homology, a notion that was undergoing serious challenge in the sixteenth and seventeenth centuries.

45. Caspar Bauhin, *De Hermaphroditorum monstrosorumque partuum natura ex theologorum, jureconsultorum, medicorum, philosophorum, etc.* (Frankfurt: Becker, 1600): 577 (Fig.7); 575 (Fig.8).

46. Ulisse Aldrovandi, *Monstrorum Historia. Cum Paralipomenis historiae omnium animalium* (Bononia, Italy: N. Tebaldini, 1642): 42, 517.

47. Note the stylized hand gestures in these early representations of hermaphrodites.

48. Illustrations are taken from the German translation of this work, Georg Arnaud, *Anatomisch-Chirurgische Abhandlung über die Hermaphroditen* (Strassburg: Umand König, 1777): Tables I–III. In a discussion of the "increasing scrutiny and voyeurism" of Enlightenment representations of sexual anatomy in relation to erotic violence, Ludmilla Jordanova remarks on the anatomical plates of hermaphrodites in the *Encyclopédie*, in which some of the subjects are looking at their own genitals. See Jordanova, *Sexual Visions: Images of Gender in Science and Medicine between the Eighteenth and Twentieth Centuries* (Madison: University of Wisconsin Press, 1989): 61.

49. Jacob Fidele Ackermann, *Dissertatio inauguralis anatomica de discrimine sexuum praeter genitalia* (Mogunt: Haeffner, 1788), and *Infantis Androgyni. Historia et Ichnographia accedunt de sexu et generatione disquisitiones physiologiae* (Jena: Maukianis, 1805). Jean-Pierre Guicciardi comments on the eighteenth century's fascination with the monstrous and with biological categories in "Hermaphrodite et le prolétaire," *Dix-huitième siècle* 12 (1980): 49–77.

50. Etienne Geoffroy Saint-Hilaire (1772–1844) conducted experiments on chicken eggs and published *La Philosophie anatomique* in 1818. The publication of Isidore Geoffroy Saint-Hilaire's *Histoire générale et particulière des anomalies de l'organisation chez l'homme et les animaux, ouvrage comprenant des recherches sur les caractères, la classification, l'influence physiologique et pathologique, les rapports généraux, les lois et les causes des monstruosités, des variétés et vices de conformation, ou Traité de Tératologie*, 3 vols. and atlas (Paris: J.-B. Baillière, 1832–1837) marks a crucial event in the history of embryology.

51. My translation. "J'ai cherché et je crois avoir réussi à démontrer que l'ensemble de nos connaissances sur les anomalies, ou pour employer dès à présent le nom que je lui donne dans cet ouvrage, la *tératologie*, ne peut plus être considérée comme une section de l'anatomie pathologique. . . . Je montrerai comment ces lois et ces rapports ne sont eux-mêmes que des corollaires des lois les plus générales de l'organisation; comment, parmi les théories proposées dans ces derniers temps, toutes celles qui ne sont pas non plus à l'ensemble des faits normaux, et doivent être reléguées au rang des systèmes; comment, au contraire, plusieurs principes, établis encore sur des bases peu solides par l'étude des faits normaux, trouvent dans celle des anomalies leur démonstration complète." Geoffrey Saint-Hilaire, *Histoire générale et particulière des anomalies de l'organisation chez l'homme et les animaux*, I, x–xi.

52. My translation. "Toute déviation du type spécifique, ou, en d'autres termes, toute particularité organique." Geoffrey Saint-Hilaire, *Histoire générale*, I: 30.

53. Geoffrey Saint-Hilaire, *Histoire Générale*, II, 32. See also Patrick Tort, *L'Ordre et les monstres: le débat sur l'origine des déviations anatomiques au XVIIIe siécle* (Paris: Editions Le Sycomore, 1980).

54. My translation. "Il en est donc des hermaphrodismes comme de toutes les autres anomalies, à mesure que l'on se rapproche d'elles, le merveilleux disparaît; mais leur intérêt scientifique s'accroît." Geoffroy Saint-Hilaire, *Histoire générale*, II, 46.

55. For historical discussions, see F.J. Cole, *Early Theories of Sexual Generation* (Oxford: Oxford University Press, 1930); Joseph Needham, *A History of Embryology* (Cambridge: Cambridge University Press, 1934); Arthur William Meyer, *The Rise of Embryology* (Stanford: Stanford University Press, 1939); and Elizabeth B. Gasking, *Investigations into Generation, 1651-1828* (Baltimore: The Johns Hopkins University Press, 1966). See also Angus McLaren, *Reproductive Rituals: The Perception of Fertility in England from the Sixteenth Century to the Nineteenth Century* (London: Methuen, 1984).I discuss preformation theories of generation at greater length in Chapter 5.

56. The thirteenth-century pseudo–Albertus Magnus text *De secretis mulierum* (*On the Secrets of Women*), published in Lyons in 1580, was particularly influential, as were commentaries on the works of Galen and Aristotle. See Helen Rodnite Lemay, "Masculinity and Femininity in Early Renaissance Treatises on Human Reproduction," *Clio Medica* 18 (1983): 21-31, for a discussion.

57. Thomas Laqueur, "Orgasm, Generation, and the Politics of Reproductive Biology," *Representations* 14 (1986): 1-41. Denis Diderot refers to the ovaries as "testicules de la femme" in his *Eléments de physiologie*, which includes a chapter on generation. Popular belief in these homologies lingers: On his children's television program "Mr. Rogers' Neighborhood," for example, Fred Rogers presents sexual difference to young children by explaining that "some people are fancy on the outside, and some people are fancy on the inside."

58. Meyer M. Melicow, "Tumors of Dysgenetic Gonads in Intersexes: Case Reports and Discussion Regarding their Place in Gonadal Oncology," *Bulletin of the New York Academy of Medicine* 42 (1966): 3.

59. Frank R. Lillie, *Sex and Internal Secretions*, ed. Edgar Allen (Baltimore: Williams and Wilkins, 1932). Brown-Séquard was collaborating with Louis Agassiz in 1865 but did not begin to publish his work until 1889. There was also in this period another strain in the science of sexual differentiation and its social ramifications: sexology. The sexologists did not do clinical research of the sort I am concerned with here, however, and their assumptions were so overdetermined by social ideology as to require separate treatment. For a useful discussion, see Robert A. Nye, "Sex Difference and Male Homosexuality in French Medical Discourse, 1830-1930," *Bulletin of the History of Medicine* 63 (1989): 32-51.

60. For useful historical studies, see Diana Long Hall, "Biology, Sex Hormones and Sexism in the 1920's," *Philosophical Forum* 5 (1973-1974): 81-96; Merriley Borell, "Organotherapy, British Physiology and the Discovery of the Internal Secretions," *Journal of the History of Biology* 9 (1976): 235-268; Merriley Borell, "Organotherapy and the Emergence of Reproductive Endocrinology," *Journal of the History of Biology*

18 (1985): 1–30; and Nelly Oudshorn, "Endocrinologists and the Conceptualization of Sex," *Journal of the History of Biology* 23 (1990): 163–187.

61. I am grateful to Iraj Rezvani, M.D., Professor of Pediatrics at Temple University and attending physician at St. Christopher's Hospital for Children in Philadelphia, for permitting me to attend his Grand Rounds presentation on "Ambiguous Genitalia," October 20, 1988, at the University of Medicine and Dentistry of New Jersey, Cooper Hospital, Camden, NJ.

62. See Barry J. Everitt and E. Barry Keverne, "Reproduction," in *Neuroendocrinology*, ed. Stafford L. Lightman and Barry J. Everitt (Oxford: Blackwell Scientific Publications, 1986): 508–509. It has been suggested that Elizabeth I was a case of Androgen Insensitivity Syndrome as an explanation for, among other things, her failure to bear children. See R. Bakan, "Queen Elizabeth I: A Case of Testicular Feminization?" in *Medical Hypotheses* 17 (1985): 277–284.

63. Claude J. Migeon, Terry R. Brown, and Kaye R. Fichman, "Androgen Insentivity Syndrome," in *The Intersex Child*, ed. Nathalie Josso, Vol. 8, *Pediatric and Adolescent Endocrinology* (Basel: S. Karger, 1981): 194–195.

64. Iraj Rezvani, M.D., Grand Rounds, Cooper Hospital, Camden, NJ, October 20, 1988.

65. The work of John Money and his colleagues on the psychosexual dimensions of gender ambiguity has received the greatest criticism. See especially Anne Fausto-Sterling, *Myths of Gender: Biological Theories about Women and Men* (New York: Basic Books, 1985). Sandra Harding writes about the social construction of human sexuality in *The Science Question in Feminism* (Ithaca, NY: Cornell University Press, 1986): 126–135.

66. One of the fields in which this occurred least controversially was animal husbandry, where observation of sex changes and gender indeterminacies was less fraught with cultural innuendo. The case of cocks' eggs—from which it was thought basilisks or cockatrices would hatch—is an exception. There are numerous accounts of cocks and their eggs being put on trial and burned at the stake with full legal formalities. See Thomas R. Forbes, "The Crowing Hen: Early Observations on Spontaneous Sex Reversal in Birds," *Yale Journal of Biology and Medicine* 19 (1947): 955–970. In antiquity, Aristotle, among others, discussed gender ambiguities in the animal kingdom in his *Historia animalium*, as did Conrad Gesner and Edward Topsel in *The History of Four-Footed Beasts and Serpents* (London: E. Cotes, 1658). John Hunter wrote two articles on this subject: "Account of the *Free Martin*," *Philosophical Transactions of the Royal Society of London* 69 (1779): 279–293, and "An Account of an Extraordinary Pheasant," *Philosophical Transactions of the Royal Society of London* 70 (1780): 527–535. Georges-Louis Buffon offered scientific explanations in his *Histoire naturelle des oiseaux* (Paris: Imprimerie Royale, 1771), as did Isidore Geoffroy Saint-Hilaire in *Essais de Zoologie générale* (Paris: Roret, 1841). See also E.P. Evans, *The Criminal Prosecution and Capital Punishment of Animals* (New York: E.P. Dutton, 1906), and William Yarrell, "On the Influence of the Sexual Organ in Modifying External Character," *Journal of the Proceedings of the Linnaean Society. Zoology* I (1857): 76–82. A number of proverbs are cited in these texts, and they suggest the invidious

ways in which sexual ambiguity has been understood as connected with the social anomalousness of women:

Den Mädchen, die da pfeifen, und den Hühnern, die da krähen,
Denen muss man bei Zeiten den Hals umdrehen.
[Girls who whistle, and hens that crow,
Should have their necks wrung in good time.
(my translation)]
[A whistling maid and a crowing hen
Are neither fit for gods nor men.

Poule qui chante, Prêtre qui danse,
Et Femme qui parle latin,
N'arrivent jamais à belle fin.
[Hens that crow, priests who dance,
And women who speak latin,
Never come to a good end.(my translation)]

Wenn die Henne krâht vor dem Hahn
Und das Weib redet vor dem Mann
So soll man die Henne braten
[If a hen crows before the cock
And a woman talks before a man
The hen should be roasted
And the woman counseled with a stick.(my translation)]

A recent comic strip suggests that this subject retains its fascination and its alarm.

Fig. 13. "Simple Beasts," 22 May 1989. Reprinted by permission: Tribune Media Services.
Figure 17: "Simple Beasts," May 22, 1989. Reprinted by permission: Tribune Media Services.

67. *Ovid's Metamorphosis*, trans. George Sandys, ed. Karl L. Hulley and Stanley T. Vandersall (Lincoln: University of Nebraska Press, 1970): 179-182. The quotations come from l. 374 and ll. 378-410.

68. See Louis de Héricourt, *Les Lois ecclésiastiques de France* (Neuchâtel: Chez la Société Typographique, 1774), G. V., article II. 67, p. 47. Héricourt reported on this case in a note on the marriages of hermaphrodites. He remarked that it was judged "que le mariage contracté par un hermaphrodite, dans lequel les deux sexes sont imparfaits, est nul & abusivement contracté, & lui fait défenses d'en contracter un autre" ("that a marriage contracted by a hermaphrodite in whom the two sexes are imperfect is null and abusively contracted, and he/she is prohibited from contracting another" [my translation]). See also Jean Domat, *Les Lois civiles* (Paris: Durard, 1777): 10.

69. "Mémoire pour Anne Grandjean, connu sous le nom de Jean-Baptiste Grandjean, accusé et appellant, contre monsieur le procureur général, accusateur et intimé. Question: Un hermaphrodite qui a épousé une fille, peut-il être réputé profanateur du sacrement de mariage, quand la nature qui le trompoit l'appelloit à l'état de mari" (Paris: n.p., 1765). The reporter was a M. de Glatigny, and the lawyer M. Vermeil. The printer was Louis Cellot in the rue Dauphine. Citations are taken from Paul Hélot, "Les tribulations d'un mari hermaphrodite en XVIIIe siècle (Sa situation vis-à-vis de la juridiction ecclésiastique, jadis et aujourd'hui)," *Histoire de la Médecine* 10 (March 1960): 7-21, who reprints large portions of the original "Mémoire." English translations are mine.

70. A. Debay, *Histoire des Métamorphoses humaines et des monstruosités. Stérilité— Impuissance. Procréation des sexes.—Calligénésie* (Paris: Maquet, 1845): 139. Debay included numerous case reports. Of one Marie-Marguerite, born in 1792, he reported that in late adolescence "ses grâces disparaissaient, sa démarche avait quelque chose d'étrange; de jour en jour, ses goûts changeaient: elle aimait mieux conduire la charrue, la voiture, que de s'acquitter des soins du ménage" ("her charms disappeared, her bearing became rather strange; from day to day, her tastes changed: she preferred driving the plough, the carriage, to taking care of the household" [my translation]) (p. 142). When her civil status was changed to male, she became a farmer, a change Debay understood as an expression of the mistake of her birth registration (p.144).

71. Lynne Friedli, "'Passing Women': A Study of Gender Boundaries in the Eighteenth Century," in *Sexual Underworlds of the Enlightenment*, ed. G.S. Rousseau and Roy Porter (Chapel Hill: University of North Carolina Press, 1988): 234-260. Men who dressed as women, in contrast, were prosecuted not for fraud but for sodomy.

72. William James Barry, M.D., "Case of Doubtful Sex," *New York Journal of Medicine and the Collateral Sciences* 8 (1847): 58. I owe thanks to Janet Golden for drawing my attention to this case.

73. See Theodric Romeyn Beck, M.D., *Elements of Medical Jurisprudence*, 2 vols. (Albany, NY: Websters and Skinners, 1823); Amos Dean, *Principles of Medical Jurisprudence: Designed for the Professions of Law and Medicine* (Albany and New York: Gould, Banks & Gould, 1850): 17-20; and Alfred Swaine Taylor, *A Manual of Medical Jurisprudence*, 7th American ed., ed. John J. Reese, M.D. (Philadelphia: Henry C. Lea, 1873): 668-679. Beck's chapter on "Doubtful Sex" (I, iv, 60-72) comes between chapters on "Impotence and Sterility" and "Rape."

74. Beck cited George Edward Male, M.D., *An Epitome of Juridical or Forensic Medicine, for the use of medical men, coroners, and barristers* (London: T. and G. Underwood, 1816): 196, as his source for the argument that one sex should be selected and then maintained. Male himself relates "that no such being of the human species ever existed, though it was formerly conceived possible, as by an old French law it was enacted, that they should choose one sex only, and keep to it."

75. Taylor, *A Manual of Medical Jurisprudence*, 676. Further refererences are given parenthetically in the text. Coke became Chief Justice of the King's Bench in 1613, when he wrote the *Institutes of the Laws of England*, the first systematic compilation of English criminal law.

76. S.D. Gross, "Hermaphrodism, involving the Operation of Castration and illustrating a new Principle in Juridical Medicine," *American Journal of the Medical Sciences*, new ser. 24 (October 1852): 387. Further refererences are given parenthetically in the text.

77. My translation. "démontre . . . qu'au point de vue physiologique l'hermaphrodite, loin de jouir de la double puissance génésique, est, au contraire, comme le dit si bien Debierre, un être dégénéré, et plus ou moins impuissants, et presque toujours inféond, un être dévoyé jusque dans ses penchants et sa psychose, en raison même de sa sexualité mal établie et pervertie. Devant les lois sociales c'est un malheureux dangereux pour autrui et contre lequel Debierre prémunit la société." A.-B. de Lip Tay, *La Vie sexuelle des monstres avec mille et une observations curieuses sur leurs organes génitaux* (Paris: Publicité Médico-Mondaine, 1904): 255.

78. My translations. "Figurez-vous un de ces hommes-femmes admis au séminaire, dans une congrégation, dans un monastère, dans un régiment, dans un lycée." "Pensez qu'une femme-homme peut tomber dans un couvent ou un pensionnat de jeunes filles, et vous vous convaincrez que l'article 57 du Code civil n'est pas assez prévoyant." Charles Debierre, *L'Hermaphrodisme: Structure, Fonctions, Etat Psychologique et Mental, Etat Civil et Mariage, Dangers et Remèdes* (Paris: J.-B. Baillière, 1891): 142-146. Article 57 of the Civil Code refers to the notion of a "dominant sex."

79. Anne Fausto-Sterling argues the need for five sexes in "The Five Sexes: Why Male and Female Are Not Enough," *The Sciences* 33(2)(1993): 20-24.

80. Charles Debierre, *L'Hermaphrodisme*, 142, 146.

81. Ambroise Tardieu, *Question Médico-légale de l'identité dans ses rapports avec les vices de conformation d'un individu dont le sexe avait été méconnu*, 2nd ed. (Paris: J.B. Baillière, 1874): 63. Tardieu titles the memoirs "Histoire d'Alexina B." All quotations from the French are taken from this edition and page references appear parenthetically in the text.

82. *Herculine Barbin, Being the Recently Discovered Memoirs of a Nineteenth-Century French Hermaphrodite*, trans. Richard McDougall with an introduction by Michel Foucault (New York: Pantheon Books, 1980): 3. All English translations are taken from this edition and appear parenthetically. In addition to Alexina's memoir, this volume contains a story based on the life of Barbin, "A Scandal at the Convent"

("Ein Skandalöser Fall") by Oscar Panizza; the report of Dr. Chesnet, "Question d'identité. Vice de conformation des organes génitaux.—Hypospadias.—Erreur sur le sexe," *Annales d'hygiène publique et de Médecine Légale*, 2nd ser. (14 July 1860): 206-209; the report of E. Goujon, "Etude d'un cas d'hermaphrodisme bisexuel imparfait chez l'homme," *Journal de l'Anatomie et de la Physiologie normales et pathologiques de l'homme et des animaux* 6 (1869): 599-616; contemporary press reports from local newspapers, *L'Echo Rochelais* (18 July 1860) and the *Indépendant de la Charente-Inférieure* (21 July 1860); and legal correspondence from the city of La Rochelle in the Department of Charente-Inférieure. Foucault uses the notes provided by Tardieu. A film derived from the Barbin file and entitled "Les Mystères d'Alexina" was produced by René Feret in 1985. Barbin's civil status was altered by judgment of the civil court of Saint-Jean D'Angély on 21 June 1860.

83. This clash also occurs in Tardieu's edition, in which the memoirs are prefaced by Tardieu's medicolegal treatise on sexual deformities. Vincent Crapanzano comments on the textual dislocations of Barbin's autobiography in "'Self'-Centering Narratives," *Yale Journal of Criticism* 5(3)(1992): 61-79. Crapanzano argues that Barbin has lost access to a genre, that of autobiography, because he cannot write in a world of narrative time. Time for Barbin is discontinuous. "Barbin was quite literally a trajectile," Crapanzano writes, "—thrown across an uncrossable border—and this trajectory, this being thrown across, not only questioned the system of classification that created that border but its very assumption" (p. 62).

84. There are hundreds of documented cases of hermaphroditism in the medical literature, including such oddities as the report by Antoine Mertrud of the infamous eighteenth-century case of Michel-Anne Droüart, whose parents displayed her for profit, in *Hermaphrodite. Dissertation*, with engraving by Jacques Gautier D'Agoty (Paris, 1749). James Akin published a pamphlet in 1839 called *Facts connected with the Life of James Carey, whose eccentrick habits caused a post mortem examination, by Gentlemen of the Faculty; to determine whether he was Hermaphroditic: with Lithographed Drawings, made at their request* (Philadelphia: n.p., 1839). (The College of Physicians of Philadelphia owns the Mertrud and Akin documents, and I want to thank Thomas Horrocks for bringing them to my attention.) Sir James Young Simpson describes cases in *Anaesthesia, Hospitalism, Hermaphroditism and a Proposal to Stamp Out Small-Pox and Other Contagious Diseases* (Edinburgh: Adam and Charles Black, 1871): 407-542. Nineteenth-century medical periodicals are filled with such cases. To name but a few: "Proceedings of the Westminster Medical Society," October 24, 1829 in *The Lancet* 1 (October 31, 1829): 181-182; D.J. Tillotson, "Case of a Hermaphrodite," *Medical and Surgical Reporter* 63 (December 6, 1890): 647-648; George Tully Vaughan, "A Case of Hermaphroditism," *The New York Medical Journal* 53 (January 31, 1891): 125-126. Franz Ludwig von Neugebeuer provided many case reports in his compendious *Hermaphroditismus beim Menschen* (Leipzig: Werner Klinkhardt, 1908).

85. E. Goujon, "Etude d'un cas d'hermaphrodisme bisexuel imparfait chez l'homme," *Journal de l'Anatomie et de la Physiologie normales et pathologiques de l'homme et des animaux* 6 (1869): 601. Further references are in the text; English translations come from the Foucault edition.

86. Ambroise Tardieu, *Question médico-légale de l'identité* (Paris: J.B. Baillière, 1874): 59. Tardieu was also the author of the two-volume *Dictionnaire de médecine légale, de jurisprudence, et de police médicale* (1858); *Etude médico-légale sur les attentats des moeurs* (2nd ed., 1858); and, with M. Laugier, of "Contribution à l'histoire des monstruosités considérée au point de vue de la médecine légale à l'occasion de l'exhibition publique du monstre pycopage Millie-Christine," *Annales d'Hygiène Publique et de Médecine Légale*, 2nd ser. 41 (January 1874): 340–371.

87. John Quincy, *Lexicon Physico-Medicum*, 2nd ed. (London: E. Bell, W. Taylor, and J. Osborn, 1722): 201.

88. James Parsons, *A Mechanical and Critical Enquiry into the Nature of Hermaphrodites* (London: J. Walthoe, 1741): 7. Friedli also cites this passage in "'Passing Women'," in *Sexual Underworlds of the Enlightenment*, ed. G.S. Rousseau and Roy Porter (Chapel Hill: University of North Carolina Press, 1988): 249.

89. Arnold I. Davidson, "Sex and the Emergence of Sexuality," *Critical Inquiry* 14 (1987): 16–48. On Davidson's account, we would have to fill the place of sexuality in earlier periods with those things that counted as transgressing categories of the normative. Sexuality becomes the modern version of carnival. For Davidson, "sexuality" is produced by a newly invented system of psychiatric knowledge with its own peculiar form of reasoning. Davidson ignores the history of sexual underworlds in his analysis.

90. Bernice L. Hausman offers a groundbreaking analysis of transsexualism with respect to medical technologies in "Demanding Subjectivity: Transsexualism, Medicine, and the Technologies of Gender," *Journal of the History of Sexuality* 3(2)(1992): 270–302. See also Marjorie Garber, "Spare Parts: The Surgical Construction of Gender," *differences* 1(3)(1989): 137–159.

91. The repair was done using the Denis Browne procedure described in D. Browne, "An Operation for Hypospadias," *Proceedings of the Royal Society of Medicine* 42 (1949): 466–468. For discussions of hypospadias repair, see L.H. Backus and C.A. DeFelice, "Hypospadias—Then and Now," *Plastic and Reconstructive Surgery* 25 (1960): 146–160, and P.P. Kelalis, R.C. Benson, Jr., and Ormond S. Culp, "Complications of Single and Multistage Operations for Hypospadias: A Comparative Review," *Journal of Urology* 118 (1977): 657–658. Backus points out that as recently as 1900, surgeons considered this condition so impossible to repair that castration in childhood was recommended by some. It is of passing interest that the first documented successful artificial insemination was performed in 1776 by John Hunter for a couple in which the husband had hypospadias.

92. R.R. Gordon, F.J.P. O'Gorman, C.J. Dewhurst, C.E. Blank, "Chromosome Count in a Hermaphrodite with some Features of Klinefelter's Syndrome," *Lancet* 2, No. 7153 (October 1, 1960): 737, 738.

93. The boy's physicians report that "[h]e was finding this [gynecomastia—his enlarged breasts] a very great embarrassment at school." His "main emotional reaction" to surgery, they report, "was of delight at having got rid 'of these things' from his chest wall." Gordon et al., "Chromosome Count," 736, 737.

94. Gordon et al., "Chromosome Count," 738.

95. Cuthbert E. Dukes, "Genetics in Relation to Surgery: A Historical Review," *Annals of the Royal College of Surgeons of England* 28 (1961): 10.

96. Sheldon J. Segal and Warren C. Nelson, "Developmental Aspects of Human Hermaphrodism: The Significance of Sex Chromatin Patterns," *Journal of Clinical Endocrinology and Metabolism* 17 (1957): 676-692.

97. See Anne Fausto-Sterling, "The Five Sexes," *The Sciences* 33(2)(1993): 20-24.

98. There are exceptions in non-European cultures, such as the categories of the *berdache* in native North America, the *basir* among the Ngadju of Borneo, and the *bissu* of southern Sulawesi. Randolph Trumbach points out that European cultures are unique in objecting to all forms of homosexuality; see Randolph Trumbach, "London's Sodomites," *Journal of Social History* 11 (1977): 2. For a very different discussion of the cultural space for a third sex, see Harriet Whitehead, "The Bow and the Burden Strap: A New Look at Institutionalized Homosexuality in Native North America," in *Sexual Meanings: The Cultural Construction of Gender and Sexuality*, ed. Sherry B. Ortner and Harriet Whitehead (Cambridge: Cambridge University Press, 1981): 80-115. See also Donald G. Forgey, "The Institution of the Berdache Among the North American Plains Indians," *Journal of Sex Research* 11 (1975): 1-15; James L. Peacock, "Symbolic Reversal and Social History: Transvestites and Clowns of Java," in *The Reversible World: Symbolic Inversion in Art and Society*, ed. Barbara A. Babcock (Ithaca: Cornell University Press, 1978): 209-224; Serena Nanda, *Neither Man Nor Woman: The Hijras of India* (Belmont, CA: Wadsworth Publishing Co., 1990); and Charlotte Furth, "Androgynous Males and Deficient Females: Biology and Gender Boundaries in Sixteenth- and Seventeenth Century China," in *The Lesbian and Gay Studies Reader*, ed. Henry Abelove, Michele Aina Barale, and David M. Halperin (New York: Routledge, 1993): 479-497. John Money reports a genetic strain of intersexuality that recurs in New Guinea, in "Psychologic Considerations of Sex Assignment in Intersexuality," in *Clinics in Plastic Surgery* 1 (1974): 215, and cites C. Gajdusek, "Congential Absence of the Penis in Muniri and Simbari Kukukuku People of New Guinea," *Abstracts of the American Pediatric Society*, 74th Annual Meeting, 1964. For discussions of 5 alpha-reductase deficiency in the Dominican Republic and the different cultural treatment ambiguous gender receives there, see J. Imperato-McGinley, L. Guerrero, T. Gautier, and R.E. Peterson, "Steroid 5 alpha-reductase deficiency in man: an inherited form of male pseudohermaphroditism," *Science* 186 (1974): 1213-1215; Imperato-McGinley, Peterson, R. Stoller, and W.E. Goodwin, "Androgens and the evolution of male gender identity among male pseudohermaphrodites with 5 alpha-reductase deficiency," *New England Journal of Medicine* 300 (1979): 1233-1237; and Peterson, Imperato-McGinley, Gautier, and E. Sturla, "Hereditary steroid 5 alpha-reductase deficiency: a newly recognized cause of male pseudohermaphroditism," in *Genetic Mechanisms of Sexual Development*, ed. H. Lawrence Vallet and Ian H. Porter, Birth Defects Institute Symposium Series, No. 7 (New York: Academic Press, 1979): 149-173. For a discussion of Julianne Imperato-McGinley's conclusions from the Santo Domingo data, see Anne Fausto-Sterling, *Myths of Gender* (New York: Basic Books, 1985): 86-88.

99. Nancy Chodorow does, however, argue that "gender difference is not absolute, abstract, or irreducible; it does not involve an essence of gender" in "Gender, Relation, and Difference in Psychoanalytic Perspective," in *The Future of Difference*, ed. Hester Eisenstein and Alice Jardine (Boston: G.K. Hall, 1980): 4.

100. My translation. "Les lois de toutes les nations admettent, parmi les membres des sociétés qu'elles régissent, deux grandes classes d'individus fondées sur la différence des sexes. A l'une de ces classes sont imposés des devoirs dont l'autre est exempte, mais aussi accordés des droits dont l'autre est privée. La destinée de chaque nouveau-né, du moment où son sexe est connu ou déclaré connu, se trouve donc réglée à l'avance pour les circonstances principales de sa vie: il est rangé dans l'une ou l'autre de ces deux grandes classes à laquelle appartiennent des fonctions non seulement différentes, mais presque inverses dans la famille aussi bien que dans la société. A cet égard, point d'intermédiaires; nos lois n'en admettent pas l'existence, n'en prévoient pas la possibilité." Isidore Geoffroy Saint-Hilaire, *Histoire générale*, III: 572-573.

101. Review of "Joseph" Geoffroy Saint-Hilaire's *An Anatomical and Physiological Inquiry into the Nature of Hermaphrodism in Man and Animals* (Paris, 1833) in *The Lancet* 2 (April 6, 1833): 51.

102. For a broader discussion of the plasticity and historically relative nature of gender, see Salvatore Cucchiari, "The Gender Revolution and the Transition from Bisexual Horde to Patrilocal Band: The Origins of Gender Hierarchy," in *Sexual Meanings: The Cultural Construction of Gender and Sexuality*, ed. Sherry B. Ortner and Harriet Whitehead (Cambridge: Cambridge University Press, 1981): 31-79. A useful collection of essays on this subject can be found in *Third Sex, Third Gender: Beyond Sexual Dimorphism in Culture and History*, ed. Gilbert Herdt (New York: Zone Books, 1994).

103. See Peter Stallybrass and Allon White, *The Politics and Poetics of Transgression* (Ithaca, NY: Cornell University Press, 1987).

104. "Lola," The Kinks, on *Come Dancing with The Kinks: The Best of the Kinks, 1977-1986*, Arista Records AL 11-8428, 1986. The song was first recorded in 1973, on an album called *Lola vs Powerman and the Money-go-round*. I have been denied permission to cite from the lyrics.

105. Carroll Smith-Rosenberg, "Davy Crockett as Trickster: Pornography, Liminality and Symbolic Inversion in Victorian America," in *Disorderly Conduct: Visions of Gender in Victorian America* (New York: Oxford University Press, 1985): 91. See also her "The New Woman as Androgyne: Social Disorder and Gender Crisis, 1870-1936" in the same volume, 245-296.

106. I owe this formulation to Elaine Scarry.

5. *Dangerous Wombs*

1. John Locke, *An Essay Concerning Human Understanding*, ed. Peter H. Nidditch (1975; reprinted Oxford, 1979): 1. Cited by William Walker, "Locke Minding

Women: Literary History, Gender, and the Essay," *Eighteenth-Century Studies* 23(1) (1990): 249. Locke's use of this quotation illustrates that physicians in early modern Europe were able to acknowledge ignorance about generation, pregnancy, and fetal development. (We think of Locke as a philosopher and political theorist, but he was also, of course, a physician.) Indeed, one of the underlying questions of the period concerned what it is possible to know about the human body.

2. See Lindsay Wilson, *Women and Medicine in the French Enlightenment: The Debate over Maladies des femmes* (Baltimore: The Johns Hopkins University Press, 1993): 65.

3. William Blackstone, *Commentaries on the Laws of England* (London: n.p., 1765): I, 129. Thomas Cobham wrote in his manual for confessors (c. 1216) that striking a pregnant woman in such a way that she miscarried was punishable by death if the fetus were "formed," but required only monetary restitution if the fetus were "unformed." Cited by G.R. Dunstan, "Introduction: Text and Context," in *The Human Embryo: Aristotle and the Arabic and European Traditions*, ed. G.R. Dunstan (Exeter: University of Exeter Press, 1990): 5. Angus McLaren comments on the demise of quickening as a juridical definition in *Reproductive Rituals: The Perception of Fertility in England from the Sixteenth to the Nineteenth Century* (London: Methuen, 1984): 138. Barbara Duden also remarks on this phenomenon in *Disembodying Women: Perspectives on Pregnancy and the Unborn* (Cambridge, MA: Harvard University Press, 1993): 82.

4. Barbara Duden argues that this change occurred in the nineteenth century, when the woman ceded place to the fetus as the focus of pregnancy, in *Disembodying Women*, 94–95 (Chapter 15, "The Uterine Police"). Before the eighteenth century, physicians demonstrated little interest in probing the interior of the female body. As internal imaging techniques became more available and accepted, women's own testimony began to lose credence.

5. See Lisa Cody, "'The Doctor's in Labour; or a New Whim Wham from Guildford'," *Gender & History* 4(2) (1992): 175–196. Cody argues that "in the eighteenth century, doctors were forced to listen to women to gain knowledge about reproduction" (p. 191) and, like Duden, dates the silencing of the female body to the nineteenth century, when medicine gained a kind of authority that no longer needed to be authenticated by women's voices. Indeed, a 1959 article in a medical journal not only questions the authority of women's accounts of their own experience of pregnancy but actively terms such accounts a factor in misdiagnosing causes of birth malformations. "*Maternal memory bias* is a source of error most difficult to control. The mother of a malformed child is likely to try hard to find a 'reason' for the child's defect in the events of the pregnancy. Thus, the mother of an abnormal child will be more likely to remember unusual events during the pregnancy than will the mother of a normal child" (emphasis in original): F.C. Fraser, "Causes of Congenital Malformations in Human Beings," *Journal of Chronic Diseases* 10 (August 1959): 97–110.

6. *Johnson* v. *State of Florida*, 578 So. 2d 419 (Fla. Dist. Ct. App. 1991). For discussions of this case, see Christina von Cannon Burdette, "Fetal Protection—An Overview of Recent State Legislative Response to Crack Cocaine Abuse by

Pregnant Women," *Memphis State University Law Review* 22(1) (1991): 119-135, Wendy Chavkin, "Jennifer Johnson's Sentence," *Journal of Clinical Ethics* 1 (1991): 140-141; Dorothy E. Roberts, "Punishing Drug Addicts Who Have Babies: Women of Color, Equality, and the Right of Privacy," *Harvard Law Review* 104(7) (1991): 1419-1482; and Ruth Colker, *Abortion & Dialogue: Pro-Choice, Pro-Life, & American Law* (Bloomington: Indiana University Press, 1992).

7. *Johnson v. State of Florida*, 602 So. 2d 1288 (Fla. 1992).

8. Center for Reproductive Law and Policy, "Punishing Women for their Behavior During Pregnancy: A Public Health Disaster," February 2, 1993. This pamphlet lists the cases to date and is available from the Center, 120 Wall St., New York, NY 10005. My thanks to Kathryn Kolbert, Vice President of the Center, for this information.

9. *State of Florida* v. *Johnson*, No. E89-890-CFA (Fla. Cir. Ct. July 13, 1989), affirmed, No. 89-1765, 1991 Fla. App. (Fla. Dist. Ct. App. April 18, 1991).

10. Dorothy E. Roberts, "Punishing Drug Addicts Who Have Babies: Women of Color, Equality, and the Right of Privacy," *Harvard Law Review* 104 (7) (1991): 1472. Roberts points out that crack cocaine addiction—overwhelmingly a phenomenon of African-Americans—has been singled out for these prosecutions, even though there is compelling evidence that other kinds of prenatal drug use—alcohol, marijuana—cause fetal harm. These drugs tend to find niches more in middle-class white populations. Johnson's crack addiction came to light because she confided to her obstetrician at a public hospital. The state organized its prosecution on the theory that Johnson's efforts to get help for her addiction showed that she knew her drug use harmed her fetus. See Roberts, "Drug-Addicted Mothers," p. 1449. In *People* v. *Hardy*, 469 N.W. 2d50 (Mich. App. 1991), the court held that use of cocaine by a pregnant woman cannot be subject to criminal prosecution under a statute that prohibits delivery of cocaine.

11. 410 U.S. 113 (1973) at 162. An interesting contrast to *Roe* v. *Wade*, and an historical precursor of abortion debates, can be found in the mid-eighteenth-century *Petition of the Unborn Babes to the Censors of the Royal College of Physicians of London*, 2nd ed. (London: M. Cooper, 1751). This document represents a response to two physicians of the Royal College, referred to as Drs. Pocus and Maulus, who argued against an inquiry into the deaths of six children delivered by a man-midwife. The *Petition* tried to convince the physicians that "these Children . . . were distinct Beings . . . and were equally entitled to Preservation with their Mothers," (pp.4-5).

12. Mary Poovey argues that the trimester scheme for viability used in *Roe* v. *Wade* produces a tripartite division in authority over a pregnancy: Pregnant women have choices in the first trimester, physicians make decisions about the second trimester, and the third trimester is regulated by the courts. Poovey points out that both pregnant women and fetuses challenge the notion of the humanist subject— pregnant women because they are not unitary and fetuses because they are not self-determining: Poovey, "Feminism and Postmodernism—Another View," *boundary 2* 19(2) 1992): 34-52. See Dawn E. Johnsen, "The Creation of Fetal Rights: Conflicts with Women's Constitutional Rights to Liberty, Privacy, and Equal Protection,"

Yale Law Journal 95 (1986): 599-625, and "Maternal Rights and Fetal Wrongs: The Case against the Criminalization of 'Fetal Abuse'," *Harvard Law Review* 101(5) (1988): 994-1012, for arguments against the notion of fetal rights. Johnson points out that criminalizing substance use during pregnancy only hinders pregnant women from seeking drug treatment and from getting prenatal care, for fear of being reported. For the most cogent argument on the other side, see John A. Robertson, "Procreative Liberty and the Control of Conception, Pregnancy, and Childbirth," *Virginia Law Review* 69(3) (1983): 405-464. Robertson assumes that all pregnancies carried to term include a free choice both to be pregnant and not to abort. Several of the articles in *Abortion and the Status of the Fetus*, ed. William B. Bondeson, H. Tristram Engelhardt, Jr., Stuart F. Spicker, and Daniel H. Winship (Dordrecht: D. Reidel Publishing Co., 1983), discuss the personhood status of the fetus from medical, legal, theological, and philosophical points of view: Leonard Glantz, "Is the Fetus a Person? A Lawyer's View," 107-117; Patricia D. White, "The Concept of Person, the Law, and the Use of the Fetus in Biomedicine," 119-157; Gerald D. Perkoff, "Toward a Normative Definition of Personhood," 159-166; H. Tristram Engelhardt, Jr., "Viability and the Use of the Fetus," 183-208; and Caroline Whitbeck, "The Moral Implications of Regarding Women as People: New Perspectives on Pregnancy and Personhood," 242-272. Whitbeck's essay is the only one in the collection that focuses on the experience and situation of pregnant women. She argues that the maternal-fetal relation has been "inadequately conceptualized" (pp. 253-254). A broad discussion of the issues implicated by prenatal technologies and knowledge can be found in Ruth Hubbard, *The Politics of Women's Biology* (New Brunswick: Rutgers University Press, 1990): Part Three, 141-198. Physicians too define the maternal-fetal relation as adversarial, in one textbook even referring to the possibility that "the intrauterine environment is hostile": Leo R. Boler, Jr. and Norbert Gleicher, "Maternal versus Fetal Rights," Chapter 14 of *Principles of Medical Therapy in Pregnancy*, ed. Norbert Gleicher (New York: Plenum Press, 1985): 141. The authors refer to "a precarious medicolegal situation" and conclude that "it remains to be determined whether fetal indications allow infringement on maternal rights." See also W.A. Bowes, Jr. and D. Selgestad, "Fetal versus Maternal Rights: Medical and Legal Perspectives," *Obstetrics and Gynecology* 58 (1981): 209-214.

13. For discussions about writings and attitudes concerning women's reproductive health in medieval medicine, see *Medieval Woman's Guide to Health: The First English Gynecological Handbook*, ed. Beryl Rowland (Kent, OH: Kent State University Press, 1981); Melitta Weiss-Amer, "Medieval Women's Guides to Food during Pregnancy: Origins, Texts, and Traditions," *Canadian Bulletin of Medical History* 10 (1) (1993): 5-23; and John F. Benton, "Trotula, Women's Problems, and the Professionalization of Medicine in the Middle Ages," *Bulletin of the History of Medicine* 59(1) (1985): 30-53. An excellent account of early modern beliefs about menstruation can be found in Patricia Crawford, "Attitudes to Menstruation in Seventeenth-Century England," *Past and Present* 91 (1981): 47-73.

14. Robert W. Fogel, "Nutrition and the Decline in Mortality Since 1700: Some Additional Preliminary Findings," Working Paper 1802 (London: National Bureau

of Economic Research, 1986): 68-69. For another discussion of nutrition during pregancy, see Michael K. Eshleman, "Diet During Pregnancy in the Sixteenth and Seventeenth Centuries," *Journal of the History of Medicine* 30 (1975): 23-39. I am indebted here to an excellent overview of pregnancy among the landed elite in England in Linda A. Pollock, "Embarking on a Rough Passage: The Experience of Pregnancy in Early Modern Society," in *Women as Mothers in Pre-Industrial England*, Wellcome Institute Series in the History of Medicine, ed. Valerie Fildes (London: Routledge and Kegan Paul, 1990): 39-67. See also Adrian Wilson, "The Perils of Early Modern Procreation: Childbirth With or Without Fear?" *British Journal for Eighteenth-Century Studies* 16(1) (1993): 1-20. Advice and practice concerning diet differs markedly from culture to culture and is significantly marked by class as well as by nationality and ethnic group.

15. See Patricia Crawford, "The Construction and Experience of Maternity in Seventeenth-Century England," in *Women as Mothers in Pre-Industrial England*, 3-38, especially 9-10. Ellen Fitzpatrick discusses one case of attitudes and treatment of unwed mothers in North America during this period in "Childbirth and an Unwed Mother in Seventeenth-Century New England," *Signs* 8(4) (1983): 744-749. For other historical discussions of prosecuting pregnant women, see June K. Burton, "Human Rights Issues Affecting Women in Napoleonic Legal Medicine Textbooks," *History of European Ideas* 8(4) (1987): 427-434, and Adrienne Rogers, "Women and the Law," in *French Women and the Age of Enlightenment*, ed. Samia Spencer (Bloomington: Indiana University Press, 1984): 33-48. Later changes in these views, and changes in views of female sexual pleasure more generally, are traced for North America in Carl N. Degler, "What Ought to Be and What Was: Women's Sexuality in the Nineteenth Century," *American Historical Review* 79 (1974): 1467-1490, and for England in Angus McLaren, "Policing Pregnancies: Changes in Nineteenth-Century Criminal and Canon Law," in *The Human Embryo: Aristotle and the Arabic and European Traditions*, 187-207. McLaren notes that the legal status of quickening was dismantled in England by the Offenses Against the Person Act of 1837.

16. Supreme Judicial Court of Massachusetts, *Dietrich* v. *Northampton*, 138 Mass. 14 (1884), 52, Am. Rep. 242.

17. See Tracy Dobson and Kimberly K. Eby, "Criminal Liability for Substance Abuse During Pregnancy: The Controversy of Maternal v. Fetal Rights," *Saint Louis University Law Journal* 36(3) (1992): 655-694. Leonard Glantz writes that "although the law rarely lends itself to blanket statements, it can be clearly stated that a fetus is not a person under the law. . . . [F]etuses are not required to be protected," in "Is the Fetus a Person? A Lawyer's View," in *Abortion and the Status of the Fetus,* 116.

18. "No: 'Fetal Abuse': Should We Recognize It as a Crime?" *ABA Journal* 75 (August 1989): 39. See also Paltrow, "When Becoming Pregnant Is a Crime," *Criminal Justice Ethics* 9(1) (1990): 41-47. This issue is a symposium on "Criminal Liability for Fetal Endangerment." It is important to mention that there remains controversy over the precise effects of maternal cocaine use on a gestating fetus. It is difficult to single out intrauterine cocaine exposure as a factor in fetal development,

because often prenatal cocaine exposure is only one of a number of factors—poor nutrition, lead poisoning, cigarettes, other drugs, as well as multiple short-term foster placements, homelessness, abuse, and the like—determining outcomes such as low birth weight or early cognitive deficits. For a discussion, see Linda C. Mayes, Richard H. Granger, Marc H. Bornstein, and Barry Zuckerman, "The Problem of Prenatal Cocaine Exposure: A Rush to Judgment," *Journal of the American Medical Association* 267(3) (January 15, 1992): 406-408. The authors argue that factors such as methodologic problems in determining the developmental effects of cocaine use during pregnancy and bias in clinical decisions about reporting low-income and black women for drug use not only make it difficult to assess the problem but also label a large group of children as "irremediably damaged" and work "toward exempting society from having to face other possible explanations of the children's plight—explanations such as poverty, community violence, inadequate education, and diminishing employment opportunities that require deeper understanding of wider social values" (pp. 408, 406). Physicians have remarked on external factors affecting fetal growth such as socioeconomic conditions and tobacco smoking. See Donald B. Cheek, Joan E. Graystone, and Margaret Niall, "Factors Controlling Fetal Growth," *Clinical Obstetrics and Gynecology* 20(4) (1977): 925-942.

19. See Barbara Duden, *The Woman Beneath the Skin: A Doctor's Patients in Eighteenth-Century Germany*, trans. Thomas Dunlap (Cambridge, MA: Harvard University Press, 1991), and Ludmilla Jordanova, "Guarding the Body Politic: Volney's Catechism of 1793," in *1789: Reading, Writing, Revolution*, Proceedings of the Essex Conference on the Sociology of Literature, ed. Francis Barker, Jay Bernstein, Peter Hulme, Margaret Iverson, and Jennifer Stone (Colchester, U.K.: University of Essex Press, 1982): 12-21. Studies of the history of visualizing female reproductive organs and the fetus in the womb demonstrate the slippery authority inherent in attempts to know women's bodies from without. See especially Jordanova's study of Hunter's 1774 obstetrical atlas, *Anatomy of the Human Gravid Uterus*, "Gender, Generation, and Science," in *William Hunter and the 18th-Century Medical World*, ed. William Bynum and Roy Porter (Cambridge: Cambridge University Press, 1985): 385-412; Janelle Sue Taylor, "The Public Foetus and the Family Car: From Abortion Politics to a Volvo Advertisement," *Science as Culture* 3(4)17 (1993): 601-618; and Karen Newman, "Fetal Politics: Medical Representation and the Discourse of Rights," paper given at the English Institute, Harvard University, August 1993, and the College of Physicians of Philadelphia, November 1993. I am grateful to Karen Newman for sharing her work with me.

20. For one view of how mechanistic ideas of physiology operated in eighteenth-century literature, see Juliet McMaster, "The Body Inside the Skin: The Medical Model of Character in the Eighteenth-Century Novel," *Eighteenth-Century Fiction* 4(4) (1992): 277-300.

21. See Thomas Laqueur, *Making Sex: Body and Gender from the Greeks to Freud* (Cambridge, MA: Harvard University Press, 1990): 283. Lynn Salkin Sbiroli offers an interesting political analysis of the concept of *regeneration* as promising social reform in "Generation and Regeneration: Reflections on the Biological and

Ideological Role of Women in France," in *Literature and Medicine during the Eighteenth Century*, ed. Marie Mulvey Roberts and Roy Porter (London: Routledge, 1993): 266-285.

22. This was especially, but not only, true in the Dutch Republic.

23. On Swift's deployment of this idea, see Susan Bruce, "The Flying Island and Female Anatomy: Gynaecology and Power in *Gulliver's Travels*," *Genders* 2 (1988): 60-76. Swift is always difficult to pin down because he slips in and out of representing medical opinion and of mocking it.

24. See Mary Poovey, *Uneven Developments: The Ideological Work of Gender in Mid-Victorian Engand* (Chicago: University of Chicago Press, 1988): 9-10.

25. Barbara Stafford, *Body Criticism: Imaging the Unseen in Enlightenment Art and Medicine* (Cambridge, MA: MIT Press, 1991): 293.

26. Daniel Turner, *De Morbis Cutaneis* (London: R. Bonwicke et al., 1714): 102-128, 105. Further references will be given parenthetically in the text.

27. This was especially clear in the controversies surrounding arguments later in the century about Caesarian sections, which more often than not killed the women on whom they were performed. These debates reveal an earlier history of medical discussions about maternal, fetal, and physician rights. On the conflicting and ambivalent scientific writings concerning female sexual anatomy, see Estelle Cohen, "The Body as a Historical Category: Science and Imagination *ca.* 1660-1760," in *The Good Body: Asceticism in Contemporary Culture*, ed. Mary G. Winkler and Letha A. Cole (New Haven: Yale University Press, 1994): 67-90. I am grateful to Estelle Cohen for sharing her work with me in manuscript and for her comments on this chapter.

28. James Augustus Blondel, *The Strength of Imagination in Pregnant Women* (London: J. Peele, 1727): Preface, unpaginated. Further references will be given parenthetically in the text. Both Stafford, in *Body Criticism*, 314-315, and Marie-Hélène Huet, in *Monstrous Imagination* (Cambridge, MA: Harvard University Press, 1993): 64-67, take up this debate. See also Philip K. Wilson, "Out of Sight, Out of Mind? The Daniel Turner-James Blondel Debate over Maternal Impressions," M.A. thesis, The Johns Hopkins University, 1987. Huet's suggestive and useful book focuses on resemblance and representation, as does Stafford's visual iconography.

29. Curiously, a 1908 obstetrics textbook discussed cravings in a very different way. They were taken seriously, even noted as a possible sign of pre-eclampsia, but despite granting that cravings were a common feature of many pregnancies, this text suggested that it should always be assumed such cravings are "deleterious" and that pregnant women must exercise self-control in order to overcome their desires. This text later asserted that "reproduction is the test of a nervous woman, and should she be in any way mentally or physically weak, her brain may give way under the trial." Ernest Hastings Tweedy, *Tweedy's Practical Obstetrics*, 6th ed., ed. Bethel Solomons (London: Oxford University Press, 1929; original work published in 1908): 218, 496.

30. See Marie-Hélène Huet, *Monstrous Imagination*, 48-49. Stafford also connects

epidermal stains with Original Sin in *Body Criticism*, 318.

31. *Aristotle's Compleat and Experienc'd Midwife*, 4th ed. (London: W. Salmon, 1721). This work was an anonymous and popular version of Aristotle's *De generatione et corruptione* and was continuously in print into the 1930s in Great Britain. See Paul-Gabriel Boucé, "Imagination, Pregnant Women, and Monsters in Eighteenth-Century England and France," in *Sexual Underworlds of the Enlightenment*, ed. G.S. Rousseau and Roy Porter (Chapel Hill: University of North Carolina Press, 1988): 86–100.

32. John Maubray, *The Female Physician* (London: James Holland, 1724): 75–76, 77. Maubray was considered a mystic and not taken very seriously by medical practitioners. Cited by Dolores Peters, "The Pregnant Pamela: Characterization and Popular Medical Attitudes in the Eighteenth Century," *Eighteenth-Century Studies* 14(4) (1981): 437.

33. *The True Description of a Childe with Ruffes*, 1566, British Library, Huth Collection 50, 34. Cited by Patricia Crawford, "The Construction and Experience of Maternity in Seventeenth-Century England," in *Women as Mothers in Pre-Industrial England: Essays in Memory of Dorothy McLaren*, ed. Valerie Fildes (London: Routledge, 1990): 7.

34. This became a major popular scandal in England, particularly for John Howard, the physician who claimed to have delivered the rabbits, and for Nathaniel St. André and Samuel Molyneux, who traveled to Guildford to ascertain the veracity of the reports. St. André was Anatomist-Royal (the royal physician), and when the hoax was exposed, he became a laughingstock, lost his job, and ended his life in poverty. The physician Richard Manningham questioned the authenticity of the events and exposed the fraud, exacting a confession from Tofts. Curiously, one of the many pamphlets that were published in England about this affair was signed by one "Lemuel Gulliver." On the Mary Tofts story, see S.A. Seligman, "Mary Tofts: The Rabbit Breeder," *Medical History* 5 (1961): 349–360 and Glennda Leslie, "Cheat and Imposter: Debate Following the Case of the Rabbit Breeder," *The Eighteenth Century: Theory and Interpretation* 27(3) (1986): 269–286. Lisa Cody offers a fascinating analysis of popular responses to the case and the way it has been recounted in "'The Doctor's in Labour; or a New Whim Wham from Guildford'," *Gender & History* 4(2) (1992): 175–196. Most accounts, Cody points out, pit the gullible and misguided St. André against the skeptical rationalist Manningham. Cody uses the case to illustrate the precarious positioning of male medical authority with respect to generation and reproduction.

35. *Gentleman's Magazine* 16 (1746): 270. Cited by Roy Porter, "Lay Medical Knowledge in the Eighteenth Century: The Evidence of the *Gentleman's Magazine*," *Medical History* 29 (1985): 148. The best places to seek case examples of birth malformations ascribed to the maternal imagination are in the manuscript casebooks of practicing midwives and obstetricians. Two studies that use these sources are Amalie M. Kass, "The Obstetrical Casebook of Walter Channing, 1811–1822," *Bulletin of the History of Medicine* 67(3) (1993): 494–523, and Barbara Duden, *The Woman*

Beneath the Skin: A Doctor's Patients in Eighteenth-Century Germany, trans. Thomas Dunlap (Cambridge, MA: Harvard University Press, 1991), though neither Kass nor Duden focuses on the maternal imagination.

36. This example is cited by Angus McLaren in *Reproductive Rituals: The Perception of Fertility in England from the Sixteenth to the Nineteenth Century* (London: Methuen, 1984): 40. Jacques Gélis, in *History of Childbirth: Fertility, Pregnancy and Birth in Early Modern Europe,* trans. Rosemary Morris (Boston: Northeastern University Press, 1991) (originally published in 1984 as *L'Arbre et le fruit*) gives an overview of ideas about cravings and imaginings (pp. 53-58).

37. Barbara Stafford, *Body Criticism,* p. 313.

38. For useful background, see Keith Thomas, *Religion and the Decline of Magic* (New York: Charles Scribner's Sons, 1971).

39. Edward Stillingfleet, *Origines sacrae, or a Rational Account of the Grounds of Christian Faith, as to the Truth and Divine Authority of the Scriptures* (London: R.W. for Henry Mortlock, 1663): 143, and Samuel Clarke, *A Discourse Concerning the Being and Attributes of God, the Obligations of Natural Religion, and the Truth and Certainty of the Christian Revelation,* Boyle Lectures of 1705, 8th ed. (London:W. Botham for J. and J. Knapton, 1732), p. 377. Both of these texts are cited by Lorraine Daston in her informative "Marvelous Facts and Miraculous Evidence in Early Modern Europe," *Critical Inquiry* 18(1) (1991); 115, 122. The Boyle lecturers cannot be taken to be representative, given the politics in which they were embroiled.

40. See Lynne Tatlock, "Speculum Feminarum: Gendered Perspectives on Obstetrics and Gynecology in Early Modern Germany," *Signs* 17(4) (1992): 725-760. The *Mishnah* stipulates that an embryo can be dismembered to save the life of a woman, "for her life takes precedence over its life" as long as its head has not yet emerged. Once its head is visible, "it may not be touched, since we do not set aside one life for another" (*Ohaloth* 7.6): cited by L.E. Goodman, "The Fetus as a Natural Miracle: The Maimonidean View," in *The Human Embryo: Aristotle and the Arabic and European Traditions,* ed. G.R. Dunstan (Exeter, U.K.: University of Exeter Press, 1990): 88.

41. The Ayurvedic views on embryology also include the notion that children's deformities can be the result of parental sin in this or a previous life. For a discussion, see Vaidya Bhagwan Dash, *Embryology and Maternity in Ayurveda* (New Delhi: Delhi Diary, 1975). See also "Upanisad of the Embryo" and Lakshmi Kapani, "Note on the Garbha-Upanisad," in *Fragments for a History of the Human Body: Part Three,* ed. Michael Feher (Cambridge, MA: MIT Press, 1989): 175-196.

42. See L.D. Hankoff and Ultamchandra L. Munver, "Prenatal Experience in Hindu Mythology," *New York State Journal of Medicine* 80 (December 1988): 2006-2014.

43. Michel de Montaigne, *Essais,* 2 vols. (Paris: Garnier Frères, 1962): I, 109; *The Complete Essays of Montaigne,* trans. Donald M. Frame (Stanford: Stanford University Press, 1965): 75.

44. See Marie-Hélène Huet, "Living Images: Monstrosity and Representation,"

Representations 4 (1983): 73-87, for an analysis.

45. Cited by Robert A. Erickson, *Mother Midnight: Birth, Sex, and Fate in Eighteenth-Century Fiction (Defoe, Richardson, and Sterne)* (New York: AMS Press, 1986): 15.

46. Cited in Valérie Crêtaux Lastinger, "Word of Mouth, Word of Womb: Denis Diderot and Hysterical Discourse," *Women's Studies* 21(2) (1992): 132. See also Erica Rand, "Diderot and Girl-Group Erotics," *Eighteenth-Century Studies* 25(4) (1992): 495-516.

47. Thomas Bull, *Hints to Mothers, for the Management of Health During the Period of Pregnancy, and in the Lying-In Room; with an exposure of popular errors in connexion with those subjects* (New York: Wiley & Putnam, 1842): 11.

48. R.B. Jessup, Jr., "Monstrosities and Maternal Impressions," *Journal of the American Medical Association* 11 (October 3, 1888): 519.

49. *Stedman's Medical Dictionary*, 22nd ed. (Baltimore: Williams & Wilkins, Co., 1972): 623-624.

50. For a discussion, see Marcia Cooper, *Pica: A Survey of the Historical Literature* (Springfield, IL: Charles C. Thomas, Pub., 1957).

51. Nicholas Culpeper, *Directory for Midwives* (London: H. Sawbridge, 1684): 145. Cited by G.S. Rousseau, "Pineapples, Pregnancy, Pica, and *Peregrine Pickle*," in *Tobias Smollett: Bicentennial Essays Presented to Lewis M. Knapp*, ed. G.S. Rousseau and P.-G. Boucé (New York: Oxford University Press, 1971): 85-87.

52. *Rovinsky and Guttmacher's Medical, Surgical, and Gynecologic Complications of Pregnancy*, 3rd ed., ed. Sheldon H. Cherry, Richard L. Berkowitz, and Nathan G. Case (Baltimore: Williams & Wilkins, 1985) contains this ungrammatical sentence alleging that pregnant women act out their conflicts through food: "Examples of cravings are ice cream, and the situation where a woman wakes her husband up in the middle of the night in winter asking for strawberries" (p. 623).

53. Marie-Hélène Huet, *Monstrous Imagination*, 52.

54. François Mauriceau, *The Diseases of Women with Child and in Child-bed*, trans. Hugh Chamberlen (London: John Darby, 1683): 58, 65, 59.

55. Isaac Bellet, *Lettres sur le pouvoir de l'imagination des femmes enceintes* (Paris: Frères Guérin, 1745): 3.

56. Martha Mears, *The Pupil of Nature; or Candid Advice to the Fair Sex* (London: for the author, 1797).

57. My translation. "Les passions de l'âme, comme la colère, le chagrin, la peur, la douleur, peuvent nuire à la conservation de l'embryon, & causent souvent l'avortement dans le commencement de la grossesse, quand on s'y livre trop vivement. Il faut donc exhorter la femme enceinte à se contenir, & ce qui est plus sûr, lui éviter toutes les occasions qui pourroient l'affecter vivement." Jean Astruc, *Traité des maladies des femmes*, 3 vols. (Paris: Guillaume Cavelier, 1765): 3: 246.

58. Joseph Antoine Toussaint Dinouart, *Abrégé de l'embryologie sacrée* (Paris: Nyon,

1762).

59. Theodore Eller, "Recherches sur la force de l'imagination des femmes enceintes sur le foetus," *Mémoires de l'Académie Royale de Prusse* 5 (1759): 166-198.

60. My translation. "L'enfant dans la matrice est à cet égard aussi indépendant de la mère qui le porte, que l'oeuf l'est de la poule qui le couve." *Encyclopédie, ou dictionnaire raisonné des sciences, des arts et des matières*, 36 vols., 3rd ed. (Genève: J.-L. Pellet, 1779): 18: 378.

61. Cited by Barbara Stafford, *Body Criticism*, 316.

62. Daniel Turner, *De Morbis Cutaneis* (London: R. Bonwicke, 1730): 158-160.

63. James Augustus Blondel, *The Strength of Imagination* (London: J. Peele, 1727): 10-11.

64. *Father Malebranche. His Treatise Concerning the Search After Truth*, trans. T. Taylor, 2nd ed. (London: W. Bowyer, 1700): 54.

65. *A Collection of Preternatural Cases and Observations in Midwifery*, 5th ed. (London: n. pub., 1774): 277-278.

66. See Jean Rostand, *La Formation de l'être: Histoire des idées sur la génération* (Paris: Librairie Hachette, 1930).

67. Cited by Joseph Needham, *A History of Embryology* (New York: Abelard-Schuman, 1959): 200, and by Andrea Henderson, "Doll-Machines and Butcher-Shop Meat: Models of Childbirth in the Early Stages of Industrial Capitalism," *Genders* 12 (1991): 113. Marie-Hélène Huet points out that the encasement theory "should have excluded the possibility that the maternal imagination could modify the shape of a progeny that had already been formed since the beginning of time" in *Monstrous Imagination*, 42.

68. Aristotle proposed a much more complex and kinetic view of sexual biology in *On the Generation of Animals* than has usually been ascribed to him by readers who interpret his form-soul/matter-body distinction to underscore a simple binary opposition between male activity and female passivity. I am indebted here to an excellent discussion of Aristotle's ideas about procreation and generation by my colleague Aryeh Kosman in an unpublished manuscript entitled "Male and Female in Aristotle's *Generation of Animals*." It should be pointed out that ideas about generation are highly dependent on cultural mores and assumptions. The Trobriand Islanders, for example, hold the view that the mother alone produces the child. See John D. Biggers, "Generation of the Human Life Cycle," in *Abortion and the Status of the Fetus*, ed. William B. Bondeson, H. Tristram Engelhardt, Jr., Stuart F. Spicker, and Daniel H. Winship (Dordrecht: D. Reidel Publishing Co., 1983): 32.

69. J. Cooke, *A New Theory of Generation* (London: J. Buckland, 1762): 15-16; cited by Nancy Tuana, "The Weaker Seed: The Sexist Bias of Reproductive Theory," *Hypatia* 3(1) (1988): 55. See the chapter on generation in James Drake, *Anthropologia Nova; or, A New system of Anatomy* (London: S. Smith and B. Walford, 1707). This chapter was probably written by Drake's sister, Judith Drake, the author of *An Essay*

in Defence of the Female Sex (London: A. Roper and R. Clavel, 1696). See Estelle Cohen, "The Body as a Historical Category," in *The Good Body*, ed. Mary G. Winkler and Letha A. Cole (New Haven, CT: Yale University Press, 1994): 67–90.

70. See Frederick B. Churchill, "The History of Embryology as Intellectual History," *Journal of the History of Biology* 3(1) (1970): 155–181. See also L.W. B. Brockliss, "The Embryological Revolution in the France of Louis XIV: The Dominance of Ideology," in *The Human Embryo: Aristotle and the Arabic and European Traditions*, 158–186.

71. See Michael R. Harrison, "Unborn: Historical Perspective of the Fetus as a Patient," *Pharos* 45 (1982): 19–24.

72. See Joseph Needham, *A History of Embryology*, 215–216. See also Shirley A. Roe, *Matter, Life, and Generation: 18th-Century Embryology and the Haller-Woolf Debate* (Cambridge: Cambridge University Press, 1981); Josef Warkany, "Congenital Malformations in the Past," *Journal of Chronic Diseases* 10 (1959): 84–96; F.C. Fraser, "Causes of Congenital Malformations in Human Beings," *Journal of Chronic Diseases* 10 (1959): 97–110; and F.C. Frigoletto, Jr. and Suzanne B. Rothchild, "Altered Fetal Growth: An Overview," *Clinical Obstetrics and Gynecology* 20(4) (1977): 915–923.

73. See Marie-Hélène Huet, "Monstrous Imagination: Progeny as Art in French Classicism," *Critical Inquiry* 17(4) (1991): 718–737. Jean-Baptiste Bérard argued that fetal development took place entirely "à l'insu" of the mother's will and, therefore, could not be affected by the imagination or the living conditions of a pregnant woman. For proof, he recorded that of 21,158 infants born in Paris in 1821, 9178 were illegitimate, but none of the latter were monsters, despite the terrible conditions their mothers had to endure during their pregnancies (Jean-Baptiste Bérard, *Causes de la monstruosité et autres anomalies de l'organisation humaine* [Paris: Didot le Jeune, 1835]: 7). This example reads like an early version of the Dan Quayle/Murphy Brown controversy over "family values."

74. Paul-Gabriel Boucé, "Imagination, Pregnant Women, and Monsters," 95, 98, 99.

75. See Andrea Henderson, "Doll-Machines and Butcher-Shop Meat," *Genders* 12 (1991): 112.

76. See Theodore M. Brown, "Descartes, Dualism, and Psychosomatic Medicine," in *The Anatomy of Madness: Essays in the History of Psychiatry*, ed. W.F. Bynum, Roy Porter, and Michael Shepherd (London: Tavistock, 1985): I, 40-62.

77. *Meditations on First Philsophy*, in *Philosophical Writings*, trans. Elizabeth Anscombe (London: Thomas Nelson and Sons, 1969 [1641]): 90, 114-115. Cited by Jacquelyn N. Zita, "Transsexualized Origins: Reflections on Descartes's *Meditations*," *Genders* 5 (1989): 96, 87.

78. Talking about *location* is misleading: L.J. Rather argues that Descartes' specification of the pineal gland does not locate mind but instead represents "a physiological hypothesis regarding the site of mind-body interaction, rather than a proposed solution for the problem of interaction itself." L.J. Rather, "Old and New Views of the

Emotions and Bodily Changes: Wright and Harvey versus Descartes, James and Cannon," *Clio Medica* 1(1) (1985): 11. Rather remarks that "Descartes may have been the first philosopher to point out the physiological survival value of the emotions" (p. 14). See also Robert Hoeldtke, "The History of Associationism and British Medical Psychology," *Medical History* 11(1) (1967): 46-65; L.J. Rather, "G.E. Stahl's Psychological Physiology," *Bulletin of the History of Medicine* 35 (1961): 37-49; and G.S. Rousseau, "An Anthropology of Mind and Body in the Enlightenment," in *Enlightenment Crossings: Pre- and Post-Modern Discourses* (Manchester, U.K.: Manchester University Press, 1991): I, 210-246.

79. Cited by Karl Figlio in "Theories of Perception and the Physiology of Mind in the Late Eighteenth Century," *History of Science* 13(3) (1975): 200.

80. Monfalcon, "Sympathie": 53: 538 (Paris: C.L.F. Pancoucke, 1812-1822). Cited by Ruth Leys, "Background to the Reflex Controversy: William Alison and the Doctrine of Sympathy before Hall," *Studies in History of Biology* 4 (1980): 7. During the course of the eighteenth century, the complex issues that were represented by the philosophical duality mind/body became, if not resolved, then at least transformed into a notion of sensibility as nervous power. As Leys demonstrates, by the early nineteenth century this nervous "power was no longer conceived, as it had been, as a property—albeit unconscious—of the immaterial soul or *mind*; rather, it was conceived to be a purely physiological or motor power of the nervous system" (p. 19).

81. See Roger Smith, "The Background of Physiological Psychology in Natural Philosophy," *History of Science* 11 (1973): 75-123.

82. See G.S. Rousseau, "Science and the Discovery of the Imagination in Enlightened England," *Eighteenth-Century Studies* 3 (1969): 108-135, and "Nerves, Spirits, and Fibres: Towards an Anthropology of Sensibility" and "Towards a Social Anthropology of the Imagination" in *Enlightenment Crossings*, I, 122-141, 1-25.

83. See the letters of Matthew Bramble to Dr. Lewis in Tobias Smollett's 1771 novel *The Expedition of Humphry Clinker,* as well as Nicholas Robinson, *A New System of the Spleen* (London: A. Bettesworth, 1729) and James Graham, *A Lecture on the Generation, Increase, and Improvement of the Human Species* (London: n.pub., 1780). See also *The Languages of Psyche: Mind and Body in the Enlightenment,* ed. G.S. Rousseau (Cambridge: Cambridge University Press, 1990), although none of the essays collected here discuss gender.

84. Cited by Mark Johnson, *The Body in the Mind*, Chapter 6, p. 145. See also David Hartley, "The Pleasures and Pains of Imagination," in *Observations of Man*, 6th ed. (London: Thomas Tegg, 1834).

85. Reva Siegel, "Reasoning from the Body: A Historical Perspective on Abortion Regulation and Questions of Equal Protection," *Stanford Law Review* 44 (2) (1992): 261-381, 296. This comprehensive analysis of the nineteenth century campaign against abortion and its importance for the history and current state of reproductive law fills in many of the gaps between eighteenth century understandings of pregnancy and the move in the late twentieth century to criminalize the behavior of pregnant women. I am grateful to Professor Siegel for bringing her work to my attention.

86. Cited by Reva Siegel, "Reasoning from the Body," 301.

87. Reva Siegel, "Reasoning from the Body," 72.

88. Katha Pollitt, "Fetal Rights: A New Assault on Feminism," *The Nation*, March 26, 1990: 410.

89. James F. Drane, "Medical Ethics and Maternal-Fetal Conflicts," *Pennsylvania Medicine* 95 (7) (1992): 12-16. The American Academy of Pediatrics Committee on Bioethics advises physicians to honor a woman's refusal of fetal procedures, unless the fetus will suffer irrevocable harm without it, the treatment is clearly indicated and likely to be effective, and the risk to the pregnant woman is low. If the woman refuses in the presence of all three conditions, the Committee recommends consultation with a hospital ethics committee and holds turning to courts only as a last resort. See "Fetal Therapy: Ethical Considerations," *Pediatrics* 81(6) (1988): 898-899.

90. Brian McCormick, "Drug trafficking conviction overturned in cocaine-baby case," *American Medical News*, August 10, 1992: 11.

91. "Help the Women Drug Users," *Philadelphia Inquirer*, September 14, 1990: A21. In ironic contrast to the situation Tracy describes, a hospital program at the Medical University of South Carolina in Charleston allegedly used threats of public exposure and of jail to force pregnant women into drug treatment. In February of 1994, the office of Civil Rights of the U.S. Department of Health and Human Services initiated an investigation into whether the South Carolina program is discriminatory, because most of the women tested for drugs or jailed are African-American. See Philip J. Hilts, "Hospital Is Object of Rights Inquiry: Blacks Make Up Majority of Pregnant Women Tested for Drugs and Coerced," *New York Times*, February 6, 1994: A29. In January of 1993, the Philadelphia Commission on Human Relations and the Women's Law Project held a public hearing to investigate drug treatment programs in Philadelphia that were denying their services to pregnant women. The situation is improving: Ten years ago virtually no drug treatment programs would accept pregnant users, whereas now about 75% do. Nevertheless, many drug treatment programs consider pregnant women too high-risk to treat because they do not have obstetricians on staff or believe they cannot handle miscarriages or other emergencies. See Fawn Vrazo, "Some Drug Programs Wary of Pregnant Women," *Philadelphia Inquirer*, January 11, 1994: B1-B2. Philadelphia's fair practices ordinance forbids denial of treatment on the basis of race, color, sex, religion, sexual orientation, or disability.

92. Paraphrased by Caroline Whitbeck, "The Moral Implications of Regarding Women as People," in *Abortion and the Status of the Fetus*, ed. William B. Bondeson, H. Tristram Engelhardt, Jr., Stuart F. Spicker, and Daniel H. Winship (Dordrecht: D. Reidel Publishing Co., 1983): 263.

93. Wendy Chavkin, "Mandatory Treatment for Drug Use During Pregnancy," *Journal of the American Medical Association* 266(11) (September 18, 1991): 1556-1561. Chavkin argues that mandating treatment furthers discrimination against poor minority women. She cites a 1986 study of court-ordered Caesarian sections: 81% were minority women, 24% were women who were non-English speaking, and 100% were clinic patients. In Florida, the rate of drug use reporting among pregnant

women was ten times higher for African-American women than for white women. Instead, Chavkin argues, we need to enhance drug treatment programs so that they are welcoming for pregnant women, are readily available, and are set up to serve their needs. As long as such programs are scarce and of poor quality, debates about mandating them remain merely symbolic. Chavkin points out that the American Medical Association and the American College of Obstetricians and Gynecologists oppose court-ordered treatment or penalties for the behaviors of pregnant women. See AMA Board of Trustees Report, "Legal Interventions During Pregnancy: Court-Ordered Medical Treatments and Legal Penalties for Potentially Harmful Behavior by Pregnant Women," *Journal of the American Medical Association* 264(20) (November 28, 1990): 2663-2670, and American College of Obstetricians and Gynecologists Statement, "Patient Choice: Maternal-Fetal Conflict," *Women's Health Issues* 1 (1990): 13-15. See also Wendy Chavkin, "Drug Addiction and Pregnancy: Policy Crossroads," *American Journal of Public Health* 80 (1990): 483-487; Lynn Paltrow, *Case Overview of Arguments Against Permitting Forced Surgery, Prosecution of Pregnant Women or Civil Sanctions Against Them for Conduct or Status During Pregnancy* (New York: ACLU Reproductive Freedom Project, 1989); M. McNulty, "Pregnancy Police: The Health Policy and Legal Implications of Punishing Pregnant Women for Harm to Their Fetuses," *Review of Law and Social Change* 16 (1987/88): 277-319; W.K. Mariner, L.H. Glantz, and G.J. Arnes, "Pregnancy, Drugs and the Perils of Prosecution," *Criminal Justice Ethics* 9(1) (1990): 30-41; and V. Kolder, J. Gallagher, and M. Parsons, "Court-Ordered Obstetrical Interventions," *New England Journal of Medicine* 316 (1987): 1192-1196.

94. Robert H. Blank, "Emerging Notions of Women's Rights and Responsibilities During Gestation," *Journal of Legal Medicine* 7(4) (1986): 441-469. See also Margery W. Shaw, "Genetically Defective Children: Emerging Legal Considerations," *American Journal of Law and Medicine* 3(3) (1977): 333-340.

95. My focus is on only one aspect of the complicated politics of reproductive change in the late twentieth century—the criminalization of the social conduct of pregnant women. Cases in which courts have mandated that a pregnant woman have a Caesarian section against her will raise some of the same issues of criminalization and adversarial definitions of mother and fetus (as they also did in the eighteenth century). See Mary Sue Henifin, Ruth Hubbard, and Judy Norsigian, "Prenatal Screening," and Janet Gallagher, "Fetus as Patient," both in *Reproductive Laws for the 1990s*, ed. Sherrill Cohen and Nadine Taub (Clifton, NJ: Humana Press, 1989): 155-183, 185-235. I touch on another kind of sanction on the conduct of pregnant women, employers' "fetal protection policies" that exclude fertile women from certain workplaces (see Note 98). For an overview of the legal and ethical issues surrounding new reproductive technologies, see Robert H. Blank, *Regulating Reproduction* (New York: Columbia University Press, 1990).

96. In this treatment, the pregnant woman is viewed as a medium or vehicle rather than an owner of property in herself. See Judith Roof, "The Ideology of Fair Use: Xeroxing and Reproductive Rights," *Hypatia* 7(2) (1992): 63-73, and Dawn Johnsen, "From Driving to Drugs: Governmental Regulation of Pregnant Women's Lives and *Webster*," *University of Pennsylvania Law Review* 138 (1989): 179-215.

97. *Stallman* v. *Youngquist*, 125 Ill. 2d at 276, 531 N.E. 2d at 359. Cited and discussed in Robin M. Trindel, "Fetal Interests vs. Maternal Rights: Is the State Going too Far?" *Akron Law Review* 24(3,4) (1991): 743-762.

98. Janet Gallagher, "Prenatal Invasions and Interventions: What's Wrong with Fetal Rights," *Harvard Women's Law Journal* 10 (1987): 57-58. The view Gallagher critiques has been extended to include all women of child-bearing age as potentially pregnant, a view that underlies employer-enforced "fetal protection" policies that exclude women from certain jobs. The best known of these recent cases was heard by the United States Supreme Court in 1992 in *United Auto Workers* v. *Johnson Controls*. The Court ruled for the women, but in an earlier hearing by the Court of Appeals for the Seventh Circuit, Judge John L. Coffey remarked, "This is the case about the women who want to hurt their fetuses." This remark is cited by David L. Kirp in "The Pitfalls of 'Fetal Protection'," *Society* 28(3) (1991): 70. For a full discussion of exclusionary employment policies, see Sally J. Kenney, *For Whose Protection? Reproductive Hazards and Exclusionary Policies in the United States and Britain* (Ann Arbor: University of Michigan Press, 1992). Susan Faludi remarks that no one has tried to prevent women from working at video display terminals, or in day-care centers where they are at risk for cytomegalovirus, in "Your Womb or Your Job," *Mother Jones* 16 (November/December 1991): 59-66; 71. See also Elaine Draper, "Fetal Exclusion Policies and Gendered Constructions of Suitable Work," *Social Problems* 40(1) (1993): 90-107, and Lucinda M. Finley, "Transcending Equality Theory: A Way Out of the Maternity and the Workplace Debate," *Columbia Law Review* 86 (1986): 1118-1182. It should also be noted that little attention has been paid to the effect of workplace toxins on fathers, despite evidence that men exposed to toxic chemicals can pass birth malformations on to their children. In addition, sperm production in the average male has declined dramatically over the last 50 years, and the reasons appear to be environmental rather than genetic. See Michael Zimmerman, "Working With Chemicals Is a Threat to Fathers," *Philadelphia Inquirer*, May 2, 1993: D5.

99. *Griswold* v. *Connecticut*, 381 U.S. 479 (1965) invalidated statutes banning contraception. The idea of holding rights to "property in one's own person" and to bodily self-determination in relation to women's bodies as the media for pregnancies is asserted by Rosalind Pollack Petchesky in "Reproductive Freedom: Beyond 'A Woman's Right to Choose'," *Signs* 5(4) (1980): 661-685. A recent discussion of privacy law in relation to abortion rights can be found in David J. Garrow, *Liberty and Sexuality: The Right to Privacy and the Making of Roe v. Wade* (New York: Macmillan, 1994). See also Iris Marion Young, "Pregnant Embodiment: Subjectivity and Alienation," *Journal of Medicine and Philosophy* 9 (1984): 45-62.

100. 410 U.S. (1973) at 459. For an important analysis of these issues with respect to abortion, see Mary Poovey, "The Abortion Question and the Death of Man," in *Feminists Theorize the Political*, ed. Judith Butler and Joan W. Scott (New York: Routledge, 1992): 239-256. For discussions of the way the construction of fetal rights intersects with abortion debates in Britain, see the essays by The Science and Technology Subgroup called "In the Wake of the Alton Bill: Science, Technology

and Reproductive Politics," in *Off-Centre: Feminism and Cultural Studies*, ed. Sarah Franklin, Celia Lury, and Jackie Stacey (London: HarperCollins Academic, 1991), especially Sarah Franklin, "Fetal Fascinations: New Dimensions to the Medical-Scientific Construction of Fetal Personhood," 190–205. Citing the work of Evelyn Fox Keller and Nancy Chodorow, Franklin argues that "[t]he fetus as bounded object of patriarchal science, through whom the body of the woman in whom the fetus exists is rendered invisible, bears a strong, and not unremarked upon resemblance to the bounded masculine self formed through a similar psychic process of disavowal of maternal dependence" (p. 202). The authors of these essays point out that fetuses are almost invariably figured as male in jurisprudential discussions of their rights. See also Franklin's "Postmodern Procreation: Representing Reproductive Practice," *Science as Culture* 3(4)17 (1993): 522–561. The apotheosis of the fetus as person is represented in Laura Freixas' extraordinary short story, "My Momma Spoils Me," in which the narrator is a 38-year old "little girl" who continues to reside in her mother's womb, watching television through a periscope, because the world outside is too dangerous—full of rapes, earthquakes, assassinations, and so on. The story was translated by Lou Charnon-Deutsch and published in *Tulsa Studies in Women's Literature* 10(1) (1991): 13–14, accompanied by an essay by Susan M. Squier, "Fetal Voices: Speaking for the Margins Within," 17–30. Squier points out that the mother's body is increasingly conceived of as a colonizer of the oppressed fetus rather than as a being who is socially as well as physically enmeshed with the fetus. She analyzes Freixas' story along with a story by Jayne Anne Phillips called "Bluegill," in which a pregnant woman speaks a monologue to her fetus.

101. 405 U.S. 438 (1972) at 453.

102. There are specific distinctions between the constitutional right to privacy, decisional privacy, and tort privacy. For example, Justice Blackmun has been cricized for his failure in *Roe* "to distinguish carefully the physical privacy of seclusion from the decisional privacy of liberty or autonomous choice." See Anita L. Allen, "Tribe's Judicious Feminism," *Stanford Law Review* 44 (1) (1991): 187.

103. Christyne L. Neff, "Woman, Womb, and Bodily Integrity," *Yale Journal of Law and Feminism* 3(2) (1991): 351. See also Rosalind Pollack Petchesky, "Reproductive Freedom: Beyond 'A Woman's Right to Choose'," *Signs* 5(4) (1980): 661–685 and Katherine De Gama, "A Brave New World? Rights Discourse and the Politics of Reproductive Anatomy," *Journal of Law and Society* 20(1) (1993): 114–130.

104. Linda C. McClain argues that privacy rights are tied to an imagery of sanctuary and refuge in "Inviolability and Privacy: The Castle, the Temple, and the Body," a paper presented at the Yale University School of Law conference on "The Sacred Body in Law and Literature" on April 2, 1994. I am grateful to Professor McClain for sharing her work with me.

105. David L. Kirp, "The Pitfalls of 'Fetal Protection'," *Society* 28(3) (1991): 76. Another discussion of the far-reaching proscriptions on pregnant women that would lie down the path of protective legislation can be found in David Westfall, "Beyond Abortion: The Potential Reach of a Human Rights Amendment," *American Journal of Law and Medicine* (1982): 94–135. Westfall remarks that such laws might forbid

pregnant women from "skiing, working in hazardous environments, flying, and riding in automobiles" (p. 111).

6. Explaining AIDS

1. Tony Kushner, *Angels in America: A Gay Fantasia on National Themes. Part Two: Perestroika* (New York: Theatre Communications Group. 1993): 148.

2. Quotations are cited in Gina Kolata, "U.S. Rule on Fetal Studies Hampers Research on AZT," *New York Times*, August 25, 1991. Researchers worked around the regulation, which has a loophole if the fathers are "unavailable," by simply asking the women about the reasonable availability of the father for permission-giving and taking their word without further investigation.

3. The incidence of HIV infection is rising four times faster among women than among men and disproportionately affects minority women in the United States. Diagnosis of women with HIV infection and AIDS is also often delayed, and women with AIDS receive fewer services than do men, so survival time after diagnosis is shorter in women. See Gena Corea, *The Invisible Epidemic: The Story of Women and AIDS* (New York: HarperCollins, 1992); Marian Segal, "Women and AIDS," *FDA Consumer* 27(8) (1993): 9-14, and "Women with AIDS Receive Fewer Services Than Men with AIDS," Agency for Health Care Policy and Research, U.S. Department of Health and Human Services, *Research Activities* 171 (December 1993): 1-2. In addition, women have very little power to negotiate safer sex practices with their male partners. See Lesley Miles, "Women, AIDS, and Power in Heterosexual Sex: A Discourse Analysis," *Women's Studies International Forum* 16(5) (1993): 497-511. Still the most complete study of women and AIDS is Paula A. Treichler, "AIDS, Gender, and Biomedical Discourse: Current Contests for Meaning," in *AIDS: The Burdens of History*, eds. Elizabeth Fee and Daniel M. Fox (Berkeley: University of California Press, 1988): 190-266. See also a photo-essay by Ann Meredith, "Until That Last Breath: Women with AIDS," in *AIDS: The Making of a Chronic Disease*, ed. Elizabeth Fee and Daniel M. Fox (Berkeley: University of California Press, 1992): 229-244.

4. See Wendy Chavkin, "Mandatory Treatment for Drug Use During Pregnancy," *Journal of the American Medical Association* 266(11) (September 18, 1991): 1556-1561. See also William D. Lyman, "Perinatal AIDS: Drugs of Abuse and Transplacental Infection," in *Drugs of Abuse, Immunity, and AIDS*, ed. Herman Friedman, Thomas W. Klein, and Steven Specter, *Advances in Experimental Medicine and Biology*, volume 335 (New York: Plenum Press, 1993): 211.

5. See Ronald Bayer, "AIDS ands the Future of Reproductive Freedom," in *A Disease of Society: Cultural and Social Responses to AIDS*, ed. Dorothy Nelkin, David P. Willis, and Scott V. Parris (Cambridge: Cambridge University Press, 1991): 191-215; Kathryn Anastos and Carola Marte, "Women—The Missing Persons in the AIDS Epidemic," in *The AIDS Reader: Social, Political, Ethical Issues*, ed. Nancy F. McKenzie (New York: Meridian, 1991): 190-199; and Mary E. Guinan, "HIV, Heterosexual Transmission, and Women," *Journal of the American Medical Association* 268(4) (July

22/29, 1992): 520–521. Several of the articles in *Women, AIDS and Activism*, The ACT UP/New York Women and AIDS Book Group (Boston: South End Press, 1990), discuss pregnancy and AIDS, and this is also one of the few books that includes issues that concern lesbians.

6. See Mikhaël Elbaz and Ruth Murbach, "Fear of the Other, Condemned and Damned: AIDS, Epidemics and Exclusions," in *A Leap in the Dark: AIDS, Art and Contemporary Cultures*, ed. Allan Klusacek and Ken Morrison (Montreal: Véhicule Press, 1992): 1–9.

7. Deborah McDowell offered a fascinating discussion of the politics of grief in a lecture entitled "Los Angeles: An Anniversary Post-Mortem, or, A Crooked Kind of Mourning" delivered at Haverford College on April 14, 1993. She discussed funerary portraits and newspaper policies concerning photographs of the dead. As she remarked, these photos reinforce cultural ideologies about African-American male criminality and its corroborating narratives. AIDS deaths, on the other hand, are represented in images only in the case of "innocent" victims such as Ryan White, Kimberly Bergalis, and Arthur Ashe. The vast majority of African-American, Latino, and gay AIDS deaths remain invisible and unrepresented. The best discussion of mourning in relation to AIDS remains Douglas Crimp's 1989 essay, "Mourning and Militancy," reprinted in *Out There: Marginalization and Contemporary Cultures*, ed. Russell Ferguson, Martha Gever, Trinh T. Minh-ha, and Cornel West (Cambridge, MA: MIT Press, 1990): 233–245. See also Daniel Harris, "On Reading the Obituaries in the *Bay Area Reporter*," in *Fluid Exchanges: Artists and Critics in the AIDS Crisis*, ed. James Miller (Toronto: University of Toronto Press, 1992): 163–168.

8. Donna Haraway, "The Biopolitics of Postmodern Bodies: Determinations of Self in Immune System Discourse," *differences* 1(1) (1989): 3–43.

9. Stephen S. Morse, "AIDS and Beyond: Defining the Rules for Viral Traffic," in *AIDS: The Making of a Chronic Disease*, eds. Elizabeth Fee and Daniel M. Fox (Berkeley: University of California Press, 1992): 23–48.

10. Hemophiliacs were added to this list, making it the "4-H club," after the July 16, 1982, Centers for Disease Control *Morbidity and Mortality Weekly Report* cited three cases of pneumocystis carinii pneumonia in patients with hemophilia A. This report set off a crisis concerning tainted blood and represented the first incursion of AIDS in the United States outside marginalized social groups. See Chapter Three, "Blood, Privacy, and Stigma: The Politics of Safety," in Ronald Bayer, *Private Acts, Social Consequences: AIDS and the Politics of Public Health* (New Brunswick, NJ: Rutgers University Press, 1989): 72–100. The most comprehensive international history of AIDS is Mirko D. Grmek, *History of AIDS: Emergence and Origin of a Modern Pandemic*, trans. Russell C. Maulitz and Jacalyn Duffin (Princeton: Princeton University Press, 1990).

11. Simon Watney points this out in "Short-Term Companions: AIDS as Popular Entertainment," in *A Leap in the Dark*, 153.

12. "AIDS and Honesty: The disease is not spreading widely, so focus attention where it matters most," Editorial, *Philadelphia Inquirer*, March 13, 1993, A6. This editorial's

opening sentence is, "If there were a TV series about AIDS, it might be called *Soho 10012*." The editorial writer goes on to worry "that the shift in emphasis will make the general public even more inclined to think of AIDS as largely a disease of gays, drug addicts and a few straight people with drug-addicted lovers—a stereotype that happens to be true." As the first sentence predicts, this is the soap opera version of AIDS in America, lots of melodrama but all denial.

13. Paul Monette, *Love Alone: 18 Elegies for Rog* (New York: St. Martin's Press, 1988): 11. Subsequent page references are given in the text. For a discussion of this volume, see Joseph Cady, "Immersive and Counterimmersive Writing About AIDS: The Achievement of Paul Monette's *Love Alone*," in *Writing AIDS: Gay Literature, Language, and Analysis*, ed. Timothy F. Murphy and Suzanne Poirier (New York: Columbia University Press, 1993): 244-264.

14. Monette takes his title from four lines by Edna St. Vincent Millay that he uses as an epigraph:

> Love can not fill the thickened lung with breath,
> Nor clean the blood, nor set the fractured bone;
> Yet many a man is making friends with death
> Even as I speak, for lack of love alone.

15. Timothy E. Cook and David C. Colby, "The Mass-Mediated Epidemic: The Politics of AIDS on the Nightly Network News," in *AIDS: The Making of a Chronic Disease*, 84-122. On media coverage, see also James Kinsella, *Covering the Plague: AIDS and the American Media* (New Brunswick, NJ: Rutgers University Press, 1989), and Cindy Patton, Chapter 2, "Media, Testing, and Safe Sex Education: Controlling the Landscape of AIDS Information," *Inventing AIDS* (New York: Routledge, 1990): 25-49.

16. The first appearance in print of early cases was in the Center for Disease Control's official publication *Morbidity and Mortality Weekly Report*, June 5, 1981, 250-252, in an item called "Pneumocystis Pneumonia—Los Angeles."

17. Cindy Patton, *Inventing AIDS*, 127.

18. Richard Meyer, "Rock Hudson's Body," in *Inside/Out: Lesbian Theories, Gay Theories*, ed. Diana Fuss (New York: Routledge, 1991): 260.

19. Cited by Meyer, "Rock Hudson's Body," 278.

20. "Rock Hudson's Home Movies," written, directed, and produced by Mark Rappoport, Couch Potato, Inc, 1992. Available on Bear Video, Inc. Distributed by Water Bearer Films, Inc.

21. A conversation with Cindy Patton helped me to clarify my ideas about Hudson's "leakiness." I am grateful to her for comments on this chapter.

22. Ronald Bayer, *Private Acts, Social Consequences*, 16.

23. Keynote Address to the International AIDS Conference, April 15, 1985, Atlanta, Georgia. Cited in Cindy Patton, *Sex and Germs: The Politics of AIDS* (Boston: South End Press, 1985): 38, and in Jeff Nunokawa, "'All the Sad Young Men': AIDS and

the Work of Mourning," in *Inside/Out*, 311. Patton reports that this statement drew fire from gay and lesbian activists, scientists, and international representatives at the conference. Nunokawa points out, in addition, the racism of Heckler's now infamous remarks.

24. Allen Barnett, *The Body and Its Dangers and Other Stories* (New York: St. Martin's Press, 1990): 115.

25. "Morning Edition," National Public Radio, February 5, 1993.

26. With reference to Rock Hudson and the 1985 shift in public perceptions of AIDS, Tom Kalin writes that "AIDS has become the physical sign of concealed deviance, the true manifestation of a secret perversion": "Flesh Histories," in *A Leap in the Dark*, 128-129. In the same volume, Paula Treichler remarks on the increase in media coverage following Hudson's illness in "Seduced and Terrorized: AIDS and Network Television," 136-151.

27. Jonathan Keane discusses the uses of identity markers for remarginalizing homosexuality in "AIDS, Identity and the Space of Desire," *Textual Practice* 7(3) (1993): 453-470.

28. On the definitional conundrums of AIDS and their political meanings, see several essays by Lee Edelman: "The Mirror and the Tank: 'AIDS,' Subjectivity, and the Rhetoric of Activism," in *Writing AIDS*, 9-38; "Homographesis," *Yale Journal of Criticism* 3(1) (1989): 189-207; and "The Plague of Discourse: Politics, Literary Theory, and AIDS," in *Displacing Homophobia*, ed. Ron Butters, John Clum, and Michael Moon (Durham, NC: Duke University Press, 1989): 289-305. See also Jeffrey Weeks, "Post-Modern AIDS?" in *Ecstatic Antibodies: Resisting the AIDS Mythology*, ed. Tessa Boffin and Sunil Gupta (London: Rivers Oram, 1990): 133-141, and Gerald M. Oppenheimer, "Causes, Cases, and Cohorts: The Role of Epidemiology in the Historical Construction of AIDS," in *AIDS: The Making of a Chronic Disease*, 49-83.

29. In October 1993, two different research teams in France announced discoveries of two molecules, CD26 and CDR3, that work along these lines. CD26 apparently is utilized by HIV to infect healthy cells, whereas CDR3, appears to stop HIV from entering unifected cells. See "AIDS Investigators Discover Molecule That Fights HIV," *New York Times*, October 31, 1993: A19.

30. Susan Sontag, *Illness as Metaphor and AIDS and Its Metaphors* (New York: Anchor Books, 1989): 116. For a sharp critique of Sontag's *AIDS and Its Metaphors*, see D.A. Miller, "Sontag's Urbanity," in *The Lesbian and Gay Studies Reader*, ed. Henry Abelove, Michèle Aina Barale, and David M. Halperin (New York: Routledge, 1993): 212-223.

31. Paula A. Treichler, "AIDS and HIV Infection in the Third World: A First World Chronicle," in *AIDS: The Making of a Chronic Disease*, 391.

32. See Huntly Collins, "Confusion Feared When AIDS Vaccine Tests Grow," *Philadelphia Inquirer*, February 10, 1994: A4.

33. Paula A. Treichler, "AIDS, Homophobia, and Biomedical Discourse: An

Epidemic of Signification," in *AIDS: Cultural Analysis, Cultural Activism*, ed. Douglas Crimp (Cambridge, MA: MIT Press, 1988); 31-70, and "How to Have Theory in an Epidemic: The Evolution of AIDS Treatment Activism," in *Technoculture*, ed. Constance Penley and Andrew Ross (Minneapolis: University of Minnesota Press, 1991): 57-106; and Douglas Crimp, "AIDS: Cultural Analysis/Cultural Activism," in *AIDS: Cultural Analysis, Cultural Activism*, 3-16. See also Philip H. Pollock III, Stuart A. Lilie, and M. Elliot Vittes, "On the Nature and Dynamics of Social Construction: The Case of AIDS," *Social Science Quarterly* 74(1) (1993): 123-135.

34. Charles E. Rosenberg, *The Cholera Years* (Chicago: University of Chicago Press, 1962): 5.

35. Treichler, "AIDS and HIV Infection in the Third World: A First World Chronicle," 377.

36. As dated as many of its examples have become, the classic work on stigma remains Erving Goffman, *Stigma: Notes on the Management of Spoiled Identity* (Englewood Cliffs, NJ: Prentice-Hall, 1963).

37. Treichler, "AIDS and HIV Infection in the Third World: A First World Chronicle," 379.

38. Iris Marion Young, *Justice and the Politics of Difference* (Princeton: Princeton University Press, 1990): 146.

39. Marjorie Garber, *Vested Interests: Cross-Dressing and Cultural Anxiety* (New York: Routledge, 1992): 16.

40. Anne Fausto-Sterling, "The Five Sexes," *The Sciences* (March/April 1993): 20-25.

41. Judith Butler, "Performative Acts and Gender Constitution: An Essay in Phenomenology and Feminist Theory," in *Performing Feminism: Feminist Critical Theory and Theatre*, ed. Sue-Ellen Case (Baltimore: The Johns Hopkins University Press, 1990): 272.

42. Julia Epstein and Kristina Straub, "Introduction: The Guarded Body," in *Body Guards: The Cultural Politics of Gender Ambiguity*, ed. Julia Epstein and Kristina Straub (New York: Routledge, 1991): 1-28.

43. With thanks here to Haverford College student Erin Jospe, Class of 1993, for her insights on armies and borders. The United States is in the minority globally in this prohibition. On a very different subject—the cultural construction of "African AIDS"—Cindy Patton analyzes the function of boundary concepts and the replacement of colonialist concepts of nation by public-health enforcement of bourgeois family values, in "From Nation to Family: Containing African AIDS," in *The Lesbian and Gay Studies Reader*, ed. Henry Abelove, Michèle Aina Barale, and David M. Halperin (New York: Routledge, 1993): 127-138.

44. Jonathan Dollimore, *Sexual Dissidence: Augustine to Wilde, Freud to Foucault* (Oxford: Clarendon Press, 1991): 144.

45. Bert Hansen, "American Physicians' 'Discovery' of Homosexuals, 1880-1900: A New Diagnosis in a Changing Society," in *Framing Disease: Studies in Cultural*

History, ed. Charles E. Rosenberg and Janet Golden (New Brunswick, NJ: Rutgers University Press, 1992): 104-133.

46. Robert A. Padgug, "Gay Villain, Gay Hero: Homosexuality and the Social Construction of AIDS," in *Passion and Power: Sexuality in History*, ed. Kathy Peiss and Christina Simmons (Philadelphia: Temple University Press, 1989): 293-313.

47. Cindy Patton, "With Champagne and Roses," talk delivered at the University of Pennsylvania, February 18, 1993.

48. Simon Watney, "Missionary Positions: AIDS, 'Africa,' and Race," *differences* 1(1) (1989): 97.

49. Randall M. Packard and Paul Epstein, "Medical Research on AIDS in Africa: A Historical Perspective," in *AIDS: The Making of a Chronic Disease*, 346-376.

50. See the essays in *In Time of Plague: The History and Social Consequences of Lethal Epidemic Disease*, ed. Arien Mack (New York: New York University Press, 1991).

51. The best account of the scandal of race and syphilis remains James H. Jones, *Bad Blood: The Tuskegee Syphilis Experiment—A Tragedy of Race and Medicine* (New York: The Free Press, 1981).

52. William H. McNeill, *Plagues and Peoples* (New York: Doubleday, 1976).

53. *Survey*, 29 July 1916, 448. Cited by Guenter B. Risse, "Epidemics and History: Ecological Perspectives and Social Responses," in *AIDS: The Burdens of History*, 66. On syphilis, see Claude Quétel, *History of Syphilis*, trans. Judith Braddock and Brian Pike (Baltimore: The Johns Hopkins University Press, 1990); Elizabeth Fee, "Sin versus Science: Venereal Disease in Twentieth-Century Baltimore," in *AIDS: The Burdens of History*, 121-146, and Allen Brandt, *No Magic Bullet: A Social History of Venereal Disease in the United States since 1880* (New York: Oxford University Press, 1985). For the relation of criminal law to syphilis and AIDS, see Martha A. Field and Kathleen M. Sullivan, "AIDS and the Criminal Law," *Law, Medicine, Health Care* 15(2) (1987): 46-60, and Gregg S. Meyer, "Criminal Punishment for the Transmission of Sexually Transmitted Diseases: Lessons from Syphilis," *Bulletin of the History of Medicine* 65(4) (1991): 549-564.

54. See Larry Gostin, "The AIDS Litigation Project: A National Review of Court and Human Rights Commission Decisions on Discrimination," in *AIDS: The Making of a Chronic Disease*, 144-169, and Thomas B. Stoddard and Walter Rieman, "AIDS and the Rights of the Individual: Toward a More Sophisticated Understanding of Discrimination," in *A Disease of Society*, 241-271. For an economic analysis of social concepts of risk, the epidemiology of AIDS, and public-health policy, see Tomas J. Philopson and Richard A. Posner, *Private Choices and Public Health: The AIDS Epidemic in Economic Perspective* (Cambridge, MA: Harvard University Press, 1994).

55. Charles E. Rosenberg, "What Is an Epidemic? AIDS in Historical Perspective," *Daedalus* 118(2) (1989): 2.

56. Leo Bersani points out that this logic occurs in AIDS discourses, in which the gay men who are dying are being turned into the killers, in "Is the Rectum a Grave?" in *AIDS: Cultural Analysis, Cultural Activism*, 197-222. For an analysis of equating sexu-

al practices with disease narratives, see Janice M. Irvine, "Regulated Passions: The Invention of Inhibited Sexual Desire and Sex Addiction," *Social Text* 37 (1993): 203–226.

57. The now infamous Tuskegee Syphilis experiment attempted to test the spurious hypothesis that untreated syphilis would take a different course in black men than in white. For an account, see James H. Jones, *Bad Blood*.

58. It would be useful to analyze Henrik Ibsen's 1881 play *Ghosts* on these terms. The play's biology lacks credibility—a son manifesting neurologic symptoms of tertiary syphilis in his late twenties having never been ill previously; a congenital transmission of syphilis from father to son that bypasses the mother—but disease is clearly positioned in the play as a sign of dissipation and a moral judgment.

59. Charles E. Rosenberg, "Disease and Social Order in America: Perceptions and Expectations," in *AIDS: The Burdens of History*, 12–32.

60. Judith Williamson, "Every Virus Tells a Story: The Meanings of HIV and AIDS," in *Taking Liberties: AIDS and Cultural Politics*, ed. Erica Carter and Simon Watney (London: Serpent's Tail, 1989): 69–80.

61. Stephen Schecter, *The AIDS Notebooks* (Albany: State University of New York Press, 1990): 117.

62. K. Codell Carter, "The Development of Pasteur's Concept of Disease Causation and the Emergence of Specific Causes in Nineteenth-Century Medicine," *Bulletin of the History of Medicine* 65(4) (1991): 528–548.

63. Elizabeth Fee and Daniel M. Fox, "Introduction: The Contemporary Historiography of AIDS," in *AIDS: The Making of a Chronic Disease*, 1–19.

64. James W. Jones, "Discourses on and of AIDS in West Germany, 1986–90," *Journal of the History of Sexuality* 2(3) (1992): 439–468.

65. Thomas Yingling, "AIDS in America: Postmodern Governance, Identity, and Experience," in *Inside/Out*, 304.

66. Mary Douglas, *Purity and Danger: An Analysis of the Concepts of Pollution and Taboo* (London: ARK Edition, 1984).

67. The paradigmatic example of this calculus of category leakage inheres in the story of an elderly woman in Michigan who refused a blood transfusion on the grounds that she feared becoming a homosexual.

68. In Germany, the newsmagazine *Spiegel* headlined its first article on AIDS in May 1982 with "Terror from Abroad," for example. Cited by James W. Jones, "Discourses on and of AIDS in West Germany," 441.

69. See Mubarak S. Dahir, "In Cuba, They Lock Up People with AIDS," *Philadelphia City Paper*, February 19–26, 1993: 12–14.

70. Gregg S. Meyer, "Criminal Punishment for the Transmission of Sexually Transmitted Diseases," 562. Marie Saint-Cyr Delpe, an AIDS activist from Haiti and founder of the Women and AIDS Resource Network in New York City, makes the

point that people continue to drink and smoke decades into public health campaigns to educate about the dangers of these behaviors and says of behavioral modification with respect to sex: "It just doesn't happen." Presentation at Haverford College, December 3, 1991.

71. Simon Watney, *Policing Desire: Pornography, AIDS, and the Media* (Minneapolis: University of Minnesota Press, 1987).

72. Judith Butler, *Gender Trouble: Feminism and the Subversion of Identity* (New York: Routledge, 1990).

73. See Dale Mezzacappa, "Condom Debate Flares as School Board Reviews Courses on Sexuality," *Philadelphia Inquirer*, October 10, 1992.

74. See George F. Will, "In New York's Misguided Condom-Distribution Program, the 1990s Mirror the 1960s," *Philadelphia Inquirer*, January 6, 1994.

75. Michel Foucault, *The History of Sexuality, Volume One: An Introduction*, trans. Robert Hurley (New York: Vintage Books, 1980).

76. For a more extended discussion, see Julia Epstein and Kristina Straub, "The Guarded Body," in *Body Guards*.

77. Daniel Harris, "AIDS and Theory," *Lingua Franca* (June 1991): 1, 16–19.

78. In 1987, Amber Hollibaugh produced a broadcast video on AIDS discrimination with this title, under the auspices of the AIDS Discrimination Unit of the New York City Commission on Human Rights. For a discussion, see Amber Hollibaugh, Mitchell Karp, and Katy Taylor, interviewed by Douglas Crimp "The Second Epidemic," in *AIDS: Cultural Analysis, Cultural Activism*, 127–142.

79. Months of delay by neighbors hampered efforts to open Betak, a hospice operated by the Lutheran Home in West Mt. Airy, Philadelphia. Since its opening, the neighborhood has ceased its protests and the program has been filled with 40 patients at a time who need its services. It continues to be threatened with closing for lack of funds, despite the desperate need for such programs.

80. See Centers for Disease Control, "Guidelines for Prevention of Transmission of Human Immunodeficiency Virus and Hepatitus B to Health Care and Public Safety Workers," *Morbidity and Mortality Weekly Report* 38 (1989): 95–110. The Acer cases remain among only a statistically insignificant handful of cases of HIV transmission from health-care providers to patients. In fact, health-care providers bear a much greater risk of becoming infected by their patients than the reverse. For discussions, see J.I. Tokars, Mary E. Chamberland, and Charles A. Schable, "A Survey of Occupational Blood Contact and HIV Infection Among Orthopedic Surgeons," *Journal of the American Medical Association* 268(4) (July 22/29, 1992): 489–494. In the same issue, see M.F. Shapiro, Rodney A. Hayward, and Didier Guillemot, "Residents' Experiences in, and Attitudes Toward, the Care of Persons With AIDS in Canada, France, and the United States," 510–515. For public knowledge about transmission dangers more generally, see (for physicians) Michael J. Yedidia, Judith K. Barr, and Carolyn A. Berry, "Physicians' Attitudes Toward AIDS at Different

Career Stages: A Comparison of Internists and Surgeons," *Journal of Health and Social Behavior* 34(3) (1993): 272-284, and (for others) Allen J. LeBlanc, "Examining HIV-related Knowledge Among Adults in the U.S.," *Journal of Health and Social Behavior* 34(1) (1993): 23-36.

81. Noted by Charles Krauthammer, "It's easy to misplace blame for AIDS, as both sides have a tendency to do," *Philadelphia Inquirer*, October 18, 1991.

82. Katharine Park, "Kimberly Bergalis, AIDS, and the Plague Metaphor," in *Media Spectacles*, ed. Marjorie Garber, Jann Matlock, and Rebecca L. Walkowitz (New York: Routledge, 1993): 232-253.

83. See Kelvyn Anderson and Shannon Duffy, "Invasive Procedure: Doctors, AIDS, and the Law," *Philadelphia City Paper*, August 16-23, 1991, 14-15, and Scott Burris, "The Senate flips over AIDS," *Philadelphia Inquirer*, July 22, 1991, A9.

84. Ana Maria Alonso and Maria Teresa Koreck, "Silences, 'Hispanics,' AIDS, and Sexual Practices," *differences* 1(1) (1989): 115.

85. I offer only brief remarks here on the writings of Sarah Schulman and Tony Kushner. Several collections of essays have approached the relations between artistic representation and AIDS more systematically. See *Confronting AIDS Through Literature: The Responsibilties of Representation*, ed. Judith Laurence Pastore (Urbana: University of Illinois Press, 1993); *AIDS: The Literary Response*, ed. Emmanuel S. Nelson (New York: Twayne, 1992); *Personal Dispatches: Writers Confront AIDS*, ed. John Preston (New York: St. Martin's Press, 1989); *Fluid Exchanges: Artists and Critics in the AIDS Crisis*; *A Leap in the Dark: AIDS Art and Contemporary Culture*; and *Writing AIDS: Gay Literature, Language, and Analysis. Writing AIDS* contains an annotated bibliography. Collections of literature on AIDS have begun to appear, including *Poets for Life: Seventy-Six Poets Respond to AIDS*, ed. Michael Klein (New York: Persea Books, 1989); Edmund White and Adam Mars-Jones, *The Darker Proof: Stories from a Crisis* (New York: NAL/Plume, 1988); and *The Way We Live Now: American Plays and the AIDS Crisis*, ed. M. Elizabeth Osborne (New York: Theatre Communications Group, 1990).

86. Sarah Schulman, *People in Trouble* (New York: Plume, 1990): 1. Subsequent page references will be given in the text.

87. Tony Kushner, *Angels in America: A Gay Fantasia on National Themes. Part One: Millenium Approaches* (New York: Theatre Communications Group, 1993): 45. Subsequent page references will be given in the text.

88. Tony Kushner, *Angels in America: A Gay Fantasia on National Themes. Part Two: Perestroika* (New York: Theatre Communications Group, 1993): 144, 148.

89. Cécile Lindsay, "Lyotard and the Postmodern Body," *L'Esprit Créateur* 31(1) (1991): 33, 37.

90. Elaine Scarry, *The Body in Pain: The Making and Unmaking of the World* (New York: Oxford University Press, 1985); Thomas Laqueur, *Making Sex: Body and Gender from the Greeks to Freud* (Cambridge, MA: Harvard University Press, 1990);

Linda Singer, *Erotic Welfare: Sexual Theory and Politics in the Age of Epidemic*, ed. Judith Butler and Maureen MacGrogan (New York: Routledge, 1993). The most recent contribution to this field appeared too late for me to take it into account in writing *Altered Conditions*: Emily Martin, *Flexible Bodies: Tracking Immunity in American Culture from the Days of Polio to the Age of AIDS* (Boston: Beacon Press, 1994).

91. Arthur W. Frank, "Bringing Bodies Back In: A Decade Review," *Theory, Culture, and Society* 7 (1990): 131–162.

92. Richard Goldstein, "The Implicated and the Immune: Responses to AIDS in the Arts and Popular Culture," in *A Disease of Society*, 21.

93. Steven Seidman, "Transfiguring Sexual Identity: AIDS and the Contemporary Construction of Homosexuality," *Social Text* 9(3) (1988): 189.

94. For an analysis of the slipperiness of behavioral definitions in the case of U.S. sodomy laws, see Janet E. Halley, "Misreading Sodomy: A Critique of the Classification of 'Homosexuals' in Federal Equal Protection Law," in *Body Guards*, 351–377.

95. Simon Watney, *Policing Desire*, xi.

96. See Susan Bordo, "Reading the Slender Body," in *Body/Politics: Women and the Discourses of Science*, ed. Mary Jacobus, Evelyn Fox Keller, and Sally Shuttleworth (New York: Routledge, 1990): 83–112, and Linda Singer, who discusses "body management" stategies, in *Erotic Welfare*, 27–28.

97. Singer, *Erotic Welfare*, 68.

98. See Dennis Altman, "AIDS and the Reconceptualization of Homosexuality," in *Homosexuality, Which Homosexuality?*, ed. Dennis Altman, Carole Vance, Martha Vicinus, Jeffrey Weeks, and others, International Conference on Gay and Lesbian Studies (Amsterdam: Uitgeverij An Dekker, 1989): 35–49.

99. Linda Singer, *Erotic Welfare*, 40.

100. Thomas Laqueur, *Making Sex*, 243.

101. Cases have now been reported in "remote" locations such as Papua New Guinea and Greenland.

EPILOGUE

1. Jeanette Winterson, *Written on the Body* (New York: Vintage, 1994): 120.

2. Robert D. Kaplan, "The Coming Anarchy," *Atlantic Monthly* (February 1994): 66, 69, 72, 75.

Index

abnormal, vs. normal, 8
abnormality, 8, 19, 22, 121; *see also* birth
abortion: campaign against, 152; as "choice,"
 3; criminalization, 152; *see also* Roe v. Wade
abstinence, 174
Acer, David, 175–176
Ackerknecht, Erwin H., 189n9, 199n33,
 201n43, 202n57, 204n77
Ackermann, Jacob Fidele, 99, 223n49
Ackroyd, Peter, 216n10
ACT UP, 162, 175, 250n5
Adam, 93
addictions, 168, 171; heroin addicts, 159;
 pregnant addicts, 153; *see also* drug use,
 pregnancy
admissions ledgers, 43, 51
adultery, 126
"AFRAIDS," 160
Africa, 165, 169, 172, 177, 182; AIDS deaths,
 18; imagined, 5
African-Americans, 125, 168, 169, 182–183
Agassiz, Louis, 224n59
Ahlfeld, Friedrich, 220n36
AIDS, 5, 6, 13, 17, 21, 52, 73, 77, 157–183,
 186; activism, 162, 169, 175, 176;
 containment, 6; and dentist, 175–176; "full-
 blown," 12; government definition, 158,
 163; heterosexual, 162; hostility, 158;
 ideology, 181; leakage, 6; literary
 interpretation, 177; metaphor of textile-
 rending, 18; narratives, 17, 18; poetry,
 159–160; prevention programs in schools,
 174; Rock Hudson, 160–163; secrecy, 172;
 syndrome vs. disease, 12; treatments, 164;
 women, 158; women and children, 153; *see
 also* epidemic, HIV
Akin, James, 229n84
alcohol use, 27–28; alcoholism, 171; during
 pregnancy, 22, 126, 127, 138,153
 Hippocratic writing, mentioned in, 60;
Aldrovandi, Ulisse, 93, 95n, 223n46
Allchin, W.H., 48, 204n73
Allen, Anita L., 248n102
Alonso, Ana Maria, 257n84
Altman, Dennis, 258n98
Alzheimer's, 52

ambiguity: genital, 21–22; sexual, 77–122; *see
 also* genitalia
ambisexuality, 118
ambulatory services, 44
American College of Surgeons, 51,
 205–206n85
American Legion, gay post, 167
American Psychiatric Association, 167
American Sign Language, 13
amputee, 16
anal sex, 161
anamnesis, 35, 200n40
anarchy, sexual ambiguity as, 121
Anastos, Kathryn, 249n5
anatomy, 182; alteration of sex, 115–116;
 ambiguity, 83; anomalous, 109; body, 121;
 developmental, 101; fetal-placental, 148;
 markers, 120; sexual, 128
Anderson, Kelvyn, 192n35, 257n83
androgens: Androgen Insensitivity Syndrome,
 79, 103, 218n23, 225n62; drugs, 103;
 excess, 103
androgyny, 93, 109
anencephaly, 134
Angels in America, 157, 178–179; *see also*
 Kushner
animal culism, 146–148
annalist, 25, 42
anomalies, 21, 88, 99–100; chromosomal, 79;
 classification of, 121; endocrine, 11, 79;
 problems in defining, 11; *see also* birth
 malformations
anthropology, 6
antibiotics, 10, 171
Aphrodite, mother of Hermaphroditus, 104
apothecaries, surgical, 44
arbovirus, 11
Aristotle, 90, 114, 146, 147, 221n39, 224n56,
 225n66, 239n31, 242n68
Armstrong, David, 195n3
Armstrong, C.N., 219n25
Arnaud, Georg, 97, 223n48
Aron, A.M., 208n3
Arsenault, André, 197n20
Asclepian temple inscriptions, 35
Ashe, Arthur, 250n7
Aspland, Alfred, 203n67
Astruc, Jean, 138, 139, 140, 141, 163, 171

Astruc, Jean, 138, 139, 140, 141, 163, 171
Avicenna, 99
Ayurvedic texts, 132
AZT, 157

Bablot, Benjamin, 142
Backus, L.H., 230n91
Bacon, Francis, 39, 45
Baglivi, Giorgio, 36–37, 38, 42, 200n42
Bakan, R., 225n62
Bal, Mieke, 198n28
Balderston, Katherine C., 210n22
Balint, Michael, 50
Baltrusaitis, Jurgis, 220n36
Banks, Joanne Trautmann, 208n4
baptism, 132
barber-surgeons, 44
Barbin, Herculine, 112–113, 115, 117, 118,
 218n21, 228n82–83
Barker, John, 200n39
Barnard, David, 208n4
Barnett, Allen, 162–163, 252n24
Baron, Richard, 194n2
Barondess, Jeremiah A., 207n94
Barry, William James, 107–108, 227n72
Barthes, Roland, 34, 199n32
Bartsocas, Christos S., 222n43
bastards, 126
Bate, Walter Jackson, 66, 210n22
Bates, Barbara, 50, 203n65, 205n83
Bauhin, Caspar (Gaspard), 93, 94n, 223n45
Bayer, Ronald, 20, 162, 249n5, 250n10,
 251n22
Béchet, Jean-François, 220n36
Beck, Theodric Romeyn, 227n73
bedside observation, 28, 38–39, 44, 45; see also
 case records
Beeson, Paul B., 197n17
Behn, Aphra, 215n8
Beier, Lucinda McCray, 209n10
Bell, Charles, 150
Bell-Magendie law, 150
Bellers, John, 37–38, 40, 51, 201n45
Bellet, Isaac, 137, 241n55
Belsey, Catherine, 215n9
Benton, John F., 235n13
Bérard, Jean-Baptiste, 243n73
Bergalis, Kimberly, 175–176, 182, 250n7; CBS
 report, 176
Berkhofer, Robert F., Jr., 197n16, 207n96
Bernard, Claude, 9
Bersani, Leo, 254n56
Biggers, John D., 242n68
bigotry, 5; see also homophobia, racism
binary: opposition, 115, 116, 120, 121, 165;
 sex differentiation, 84, 90, 115
Bingham, Caroline, 222n43
biomedicine, 10, 77; and ambiguous sexuality,
 81; biological indeterminacy, 84
birth: of addicted baby, 132; anomalous,
 eighteenth-century fascination with,
104–105; and "choice," 3; of defective
 infant, 91, 132; imperfect, etiology of, 151;
 malformations, 6, 21, 132; sexually
 ambiguous, 103
birth abnormalities/malformations, 77, 127,
 186; blame for, 130–131; see also birth,
 maternal imagination, pregnancy
birth certificates, and transsexuals, 86–87
birth control: condoms, 173, 175, 182;
 distribution, 155; methods, 177
birth registration, 114
birthmarks, 127, 142; and imagination,
 129–130
bisexuality, 160, 168, 183
Black Death (bubonic plague), 12, 169;
 analogy to AIDS, 12; see also epidemic,
 plague
Blackmun, Harry, 155
Blackstone, William, 124, 233n3
blame, 77, 176; absolution, 149; and AIDS,
 163, 169; for birth malformation, 131; for
 deviations from "normal," 21; for outcome
 of pregnancy, 127; see also maternal
 imagination, responsibility
Blank, Robert H., 246n94–95
Bleier, Ruth, 219n32
Blondel, James Augustus, 129, 132, 137, 138,
 142, 144, 146, 148, 149, 238n28, 242n63
blood: donations, 182; supply, and AIDS, 17
Blumberg, Joan Jacobs, 193n41
body politic, 20, 22, 173; analogy to human
 body, 5
body: as classificatory system, 128; female, 128;
 as envelope, 143; image, 193n41;
 interaction with brain and nerves, 151;
 language, 186; ownership, 154; piercing, 2;
 political nature, 20; politics, 186;
 psychophysiological idea, 9; physical
 boundaries, 166; and self, 1, 4, 128; sexual,
 167; social and anatomic, 121; social
 deployment, 4; woman's, 124, 128
Boerhaave, Hermann, 30, 36, 194n4, 196n11,
 200n41, 209n7
Boissier de Sauvages, 48
Boler, Leo R., Jr., 235n12
Bonet, Théophile, 35, 200n38
"border anxiety," 165, 166, 177
borders: bodily, 128, 166, 185; political, 185;
 see also boundaries
Bordo, Susan, 29, 193n41, 196n9, 258n96
Borell, Merriley, 224n60
Boswell, James, 64–65, 68, 210n16–20,
 211n29
Boucé, Paul-Gabriel, 149, 239n31, 243n74
boundaries, 122, 181; biological
 indeterminacy, 84; bodily, 177; challenges
 posed by ambiguity, 83; gender, 82;
 between normal and abnormal, 165; private
 and public, 80–81; sexuality, 79; skin, 128;
 social, 112; see also borders, identity
boundary-crossing, 113, 121; and

homosexuality, 173
Bovary, Emma, 61
Bowes, W.A., Jr., 235n12
Bowie, David, 121
Bowman, John G., 205n85
Boy George, 121
Boyle, lectures of 1705, 132
Bracken, Henry, 137
brain, 151; imprinting, 145; and pregnant woman, 131; residence of imagination, 129; sensorium, 150
Brandt, Allen, 254n53
Braudy, Leo, 199n31
breast cancer, 22; implants and prostheses, 22
Bremond, Claude, 198n28
Brillon, Pierre Jacques, 85, 91, 92, 217n17, 217n20; 221n37
Brockliss, L.W.B., 243n70
Brodal, A., 71–73, 211n32
Brody, Howard, 194n3
Brooks, Peter, 193n37
Brown, Theodore M., 243n76
Brown-Séquard, Charles Edouard, 101, 224n59
Bruce, Susan, 238n23
Bruhn, John G., 206n91
Brundage, James A., 217n14
Bruner-Lorard, Joyce, 219n26
bubonic plague, see Black Death
Buffon, Georges-Louis, 225n66
Bull, Thomas, 134, 241n47
Bullitt, H.M., 45, 203n69
Burdette, Christina von Cannon, 233n6
Burney, Frances, and Samuel Johnson, 64, 68, 210n14–15, 212n35
Burnum, John F., 207n94, n95
Burris, Scott, 192n35
Burshatin, Israel, 222n43
Burton, June K., 236n15
Butler, Judith, 165, 173, 216n9, 253n41, 256n72
Bylebyl, Jerome J., 199n36, 201n46
Bynum, W. F., 209n8

Cabot and Adams, 50
Cabot, Richard C., 205n82, 205n84
Cady, Joseph, 251n13
Callen, Michael, 192n32
Cameron, Archibald, 65
Campbell, E.J.M., 190n13
cancer, 52, 171, 179; gay, 160; see also AIDS
Cannon, Walter B., 51, 205n84
Capron, Alexander Morgan, 217n15
cardiovascular disorders, 11
Carr, David, 198n23
carrier: of HIV, 19; human body as, 172, 179
Carter, K. Codell, 255n62
Cartesian duality, 150
Cartwright, Samuel A., 190n14
case histories/records/reports, 25–26, 42, 43, 44, 50, 52, 186; case fiction, 57; effect of technology, 48–50; in eighteenth century,

74; forms, 48; genre of medical documentation, 51; and hermaphroditism, 93; Hippocratic, 29; need for detail in, 45; see also medical case history
"Case Method of Teaching Systematic Medicine," 51
cases, detailed: ambiguous sex, 104–118; CNS lymphoma, 71–72; phrenitis, 60–62; St. Vitus' Dance, 57–58, 65; stroke, 69–71; Tourette's syndrome, 67–68; see also Barbin, Grandjean, Johnson, Suydam
Cassedy, James H., 204n75
Castle, Terry, 214n5, 215n8
castration, 109–110
Caufeynon, Dr., 216n12
cause/causation, 26, 30, 48, 77, 171; of death, registration of, 48; of disease, 170
Céard, Jean, 220n36
celibacy, coercion of, 86, 110
cells: production, 147; specialized, 147; theory, 148
Centers for Disease Control, 17, 52, 163, 175–176, 256n80
central nervous system (CNS) lymphoma, case history, 71–72
cerebral palsy, 12
cerebrovascular accident, see stroke
Chamberlen, Hugh, 136n
Charcot, Jean Martin, 66
Charité hospital, 43
Charnon-Deutsch, Lou, 248n100
Charon, Rita, 187n7, 190n15, 194n3
Chase, Peter Pineo, 210n21, 211n30
Chatman, Seymour, 198n28
Chauvin, Etienne, 220n36
Chavkin, Wendy, 234n6, 245–246n93, 249n4
Cheek, Donald B., 237n18
Cheyne, George, 73–74, 210n20, 212n40
chief complaint, part of medical case history, 31–32
Chodorow, Nancy, 232n99, 248n100
"choice," and birth abnormalities, 3
cholera, 11, 169, 171
Chorea St. Viti, see St. Vitus' Dance
chorea, 72
chromatin, 89, 118
chromosomes: anomaly, 117; combinations, 90; criteria for sex determination, 88, 118, 119; patterns, 116–117; sex identity, 88n; tests, 79; typing of, 103; see also genes
Churchill, Frederick B., 243n70
Churchill, Larry R., 208n4
Cipolla, Carlo M., 199n36
circumcision, female and male, 12
citizenship, privileges of, 107
civil rights, 167; curtailment, 153
civil status: Barbin, 112, 115, Grandjean, 105; hermaphrodites, 92, transsexuals, 86–87
Clarke, Samuel, 132, 240n39
Clarke, Stuart, 214n7
class: social, 4, 125, 167, 168; oppression, 170

Clifton, Francis, 38–45, 51, 201n48
clinical: case studies, 20; data, interpretation of, 54; diagnosis, and narrative epistemology, 31; education, 51, 52; inference, 75; medicine, 20; parsinomy, 34; picture, 32, 60; practice, 186; storytelling, 25; tales, 58
clinics, origins of modern, 44
Clinton, Bill, 162
clothing, gender-coded, 118; women's, 106; see also cross-dressing
Cobham, Thomas, 233n3
cocaine, 168; crack, 124–125; during pregnancy, 153
Codman, Ernest A., 205n85
Cody, Lisa, 233n5, 239n34
Cohen, Estelle, 238n27, 242–243n69
Cohen, Sande, 198n28
Cohen, Sir Henry, 190n16
Cohn, Roy, 178–179
Coke, Sir Edward, 108
Cole, F.J., 222n55
Colker, Ruth, 234n6
Collas, Antide, 92
College of Physicians of London, 129
colonialism, 11
colonization, 10; of HIV, 158; vs. infection, 10
Comiti, V.P., 194n4
communication, nonverbal, in physician-patient relationship, 50
computers, and history-taking, 53; see also health-care system, medicine
Condorcet, Marie Jean, 206n87
congenital adrenal hyperplasia, 79
congenital malformations, 91, 99, see also birth
contagion, 77, 158, 160, 167–168, 180
containers, bodies as, see containment
containment, 6, 21, 156, 160, 168, 181, 182, 185, 186; strategies, 156, 159; see also AIDS, HIV
continuum of sexes, 114
contraceptives, see birth control
Cook, Timothy E., 251n15
Cooke, James, 148, 242n69
Cooper, Gary, 162
Cooper, Marcia, 241n50
Copeland, Dana D., 196n8
Corea, Gena, 249n3
Cornell Medical Indices, 50
costume, 107; see also clothing, cross-dressing
countertransference, 54
"crack baby," 132
craniotomy, 132
Crapanzano, Vincent, 229n83
cravings, influence on fetus, 127, 130; see also pregnancy
Crawford, Patricia, 235n13, 235n15, 239n33
crime, 163, 170, 171, 172, 177; hate, 5–6; inner-city, 153
criminalization of maternal behavior during pregnancy, 124–125, 127, 158
Crimp, Douglas, 164, 250n7, 253n33

Critchley, Macdonald, 211n30
Crompton, Samuel, 203n70
Crookshank, F. G., 209n6
cross-dressing, 82, 114, 165; see also clothing, costume
Csordas, Thomas J., 195n3
Cucchiari, Salvatore, 232n102
Cullen, M. J., 204n76
Cullen, William, 48
Culpeper, Nicholas, 134, 241n51
culture: and concepts of disease, 7–8, 9–10; pressure, 114; somatization of assumptions of, 17
Curry, David, 187n4
Cutler, Paul, 197n19
cyborg, 3
cytomegalovirus, 12, 175; see also AIDS

d'Alembert, Jean leRond 142
Dahir, Murbarak S., 255n69
Daniel, Steven L., 194n3
Dannemeyer, William, 176
Danto, Arthur C., 30, 196n14, 198n23, 202n53
Dash, Baidya Bhagwan, 240n41
Daston, Lorraine, 213n3, 218n21, 221n39, 240n39
Davidson, Arnold I., 115, 116, 230n89
Davis, Audrey B., 204–205n79
Davis, Michael M., 206n85
Davis, Natalie Zemon, 208n5, 216n11
Day, Doris, 162
De Gama, Katherine, 248n103
de Graaf, Regnier, 147
Dean, Amos, 227n73
Dear, Peter, 189n7
death: AIDS, 157, 164; hermaphrodites, punishment for, 90, 91, 122; and loss, 158; registration of causes, 48; Rock Hudson, 163; see also disease, epidemic, plague
Debay, A., 227n70
Debierre, Charles, 111, 115, 118, 228n77, 228n80
"decency," 83
Decline and Fall of the Roman Empire, 30, 34
deformity, 80, 169; classification of, 121; and imagination, 130–131; see also birth malformations, monsters
Degler, Carl N., 236n15
DeGowin, Elmer L., 197n19
Delpe, Marie Saint-Cyr, 255n70
Demangeon, Jean-Baptiste, 142
Demick, Barbara, 188n11
demonology, 103, 104
demyelination, 11
dermatology, 129; first English textbook, 129
Des Jarlais, Don C., 192n34
Descartes, 149–159, 243–244n78
desires: erotic, 175; homoerotic, 172; human, 166; of pregnant women, 131; sexual, 110; transmission to fetus, 131; women's, 135

Devaux, Jean, 201n44
development: embryonic, 139–141; fetal, 132
Devereux, George, 54, 207n96
deviance, from normal, 22; and narrative, 25
"deviant sexual practices," 84
devil, 92
diabetes, 27
diagnosis, 22, 28–29, 43, 54; of Barbin, 113; differential, 25, 33, 54; disease, 27–28; legal ramifications of, 123; narrative enterprise, 25, 43; patient-physician interactions, 58; process, 186; Rock Hudson's, 161; social and medical roles, 59; technology, effect of, 48
Diagnostic and Statistical Manual of Mental Disorders, 80
Diderot, Denis, 133, 142, 224n57, 241n46
Dieke, W., 220n35
diet, 171; during pregnancy, 126, 127, 152; see also cravings, pregnancy
Dietrich v. Northampton, 127, 236n16
differentiation, sexual, 80, 89
Dinouart, Abbé (Joseph Antoine Toussaint), 138, 241n58
diphtheria, 171
disability, 9, 11, 16, 77, 116, 145, 166, 170; classifications of, 14–15; language for, 14
discharge ledgers, 43, 51
discourse, 160; AIDS, 168, 172; body as product of, 180; cultural, 77; Enlightenment, 149; HIV, 158; institutional, 175; professional, 121; regulatory, 152
discrimination, 166, 179; AIDS, 175; HIV, 164, 177
disease, 54, 77, 190–191n18; antibiotic treatments, 171; Arabic traditions, 8; Asian traditions, 8; biomedical model, 1; body's response to, 8; conceptualization of, 7; cultural artifact, 1, 164–165; defining, 7–22; diagnosis, 27–28; dis-ease, 8, 16; eighteenth-century views, 60; entity, 29, 173; etiology, 8, 35; germ theory, 7; vs. health, 17, 53; humors, imbalance of 8; vs. illness and sickness, 8, 52; and individual behaviors, 173; initiating cause, 11; malaise, 8; mandated treatment, 153; microbial causes, 171; natural history of, 29, 52; nature of, 8; physiologic systems, 8; during pregnancy, 138; preliterate cultures, 7–8; prevention, 164; reducible to disturbances, 7; responsibility for, 170; sexually transmitted, 173; skin, 129; social constructions, 1–2, 9, 165; teething as, 190n14; Western European traditions, 8; womb, 133; see also AIDS, epidemics, HIV
Disney, Walt, 135
disorders, 9, 11; eating, 134; endocrine, 119n; problems in defining, 11
Dobson, Tracy, 236n17
Dollimore, Jonathan, 253n44
Domat, Jean, 227n68
Donnelly, William J., 197n18, 207n94

Donoghue, Emma, 215n8
Dora, 33, 198n26
double sex, 93, 122
doubling, 93, see also genitalia
doubtful sex, 117
Doucet, Michael and the Cajun Brew, 81
Douglas, Mary, 172, 255n66
draft status, and transsexuals, 86
"drag," 82–83
Drake, James, 242n69
Drake, Judith, 242n69
Drane, James F., 245n89
Draper, Elaine, 247n98
drapetomania, 9
Dray, W. H., 30, 196n14, 198n23, 202n53
drive-by shootings, 153, 163
drowning, and intersex, 90
drug use, 5, 159, 161, 163, 164, 167, 172–175, 177, 178, 180; during pregnancy, 125, 153–154; treatment programs, 124, 153, 158, 175; women, 168; see also pregnancy
Duchanoy, Claude-François, 43
Duckworth, D., 191n23
Duden, Barbara, 233n3–4, 237n19, 239n35
Duffin, Jacalyn M., 212n39
Dukes, Cuthbert E., 117–118, 231n95
Dunstan, G. R., 233n3
Duval, Jacques, 93, 222n43–44
dwarfs, 142

Eagleton, Terry, 208n5
ear-piercing, 12
Easton, Richard E., 197n18
eating disorders, 134, 193n41
eating habits, influence on fetus, 133; see also maternal behavior, pregnancy
Edelman, Lee, 252n28
Edgerton, Robert, 213n1
Edinburgh, clinical center at, 37; Medical School, 40; Royal Infirmary of, 40–41; University of, 44
egg: human, 147; egg, hen's, 142, 147
Eisenstadt v. Baird, 155
Elbaz, Mikhaël, 250n6
eligibility for professions, and hermaphrodites, 86
Eliot, C. W., 205n84
ELISA test for HIV, 19
Eller, Theodore, 142, 242n59
Ellis, Havelock, 115
Ely, Richard G., 197n23
embryo, 91, 99, 101, 104, 127, 132, 139, 140, 145, 146, 147, 154; development, 102n; effect of emotions on, 138, 142; Enlightenment debates about, 151; female, 104; frozen, 3; hermaphroditism, 90; history, 152; influence of maternal behavior, 152; pseudohermaphroditism, 79; sexual anomalies, 83; sexual differentiation, 119n; see also birth, fetus, maternal imagination, pregnancy

Empedocles, 133, 137
Enders, J.F., 203n63
endocrinology, 21–22, 88; 99, 104, 118; disorders, 11, 119n; intersex, 83; pediatric, 101, 103; reproductive, 101
Engel, George, 28, 190n13, 195n1–2, 205n84
Englehardt, H. Tristram, Jr., 10, 190n16, 195n8, 235n12
Enlightenment, European, 4, 123, 128, 129, 137; discourse, 149; embryology debates, 151, 152; explanation vs. Hippocratic observation, 62
enterovirus, 11
environmental and workplace toxins, 156
epidemic, 159, 160, 162, 163, 167, 170, 171; AIDS, 177–179; global, 12, 162, 164; origin of term, 158; recognized from statistics, 52; studies of, 168
epigenesis, 147–149
epilepsy, 111
epistemology, 25–26; patient history, charted by, 59; medical, 77; standards, 123
Epstein, Julia, 212n35, 253n42, 256n76
Equal Employment Opportunity Commission (EEOC), 153
Erickson, Robert A., 241n45
Escamilla, Michèle, 222n43
Eshleman, Michael K., 236n14
estrogens, maternal, 101
ethics, 154; ambiguities, 3; fetal research, 157
ethnicity, 4, 171
ethnography, 25, 74–75; theories of, 6
etiology, 43; AIDS, 18; disease, 11; of imperfect births, 151; and narrative, 26; see also causation
European Enlightenment, see Enlightenment
Evans, E.P., 225n66
Everitt, Barry J., 225n62
exercise, 171; during pregancy, 126, 127
external genitalia, see genitalia
eyebrow-plucking, 12
Eyler, John M., 204n76

Faber, Knud, 189n6, 195n5
Fabrega, Horacio, Jr., 195–196n8
fabric, social, 18
Falk, Richard, 187n8
false pregnancies, 126
Faludi, Susan, 247n98
family: dislocations, 169, 174; history, as part of medical case history, 31; values, "traditional," 181
Farmer, Paul, 193n36
Farr, Samuel, 85, 86, 217n18
Farr, William, 48, 204n76
father: permission needed for fetal research, 157; resemblance to, 132
Fausto-Sterling, Anne, 118, 165, 225n65, 228n79, 231n97–98, 253n40
fear, transmission to fetus, 131

Fee, Elizabeth, 254n53, 255n63
female, 80, 85, 87, 88, 99; desire, 135; egg, 147; interiority, 124; orgasm, as requirement for conception, 126; privileges, 114; seed, 101; see also women
femininity, 80
feminists, 103; bookstore, 158; legal scholars, 154
Ferriar, John, 45, 203n64
fertilization, 148
fetal alcohol syndrome, 126, 153; see also alcohol
fetus, 101, 125, 126, 131, 133, 134, 138, 144, 149, 151, 152, 156; anatomy, 148; born dead, legal status, 127; circulatory communication with mother, 156; dead, removal of, 132; development, 132, 149; and drugs, 158; influence of cravings on, 130; influence of mother's mental activity, 123–124; maternal responsibility for healthy development, 154; vs mother, 157; part of mother, 127; passenger, 148; personhood, 125, 127, 132, 154; previable, 154; skin, 129; research subject, 157; rights, 152, 153, 155; viability, 126; see also birth, embryo, maternal imagination, pregnancy
Feudtner, Chris, 193n41
Fiedler, Leslie, 219n27
Field, Martha A., 254n53
Fielding, Henry, 34, 198–199n30
Fifth Circuit Court of Appeals, 176
Figlio, Karl, 244n79
findings, part of medical case history, 31
Finley, Lucinda M., 247n98
"First World," and AIDS, 164
Fitzpatrick, Ellen, 236n15
5-alpha reductase deficiency, 79
Flaubert, Gustave, 61
Flax, Jane, 188n10
Floyer, Sir John, 61–63, 74, 199n34, 210n12
fluids, bodily, 173, 181; see also leakage
Flynn, Carol Houlihan, 209n8
Flynn, Errol, 162
Fogel, Robert, 126, 235n14
folk beliefs, 123, 142; about cravings, 135
foot-binding, 12
Forbes, Thomas R., 225n66
foreignness, 158, 170, 172
Forgey, Donald G., 231n98
fornication, 126
Fost, Norman, 157
Foster, Edward, 44, 46, 202n60
Foubert, Pierre, 43
Foucault, Michel, 1, 28, 112, 174, 180, 195n3, 203n61, 218n21, 228n82, 256n75
Fourteenth Amendment, 126
Fox, Margalit, 187n5
Frank, Arthur W., 258n91
Franklin, Sarah, 248n100
Fraser, F. C., 233n5, 243n72
fraud, 84, 87, 107, 114; "rabbet woman," 131

Freixas, Laura, 248n100
Freud, Sigmund, 9, 33, 115, 182, 198n26
Friedli, Lynne, 214n8, 227n71, 230n88
Friedman, John B., 220n36
Frigoletto, F.C., 243n72
"fruitfulness" vs. reproduction, 128
Furth, Charlotte, 231n98
Fuseli, Johann Friedrich, 217n18

Gable, Clark, 162
Gajdusek, C., 231n98
Galen, 35–36, 62, 99, 101, 149, 199n34,
 222n44, 225n56
Gallagher, Janet, 155, 246n95, 247n98
Gallie, W. B., 30, 196n14
Garber, Marjorie, 165, 180, 216n10, 218n24,
 230n90, 253n39
Garçon, Maurice, 220n35
Garrow, David J., 247n99
Gasking, Elizabeth B., 225n55
Gatens-Robinson, Eugenie, 194n2
"Gay Decades," 161
gays, 17, 159, 160, 161, 166, 172, 173,
 181–183; activism, 166, 172, 176;
 bookstore, 158; community, 163; denied
 housing and insurance, 175; disease, 160,
 179; and drugs, 168; gathering places, 163;
 military ban, 166; politics, 181; and sports,
 181; subculture, 163; veterans, 167; see also
 AIDS, homosexuality, lesbians
Geertz, Clifford, 74–75, 212n41–42
Gelfand, Toby, 201–202n50, 202n55–56,
 203n61, 206n86
Gélis, Jacques, 240n36
gender, 4, 80, 84, 90, 121, 120, 168, 186;
 assignment, 21–22; assumptions, 103;
 behavior, 84, 113; boundaries, 82; classifi-
 cations, 118–119, 180; codes, 82; cultural
 construction, 115, 116; definition, and social
 order, 83; differentiation, 82–83; disorders,
 79, 88n, 91; dysphoria, 80; embryology,
 148; history, 112; identity, 93, 103, 107,
 110; and linguistics, 105, 115; medicali-
 zation of, 104; normative, and intersex, 83;
 psychological, 80; roles, 82, 84; social and
 legal, 115, 119; status, 115; taxonomies, 122
"general population," 12, 159, 173
generatio ("fruitfulness"), 128
generation: as divine creation, 128; and
 pregnancy, 137, 146, 149, 151
genes, 52, 88, 119; see also chromosomes
Genesis, 93, 133
genitalia,113; abnormalities, 89; ambiguous,
 21–22, 83, 87, 110; development, 88n, 102;
 doubled, 93, 94n, 95n, 99; external, 119n,
 135, 136n; gland, 86; identities, 99; internal,
 117; newborns, 101; pluralism, 99; sex
 assignment, 79–80, 92; and social definition,
 113; surgery, 115
Geoffroy Saint-Hilaire, Etienne, 99,
 137,223n50

Geoffroy Saint-Hilaire, Isidore, 99, 100, 120,
 137, 223n50-52, 224n53–54, 225n66,
 232n100-101
George II, 65
Gesner, Conrad, 225n66
gestation, 148; physiology, 149; substance use,
 124
giants, 142
Gibbon, Edward, 30, 34, 198n29
Gilbert decision, 153
Gilbert, Sandra M., 215n9
Ginzburg, Carlo, 208–209n5
Giovanni's Room, 158
Gladwell, Malcolm, 176
Glantz, Leonard, 235n12, 236n17
Glass, James M., 193n41
Goffman, Erving, 253n36
Gogel, Edward L., 194n3
Goldstein, Kurt, 189n10
Goldstein, Richard, 258n92
gonads: abnormalities of, 89; development of,
 88n; dysgenesis of, 103; sex, 119n; see also
 genitalia
Good, Mason, 48
Goodman, L.E., 240n40
Gordon, R. R., 230n92–93, 231n94
Gossman, Samuel D., 109, 110, 118, 228n76
Gostin, Larry, 254n54
Goubert, Jean-Pierre, 204n77
Goujon, E., 113, 229n82, 229n85
Gould and Pyle, 88
Gould, George M., 219n27
Graham, James, 244n83
Grandjean, Anne/Jean-Baptiste, 105–107, 108,
 111, 113, 118, 227n69
Granger, Carl V., 191n25
Graunt, John, 48
green monkeys, 177
Greenblatt, Stephen, 93, 222n44
Greenwich Village, 177
Greenwood, Major, 204n75
GRID (gay-related immunodeficiency), 18
grief, 5, 158, 175; see also AIDS, death
Griswold v. Connecticut, 155, 247n99
Grmek, Mirko D., 250n10
Grosrichard, Alain, 130
Grossman, Lionel, 196n16
Guicciardi, Jean-Pierre, 223n49
Guy's Hospital, 45
Guy, William Augustus, 45, 203n68
gynecomastia, 116

Haag, Jeannine S., 217n13
Hacking, Ian, 193n41
Haitians, 159, 172, 175, 182, 183
Hall, Diana Long, 224n60
Hall, Marshall, 150
Hall, Stuart, 188n11
Haller, Albrecht von, 99, 147
Halley, Janet E., 258n94
handicaps, classification of, 14; see also disability

handicaps, classification of, 14; *see also* disability
Hankoff, L.D., 240n42
Hansen, Bert, 253–254n45
Haraway, Donna, 3, 158, 187n6, 250n8
Harding, Sandra, 20–21, 193n39, 225n65
Harris, Daniel, 250n7, 256n77
Harrison, Michael R., 243n71
Hart, Lynda, 81, 214n5
Hartley, David, 244n84
Hartsoeker, Nicolas, 147
Harvey, A. McGehee, 207n98
Harvey, William, 133, 146
Hausman, Bernice L., 218n24, 230n90
Hawkins, Anne Hunsaker, 211n26
Hawkins, Francis Bisset, 48
Hawley, Donna Lea, 217n13
Hayt, Emanuel, 204n78
Health and Human Services, Secretary of, *see* Heckler
health vs. disease, 53
health-care system, 4, 53, 169; conceptualization of body, 1; fragmentation, 4–5; institutionalization of, 206n94; insurance, 164; "product lines," 4; subspecialties, 4–5; unequal access, 155; workers, mandatory testing for HIV, 176
heart disease, 171
Heberden, William, and Samuel Johnson, 70, 72, 211n31
Heckler, Margaret, 18, 162, 252n23
Heidel, William Arthur, 199n34
Heliodorus, 137
Helms, Jesse, 162–163, 176, 192n35
Hélot, Paul, 227n69
hemophilia, 11, 159
Hempel, Carl, 30, 196n13
Henderson, Andrea, 242n67, 243n75
Henifin, Mary Sue, 246n95
Henry IV, Part Two, 7
Héricourt, Louis de, 218n20, 227n68
Hermann, Anne, 216n10
hermaphroditism, 6, 21, 79, 80, 83–85, 87, 88n, 89–93, 94–97n, 99, 100, 103–105, 108, 111, 114, 117, 122, 186; classified with monsters, 88; and criminal propensities, 118; legal status, 84, 108; medical jurisprudence, 84; medicalization, 90; mythology, 81; true, 79; twin, 94n, 98n
Hermaphroditus, son of Hermes and Aphrodite, 104
heroin addicts, 159; *see also* drugs
Hertwig, Oskar, 148
heterosexuality, 81, 84, 122, 159, 160, 161, 166, 170, 178, 180; image, 163; normativity, 89; social order, 81, 84, 121
high schools, condom availability, 173–174
high-risk behaviors, 173; *see also* risk
Hillman, James, 208n4
Hills, Alfred K., 45, 204n72
Hindu medical treatises, 132
Hippocrates, 8, 39 60, 62, 68, 74, 149, 194n4,

199n33–35, 209n11; case-writing, 29, 35; edited by Francis Clifton, 38; eighteenth-century interpretation, 61–62; origins of record-keeping, 26
Hippocratic medicine, 52, 61, 132, 170; environmental nature, 60
historiae morbi, 67
historiography, 6, 31
history: of medicine, 6; narrative philosophers of, 30–31; of present illness (HPI), 32; theories of, 6; *see also* patient history
HIV, 12–13, 17, 19, 160, 161, 163, 164, 165, 166, 168, 172, 175 177, 182; "AIDS virus," 18; antibody status, reporting, 176–177; "carriers," 19; hospice, 175; infection, early history of, 18; newborns, 153; stigmatization of, 167, 176; testing for, 18–19, 173, 176, 177; and women, 157–158, 168; *see also* AIDS, seropositivity
Hodge, Hugh Lenox, 57–58, 72, 152, 208n1–2
Hoeldtke, Robert, 244n78
Hogarth, William, and Samuel Johnson, 65, 67
Hollibaugh, Amber, 175, 256n78
Hollywood, 160, 162
Holmes, Oliver Wendell, 127
Holquist, Michael, 194n2
Home, Francis, 44–45, 54, 203n63
homelessness, 153, 178
homophobia, 81, 122, 158, 166, 168, 169, 173
"homosexual panic," 166
homosexuality, 87, 89, 106, 114, 115, 121, 158–159, 161–164, 166–167, 171–172, 179, 180–181; acts, 84; alliances, 85; "disease" in nineteenth century, 167; identity, 168; male, 168; medicalization, 22; "mental disorder," 167; *see also* gays, lesbians
Hooper, Robert, 28, 195n4
hormones: discovery of, 101; dominance, 89n; interventions, 80, 118, 120; technologies, 116
Horton, Willie, "HIV version," 176
Hosack, David, 203n66
hospice, AIDS, 175, 256n79
hospitals: administration, 44; architecture, 44; case-takers employed by, 40; development of modern, 44; nineteenth-century, 53; and philanthropy, 202n60; record-keeping in eighteenth century, 51; teaching, 44
Hoult, Thomas Ford, 219–220n32
Howard, Jean, 214n7
Howard, Martin, 219n27
Howden, James C., 49, 204n74
Howell, Joel D., 204n79
HPI, *see* history of present illness
Hubbard, Ruth, 235n12
Hudson, Rock, 160–163, 166; filmography, 161, 251n18–21, 252n26
Huet, Marie-Hélène, 130, 135, 238n28, 238n30, 240n44, 241n53, 242n67, 243n73
Hull, David L., 198n23
human body: carrier of cultural critique, 180; cultural beliefs about, 128; and

environment, 151; *see also* body
human immunodeficiency virus (HIV), *see* HIV
Humphrey, Nicholas, 193n41
Hunter, John, 99, 225n66, 230n91
Hunter, Kathryn Montgomery, 194n3, 209n6
Hunter, William, 237n19
Huntington's disease, 12
husbands, abusive, 138
Hutchinson and Rainey's *Clinical Methods*, 50
Hutchinson, Robert, 205n81
hypospadias, 116, 213n2, 230n91
hysteria, 111, 133; public, 160

Ibsen, Henrik, 255n58
identity, 168, 179, 185; boundaries, 4;
 categories, 4, 168; class, 4; chromosomal,
 88n; ethnic, 4, 171; fragmentation, 3;
 gender, 107; genital, 99; housed in body, 1;
 markers, 163; personal, 6; personhood, 1;
 racial, 4, 171; religion, 4; selfhood, 4;
 sexual, 93; social and civil, 120; subjectivity,
 1; visibility vs. invisibility, 13
Iggers, Georg G., 197n21, 199n32
Ignatieff, Michael, 187n8
illness, 12, 159; differentiated from disease and
 sickness, 8; *see also* disease
imagination, 151; and birthmarks, 129; and
 deformity, 130–131; force of, 129–131;
 physiology, 143; power, 129, 133, 143, 150;
 and skin, 129; *see also* maternal
 imagination
imaginationists, 149, 151
imaging technologies, 124
Immigration and Naturalization Service, 164
immune system, 8, 52; breakdown, 165;
 dysfunction, 11; weakened, 161
immunity, 177; social, 172
Imperato-McGinley, Julianne., 231n98
implants, breast, 22
impotence, 85, 111
impressions, maternal, *see* maternal
 impressions, pregnancy
imprinting of fetuses in womb, 127, 144
Index Medicus, 134
infantile paralysis, *see* polio
infected individuals, legal status, 170
infection, 170; "natural," 164; opportunistic,
 165, 175; vaccine-induced, 164; vs.
 colonization, 10; *see also* HIV
inference, clinical, 75
infertility, 111
influenza, 169
informed consent, 29, 155
inheritance, 91, 132, 151; and hermaphrodites,
 86, 108
inner city: ghettoes, 163; youth, 153
"innocent victim," 17, 176; *see also* AIDS
insurance coverage, denial, 175; *see also* health-
 care system
intemperance, 138; *see also* alcohol
International Conference on AIDS, 162

intersexuality, 79–80, 83, 87–88, 103, 107,
 114, 116–118, 122–123; discovered at
 puberty, 80; and law, 86; and newborns, 80
interventions: medical, and hermaphroditism,
 90; surgical and hormonal, 120, 122
intimacy, *see* sex
intravenous drug users, *see* drug use
"inversion," 166
invisibility: cultural, 159; of hermaphrodites,
 116; and identity, 13; people in wheelchairs,
 13
Irvine, Janice M., 219n24, 255n56
Itard, Jean, first described Tourette Syndrome,
 66

Jacquart, Danielle, 189n5
James I, 133
James, Robert, 143
Jardine, Lisa, 214n7
Jessup, R.B., Jr., 241n48
jeu de nature, 91
Jews, 167, 169
Jewson, Norman, 195n7, 209n9
Johns Hopkins Hospital Psychohormonal and
 Pediatric Endocrine Clinics, 103
Johnsen, Dawn E., 234n12, 246n96
Johnson v. *Florida,* 132, 233n6–7, 234n9
Johnson, Jennifer Clarice, 124–125, 132, 153,
 234n6
Johnson, Mark, 244n84
Johnson, Samuel, 57, 64–73, 151, 210n14–23,
 211n29–31; afflictions, 65–71; literary fame,
 67; stroke, 69–70
Jones, Ann Rosalind, 221n39
Jones, Howard W., 88n, 89n, 119n, 219n31
Jones, James H., 254n51; 255n57
Jones, James W., 255n64, n68
Jones, W. H. S., 199n34
Jordanova, Ludmilla, 223n48, 237n19
Jospe, Erin, 253n43
jouissance, 143
Judeo-Christian tradition, 133
Jumelin, Jean-Baptiste, 43
"junkie pneumonia," 18
jurisprudence: in early modern Europe, 123;
 medical, 108; medicolegal, 123; professional
 discourse of, 122; and sodomy, 85; *see also*
 law, medicine
"just say no," 174

Kalin, Tom, 252n26
Kamm, Henry, 188n11
Kampmeier, R. H., 194n4
Kapani, Lakshmi, 240n41
Kaplan, Robert D., 185, 258n2
Kaposi's sarcoma, 12, 22, 175; *see also* AIDS
karyotyping, 103
Kass, Amalie M., 239n35
Keane, Jonathan, 252n27
Keel, Othmar, 203n62
Kelalis, P.P., 230n91

Keller, Evelyn Fox, 248n100
Keller, R., 220n35
Kellner, Hans, 196n16, 197n22
Kenney, Sally J., 247n98
Kermode, Frank, 208n5
Kessler, Suzanne J., 213n2–3, 219n25
King, Lester L., 9, 189n11
Kinks, The, 232n104
Kinsella, James, 251n15
Kirp, David L., 247n98, 248n105
Klawans, Harold L., 208n4
Kleinman, Arthur, 187n3, 206n89, 207n94
Klinefelter's Syndrome, 79, 116; see also gender disorder
knowledge: framework, 75; produced by body, 73; see also medical knowledge
Kolata, Gina, 213n2, 218n22, 249n2
Kolder, V., 246n93
Kolin, Elizabeth A., 211n33
Kosman, Aryeh, 242n68
Krafft-Ebing, Richard von, 115
Kramer, Lloyd S., 196n16
Krauthammer, Charles, 257n81
Kristeva, Julia, 180
Kunitz, Stephen B., 197n17
Kurtz, Dorothy, 206n85
Kushner, Tony, 157, 178, 249n1, 257n85, n87–88

labels, 12; for altered conditions, 12
Laclau, Ernesto, 187n9
lactation, 126
"Lady and the Tramp," 135
Laënnec, René, 51, 194n4
Lambda Legal Defense Fund, 176
lang, k.d., 121
language, 114; abuse of, 45; of AIDS, 175; biomedical, and ambiguous sexuality, 81; body, 186; of catastrophe, 164; editorial, 159, 170; juridical, 112; medical, about maternal imagination, 142–143; of pathology, 117; professional, 63, 77; used to describe "normal," 8; see also discourse, narrative
laparotomy, 116–117
Laplace, Pierre, 206n87
Laqueur, Thomas W., 29–30, 101, 180, 182, 196n10–11, 209n7, 224n57, 237n21, 258n100
Lastinger, Valérie Cretâux, 241n46
latency, 172
Latinos, 168, 169, 172, 183
Lavater, Johann Caspar, 142
law: anomalous births in eighteenth century, 105; and Herculine Barbin, 113; and birth malformations, 132; and diagnoses, 123; domination of one sex, 108; hermaphrodites, 83–84, 86, 91, 108; and infected individuals, 170; literature, 119; vs. medicine, 121; and pregnancy, 127, 152; privileges, 110; ramifications of sex

differences, 89, 120; sex assignment, 103; sumptuary, 83; see also jurisprudence, medicine
leakage, 6, 17, 158, 162, 170, 172, 173, 186, see also AIDS, containment
LeBlanc, Allen J., 257n80
legitimacy, 121, 132; and hermaphrodites, 86
Leiden, University of, 129, 137; bedside teaching at, 37, 38
Lemay, Helen Rodnite, 224n56
leprosy (Hansen's disease), 167, 169, 171
lesbians, 106, 107, 166, 166, 172, 182, 183; and drugs, 168; and sports, 181; see also gays, homosexuality
Lesbos, 106
Lesky, Erna, 199n36
Leslie, Glennda, 239n34
Lettsom, John Coakley, 37, 63, 64, 210n13
Leuwenhoek, Antoni van, 146
Levin, David Michael, 203n61
Levine, Laura, 215n9
Levinson, Stephen F., 192n30
Lewis, Paul, 188n11
Leydig cells, 88n
Leys, Ruth, 193n41, 244n80
liberals, 166
Life of Johnson, 64–65
Lillie, Frank R., 101., 224n59
Lindsay, Cécile, 257n89
Linnaeus, Carolus (Carlvon Linné), 202n58
Lip Tay, A.-B. de, 111, 228n77
liposuction, 12
Lizza, John P., 193n41
Locke, John, 45, 123, 135, 232n1
"Lola," 121
Lorch, Donatella, 188n11
Lorde, Audre, 193n40
loss: of bodily control, 71–72; and death, 158; of function, 14–15
Lothstein, L.M., 218n24
Loudon, Irvine, 201n49
Louis, Antoine, 202n55
Love Alone, 159–160
Ludmerer, Kenneth M., 205n84
Lyman, William D., 249n4
Lyne, John, 191n20
Lyotard, Jean-François, 180

MacBride, David, 200n40
Maclean, Ian, 221n39
Madame Bovary, 61
madness, 111
"magic bullet" approach to therapy, 10
Mahfouz, Naguib, 1, 187n1
male, 80, 85, 87, 88, 99; lineage, 151; power, 113–114; privileges, 114; seed, 101, 146
Male, George Edward, 228n74
Malebranche, Nicholas, 130, 133, 137, 144–146, 242n64
maleness, usurpation of, 107–108

malformations, 91, 100, 144; birth, 127, 131, 132; congenital, 91; and maternal imagination, 133; natural, 99; *see also* birth abnormalities, pregnancy
Malleus Maleficarum, 210n25
malnutrition, 155; *see also* diet, socioeconomic problems
Malpighi, Marcello, 147
Mandelbaum, Maurice, 197–198n23
Maranhão, Tullio, 207n95
Marcus, Steven, 33, 198n26
Marie/Marin le Marcis, 93
Mariner, W.K., 246n93
markers, sexual, 82
marketing of sex, 182
marriage, 85, 86, 110, 113, 114, 120, 121, 126, 130; of Jean-Baptiste Grandjean, 105–106; same-sex, 84
Martin, Emily, 10, , 190n15, 258n90
Martin, Ernest, 217n16, 221n38
Martin, Wallace, 196n12
masculinity, 80, 161
Massachusetts General Hospital, 50
mastectomy, 116
maternal: autonomy, 127; duty, 152; imagination/impressions, 129–131, 133, 134, 135, 137, 142, 143, 144, 145, 146, 147, 148, 149, 151, 152; interaction with fetus, 134, 137–138, 144, 145, 148, 149; sacrifice during pregnancy, 154
maternity benefits, 153
Mattei, Antonio, 54, 207n97
Maubray, John, 130, 239n32
Mauclerc, John Henry, 138
Maulitz, Russell, 195n5
Mauriceau, François, 135, 136n, 241n54
May, Robert, 192n33
Mayer, Musa, 187n2
Mayes, Linda C., 237n18
McClain, Linda C., 248n104
McClure, Kirstie, 187–188n9
McCormick, Brian, 245n90
McCullagh, C.B., 42, 202n52
McCullough, Lawrence B., 207n98
McDowell, Deborah, 250n7
McHenry, L.C., 210n23
McHenry, Lawrence C., Jr., 211n31
McLaren, Angus, 225n55, 233n3, 236n15, 240n36
McMaster, Juliet, 237n20
McNeill, William H., 52
McNulty, M., 246n93
Meaney, Audrey L., 189n5
Mears, Martha, 137, 241n56
media, mass: and AIDS, 159–163, 178; hysteria, 173; *see also* editorials
medical case histories/records, 6, 27–55; clerical task, 40–41; and computers, 53; epistemological purposes of, 42; Hippocratic origins, 26; history of, 6; institutional recording mandate, 37; layers of meaning,

55; and medical education, 32, 38; medicolegal function, 28; social document, 27; standard order, 31; system for producing and maintaining, 39–40; tabular method, 41; teaching strategies, 35; *see also* cases, case history
medicalization, 28, 171; of body, 19; of conditions, 13; of gender disorders, 104; of hermaphrodites, 84; of homosexuality 22; social functions of, 26; *see also* pregnancy
medicine, 120, 121, 185; advice, 59; changing attitude toward, 59; cultural diagnoses, 20, 22; and discourse, 28–29, 122; education, 32, 35, 44, 45, 51; epistemology, 77, history, 6, 129, 189n5–6; influence on definitions of disease, 10; and law, 28, 87, 92, 114, 120, 123, 154, 186; at Leiden, Edinburgh, and Vienna, 37; narratives, 22, 58; norms, 190n15; political motivations, 53; rehabilitation, 191n28, n30–31; right to refuse treatment, 155; statistics, 48, 52; surgical interventions, 80; textbooks, 48; *see also* medical case history, medical students
Melicow, Meyer M., 224n58
meningitis, 159
Menkes, Suzy, 187n4
menstruation, 107, 235n13
mental state, active and passive, 134; effect on fetus, 152; *see also* maternal imagination
Meredith, Ann, 249n3
Merskey, Harold, 189n13
Mertrud, Antoine, 229n84
Metamorphoses, 104, 114
metaphor, military, 10, 190n17
Mettler, Fred A., 219n29
Mezzacappa, Dale, 256n73
Meyer, Arthur William, 222n55
Meyer, Gregg S., 173, 254n53., 255n70
Meyer, Richard, 161, 251n18–19
Middle Ages, and hermaphrodites, 83; and intersexuality, 90
Middleton, Peter, 200n39
midwifery, 124, 130, 132, 137, 145
Migeon, Claude J., 225n63
Miles, Lesley, 249n3
Miller, D.A., 252n30
Miller, Gordon L., 35, 199n35
Miller, J. Hillis, 208n5
Milton, John, 27, 68, 211n28
mind/body, 1, 3, 149, 151
mind/self, 185
Mink, Louis O., 33, 196–197n16, 198n23, n25
miscarriage, 144
mistakes, medicolegal, 87
molly houses, 82
Monette, Paul, 159–160, 251n13–14
Money, John, 213n1, 219n30, 225n65, 231n98
Monfalcon, J.B., 150–151, 244n80
monsters, 83, 85, 91, 92, 93, 95n, 99, 103, 104, 122, 128, 129, 130, 132, 134, 142, 146, 149,

154, 219n27, 220n36; etymology of, 91; and forbidden fruits, 130; lion-like, 131; study of, 88; see also birth, hermaphroditism, teratology

monstrosity, 21, 99, 100; vs. anomaly, 122; see also monsters

Montaigne, Michel de, 92, 133, 212n36, 221n41, 240n43

Montgomery, Scott L., 190n17

Moore, Keith L., 102, 213n2, 219n30

"Moral Majority," 161

morality, public, 84; regulation of, 84

Morbidity and Mortality Weekly Report, 52

Morman, Edward T., 204n79

Morris, David B., 212n35

Morrison, Paul, 192n29

Morse, Stephen S., 158, 250n9

mortality statistics, 52

Mosley, Philip, 208n4

mother: bad, 177; blame, 152; cultural beliefs about, 128; vs. fetus, 157; romanticization of, 153; see also maternal imagination, pregnancy

Müller, Johannes, 150

Müller, M. Jacob, 222n42

Multiple Personality Disorder, 22, 193n41

murder, witness to, 133, 146

Murphy, Terence D., 202n51, 206n87

Murray, T. J., 210n23

mycobacterium, 11

Nance, Brian K., 190n14

Nanda, Serena, 231n98

narrative, 20, 34, 73, 194n2, 196n15; AIDS, 17, 163; authority, 186; autobiographical, 70; cultural, 19; desire, 19; of divine punishment, 182; and diagnostic process, 25, 53; efficient, 26; and etiology, 26; explanatory, 21, 25, 151–152; form, 30, 59; historians, twentieth century, 42; irony, 185; medical, 1, 25–26, 208n4; patient, 6; philosophers of history, 30–31; pollution, 164, 177, 182; stigmatizing, 169; theories of, 6; see also case record, medical case history

National Academy of Sciences, 159

National Institutes of Health (NIH), 157

National Research Council, 159, 180, 193

natural history, of disease, 29, 52; growing interest in, 91

natural, conceptions of, 90, 92, 104

Needham, Joseph, 222n55, 242n67, 243n72

needles, contaminated, 5, 174, 175; exchange programs, 173–174, health-care workers' exposure, 176; see also drugs

Neff, Christyne L., 155, 248n103

Nelson, Warren O., 118

nervous system, 150, 151

neurologic disease, 66

neurophysiology, 127, 151; nervous communication, 131

New Jersey Superior Court, 177

New Orleans, 170, 171

New Right, 161, 181

New York City, 181; cholera epidemic, 169

New, Maria, 213n2

newborns, 80, 101, 103, 120; women as threat to, 152

Newman, Charles, 194n4

Newman, Karen, 237n19

Newton, Esther, 216n10

normal, 3–4, 11, 14, 59, 100, 121, 165; vs. abnormal, 8; disease as alteration of, 8; gait, 16; "general population," 21, 159, 173; and human body, 6; language used to describe, 8; and narrative, 25; passing as, 160; physiologic conditions, 7; sexual identity, 119; standards developed from data collection, 53

normativity, 9–10, 12, 14, 17, 19, 104, 121, 174; of heterosexuality, 89; and sexual identification, 80

norms: cultural, 6; deviation from, 104; and measurement of clinical progress, 58; social, 4, 171

North America, development of case recording in, 45, 51

nosography, 36

nosology, 52, 73; statistical, 48

novels, 34, 59; about AIDS, 177

Nunokawa, Jeff, 251–252n23

nursery sex, 119n

Nye, Robert A., 224n59

O'Donovan, Katherine, 217n13

Oakeshott, Michael, 202n53

observation, 45, 53, 54; bedside, 28, 38–39, 44; empirical, 77; Hippocratic, 60–62; importance of, 39; in medical case history, 37; records, types of, 43

obstetrics, 103, 124, 128; and cravings, 135; see also birth, pregnancy

Oppenheimer, Gerald M., 252n28

opportunistic infections, see AIDS

order of medical case history, 31; see also SOAP

orgasm, female: and generation, 101; as requirement for conception, 126

orientation, sexual, see sexual orientation

Orlan, 2

Ormrod, Roger, 217n13

Osborne, Thomas, 203n61

Otherness, 5, 166, 172, 183

Oudshorn, Nelly, 225n60

ovarian follicle, 147

ovaries, 136

Ovid, 104, 114, 226n67

ovism, 147–149

Owen, Richard, 148

Packard, Randall M., 254n49

Padgug, Robert A., 254n46

Paget, Marianne A., 187n2

palpation, 124

Paltrow, Lynn M., 127, 236n18, 246n93
Panizza, Oscar, 229n82
papilloma virus, human, 176
papyri, ancient medical and surgical, 35
Paradise Lost, 27, 64, 68
parasites, 11
Paré, Ambroise, 91, 92, 221n40
parentage, 132, *see also* legitimacy
Park, Katharine, 176, 191n21, 222n43, 257n82
Parker, Patricia, 222n43
Parlee, Mary Brown, 193n41
Parsons, James, 115, 230n88
parthenogenesis, 148
Partner, Nancy F., 197n16
paternity challenges, and hermaphrodites, 86
pathography, 211n26
pathologization of behavior, 9–10
pathology, 10, 14, 17, 48, 67, 71, 117;
 anatomy, 28; cutaneous, 129; development
 of, 44and hermaphroditism, 90; *see also*
 cellular pathology, Virchow
patients: charts, 60; history, 25, 26,28, 31–32,
 45, 55, 59; interviews, 50; narratives, 6;
 own words, 32; records, 25, 204n79; vs.
 technological intervention, 53
Patton, Cindy, 160–161, 212n37, 251n15,
 251n17, 251n21, 251n23, 253n43, 254n47
Pauker, Stephen G., 206n93, 207n94
Peace Corps, 164
Peacock, James L., 216n10, 231n98
Peal, Raymond, 206n85
pelvic inflammatory disease, 175
Pennsylvania Health Department, 177
People in Trouble, 177–178
Perestroika, 179; *see also Angels in America,*
 Kushner
performance art, 2
Perkoff, Gerald D., 235n112
personhood, fetal, 132; *see also* fetus
perversion, sexual, 84
Petchesky, Rosalind Pollack, 247n99, 248n103
Peters, Dolores, 239n32
Peterson, R. E., 231n98
philanthropy, and hospitals, 51, 202n60
Phillips, Jayne Anne, 248n100
Philopson, Tomas J., 254n54
philosophers, 25; of history, 30–31
physical medicine and rehabilitation, new
 medical specialty, 13; *see also* medicine
physicians, ancient vs. modern, 38–39;
 authority, 72, 170; butt of jokes in
 eighteenth century, 129; in early modern
 Europe, 123; as ethnographers, historians,
 biographers, 75; and narratives, 25–26;
 relationship with patient, 50; shifting roles
 during eighteenth century, 59; as
 storytellers, 25
physiology, 119n, 150–152; of perception, 150
pica, 134, 149; *see also* cravings, pregnancy
pickles and ice cream, *see* cravings
pineal gland, 150

Pinel, Philippe, 44, 202–203n59, 203n66,
 206n87
pink triangle, 167
plague, 158, 169, 171, 191n21, 192n29;
 bubonic, 12, 169
Plato, 1, 93, 212n36
pleasure, sexual, 107, 111; *see also* sex
Pliny, the Elder, 220n35
pneumocystis carinii pneumonia, 175
poetry, and AIDS, 159–160, 177
polio (poliomyelitis), 11; epidemic, 169
politics, 3, 4, 185; of courtship, 82; of
 difference, 167; gay, 181; and medical
 system, 53; and personal choice, 3; power,
 151; protest, 178; of repression, 173; and
 "rights," 3; and self-determination, 4
Pollitt, Katha, 152, 245n88
Pollock, Linda A., 236n14
Pollock, Philip H., III, 253n33
pollution narratives, 164, 177, 182
pollution, 158, 169, 178; homosexual, 173
polyps, regeneration in, 128
Poovey, Mary, 204n77, 234n12, 238n24,
 247n100
Pope, Alexander, and Samuel Johnson, 65
Porter, Dorothy, 209n8
Porter, Roy, 59, 209n8, 239n35
postmodernism, 5, 175, 180
poverty, 5, 125, 153, 155, 163, 169, 171, 174
Powell, Robert S., 204n70
power, male, 113–114
precipitating factors, noted in Hippocratic
 writing, 60
preformationism, 146–149, 158
pregnancy, 123–125, 128, 130–132, 137, 146,
 149, 155, 156; and AIDS, 158; and alcohol
 use, 22, 138; and AZT, 157; birthmarks,
 127, 129, 142; and bodily integrity, 155;
 coercive stance toward, 155; criminalization
 of behavior during, 124, 153, 158; desires
 during, 131; diet, 152; domain of women,
 124; drug use, 125, 153–154, 158; exercise,
 126; generation, 137; guide, 133;
 imagination, 129–130; and law, 154;
 medicalization, 124; mental activity as
 possible cause of birth abnormality, 123;
 nutrition, 126; prosecutions in early modern
 Europe, 126; rape, 126; responsibility for
 birth abnormalities, 130–131; as "rough
 sea," 135; technology, 124; teenage, 153,
 163; travel, 126, 138, 152; women vs.
 medical authority, 152
preliterate cultures, and concepts of disease,
 7–8
Premenstrual Syndrome, 193n41
prenatal: care, 126, 153; damage to fetus, 125;
 injuries, mother sued for, 154; technology,
 154
primogeniture, 132, and hermaphroditism, 108
prison, and Jean-Baptiste Grandjean, 106
privacy rights, 124, 154–155; and AIDS, 172

Probst, Christian, 194n4
property rights, 132; and hermaphroditism, 108
prostheses, 16; breast, 22
prostitutes, 172, 180
pseudohermaphroditism, 79, 88n, 89, 100n, 117; causes of, 103
psyche, 4, 149
puberty, 80; and sex assignment, 101
public health: agenda, 158; education, 173; individual responsibility, 170; policy, 20; strategy, 173; *see also* health-care system
punishment, of hermaphrodites, 114
quackery, 41
quarantine, 173

Queer Nation, 162
Quétel, Claude, 254n53
quickening of fetus, 124, 126
Quincy, John, 114, 230n87

"rabbet woman," 131, 239n34
Rabkin, Eric, 208n4
race, 125, 166, 168, 171, 177; classification systems, 180; difference, 159; oppression, 167; pertinence in medical case history, 27; and selfhood, 4
racism, 5, 158, 169; *see also* race, discrimination
Rackin, Phyllis, 214n7, 215n9
Rand, Erica, 241n46
Randall, Tony, 162
rape, and pregnancy, 126
Rappoport, Mark, 251n20
Rather, Lelland J., 189n9, 190n16, 243–244n78
Raymond, Janice, 218n24
Reagan, Ronald, 18, 179
refugees, 5, 188n11
regulation: of bodily functions, 167; of pleasures, 167; *see also* control
rehabilitation: and AIDS patients, 17; for drug users, 124; as medical specialty, 13–16, 186
Reid, Evelyn, 187n9
Reiser, Stanley Joel, 26, 194n4, 205n79, 207n94
religious right, 182
repression: and AIDS, 172; politics of, 173
reproduction, 121, 128, 151; vs. "fruitfulness," 128; endocrinology, 101; freedom, 155; parthenogenic, 148; regeneration, 128; regulation, 152; rights, 127, 157; role of male and female in, 101; women's roles, 152
research, fetal, 157
responsibility: for birth abnormalities, 130–131, 151; individual, 170, 173; location of, 155; *see also* blame
Reynolds, Sir Joshua, and Samuel Johnson, 65–66
Rezvani, Iraj, 213n1, 225n61, n64
Rich, Frank, 161

Richardson, Samuel, and Samuel Johnson, 65
Ricoeur, Paul, 31, 196n15
Riese, Walther, 52, 190n16, 199n34
Riesman, David, 202n54
rights: citizenship, 109; of fetuses, 155; human and civil, 167, 169; language of, 155; legal, 185; privacy, 155; reproductive, 127, 157
Riley, Thomas J., 169–170
Riolan, Jean, 222n43–44
risk: behaviors, 180; and Kimberly Bergalis case, 176; categories, 160; factors, 6; groups, 19, 158–159, 162, 180; for transmission of HIV, 158
Risse, Guenter B., 25, 26, 40, 194n4, 201n49, 206n90, 254n53
Rivera, Geraldo, 213n1
Roberts, Dorothy E., 125, 234n6, n10
Robertshaw, Paul, 217n13
Robertson, Jennifer, 216n9
Robertson, John A., 235n12
Robertson, Matra, 193n41
Robinson, Nicholas, 244n83
Roe v. Wade, 125–126, 153–155, 157, 234n11, 247n99
Roe, Shirley A., 243n72
Rogers, Adrienne, 236n15
Rogers, Fred, 224n57
Rogers, Pat, 215n9
Rolleston, Sir Humphrey, 210n21, 211n30
Romm, James, 220n36
Ronsil, George Arnaud de, *see* Arnaud
Roof, Judith, 246n96
Rosenberg, Charles E., 165, 194n4, 253n34, 254n55, 254n59
Rostand, Jean, 242n66
Roth, Paul A., 198n23
Rouen, 93
Rousseau, Alain, 206n91
Rousseau, G. S., 209n6, 241n51, 244n78, 244n82
Royal College of Physicians, 70
Royal Infirmary of Edinburgh, 40–41
Royal Society of Medicine, French, 123
Ru Paul, 121
"ruffed" neck, 130–131
Rufus of Ephesus, 35
Ryles, Gilbert, 74

Sacks, Oliver, 58, 66, 208n4, 210n24
sadomasochism, 167
Saint Augustine, 90, 92, 93, 220n33
Saint Pius, child resembling, 133
Saint-Hilaire, Etienne, 99, 137, 223n50
Saint-Hilaire, Isidore Geoffroy, 99, 100, 120, 137, 223n50–52, 224n53–54, 225n66, 232n100–101
Sarton, May, 211n33
Satan, 92
Sbiroli, Lynn Salkin, 237n21
scarification, 12
Scarry, Elaine, 73, 180, 212n35, 232n106,

257n90
Schafer, Roy, 208n4
Schecter, Stephen, 171, 255n61
Schiebinger, Londa, 214n5
Schneider, Naomi, 187n2
Schulman, Sarah, 177–178, 257n85–86
science: description in, 33; value-neutral, 20–21
scientific method, 55
Scott, Sir Walter, 133
Scott, William Wallace, 88, 89, 119
Seamons, Roger G., 198n25
secondary sex characteristics, 88, 89, 119
secrecy, and AIDS, 172
security clearance, and transsexuals, 86
seed: male, 146–147; male and female, 101
Segal, Marian, 249n3
Segal, Sheldon J., 118, 231n96
Seidman, Steven, 180, 258n93
"self-control," women's alleged lack of, 154
self-mutilation, and skin art, 2–3, see also style, mutilation
self/body relation, 4; see also body
Seligman, S.A., 239n34
semeiotics, 28–29, 35, 36; of clothing, 82; of monsters, 91; of teratology, 104
semen, 147; semen virile, 148
Sendrail, Marcel, 220n36
Senelick, Laurence, 215n8
seropositivity for HIV, 12–13, 173, 175, 176; see also HIV
Sertoli cells, 88n
sex: ambiguity, 77–122; anal, 161; assignment of, 80; attraction, 87; binary, 115; biological, 87, 89; and birth certificates, 86–87; categorization, 86; change, in Renaissance, 93; chromatin, 89; criteria, 88n, 89n; definitions, 119; designation, 84; determination, 80, 84, 108, 165; differences, 182; differentiation, 80, 89, 101, 103, 119n; "doubtful," 111, 117; and hermaphrodites, 90; identification, 80, 84, 120; identity, 82, 93, 119; immorality, 126; intimacy, 172; labeling, 90; marketing, 182; neutral, 87; nonprocreative, 168; obvious, 117; organs, developmental commonalities between, 101; orientation, 4, 107, 166; pertinence in medical case history, 27; "perversion," 84, 167; pleasure, 107, 111; predominating, 88; "prevailing," 86; of rearing, 89n, 90, 118, 119; safe, 181; safer, 182; social, 89; state's interest in, 84; statistics, 174; surgical reassignment, 80, 86–87; and teenagers, 174; unprotected, 174; varying definitions, 87; see also embryo, gender, sexualitysex acts, 84, 167–168, 172, 174, 175, 180, 181, 182, 186; "abnormal," 181; "deviant," 84; same-sex, 84
sex assignment, 80; biosurgical capacity to alter, 2; of newborns, 103
sex characteristics, secondary, 88, 89
sex objects, 80, 160, 162

sex workers, 172, 180
sex-change operation, 115
sex-trashing, 169
sexology, 115–116, 121; in nineteenth century, 83
sexual markers, 82
sexuality, 152, 160, 166, 167, 186; confusion, 121; control of, 121, 122; costume, 82; desire, 110, 174; epidemic, 181; expression, 181; female, 128; human, 181; influence on fetus, 133; multiple, 3; "normal," 181; promiscuity, 171; see also homosexuality, sex
Shakespeare, William, 7, 93
shame, and AIDS, 172
Shapin, Steven, 189n7
Shapiro, Arthur K., 210n23
Shapiro, Judith, 218n24
Shapiro, M.F., 256n80
Shaw, Margery W., 246n94
Shaw, Peter, 35, 200n39
Sherry, Michael, 190n17
Short, R. V., 219n25
Shyrock, Richard Harrison, 202n54
sickness, differentiated from disease and illness, 8
Siegel, Riva, 152, 244n85, 245n86–87
Siegel, Rudolph E., 199n34
signs, 29; objective, 52; part of medical case history, 31; and symptoms, 52
Simpson, Sir James Young, 229n84
Sims, James, 200n39
Singer, Linda, 180–182, 258n90, 258n96–97, 258n99
single-mother households, 153
"60 Minutes" report on Kimberly Bergalis case, 176
skin art, 2–3
skin, as boundary, 128
sleepwalking, influence on fetus, 133
smallpox, 129
Smellie, William, 145–146
Smith, David H., 208n4
Smith, Roger, 244n81
Smith-Rosenberg, Carroll, 121, 232n105
Smollett, Tobias, 244n83
Snow, C.P., 3
SOAP, acronym for parts of medical case history, 32, 53, 197n18, 203n65
social history, as part of medical case history, 31
social hygiene movement, 181
society: categories, 8; change in eighteenth century, 59; and construction of disease, 9; deviance, 20; disadvantage, 170; disruption, brought about by medical diagnoses, 20; fabric, 18; fears, 17; ideologies, 75, 77, 113; mores, 17; mutability, 83; norms, reinforcement, 171; order, 121; organization, 82, 84, 151; stigma, 21; undesirable elements blamed for disease, 171
socioeconomic problems, 153–154, 163, 169

sodomy, 85, 92
soma, 4, 149
somatic narrative, and AIDS, 17
Sontag, Susan, 164, 252n30
Spallanzani, Lazzaro, 147
Spence, Donald P., 198n27, 208n4
spermaticism, 147
spermatozoa, 146, 148
spirochetes, 11
sports, *see* Gay Games
Sprat, Thomas, 200n42
Squier, Susan M., 248n100
St. Bartholomew's Hospital, 48
St. Vitus' Dance (Sydenham's Chorea), 57–58, 65, 208n3; and Samuel Johnson, 65
Stafford, Barbara Maria, 129, 131, 238n25, n28, n30, 240n37, 242n61
Staiano, Kathryn Vance, 207n95
Stakes, John W., 212n34
Stallman v. *Youngquist,* 154, 246n97
Stallybrass, Peter, 232n103
Starobinski, Jean, 212n37
statistics, developed from medical records, 42; medical, 52; morbidity and mortality, 52
Stead, William W., 206n93, 206n94
sterility, 118
Sterne, Laurence, 199n30
Steudel, Johannes, 194n4
stigmatization, 129, 168–169, 180, 191n27; AIDS, 165; social, 104
Stillingfleet, Edward, 132, 240n39
Stoddard, Thomas B., 254n54
Stoeckle, John D., 194n4
Stone, Sandy, 218n24
Stonewall uprising, 181
story-telling, 186; cultural functions of, 13; medical, 6, 9; and physicians, 25
"straight," 159, 166
Straub, Kristina, 215n8
stroke, 66–67, 69–73
style, cultural norms for, 12
subculture: gay, 163; marginalized, 180; underground, 83
substance use, *see* drug use
suffrage, 109; and hermaphroditism, 108; *see also* voting
suicide, and Herculine Barbin, 112
supersexuality, 111
Supreme Court, *see* U.S. Supreme Court
surgery, 80, 83, 110, 117–118, 120, 122; ability to alter sexual anatomy, 115, 116; gender construction, 116; genito -urinary, 104; and hermaphroditism, 90; sex reassignment, 80, 86–87
Susman, Joan, 191n27
Suydam, Levi, 107–108, 113, 120, 217n19
Swift, Jonathan, 238n23
Sydenham's Chorea, *see* St. Vitus' Dance
Sydenham, Thomas, 35–39, 45, 201n47
symptoms, 29; part of medical case history, 31; and signs, 52; subjective, 52

syphilis, 11, 169, 171; *see also* disease, epidemic
systematic outline for producing and maintaining patient records, 39–40
systems review, as part of medical case history, 31

T-cell count, 12; *see also* AIDS, HIV
taboo, 180; against homosexuality, 84
Tamm, Johanna M., 220n35
Tardieu, Auguste-Ambroise, 111, 114, 228n81–83, 230n86
Tatlock, Lynne, 240n40
tattooing, 2
Taussig, Michael T., 53, 206n92
taxonomies, 121, 180; gender, 122
Taylor, Alfred Swaine, 108–109, 118, 227n73–74
Taylor, F.D., 189n6
Taylor, F. Kräupl, 189n13
Taylor, Janelle Sue., 237n19
technology, 53; effect on diagnosis, 48; prenatal, 154; twentieth-century, 53
teenagers: pregnancy, 163; sexual activity, 174; *see also* sex
Temkin, Owsei, 37, 190n16, 199n34, 201n43, 206n88, 206n91
teratology, 21, 83, 137, 142; etymology, 99; semeiotics, 104; *see also* monsters
testosterone, 103
textile-rending metaphor for AIDS epidemic, 18
theater, and sexual ambiguity, 82–83
"Third World," and AIDS, 164
Thivel, Antoine, 194n4
Thomas, Keith, 240n38
Thompson, C.J.S., 220n36
Thompson, Richard, 79, 81, 121, 214n6
Thrale, Hester, and Samuel Johnson, 57, 70
thrush, 12, 175
Ticknor, Dr., 107–108
tics, *see* Tourette Syndrome
Tidy, Charles Meymott, 86, 217n19
Tillotson, D. J., 119n84
tobacco, use during pregnancy, 127
Tofts, Mary, *see* "rabbet woman"
Tokars, J.I., 256n80
Tom Jones, 34, 198–199n30
tongue-piercing, 12
Tourette Syndrome, 66–68, 210n23, 210n24; and Samuel Johnson, 66–67
Tourette, Gilles de la, 66
Townshend, Gary L., 199n34
toxins, environmental and workplace, 156
Tracy, Carol E., 153l, 245n91
"traditional family values," 181
transsexualism, 22, 80, 116; civil status, 86–87
transvestism, 82, 83; *see also* cross-dressing
travel during pregnancy, 126, 138, 152
Treichler, Paula, 164, 165, 249n3, 252n26, 31; 252–253n33; 253n35, 37
Trindel, Robin M., 247n97

Tristram Shandy, 199n30
Trumbach, Randolph, 215n8, 231n98
Tuana, Nancy, 242n69
tuberculosis, 169, 171
tumors, virilizing, 103
Turner's Syndrome, 79
Turner, Daniel, 129–130, 132, 137, 142–144, 146, 148, 238n26, 238n28, 242n62
Tweedy, Ernest Hastings, 238n29
Twelfth Night, 93
21–hydroxylase deficiency, 79
"two cultures," 3
Tyler, Carole-Anne, 219n24
typhoid, 169, 171

U.S. Armed Forces, *see* armed forces
U.S. Supreme Court, 125–126, 157
unemployment, 154–155, 169
United Nations High Commission for Refugees, 5, 188n11
urban life: despair, 163, 169; U.S. ghettos, 182

vaccines, 164; for AIDS, 18
"variation" vs. "abnormality," 103
Vaughan, George Tully, 229n84
Veith, Ilza, 190n16
Vess, David M., 202n54
Veyne, Paul, 196n12
Vicinus, Martha, 215n8
Vicq d'Azyr, Félix, 123
Vienna, clinical center at, 37
Vieth, Ilza, 212n33
Villey, Raymond, 194n4, 207n95
Virchow, Rudolf, 7–10, 32, 188n1, 188n2, 189n3, 189n8–10
virus: discovery of, 10; human papilloma, 176; *see also* AIDS, disease
visibility: cultural, 159; and identity, 13
von Neugebeuer, Franz Ludwig, 220n35, 229n84
vote: 113, 120; right to, dependence on male sexual organs, 109; *see also* suffrage

Walker, William, 232n1
Walkup, James, 208n4
Wallace, Mike, 176
Walton, John N., 208n3
Ward, Edward, 214n8
Warkany, Josef, 243n72
Warner, Francis, 195n6
Warner, John Harley, 25, 26, 50, 194n4, 205n80
Warter, John Southey, 45, 204n71
Wartofsky, Marx W., 206n93
Watney, Simon, 169, 180–181, 250n11, 254n48, 258n95, 265n71
Wayne, John, 162
Wear, Andrew, 209n10
Weed, Lawrence L., 32, 197n18
Weeks, Jeffrey, 252n28
Weiss-Amer, Melitta, 235n13

welfare, 163
Western Blot test for HIV, 19
Westfall, David, 248n105
Weston, Kath, 216n9
wheelchairs, invisibility of people in, 13
Whitbeck, Caroline, 235n12, 245n92
White, Edmund, 257n85
White, Hayden, 33, 196n16, 198n24, 202n53
White, Patricia D., 235n12
White, Ryan, 250n7
Whitehead, Harriet, 231n98
Will, George F., 256n74
Williamson, Judith, 171, 255n60
Wilson, Adrian, 236n14
Wilson, Lindsay, 233n2
Wilson, Philip K., 238n28
Wiltshire, John, 210n21
wine, during pregnancy, 126; *see also* alcohol use, pregnancy
Winterson, Jeanette, 185, 258n1
Witschi, E., 219n28
Wittman, Juliet, 187n2
Wolff, Caspar Friedrich, 99, 147
"Woman or a Man?" 81–82, 121
womb, 99, 136, 138, 142, 152; as center of imagination, 133–134; dangerous, 123–156; diseases, 133; interior view, 135, 136
women, 121, 123–124, 125, 128, 151; and AIDS, 158, 164; cultural beliefs about, 128; descriptions in case reports, 58; and HIV, 157–158, 164; imagination associated with, 151; ownership of bodies, 154; as pack animals for fetuses, 158; reproductive roles, 152; reproductive rights, 127, 157; restraints on, 152; right to privacy, 154; social place, 152; and state, 152; wants, 135
Wood, P. H. N., 191n24
Woodbridge, Linda, 214n7
Woodhouse, Annie, 216n10
workplace and environmental toxins, 156
World Health Organization, 14, 191n26
Written on the Body, 185
Wyman, Jane, 162

Yarrell, William, 225n66
Yedidia, Michael J., 256n80
yellow fever, 11, 169, 170, 171
yellow star, 167
Yingling, Thomas, 172, 255n65
Young, Iris Marion, 165–166, 247n99, 253n38

Zacchias, Paul, 92, Paulus, 222n42
Zeitlin, Froma I., 215n9
Zhirinovsky, Vladimir, 188n9
Zimmerman, Michael, 247n98
Zita, Jacqueline N., 243n77